ANATOMY *of* STEAMPUNK

The Fashion of Victorian Futurism

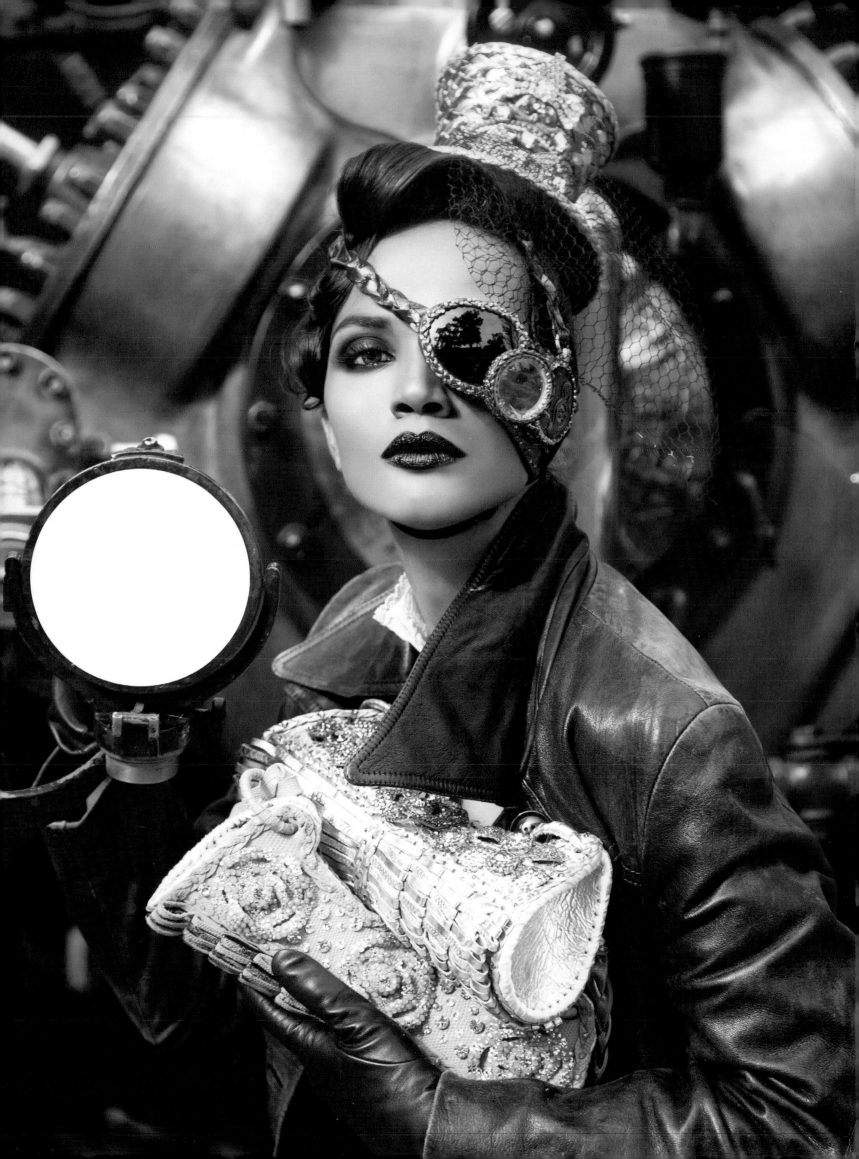

ANATOMY *of* STEAMPUNK

The Fashion of Victorian Futurism

Katherine Gleason

Foreword By K. W. Jeter
Introduction by Diana M. Pho

Race Point
PUBLISHING

Race Point
PUBLISHING

A division of Book Sales, Inc.
276 Fifth Avenue, Suite 206
New York, New York 10001

RACE POINT PUBLISHING and the distinctive Race Point Publishing logo
are trademarks of Book Sales, Inc.

DESIGNER Tim Palin Creative

ISBN-13: 978-1-937994-28-0

Printed in China

2 4 6 8 10 9 7 5 3 1

www.racepointpub.com

Contents

Foreword
by K. W. Jeter

Notes On Steampunk Fashion

I.

The goggles . . . everybody asks about the goggles. Possibly no more than a way of getting a leather-'n'-brass fetish right up there on the face, where everybody can see it, first thing. But maybe more—the rest of a styling steampunk ensemble might take a little while to be fully absorbed into the mundane observers' consciousness, but hit them right off the bat with either those perfectly circular optometrist-escapee lenses, with their disquieting mad scientist associations—yes, it's come to this; you're not only unhip, not caught up with this whole steampunk *mishegas* that has started bubbling up through the pages of the *New York Times* and the slick, glossy fashion magazines, but now you're being examined like a not-particularly-interesting bug under a microscope—or those bigger, teardrop-shaped jobs, perhaps with the additional glass segments at the side so they curve around the head a little bit, like something

K. W. Jeter is the author of Morlock Night, Dr. Adder, The Glass Hammer, Noir, *and other visionary science fiction and dark fantasy. In 1987, when discussing his novel* Infernal Devices, *he coined the term "steampunk." The sequel to that book is* Fiendish Schemes *(Tor Books, 2013). A native of Los Angeles, he currently lives in Ecuador.*

an insanely laughing terrorist-motorcyclist out of Fritz Lang's *Spione* would wear while vaulting right over you, on his way to blow up whatever *die Anarkisten* are annoyed about today. So yes, if the un-'punked onlooker is at least a little unnerved—which of course is the intent all along, *"Épater le bourgeois!"* always the battle cry as the *fashionistas* mount the downtown barricades—then fine, mission accomplished. There's that whiff of incipient violence that comes with accessorizing via old-school military gear. Or if not violence, then at least action, more or less the same thing. Even with the goggles pushed up to the ribbon band of a stylishly furry top hat, the effect is as if Amelia Earhart's adventure-ish great-grandmother has crashed your tea party. The Limoges cup might be held with pinkie properly extended, but the goggled young lady is prepared for chaos. *Anything could happen.*

II.

Anarchists, indeed. Steampunk fashion, with its home-grown DIY ethos, seems at least democratic—anyone can play— but the rebellious streak goes deeper than that. Basic unwritten and unquestioned tenets are thrown out the window. The tyranny of the body type is o'erthrown, something that my way cooler and hipper wife pointed out to me. Whereas Cosplay 1.0, happily percolating and gestating away in its Asian *Urgrund*, was predicated on its practitioners being insanely cute, five-foot-nothing, ninety-five-pound Japanese teenage girls, working out their *manga* fixations in some public park in Tokyo, steampunk lays down no such strictures. *Everybody looks good in it.* To the degree that there *are* strictures, they're of the corset-'n'-laces variety, Scarlett O'Hara's holding-on-to-the-bedpost undergarment all kinked out now in studs and glossy black leather. Which is, of course, a look that requires a certain degree of what politically incorrect admirers of the female form would once have rudely described as "meat on the bone." If those clods aren't saying that now, it's because they've discovered along with other men that they can get in on the action as well, be they whippet thin or sturdy as an ox, or even several oxen combined. Bristly tweeds and Dr. Watson-ish waistcoats slung with chains heavy enough to pull the *Queen Mary* to port—it all fits the steampunk aesthetic. Why should the girls have all the fun?

III.

But even as we try to put our finger upon it and say, *This is what it is*—it's slithering out from under our analytical digit like quicksilver. If there were no prescriptive rules at the beginning of steampunk fashion, then by now there are *anti*-rules, a relentless push and mad rush toward mutation and a furious inventiveness. As the mode's adherents have vaulted forward into a past that never was but should have been, the further escape routes lie along an orthogonal axis. Even in duller reality, there was a whole world beyond Victorian London's smoky cityscape. The sun might never have set on Kipling's Empire, but in refusing to do so, it also revealed everything else that was going on at the same time. To smash history and reassemble the pieces—which is what steampunk literature attempts to do, at least some of the time—leaves the prison of our hitherto stifled imagination much more fragile than before. Anything can push its way through the hissing cracks now. If someone considers herself or himself free to dress not just anachronistically—outside of Time, *as it were*—then it's just as possible to dress *anti*-chronistically: not just outside of Time as it happened, but outside of Time as we've been taught it *must* have happened. This is a liberating thing to bring into one's mind. Steampunk fashion, as a way of having fun, is all it has to be; it doesn't need to be any deeper than that. But maybe, just maybe, it might be a little more. We don't just look at someone wearing goggles; someone is looking back at us, through those lenses. What does she see?

K. W. Jeter
Ecuador
2013

Welcome to the Worlds of Steampunk Fashion!

An Introduction by Diana M. Pho

Diana Pho, also known in the steampunk community as Ay-leen the Peacemaker, gives some brief comments about steampunk fashion.

What is steampunk?

Steampunk re-imagines a better yesterday today. An aesthetic movement inspired by nineteenth-century science fiction and fantasy, steampunk encompasses literature, design, technology, music, film, gaming, theater, and, of course, fashion. Steampunk style is best known for combining intense retro-futuristic detailing with modern sensibilities. Wisps of the past are woven into the fabric of the present to construct the architecture of an alternate future. History, science, and art combine to create enthralling displays that provoke wonder and awe for a world that never was.

Anatomy of Steampunk tracks the various paths that steampunk fashion has taken. The word "steampunk" was coined by science fiction author K. W. Jeter more than twenty years ago—which is why we are so honored to have him write the Foreword of this book! One element of steampunk fashion, then, comes from the fantastic possibilities presented in genre fiction. Initially, steampunk was used to describe anachronistic, Victorian science fiction novels. Now, the term has evolved. Today's science fiction authors and yesterday's literary greats—such as Jules Verne, H. G. Wells, Arthur Conan Doyle, and many more—built the worlds that inspire steampunk fashion. A sense of high-flying adventure, discovery, invention, and elaborate theatricality are intrinsic to steampunk outfits.

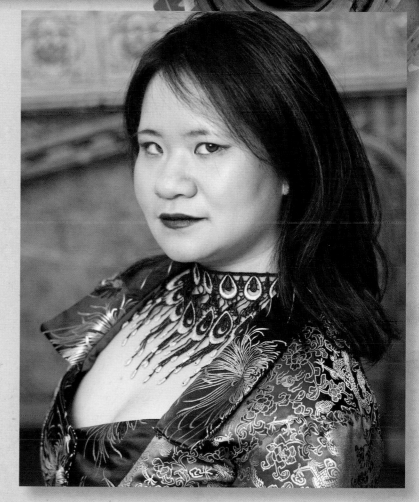

Diana M. Pho possesses a deep-seated love for science fiction and fantasy literature. In the steampunk community, she is known as Ay-leen the Peacemaker. She speaks about steampunk and social issues at conventions across the United States and runs the multicultural steampunk blog Beyond Victoriana. *Her non-fiction writing has appeared on science fiction and pop culture blogs such as* Racialicious, Tor.com *and* Steampunk Magazine, *and in the books* Steampunk Reloaded II *(Tachyron Publications, 2010), and* Fashion Talks: Undressing the Power of Style. *Pho holds a dual degree in English and Russian Literature and Culture from Mount Holyoke College. She currently lives and works in New York City.*

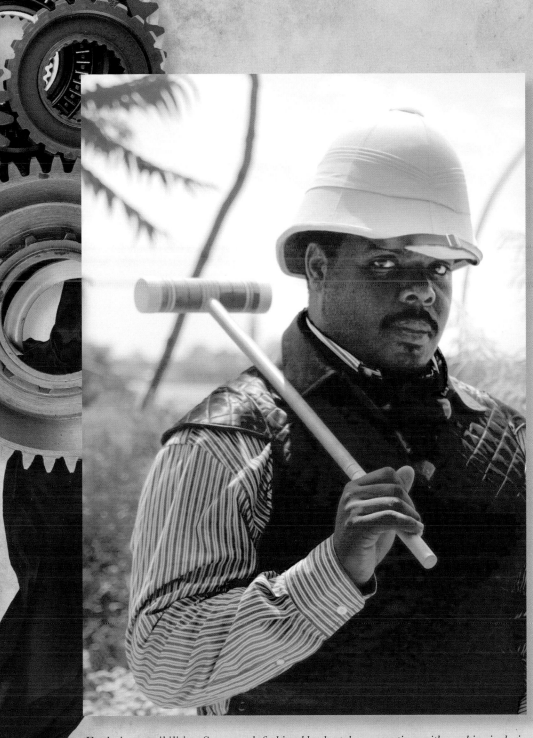

History is another element of steampunk fashion. During the nineteenth century, the Industrial Revolution, global exploration, and dramatic warfare transformed the face of the globe. Inspired by these real-life events and by the period's heightened sense of possibility, steampunk fashion embodies the dreams of the era while infusing grit and romance into our modern design.

Like a two-faced coin that signifies this quickly changing historical era, steampunk fashion is also about highlighting contradictions. Metalwork and leather combined with satin and lace. Warm browns and creams mix alongside vibrant colors. Bustle skirts and tailcoats fit in with gritty shirtsleeves or ripped fishnets. Bowlers, top hats, pageboys, pith helmets, and aviator caps adorn the heads of men and women alike in a shared sense of play. The luxurious corset complements full-length dresses, flaunting sexuality while preserving modesty. The dandy and the military officer, the frontier school marm and the baroness, the street rat and the reclusive mad scientist are all figures present in the steampunk scene. The wearer cuts a dapper figure while also playing a joke at the stodginess of history.

Exploring possibilities: Steampunk fashion blends styles across time with a whimsical air.

Both our real and imagined pasts foster a sense of technological possibility (and some impossibilities) reflected in steampunk tastes. Steampunk fiction takes pride in contraptions: the time machine, the Babbage engine, the clockwork automaton, and the dirigible. Thus, steampunk outfits often contain mechanical bits and pieces like gears, cogs, bolts and screws, brass piping, and wire. Accessories become key; no steampunk outfit is complete without a watch fob or that indispensable pair of goggles.

Finally, out of the shock of the old explodes the rebellion of the new. Steampunk fashion is often confused with neo-Victorian styles. Steampunk, however, by combining various sartorial influences, is so much more than an offshoot of the Victorian. Other subcultures—punk, goth, cyberpunk, burner, maker, and even Japanese anime and cosplay culture—have also impacted steampunk fashion. Cultural fusion occurs as nations speak through their clothes, combining traditional fashions from all backgrounds. Steampunk fashion gives a tip of the hat and the flip of the bird to the blandness of today's minimalism and mass-produced style in favor of the individual, handcrafted aesthetic. No two steampunks ever look the same. This is one of the ways that "punk" lives on in steampunk.

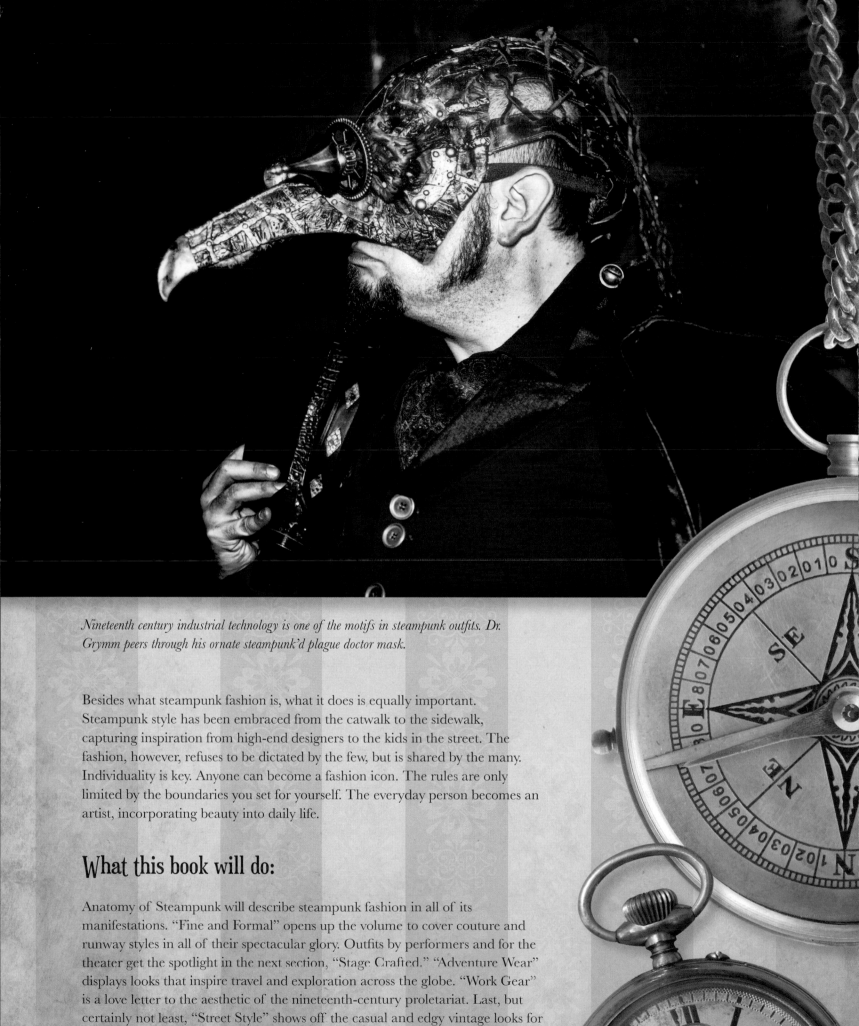

Nineteenth century industrial technology is one of the motifs in steampunk outfits. Dr. Grymm peers through his ornate steampunk'd plague doctor mask.

Besides what steampunk fashion is, what it does is equally important. Steampunk style has been embraced from the catwalk to the sidewalk, capturing inspiration from high-end designers to the kids in the street. The fashion, however, refuses to be dictated by the few, but is shared by the many. Individuality is key. Anyone can become a fashion icon. The rules are only limited by the boundaries you set for yourself. The everyday person becomes an artist, incorporating beauty into daily life.

What this book will do:

Anatomy of Steampunk will describe steampunk fashion in all of its manifestations. "Fine and Formal" opens up the volume to cover couture and runway styles in all of their spectacular glory. Outfits by performers and for the theater get the spotlight in the next section, "Stage Crafted." "Adventure Wear" displays looks that inspire travel and exploration across the globe. "Work Gear" is a love letter to the aesthetic of the nineteenth-century proletariat. Last, but certainly not least, "Street Style" shows off the casual and edgy vintage looks for everyday wear, taken from the streets of New York to Tokyo.

In the spirit of the steampunk community's optimism and with a punk attitude against the norms of the fashion industry, this book presents the wide variety of people who embrace steampunk fashion. Young and old, different sizes and abilities, people of various cultural and racial backgrounds: These are the people of steampunk.

More than a simple look book, Anatomy of Steampunk also offers readers a chance to create their own steampunk designs. Between each section, professional craftsmen Noam Berg and Won Park provide detailed projects to kindle the fires of your own personal creativity.

Age-old beauty with a razor-edge twist, lasting quality in a throwaway culture, accessibility to everyone, and the elaboration of the imagination: These ideas are the ethos of steampunk fashion. So what should this fashion book mean to you, dear Reader? It wasn't written to dictate to you; it is here to inspire and involve you. Steampunk is a verb now. Enjoy the journey as we lead you through the worlds of steampunk fashion. Then go forth, have fun, and retro-style your life as you see fit.

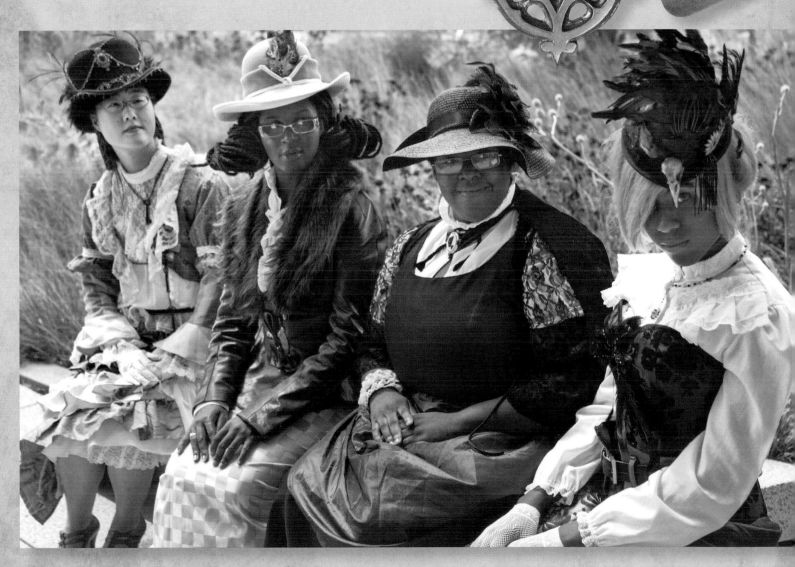

Let's never forget to add some "punk" to our steamwear.

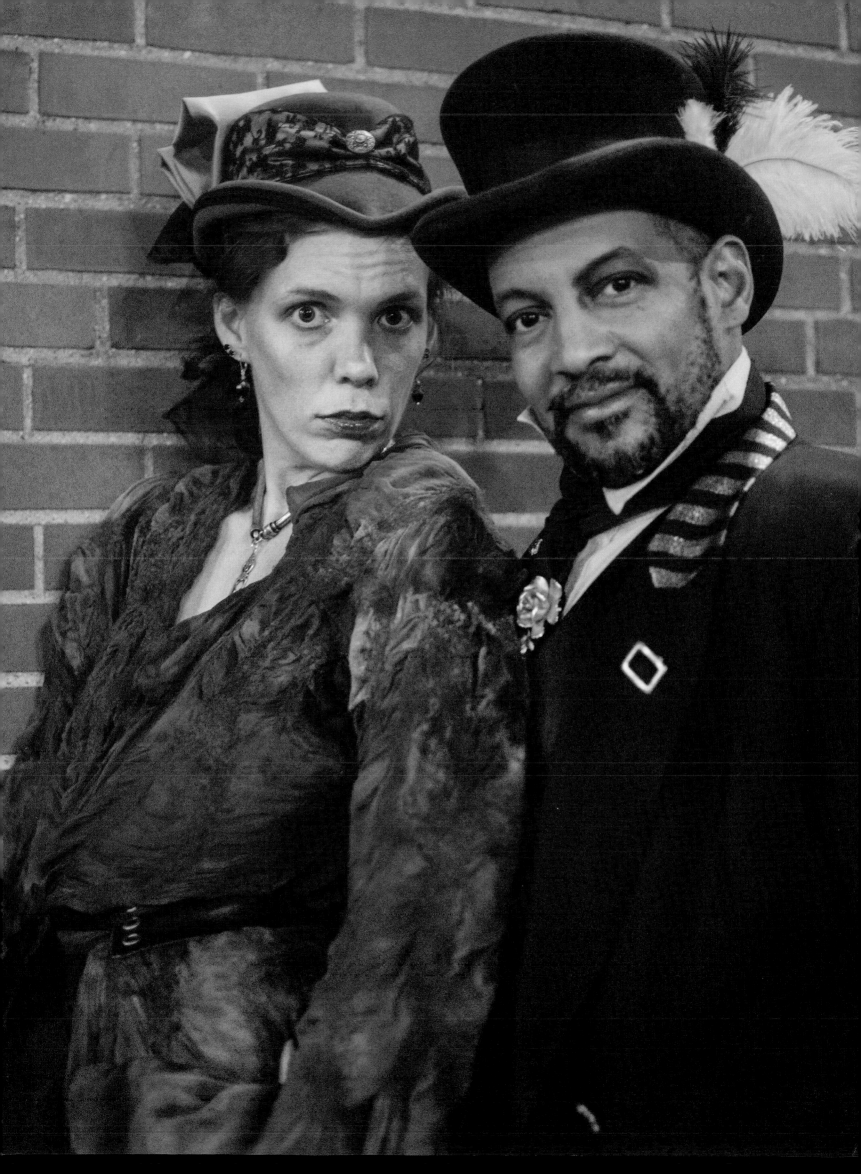

CHAPTER ONE
FINE AND FORMAL

THE STEAMPUNKS ARE GATHERING IN NEW YORK. DRESSED IN THEIR FINERY, THEY FLOCK FROM AS FAR AWAY AS BOSTON AND WASHINGTON, D.C., FROM THE NEIGHBORHOODS OF BROOKLYN, AND FROM JUST DOWN THE STREET. THEY COME TOGETHER TO ENJOY AN EVENING OF STEAMPUNK MUSIC AT A CAFE IN MANHATTAN'S EAST VILLAGE. THEY ATTEND TO SUPPORT THE MUSICIANS, TO ENJOY EACH OTHERS' COMPANY, AND TO TALK CLOTHES. CLOTHES ARE A MEANS OF SELF-EXPRESSION, A WAY OF COMMUNICATING IDENTITY AND BELONGING, AND A MARKER THAT EACH INDIVIDUAL HAS MADE THE CHOICE TO LEAD A REFINED LIFE, A LIFE OF CREATIVITY, TRADITION, INNOVATION, AND BEAUTY.

Once fine and formal steampunk dress centered on the archetypical aristocrat, a romantic character drawn from the upper classes of an imagined Victorian London. Today steampunk is much more than recreations of such Victorian garb. Steampunk style is growing to encompass many different concerns and traditions. This chapter presents fashion confections derived from various lands—elegant dresses, corsets and waistcoats, kimono and haori, and repurposed sari silks—all refracted through the lens of retro-futuristic steam.

Mary Holzman-Tweed, a jewelry and accessories designer, wears a thrifted full black skirt. Her overskirt is actually a hooded cloak that she has tied over her hips and pinned up for a bustled silhouette. Her jacket is crafted from the same fabric as her cloak comme bustle—silk chiffon and wool. Both pieces were purchased at a Faerie event some years ago. Holzman-Tweed cinches her waist with a lace-up belt that adds flair without resorting to a corset. Her look is topped off with a hat obtained from an Etsy vendor. Phil Powell, a Washington, D.C.–based dandy, is known for his sharp suits, love of colors, and for the dashing feather in his hat.

OPPOSITE PAGE *Mary Holzman-Tweed and Phil Powell in New York City.*

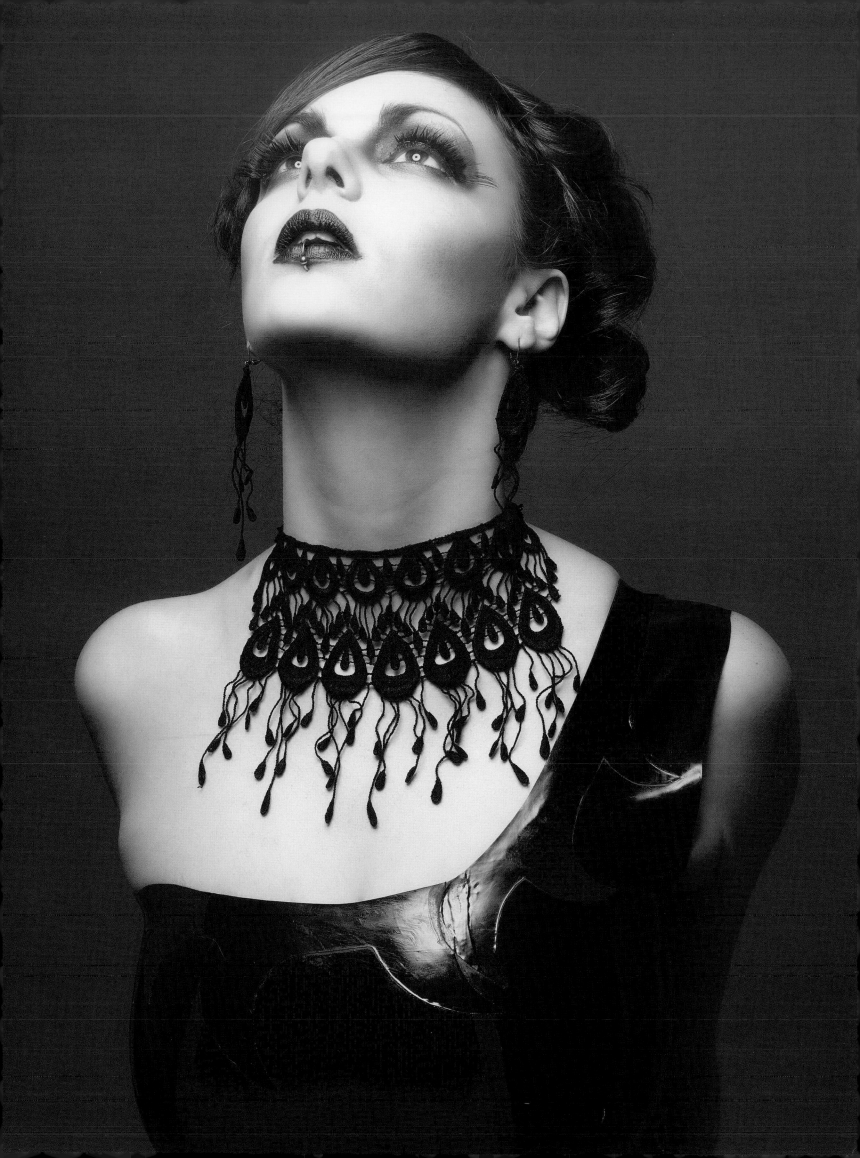

Muses Well

Designer Mary Holzman-Tweed, who sells her Muses Well line of accessories at craft events and steampunk conventions and on Etsy, had dabbled with art and design projects since childhood, but it was not until she became a part of the steampunk community that she found her artistic wings and then opened her own shop. While once she wore clothing crafted by others, today she appears at steampunk events decked out in items she has made or modded herself. As a creator of accessories, she particularly likes to work with natural materials and with venetian lace, which she finds to be both versatile and sturdy. She crafts a range of items from this type of lace, including earrings, half-gloves—a steampunk staple—and hair ornaments.

In a lace peacock choker, model Leah Siren is powerful and glamorous, with a dollop of the old-fashioned. The softness of the venetian lace gives her a handcrafted, historic feel.

The feathers at the model's neck frame her face, lending drama, lightness, and a sense of fantasy. She is the heroine of her own story, a grand diva, a fairy queen, a glamorous, old-time Disney villainess. At the wrist, feathered gauntlets, with their ornate gathers, highlight the grace of her hands and reinforce the illusion—she could take flight, soaring through the skies and dancing into our dreams.

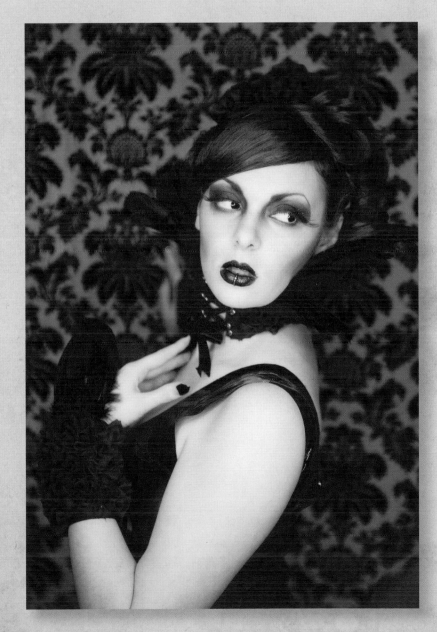

RIGHT *In a feathered collar and gauntlets, Leah Siren embodies glamour and fantasy.*

OPPOSITE PAGE *This peacock choker is handcrafted from venetian lace.*

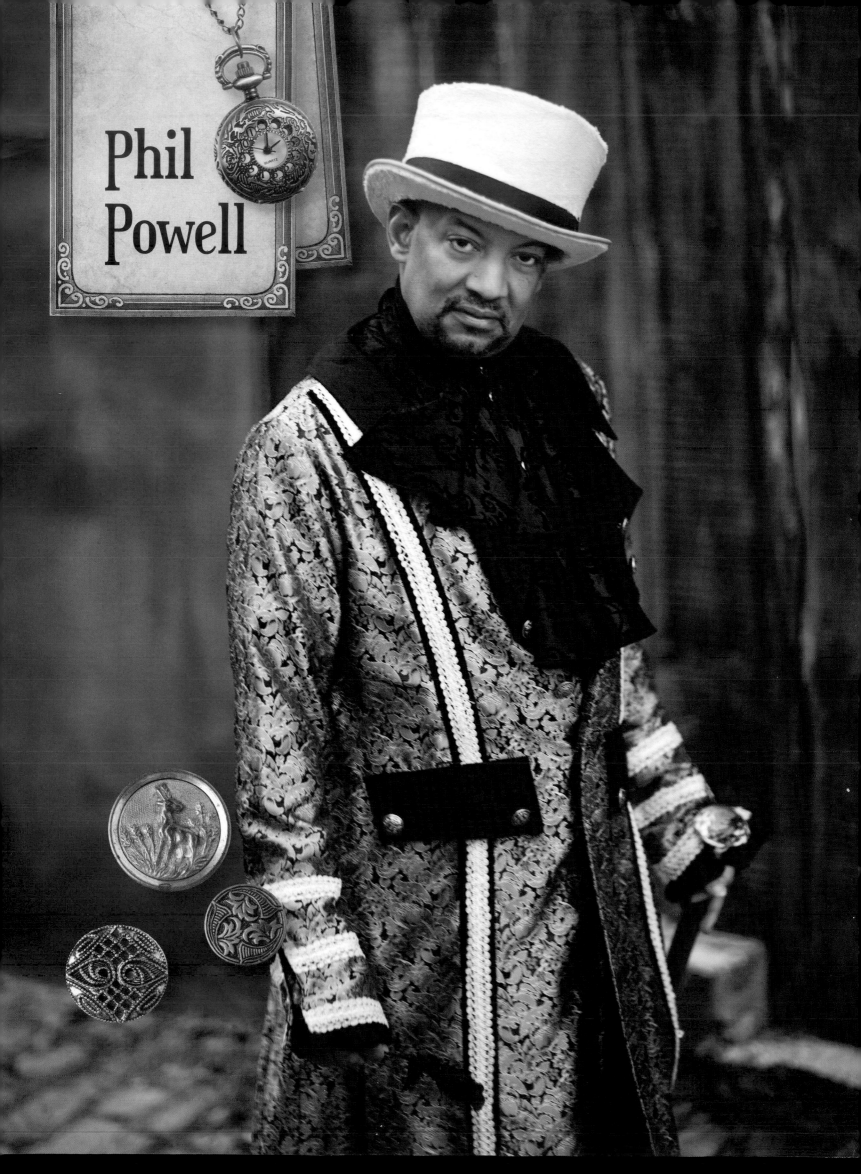

Phil Powell

Phil Powell, a self-described dandy, owns thirty hats. He says he always wears one as he "was not blessed with long hair." Powell, who used to be part of the goth world, gathers the elements of his outfits from a range of sources, from large chain department stores to thrift shops to having pieces custom made. In describing his style he says, "Combine pure fantasy with twists on ancient mythology, and sprinkle lightly with drag queens, and you get an idea of how I dandify." Here Powell models two different looks: a black hat trimmed with black and yellow feathers above a thrifted black jacket with a glittering striped collar, and a large white hat with a long brocade coat from Gothic Renaissance in New York City and a cane.

Powell cites a number of people as his steampunk muses, those who helped to start him off, including members of the band The Uprising of the Gin Rebellion; Anthony Canney of the House of Canney; Matthew Ellenwood and Keith Green, two dapper gentlemen from Chicago; and Kory Doyle from the San Francisco Bay Area, cofounder of the steampunk convention Clockwork Alchemy.

OPPOSITE PAGE *Powell shows a bit of his goth roots in a coat from Gothic Renaissance.*

RIGHT *In addition to a feathered hat, Powell wears a black coat with an unusual collar that he snagged at a thrift shop.*

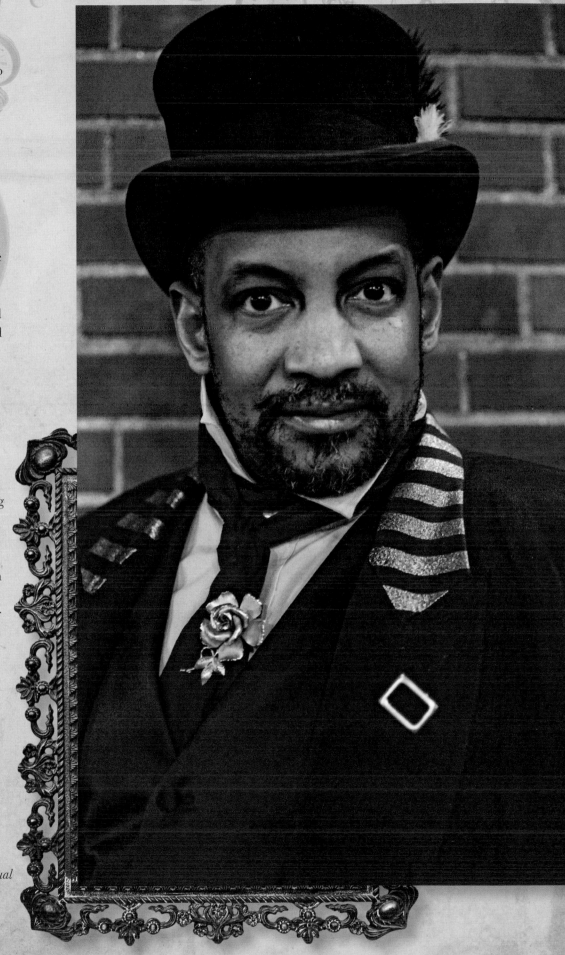

Clockwork Couture

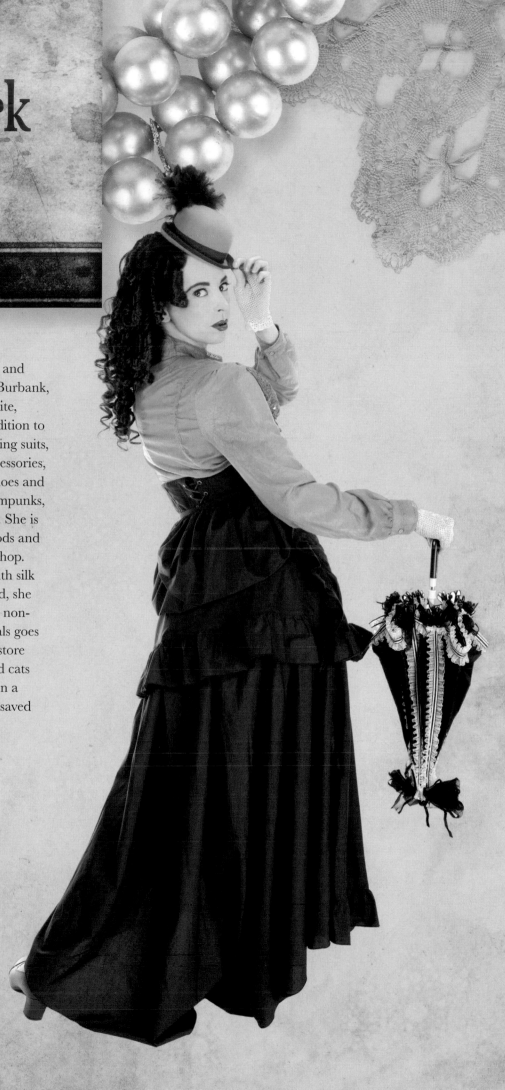

Here Donna Ricci, designer, model, and president of Clockwork Couture, a Burbank, California-based boutique and website, models two of her ensembles. In addition to elegant gowns, Victorian-style traveling suits, and all the necessary steampunk accessories, Clockwork Couture carries vegan shoes and faux-leather jackets. Like many steampunks, Ricci strives to create a better world. She is committed to selling cruelty-free goods and does not carry leather or fur in her shop. While Ricci sometimes sells items with silk trim or ones made from a wool blend, she ensures that all wool is sourced from non-mulesed sheep. Ricci's love of animals goes even further. Her brick-and-mortar store serves as a rescue hub for abandoned cats and small dogs. She has even taken in a rabbit and fostered a horse that was saved from a trip to the dog food factory. In addition to her dedication to the humane treatment of animals, a portion of the shop's profits is donated to programs that bring arts into the public schools.

This steampunk lady, wearing a cotton skirt and a top crafted from a modern synthetic blend, tips her hat in greeting.

But what of her clothes? Ricci's dashing brown ensemble is crafted from practical cotton and a modern synthetic blend. The bodice of Ricci's green taffeta traveling suit is accented with small fabric-covered buttons. The high collar is outlined with black lace. The full-length skirt sports modern conveniences—an attached bustle and train. Images of Ricci in this suit grace the covers of Gail Carriger's *Parasol Protectorate* series of novels, cementing her definitive style as that of a steampunk icon.

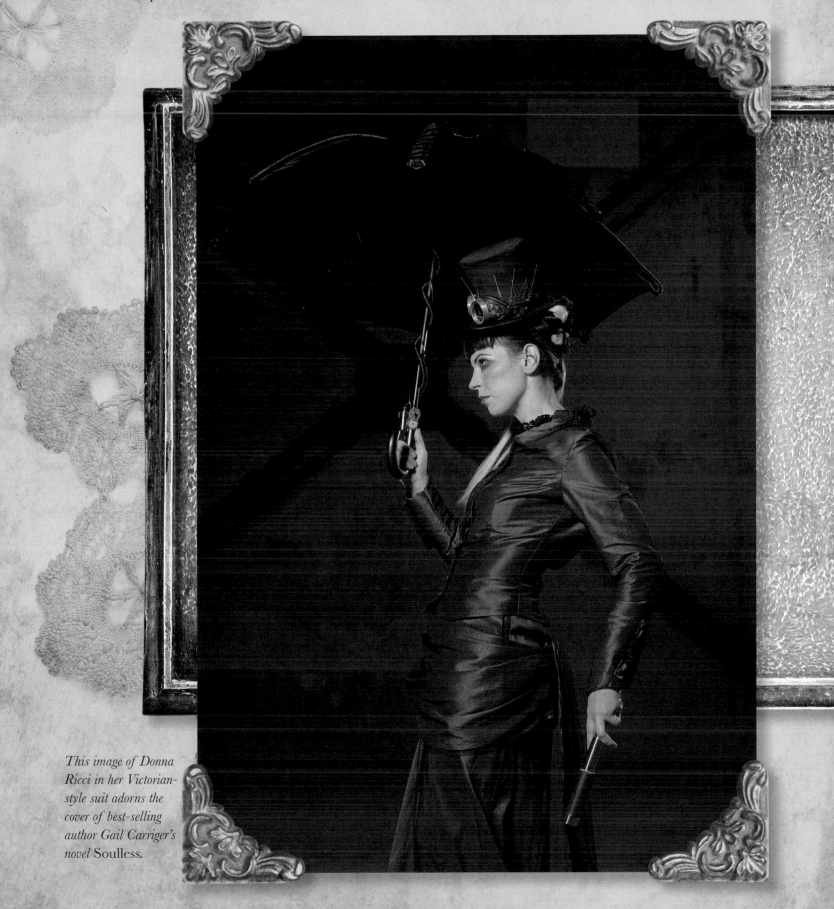

This image of Donna Ricci in her Victorian-style suit adorns the cover of best-selling author Gail Carriger's novel Soulless.

Festooned Butterfly

Angie Carter, a seamstress and fiber artist from Cincinnati, Ohio, possesses the imagination and nimble fingers that created these looks. Carter is the proprietor of Festooned Butterfly, a specialty store and custom shop, which focuses on handcrafted steal-boned corsets, vintage clothing, made-to-measure garments, and costume pieces.

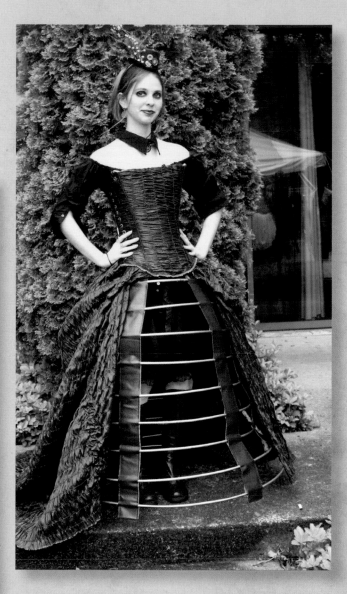

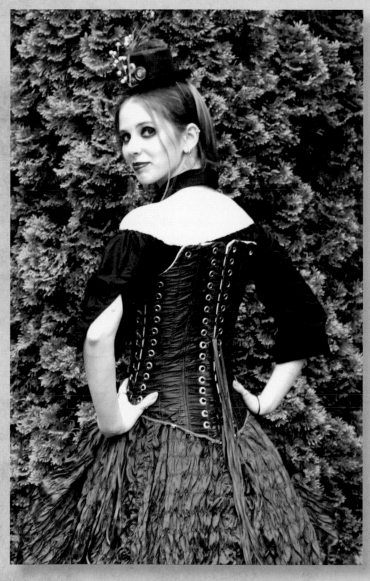

From the back, this frock seems like proper period ladieswear, but the front tells a different story.

Here Samara Martin, in an overbust corset, looks back at the camera. The crushed copper satin of her full skirt cascades to the ground. Then she turns, revealing her exposed crinoline, black velvet bloomers, and bright red boots. While this crinoline is based on historic designs, it has been updated. Not only does it reveal its structural secrets but it is constructed from leather and industrial copper pipes.

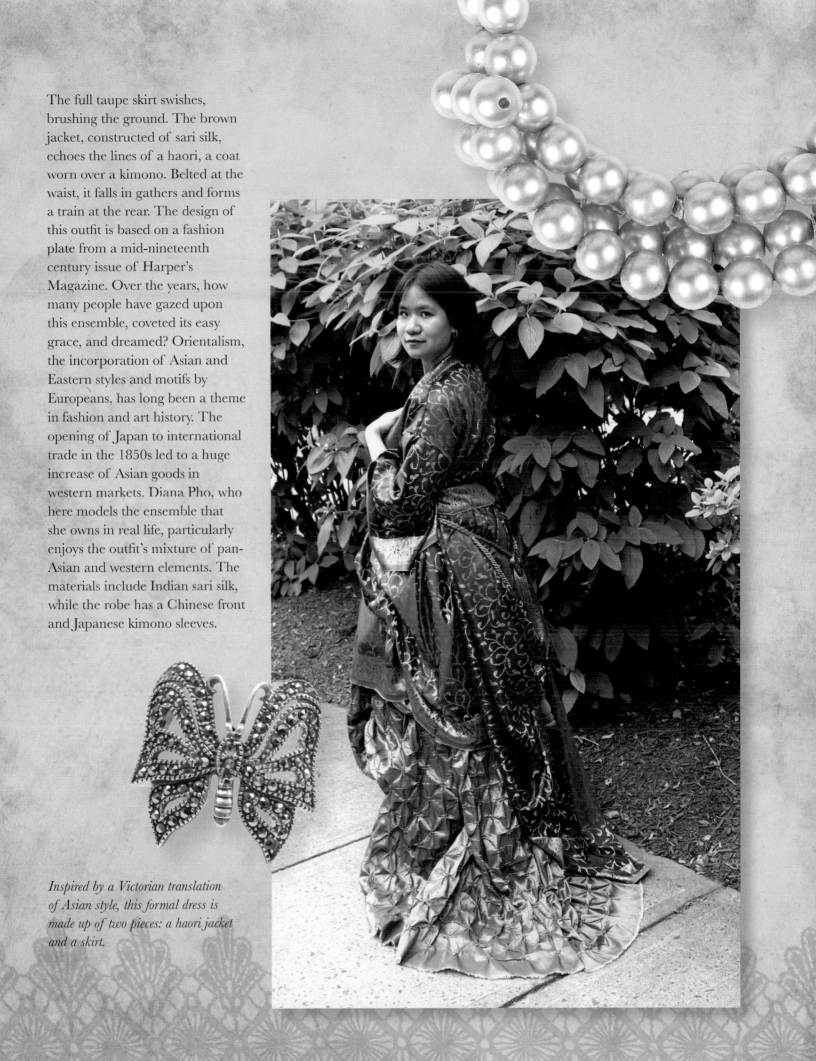

The full taupe skirt swishes, brushing the ground. The brown jacket, constructed of sari silk, echoes the lines of a haori, a coat worn over a kimono. Belted at the waist, it falls in gathers and forms a train at the rear. The design of this outfit is based on a fashion plate from a mid-nineteenth century issue of Harper's Magazine. Over the years, how many people have gazed upon this ensemble, coveted its easy grace, and dreamed? Orientalism, the incorporation of Asian and Eastern styles and motifs by Europeans, has long been a theme in fashion and art history. The opening of Japan to international trade in the 1850s led to a huge increase of Asian goods in western markets. Diana Pho, who here models the ensemble that she owns in real life, particularly enjoys the outfit's mixture of pan-Asian and western elements. The materials include Indian sari silk, while the robe has a Chinese front and Japanese kimono sleeves.

Inspired by a Victorian translation of Asian style, this formal dress is made up of two pieces: a haori jacket and a skirt.

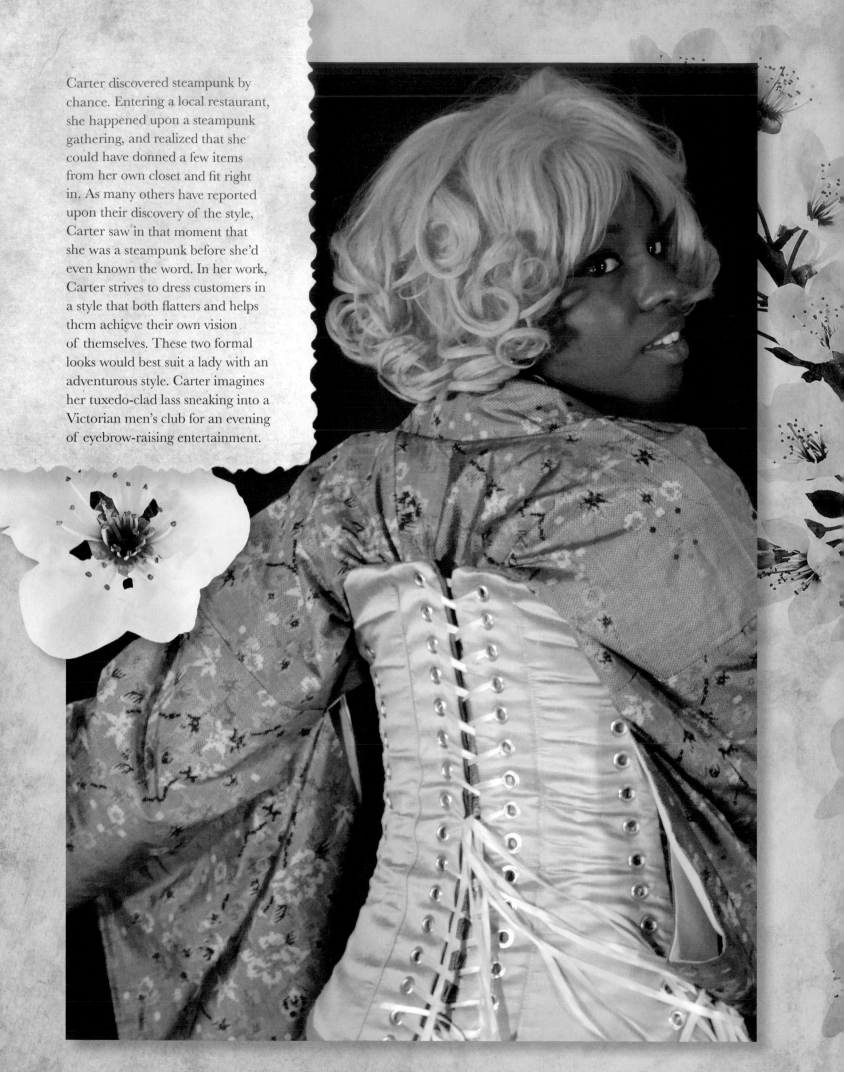

Carter discovered steampunk by chance. Entering a local restaurant, she happened upon a steampunk gathering, and realized that she could have donned a few items from her own closet and fit right in. As many others have reported upon their discovery of the style, Carter saw in that moment that she was a steampunk before she'd even known the word. In her work, Carter strives to dress customers in a style that both flatters and helps them achieve their own vision of themselves. These two formal looks would best suit a lady with an adventurous style. Carter imagines her tuxedo-clad lass sneaking into a Victorian men's club for an evening of eyebrow-raising entertainment.

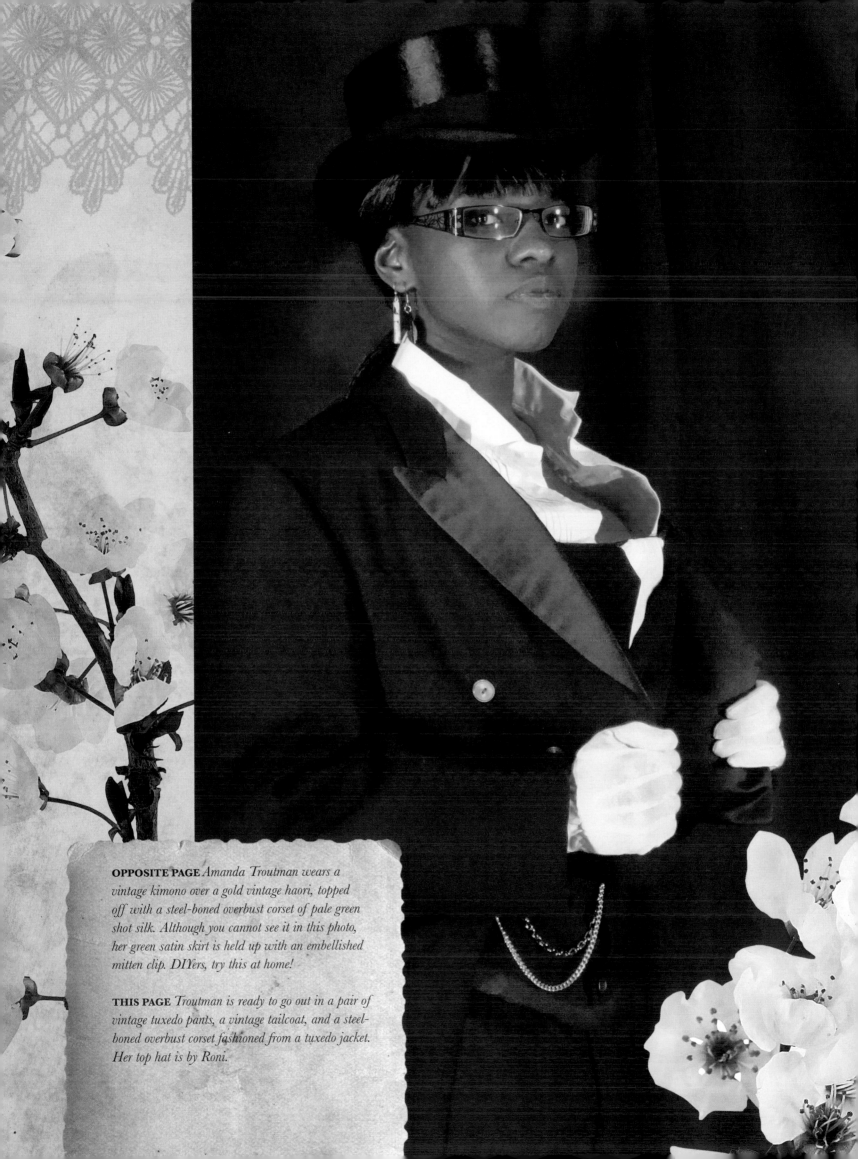

OPPOSITE PAGE *Amanda Troutman wears a vintage kimono over a gold vintage haori, topped off with a steel-boned overbust corset of pale green shot silk. Although you cannot see it in this photo, her green satin skirt is held up with an embellished mitten clip. DIYers, try this at home!*

THIS PAGE *Troutman is ready to go out in a pair of vintage tuxedo pants, a vintage tailcoat, and a steel-boned overbust corset fashioned from a tuxedo jacket. Her top hat is by Roni.*

Berít New York

Brit Frady-Williams, the designer and proprietor behind Berít New York, began sewing as a child and got into designing clothes as a teenager. She founded her label, which gets its name from her Hebrew name, in 2007. When Frady-Williams started out and was selling at craft fairs, other vendors said that her work looked steampunk. "At the time," she says, "and this still holds true, I was just designing what I liked, which tended to fall either into the Victorian or retro-futuristic categories." Frady-Williams did some research on steampunk and realized, like so many others, that she was already a part of it.

This Berít New York princess, a fairy light and quick, possesses powers beyond the ken of mere men. For a moment she is still, stopped by a thought, a memory. Or perhaps she is gazing into the future. In actual fact, model Keri Lynn Timlin is garbed in Berít New York's Fairy Warrior collection. She wears a floral headpiece crafted for Berít New York by Elena Minkina, a lace-up neckpiece with flower appliques at the shoulders, a blouse and corset, and a tiered lace-up microsuede skirt with chiffon panels. Our fairy is joined by Jocelyn Cattley, a sister sprite. Over her shoulders, she sports a velvet mini-jacket that laces closed at the front and features a chiffon overlay and chiffon sleeves. Below the jacket, a vinyl cincher with a tailcoat-style skirt encircles her waist. A vintage hat, a clockwork necktie, and a pair of tall, over-the-knee spats round out her look.

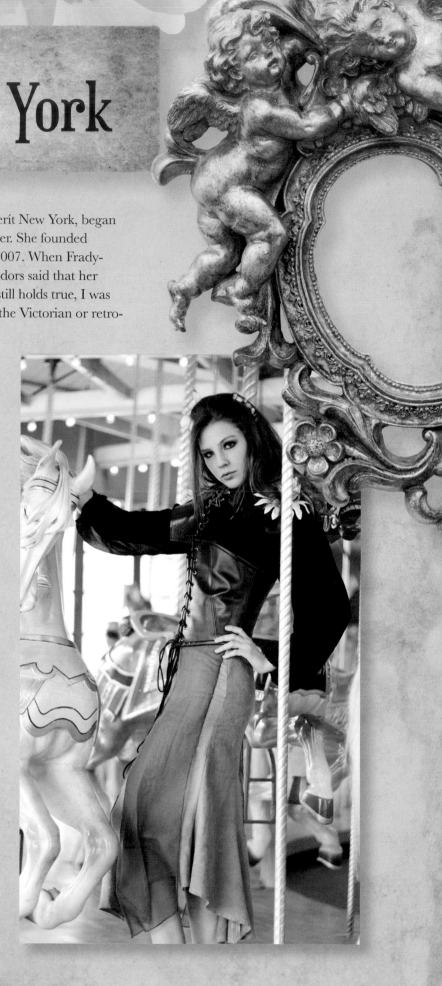

RIGHT *Berít New York's Fairy Warriors collection mixes otherworldly charms with historical touches for a contemporary look that embodies both fragility and strength.*

OPPOSITE PAGE *The laces on this jacket and waist cincher pass through sewn-in eyelets, a period detail that bumps up the quality and the allure.*

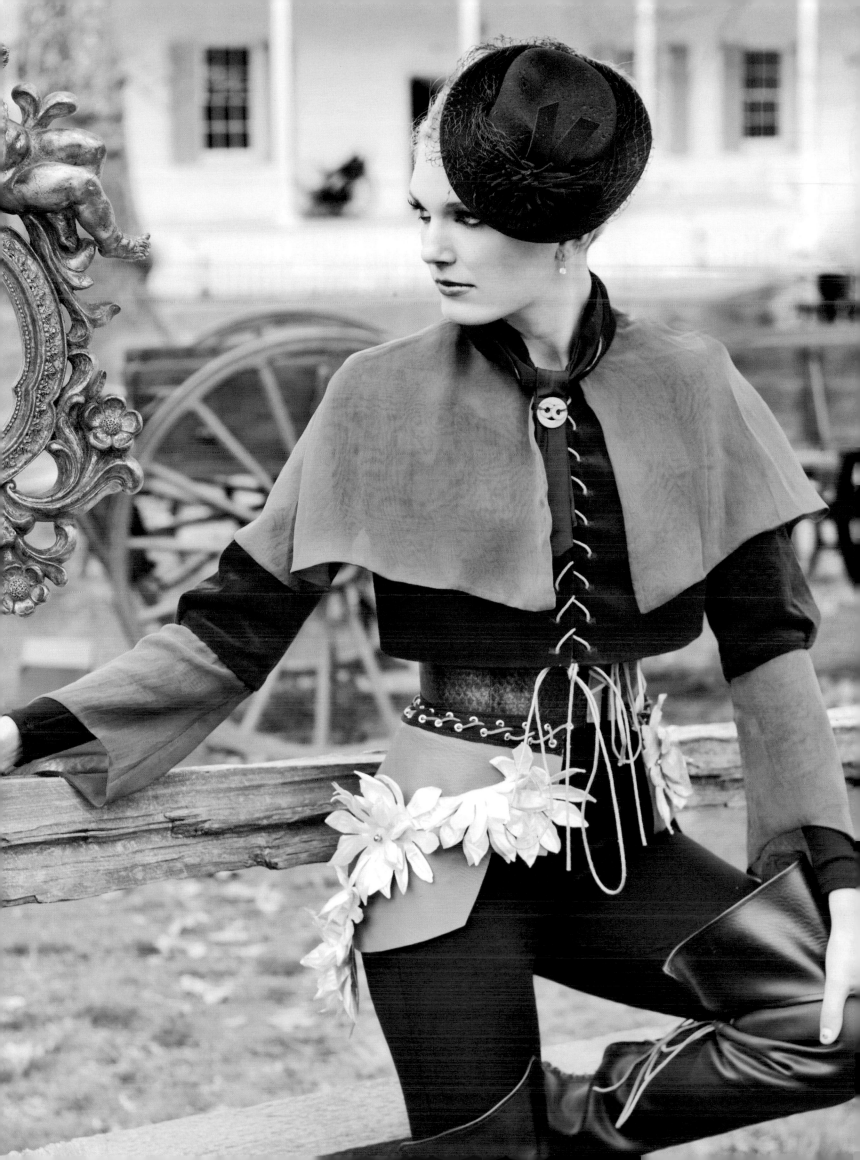

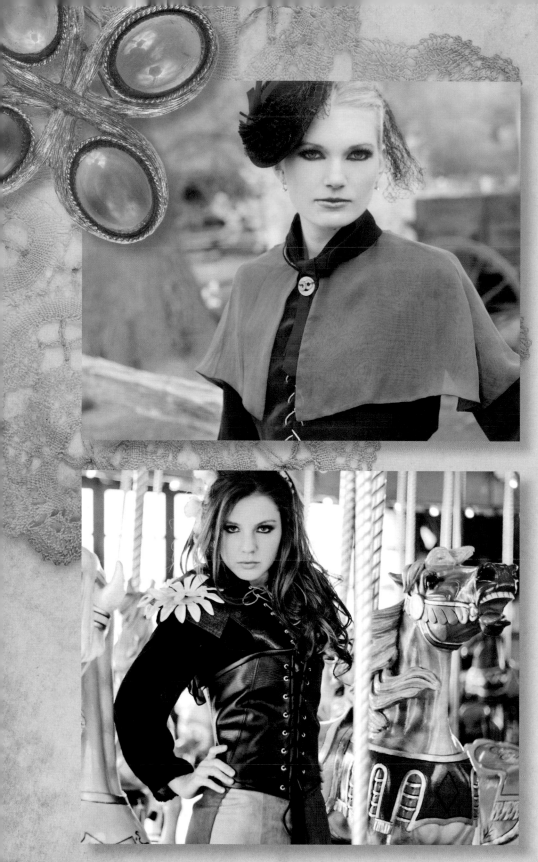

Berít New York's Fairy Warriors collection was inspired by medieval clothing. Yet it also recalls Victoriana by way of the Pre-Raphaelites, who often looked back to the Middle Ages. The designer points out that the clothing laces in this collection pass through sewn-in eyelets rather than metal grommets, in keeping with medieval style. The rich cotton velvets also hark back to that earlier era. The recounting of fantasy stories and fairy lore, popular pastimes in the steam era, inspired the whimsical floral décor, chiffon fabric, and draping.

The chill coming off the water is no match for this male model's warm cape. Crafted from 100% wool with cotton velvet side panels and a satin lining, this outdoor look draws from both medieval and Victorian fashions. With the addition of a top hat, a pocket watch with a chain, and a pair of goggles, this outfit would become steamier still.

In addition to designing clothes, Frady-Williams has co-produced steampunk events and has organized fashion shows at both steampunk and fantasy conventions. Currently, her wares are available at local markets and at steampunk and club events, and she takes custom orders through the Berít New York website.

ABOVE *These fairy warriors seem ready to fly off to a luxurious event.*

OPPOSITE PAGE *Inspired by medieval and Victorian fashions, this cape is steamily warm.*

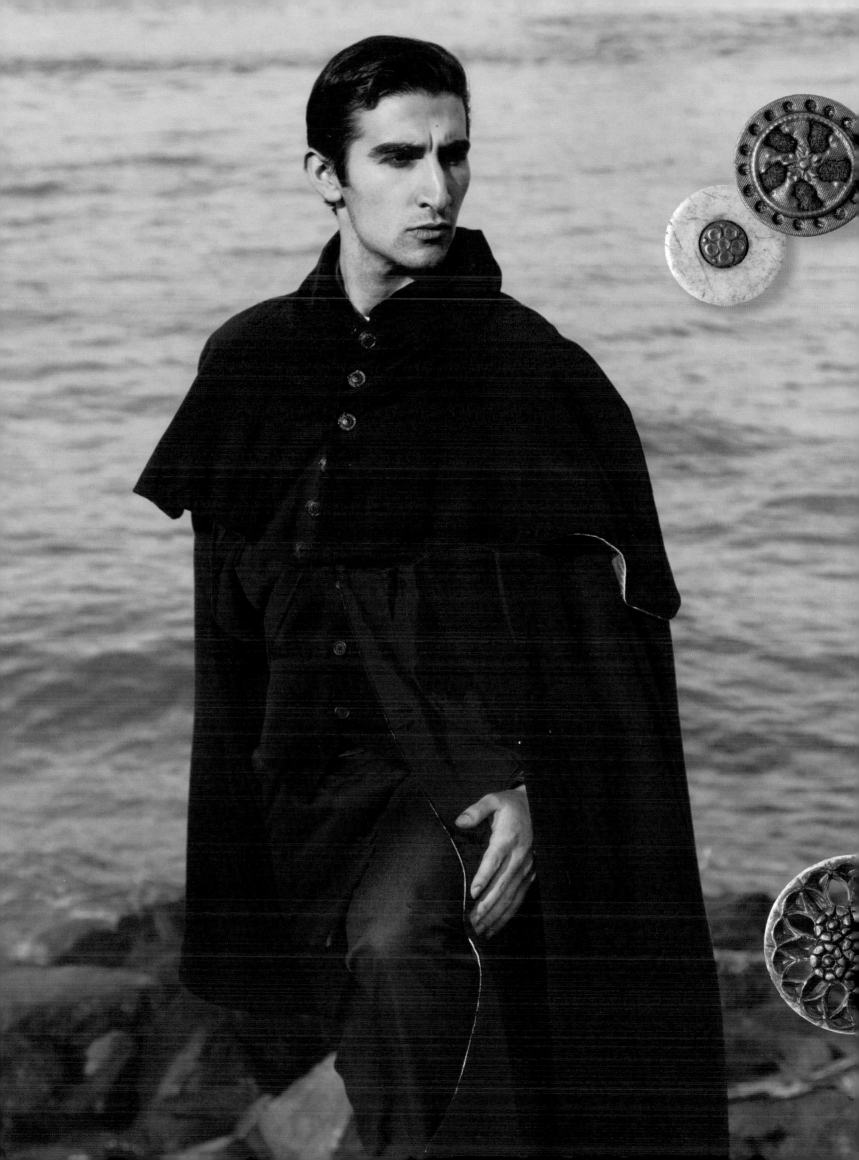

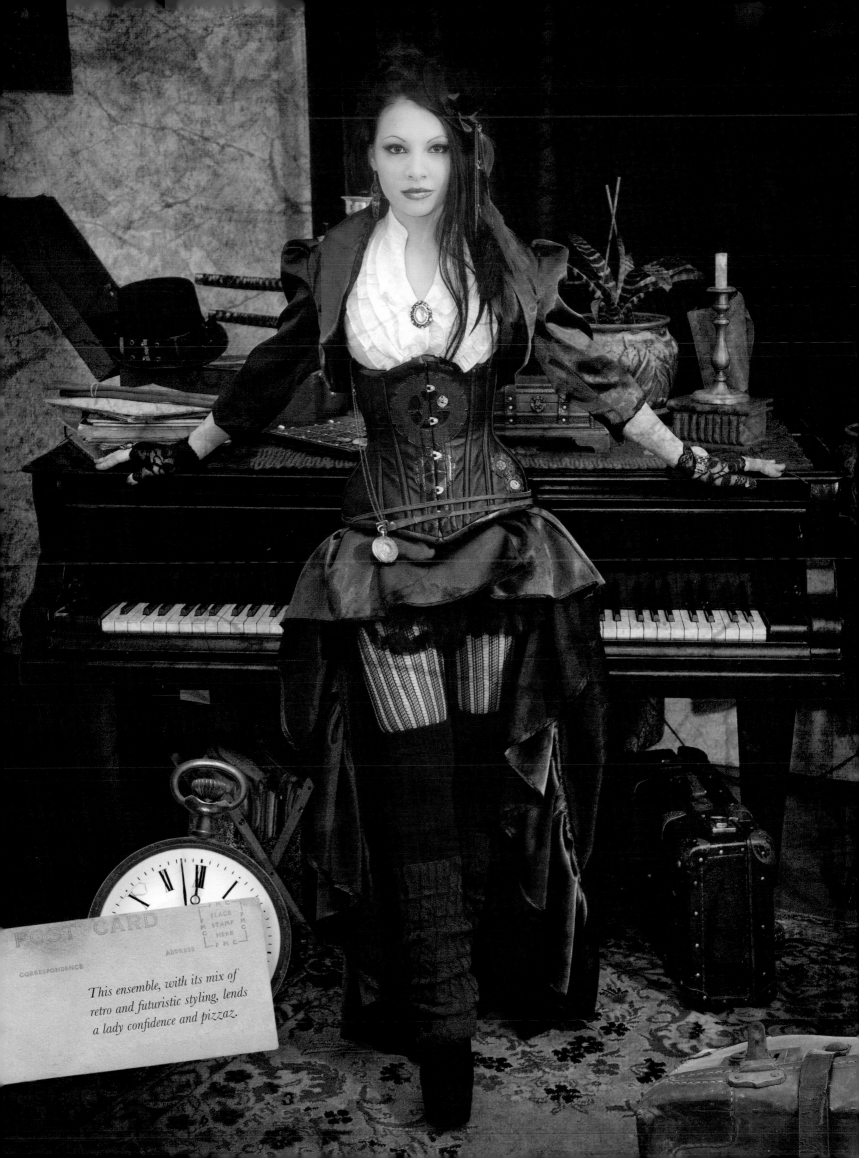

POST CARD

CORRESPONDENCE

ADDRESS

P. M. C.
PLACE
STAMP
HERE

This ensemble, with its mix of
retro and futuristic styling, lends
a lady confidence and pizzaz.

Black Garden

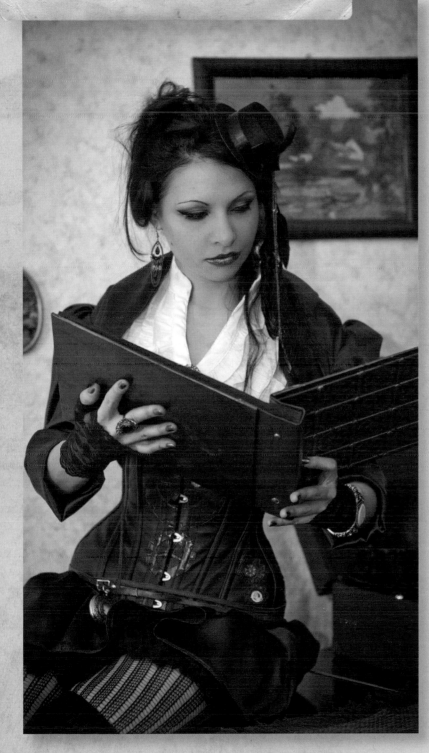

Model Agnieszka Koseatra Juros wears an underbust corset by Black Garden and Lady Ardzesz.

Black Garden, an online boutique based in Poland, launched its first line of clothing in the fall of 2012. Designer and proprietor Angelika Jakóbik works with seamstress Lady Ardzesz to create their meticulously crafted line. The shop's style tends toward gothic and they carry items from other brands, such as Bat Attack and Hades shoes. In addition, Black Garden sells secondhand and vintage items as well as jewelry and accessories. Jakóbik herself typically dresses in a gothic/industrial style. While browsing on YouTube, she first discovered steampunk with a Doctor Steel video. This led to a search for more steampunk bands. Jakóbik then found herself drawn to the style of Abney Park and Beats Antique. With a smile and a bit of a wink, she says, "I love steampunk fashion—and who knows?—maybe I will change my personal style." She hopes to open a physical store soon.

Here model Agnieszka Koseatra Juros embodies retro-futuristic confidence and style. Her gaze is direct and steady. She commands the space and at the same time seems welcoming. She wears a black leather underbust corset by Black Garden and Lady Ardzesz. Her brown satin bolero jacket features dramatically puffed sleeves and laces at the back. And her black satin skirt's back sports a brown valance and a bustle. In her fine attire, she could be a prominent hostess, inviting her stylish guests to enjoy an evening of cutting-edge poetry and music. She is a lady, and at the same time she is contemporary, very much of the now, living on the edge of yesterday and tomorrow.

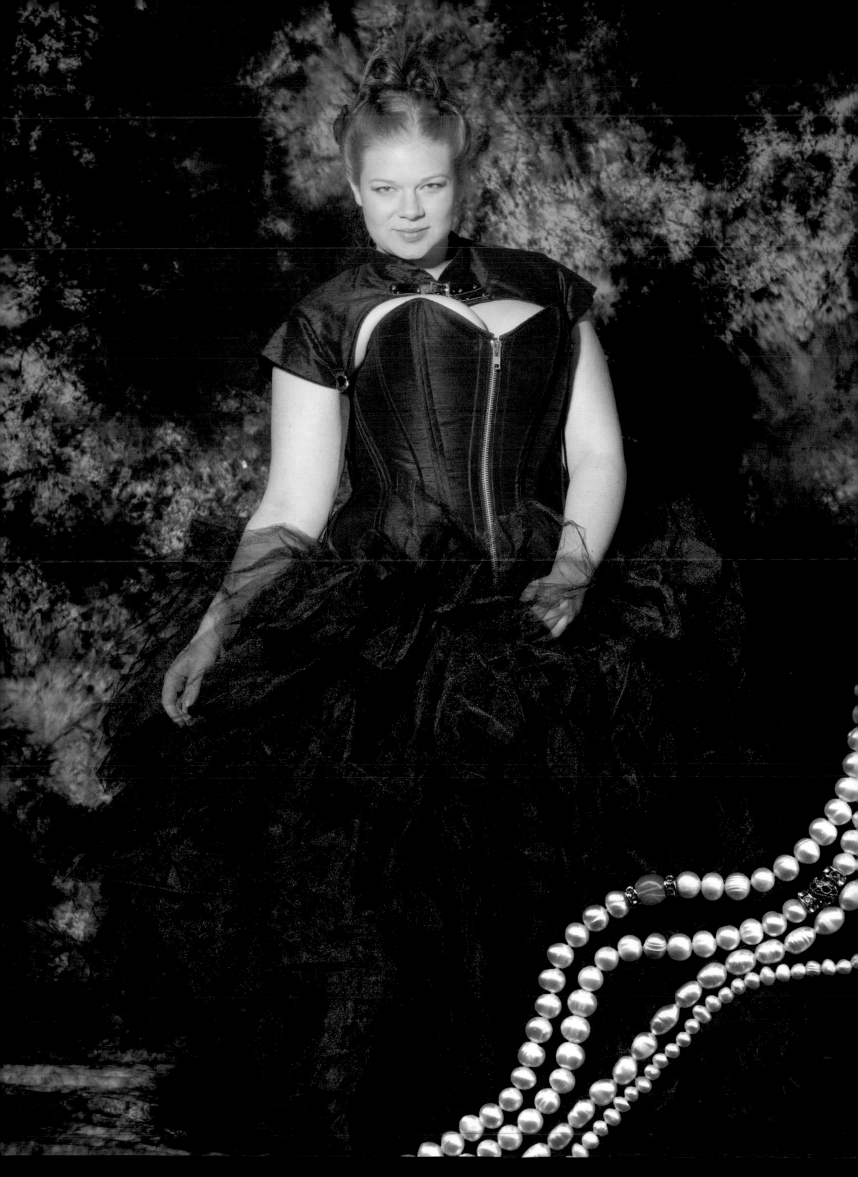

KMKDesigns

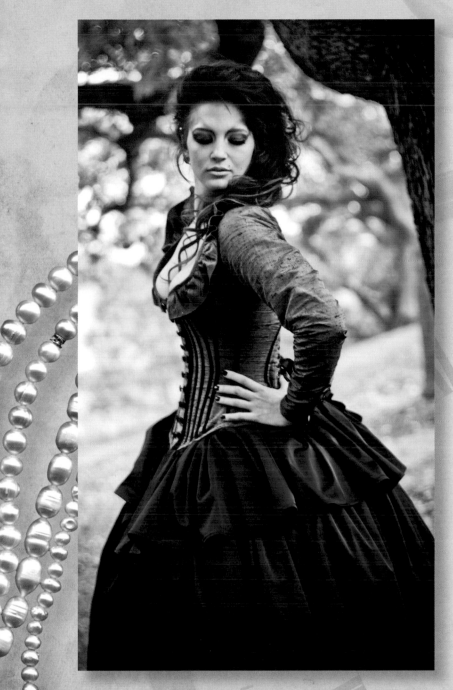

Located in Stillwater, Minnesota, KMKDesigns is a mother/daughter collaboration begun in 2008. Sheridyn McClain, who had sewn since childhood, and her artist daughter Kaitlyn started out selling some of their wares at a convention, and soon they were hooked. They opened an online shop and began vending on Etsy. They both discovered that by making clothes they could "create a tool for men and women of all shapes, sizes, and types to feel more confident and beautiful."

Karen, a nurse in the Pacific Northwest, was talking with her wedding planner, trying to describe the event that would satisfy her heart. "Victorian," she said. "With brassy bits. And we'll invite everyone to dress up and we'll pretend we're having an adventure in a submersible or a dirigible or...." She trailed off. The wedding planner beamed. *My wedding planner thinks I'm crazy*, Karen said to herself. "I get it," the wedding planner said. "You want a steampunk wedding." "A what?" Karen replied, blinking. "Steampunk," the wedding planner said with a grin. "Okay," Karen said, "but what in the world is steampunk?" The wedding planner explained, and Karen discovered a name for her fascination. Conversations such as this one are happening all over, and images of steampunk weddings are proliferating on the internet. Many brides have found the wedding dress of their steampunk dreams, such as the ones pictured here, at KMKDesigns.

In addition to steampunk and alternative wedding gowns, the McClains create menswear, corsets, and Lolita looks in a range of sizes. They now have both a local and an international clientele, and their work has been featured in magazines such as *Dark Beauty*.

OPPOSITE PAGE *KMKDesigns created this look in collaboration with Heather Luca of Scoundrelle's Keep.*

ABOVE *A steel-boned corset jacket makes up the backbone of this alternative wedding look.*

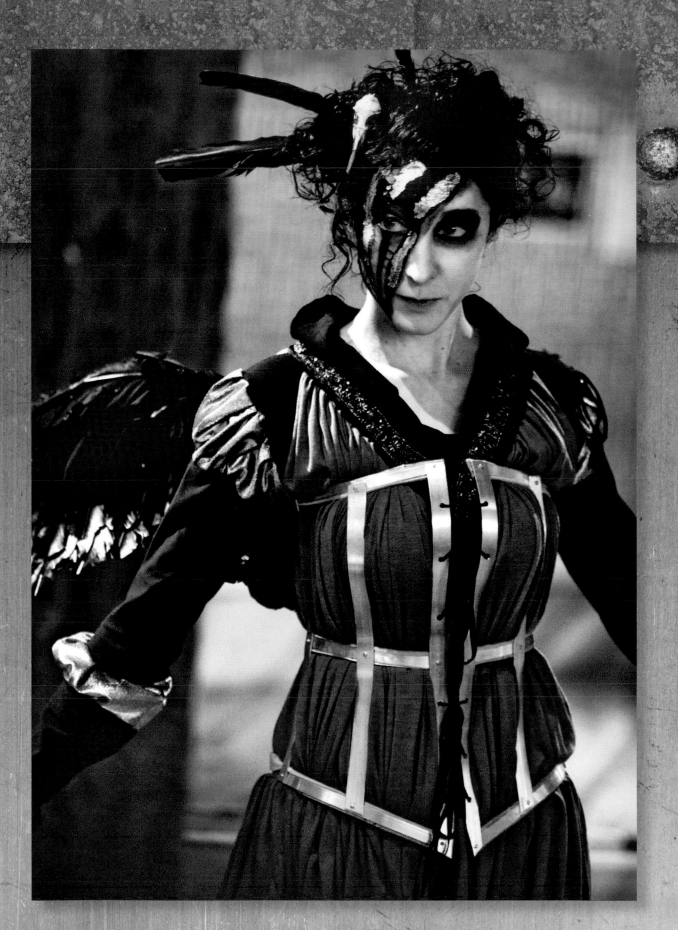

This metal corset with attached wings is constructed from flat stock aluminum, feathers, steel, glue, and fabric.

Kristin Costa

Kristin Costa has designed clothes for as long as she can remember. She started making her own outfits in grade school and began taking costume commissions while still in college. Although she studied painting and teaching at Pratt Institute, she managed to participate in runway fashion shows via Pratt Fashion Society, a school club. Her grounding in fine art allows her to think outside the usual fashion box and helps her to create her wearable art. Costa first discovered the term steampunk after watching the short animated film *The Mysterious Geographic Explorations of Jasper Morello*. Then she realized that a community was forming around subject matter that she liked. She'd been participating in fashion shows, performances and the burlesque scene in New York City, but really felt something click when she started getting spots in shows at steampunk events.

These two shots are from one of Costa's runway shows. Over the model's dress, a metal corset binds her waist, and yet, with her wings, she seems ready to fly free. Another model, a man, wears a shirt of feathers and a bird-like headpiece of papier-mâché and silver leaf that has been painted to look like oxidized steel. These looks are from Caged, Kristin Costa's spring/summer 2011 collection. The designer often focuses on psychological concepts in her work and thus creates a strong sense of drama. Caged, which features birdcage motifs, deals with ideas of entrapment, protection, and belonging.

In addition to a bird mask, this model wears a shirt of canvas and feathers.

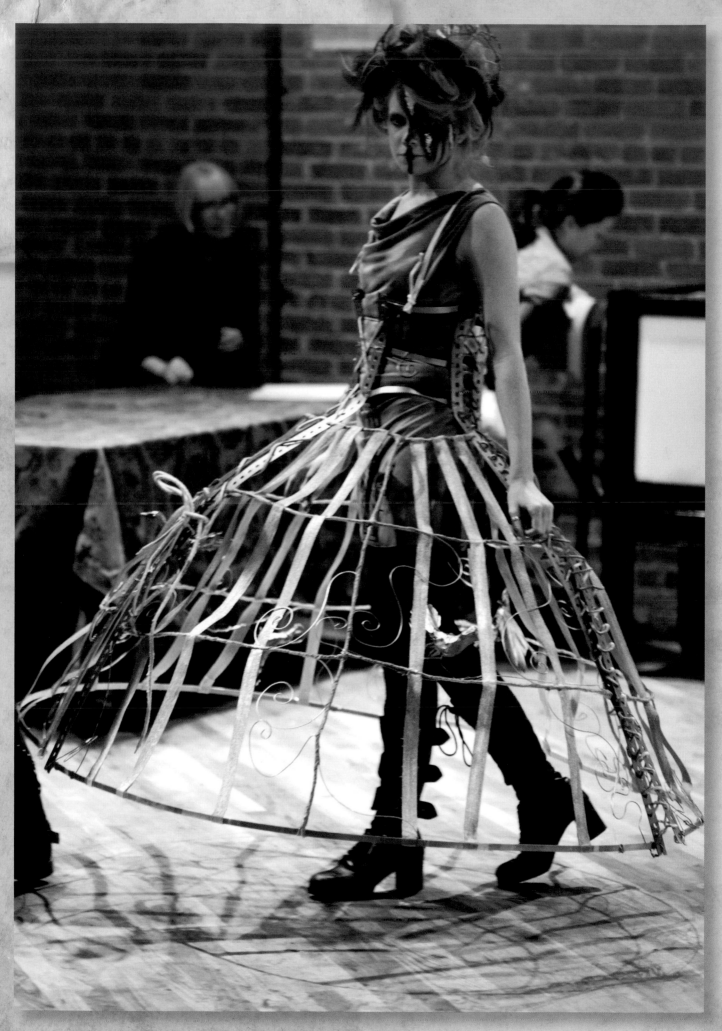

"The steampunk community is the first real group of people with a name that accepted me," Costa says. She feels that steampunk crowds understand her work, which is inspired by historical fashion but not confined to reproducing it. She likes the fact that steampunk has been growing and branching out from its Victorian roots to encompass other historical cultures. When working on her Caged collection, rather then employ what are often considered typical steampunk colors, such as brown and brass, Costa chose cement, oxidized steel, and other metallic hues, along with grey, green, and black. In addition to creating two new lines of clothes a year, Costa costumes dancers and has made costumes for theatrical and rock music performances. She has also worked for costume shops, such as Izquierdo Studios. It was there, while working on a pair of wings for Julie Taymor's film *The Tempest*, that she got the inspiration to create her own. Crafted from canvas, steel, and aluminum, these wings sing of freedom.

Costa, who has been actively promoting her own label since 2009, began by selling her wears at fairs and conventions. Soon after that debut, she opened an Etsy shop. While she still utilizes these platforms, she and her work have grown. She has participated in Couture Fashion Week in New York, an event held in the Grand Ballroom of the landmark New Yorker Hotel, and she's begun selling to boutiques. In addition, she has recently expanded her collection to include bridal wear.

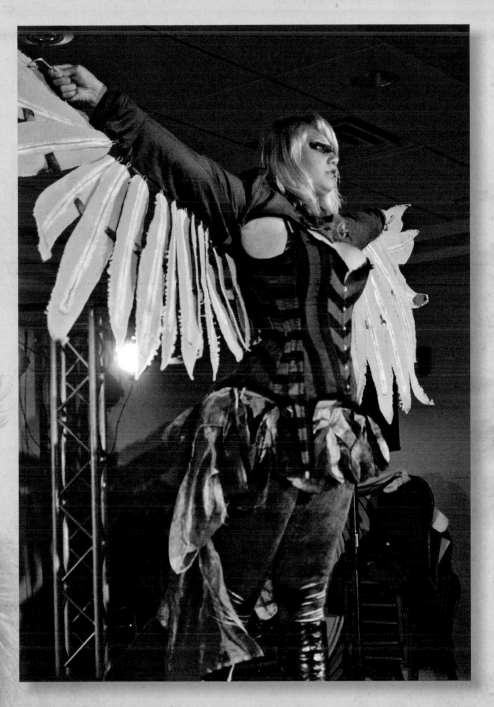

OPPOSITE PAGE *When the Caged line was presented on the runway, this cage dress served as the collection's finale.*

ABOVE *Costa's work in a costume shop inspired her to craft a pair of wings of her own.*

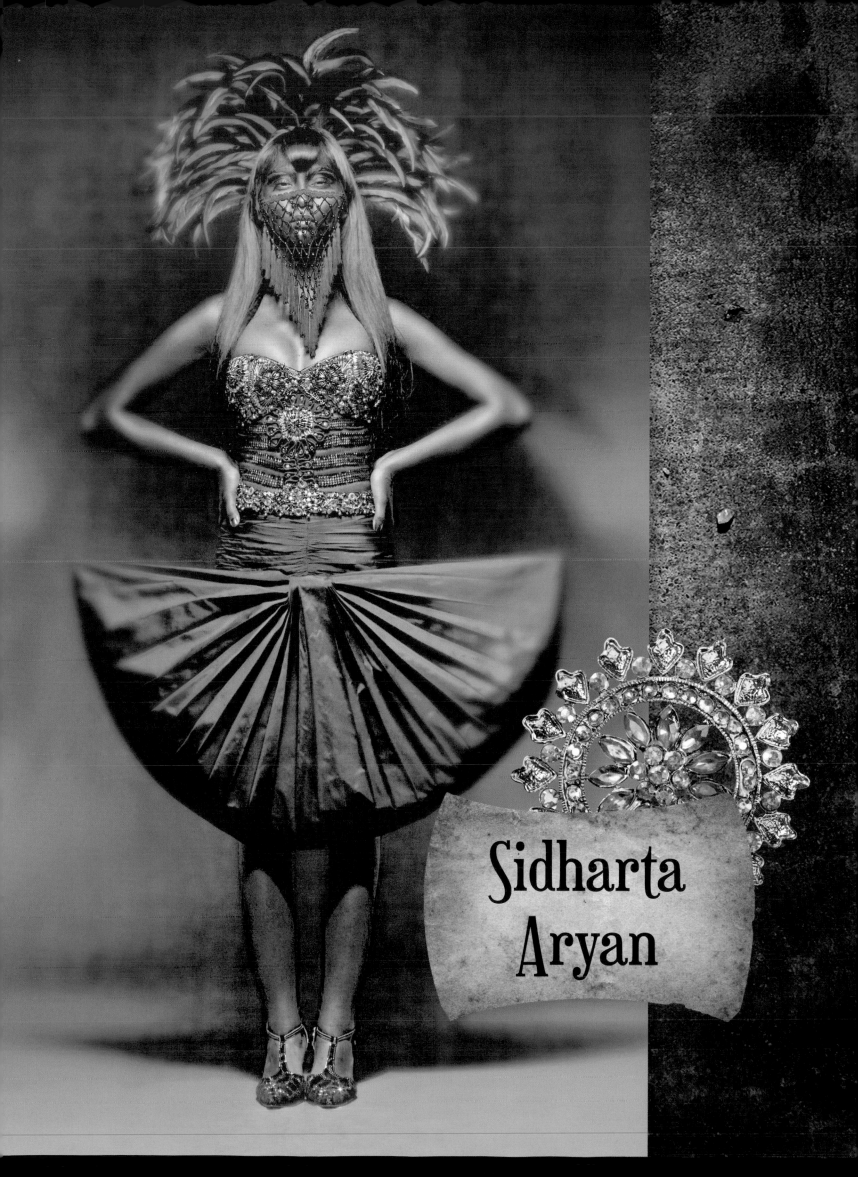

Sidharta
Aryan

In 2011, designer Sidharta Aryan of Mumbai made his fashion week debut at the age of twenty-nine. Selected to participate in Gen Next, a program of India's Lakmé Fashion Week that aims to promote the work of young talent, he presented Steampunk, his debut line. Fusing Indian and Western styles with goth, cyberpunk, and sci-fi influences, his work appears utopian and dystopian at the same time, thus embracing the contradictions of contemporary life.

Peering over her veil with her hands on her hips, the model exudes a confidence rooted in a deep tradition. At the same time, she is very much a part of the modern world. The full structured skirt of her cocktail dress stands out, moving beyond the merely flirty.

Both hands balled into fists, one hand wrapped in chain. Is this a weapon ready to be swung into action? Or is it a weight tethering the model in place? At first glance, the look seems ancient, tribal, a costume for a warrior. Winged armor guards her hips. Jewels encrust her intricate corset. Closer inspection reveals gears on the center plate of her armor hinting at industrial roots. The woven midsection of her corset is crafted from zippers—more evidence of the machine age. Closely placed buttons stand in for precious stones over her bust and shoulders, while a length of folded zipper caps each shoulder with metal teeth. Her leggings, which at first glance may seem to be embroidered, are actually printed with a zipper pattern.

OPPOSITE PAGE *This ensemble by Sidharta Aryan appears to be both traditional and contemporary.*

RIGHT *Winged armor and cleverly crafted zippers are just two of the elements that make up this innovative look.*

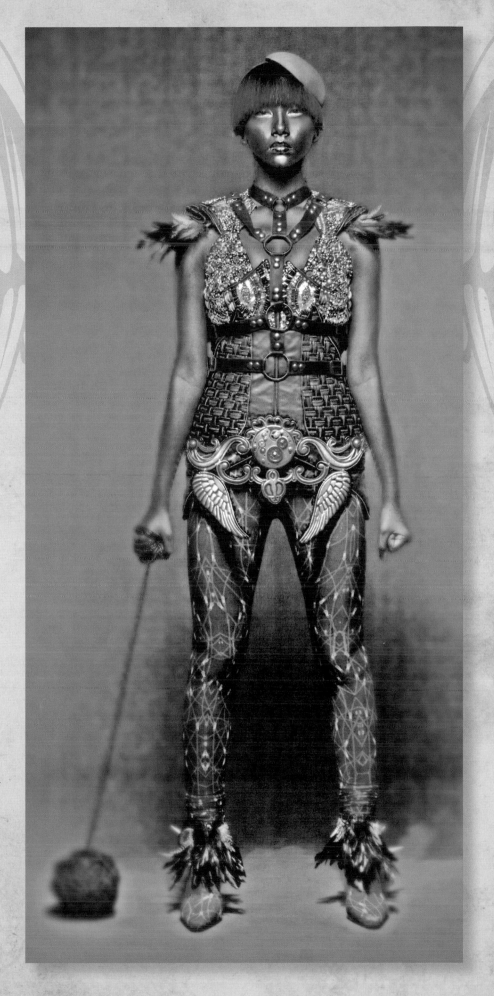

The press has called Sidharta Aryan's work striking and innovative, noting his heavily structured silhouette. Subsequent collections have incorporated tribal, futuristic, and steampunk influences. His style is increasingly infused with elements drawn from traditional Indian wear, which he hopes to reinvent to suit the modern urban woman of today. For example, his most recent collection included lehengas, long pleated skirts, which are typically elaborately embroidered. Instead of using embroidery, which can be heavy, uncomfortable to wear, and difficult to care for, Aryan created his skirts from digitally printed silk, successfully bringing a traditional Indian garment into the computer age.

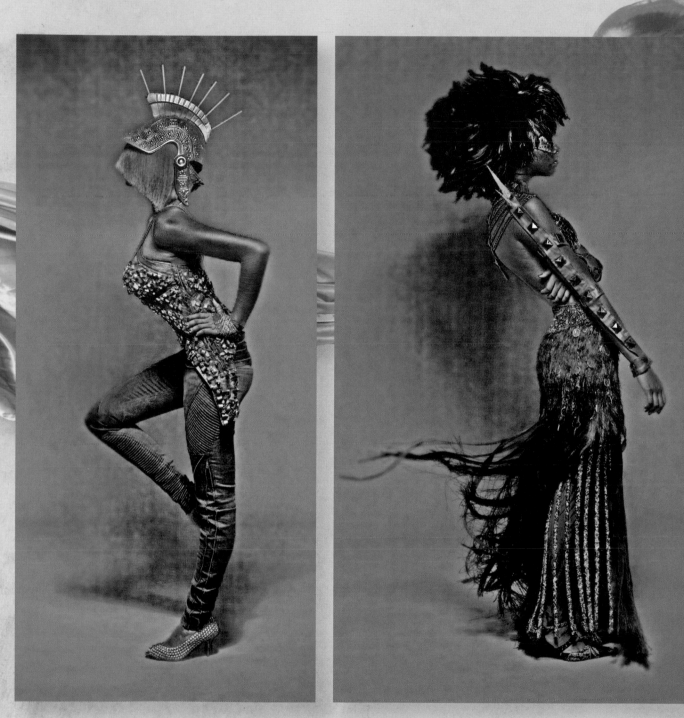

OPPOSITE PAGE *A digitally printed body suit creates the illusion of exposed skin, embroidery, and lace.*

ABOVE LEFT *It may appear that this model is wearing an embroidered tribal costume. She's actually wearing jeans liberally festooned with zippers. Her ornate top is decorated with strips of leather, safety pins, and buttons.*

ABOVE RIGHT *Is this skirt—crafted from hair, metal chain, and glitter embossed fabric—tribal or modern?*

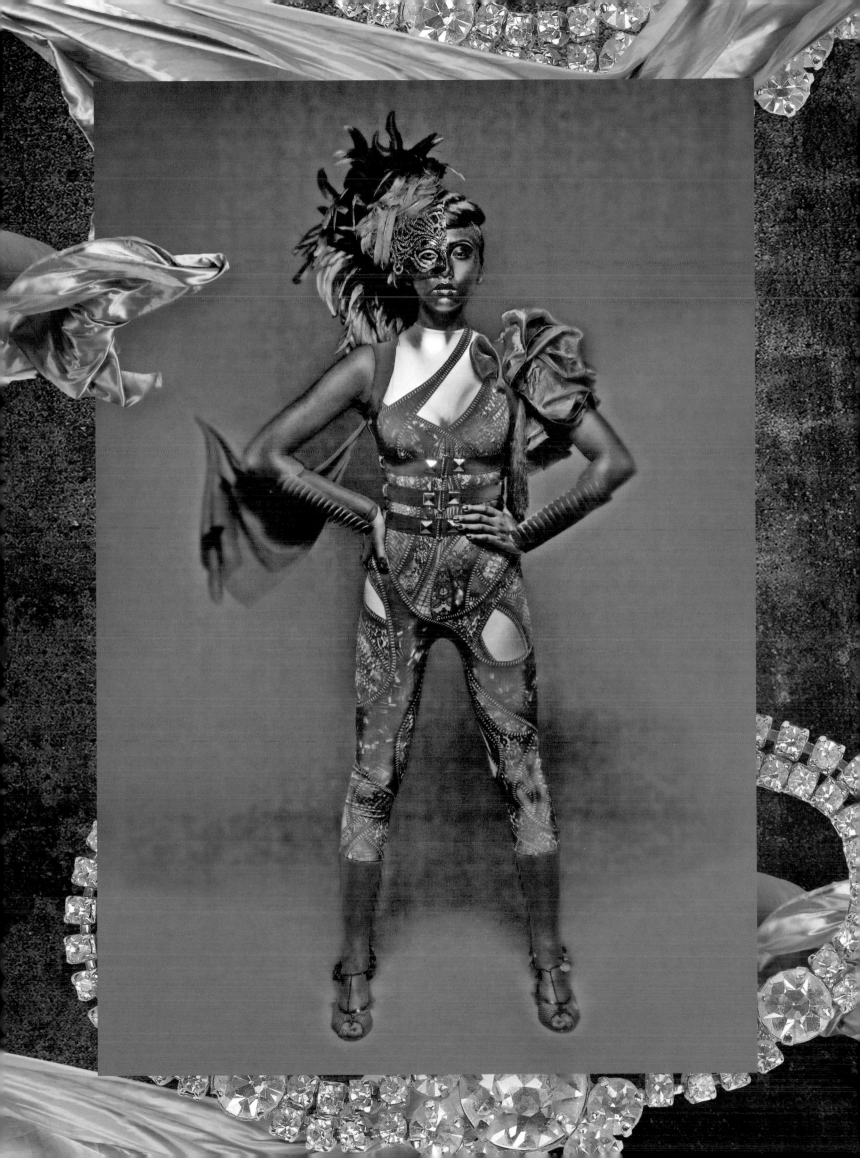

Redfield Design

Kathryn Paterwic has been creating looks like these under her own label, Redfield Design, for two years and has been sewing full time for four. With a background in sculpture and art history, she has worked as a theatrical costumer and brings drama and her deep understanding of the plastic arts into her fashions. Paterwic has researched and studied the history of clothing for years and brings that knowledge to bear when she blends the trends of today with the looks of the past.

Her work has been seen on the runway at numerous steampunk conventions, and her commissioned outfits have lent grace and elegance to several steampunk luminaries, including Dr. Grymm, author of *1000 Steampunk Creations*. In addition to work based on historic European designs, Paterwic has crafted garments inspired by Japanese patterns as well (see page 42.) Drawn to Russia's ancient traditions of ritual and ceremony and fueled by visions of historic Slavic looks, she's currently working on a line of Russian coats, an early version of which appears here. The designer enjoys wearing steampunk fashions herself and sometimes appears at conventions dressed as a steampunk seamstress.

Model Myra D'amaged stands in a graveyard, bold in her yellow dress. Has this young lady just poisoned the frog who was destined to become her handsome prince? Unlike a proper lady of yesteryear, this young woman wears her corset on the outside for all to see. Visible and imaginatively executed corsets are a hallmark and signature of many steampunk looks.

LEFT *An early example of one of Redfield Design's Russian looks, this coat started life as a smoking jacket. Then the designer added the cuffs and fur trim.*

OPPOSITE PAGE *Although she's dressed in a bright color, this model is surrounded by a sense of dark magic.*

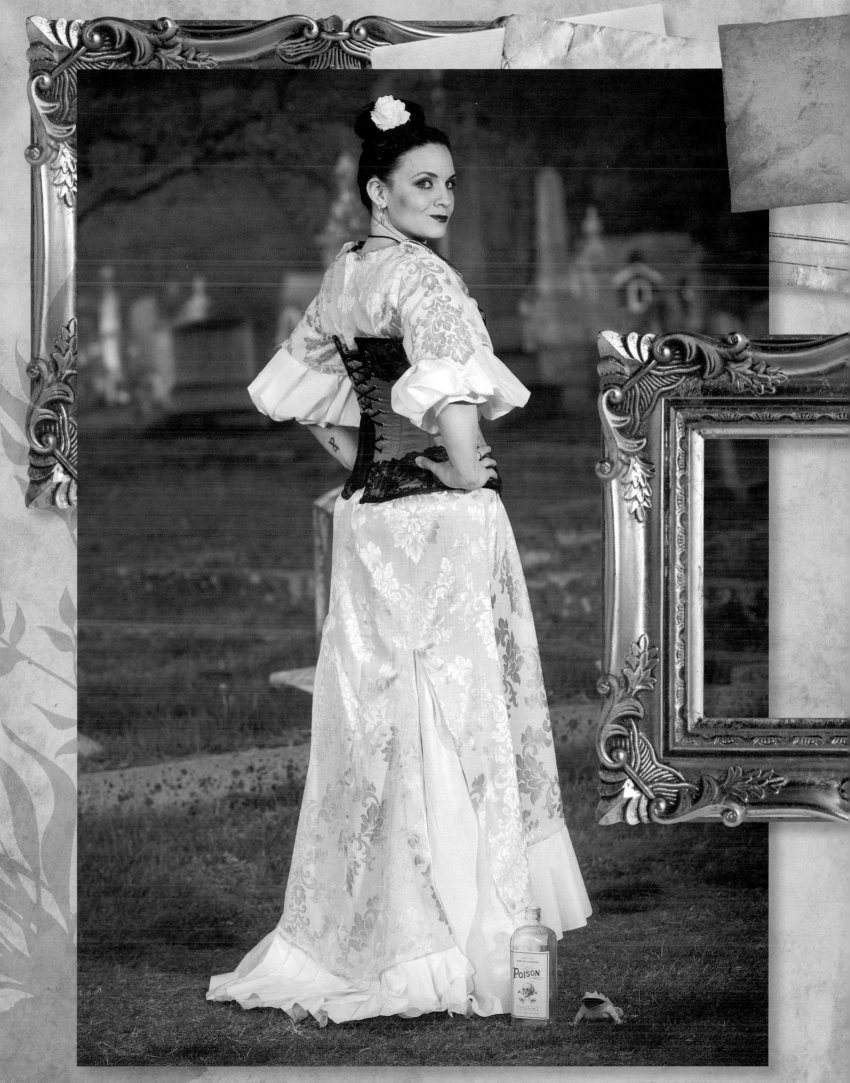

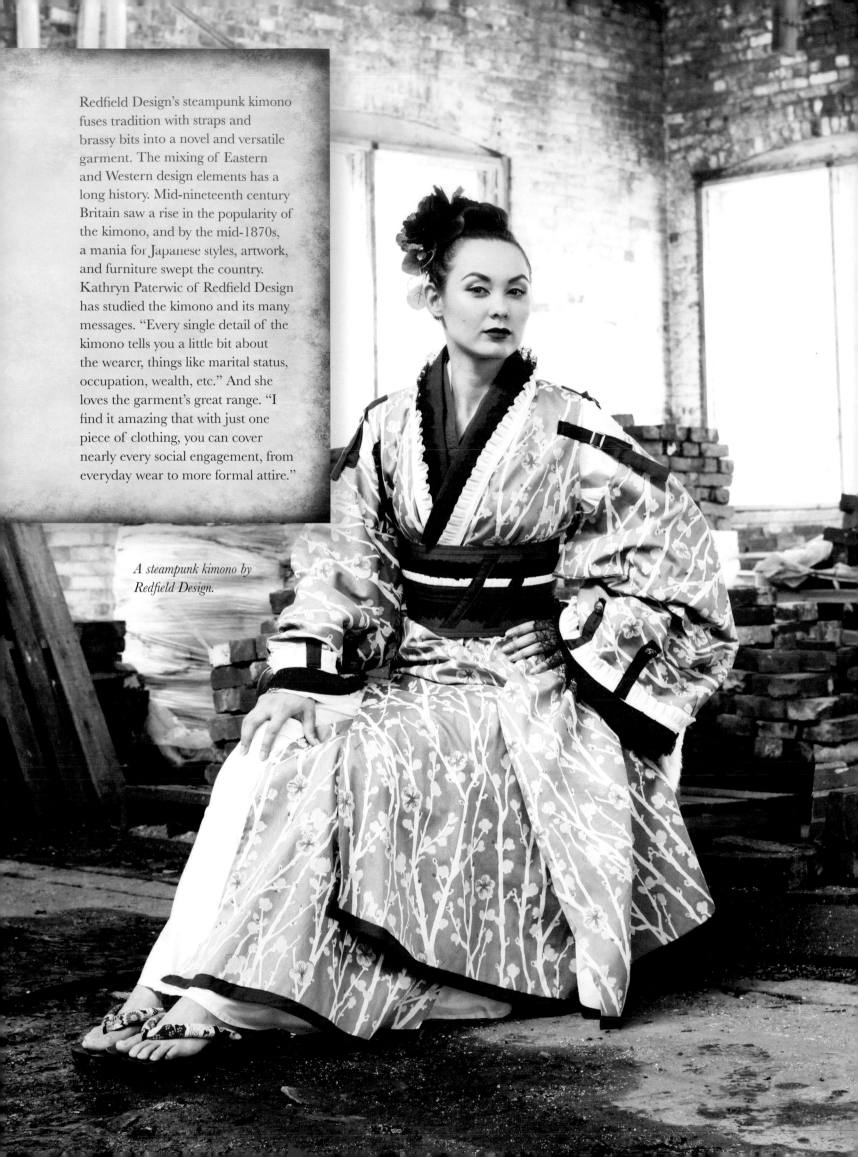

Redfield Design's steampunk kimono fuses tradition with straps and brassy bits into a novel and versatile garment. The mixing of Eastern and Western design elements has a long history. Mid-nineteenth century Britain saw a rise in the popularity of the kimono, and by the mid-1870s, a mania for Japanese styles, artwork, and furniture swept the country. Kathryn Paterwic of Redfield Design has studied the kimono and its many messages. "Every single detail of the kimono tells you a little bit about the wearer, things like marital status, occupation, wealth, etc." And she loves the garment's great range. "I find it amazing that with just one piece of clothing, you can cover nearly every social engagement, from everyday wear to more formal attire."

A steampunk kimono by Redfield Design.

Dawnamatrix

A coat or jacket can do a lot to pull together a steampunk look. Dawnamatrix's brown Victorian riding jacket, crafted from pure latex, mixes traditional style and innovative material. It features a ruffled collar and cuffs, and snap closure. The sleeve caps are pleated and puffed, enhancing the shoulder line. At the front, the jacket's skirts button back to emphasize the sweep of the tails. (See more of Dawnamatrix's work on page 94.)

This elegant Victorian-style riding jacket might surprise the queen. It's not made from cloth, but instead from latex.

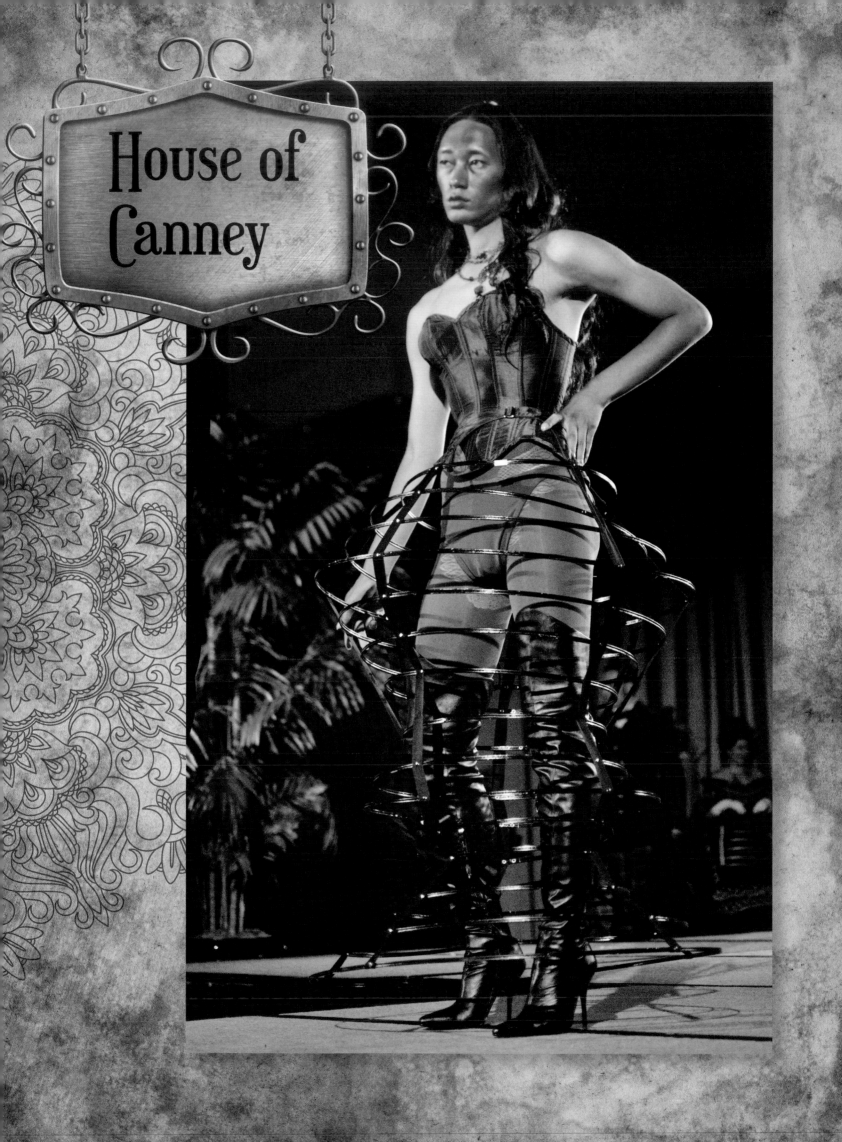

House of Canney

Anthony Canney specializes in neo-Victorian clothing, corsetry, historical recreations, pageant couture, and fetish wear, which he constructs under his label House of Canney. As the child of Civil War re-enactors, Canney began sewing as a child, crafting his own costumes by the time he was sixteen. When he was still in high school, his precocious skills caught the eyes of both his classmates and the press. The wire service AP picked up the story of the intense competition between Anthony's female classmates to secure him as their prom dress designer. The seventeen-year-old Canney turned down ten design propositions and accepted only four.

Worn over clothing, instead of as support underneath, these cage hoop skirts make a bold statement. They appear both elegant and rebellious, breaking the rules of propriety and yet still maintaining a certain decorum. A padded extension at the back of the waistband on this short elliptical hoop skirt (**RIGHT**) helps maintain the shape with greater fullness at the rear, creating a slight bustle effect. This particular shape was popular in the 1860s. By the decade's end, though, the hoop skirt fell from favor, replaced by the bustle. Of course these contemporary hoop skirts can also be worn under a dress for a more traditional look. Each House of Canney item is custom made and crafted by hand in Decatur, Georgia.

OPPOSITE PAGE *Exposing the crinoline and corset gives this outfit a contemporary steamy twist.*

RIGHT *This ensemble departs from historical recreation in a manner that a lady may consider shocking.*

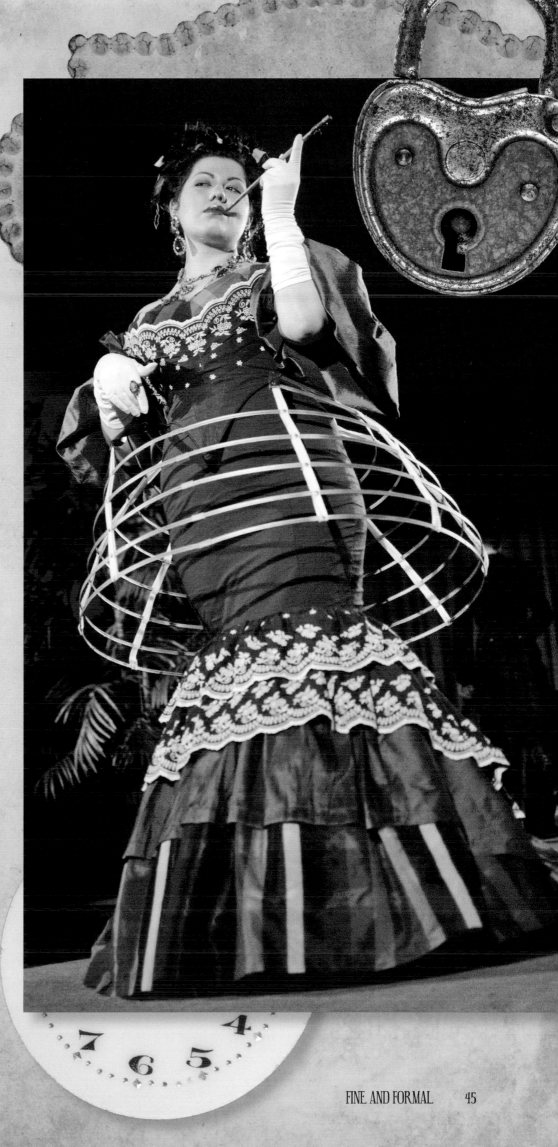

In addition to historically-based women's wear, Canney also has costumed a number of award-winning drag performers, and he in fact specializes in making clothing for men, including corsets. In crafting corsets, he uses coutil, a traditional tightly woven cotton-based fabric that was developed particularly for that purpose. Each corset contains three layers of fabric—the outer fashion layer, which can be any color or pattern; the coutil; and then a cotton sateen lining. Canney's work seems both innovative and gender bending. That said, in terms of fashion history, men have actually worn corsets for a long time. In Europe in the early 1800s, a corset was part of a military officer's uniform. By the 1820s, middle and upper class men began wearing the waist-nipping garments. In addition to trimming the waist, men's corsets, like the ones for women, can be used to support the back and slim the figure overall.

While tight-lacing corsets, those designed to effect extreme waist reduction, are probably not for everyone, steampunks and corset makers know that a corset is not just an uncomfortable relic of a bygone age best left in the past. A corset does not have to be an instrument of torture. When properly fitted, they can actually be quite comfortable. Gail Carriger, author of the popular Parasol Protectorate series, says she often wears a corset for back support while she writes. She describes a well-fitting corset as being "like an ace bandage," snug and supportive, but not restricting.

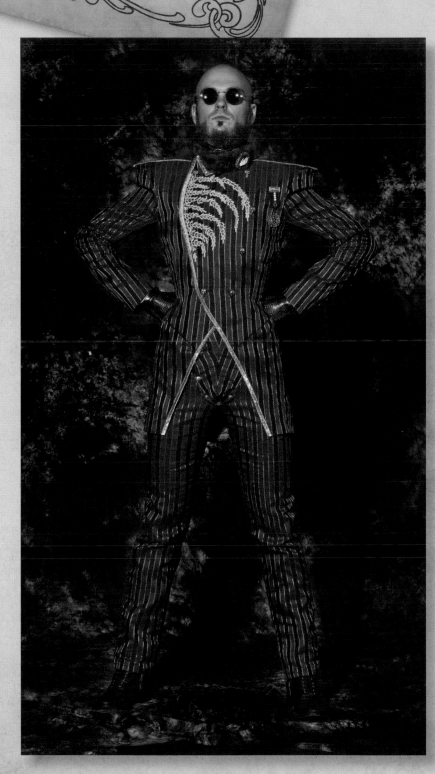

OPPOSITE PAGE AND ABOVE *Anthony Canney models one of his own corsets.*

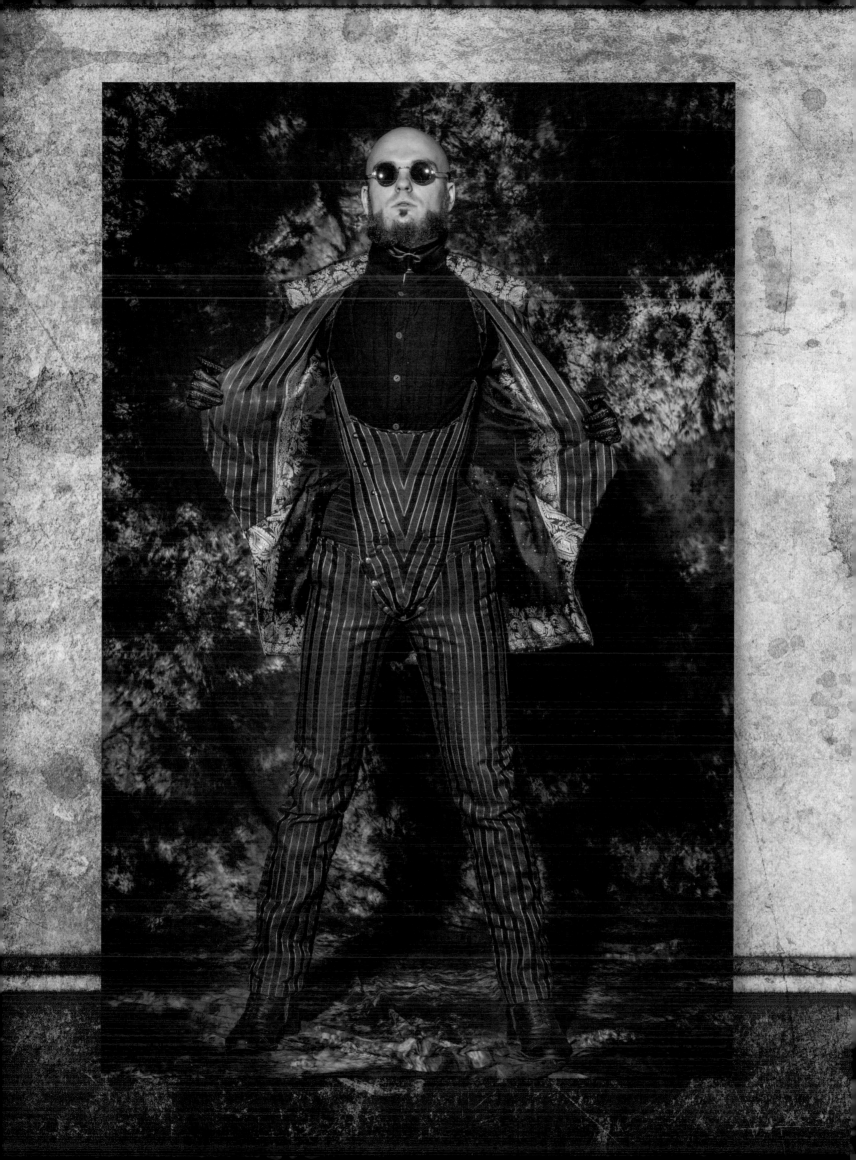

Kristi
Smart

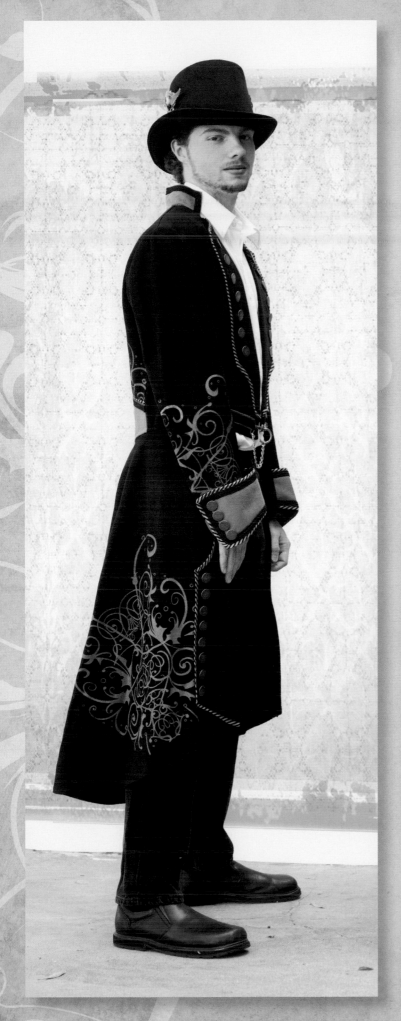

Kristi Smart has outfitted magicians and circus performers, grooms on their wedding day, and many dapper steampunks. Her customers are so loyal that a few of them, like the owner of the coat pictured here, have become collectors of her work. Finding her inspiration in fabrics and trims, Smart takes a painterly approach to her work. "It's like squeezing paint out of a tube and turning it into something beautiful. It's too much fun. I'm forever grateful that people like what I do."

This long black frock coat gives model Ari Giancaterino, who also happens to be Smart's neighbor, instant flair. This one-of-a-kind silk-screened coat turns up the steam and travels equally well to a formal event or to a rock concert. Smart created this coat in collaboration with a silk screen artist who had a studio next to hers. Some day she wants to design more silk-screen coats, but she says, "Right now I am having so much fun with appliqué, it's hard to stop and switch gears." (See more about Kristi Smart and her coats on pages 124-125.)

OPPOSITE PAGE *Contrasting fabric, brass rings, and beading emphasize the back of the waist.*

LEFT *This Smart coat was purchased by a collector. The designer borrowed it back for a photo shoot.*

ABOVE *Rows of brass buttons, piping, and an intricate silkscreened design make this coat fancy and fantastic.*

DASOWL

Dressed up does not always mean wearing a black jacket, as the cutaways and vests from DASOWL demonstrate. DASOWL's steampunk wedding ensemble is both colorful and dashing. The coral red coat, designed in accordance with an antique pattern, features splendidly large lapels and the swaggering cutaway shape that first rose to popularity in the 1780s. The body of the jacket is crafted from a silk and hemp blend, with lapels and generous cuffs fashioned from a red-and-tan tapestry cloth, while the lining is a red iridescent satin. Decorative brass button at the chest, back of the waist, and cuffs finish off the finery.

Worn under a jacket, a vest or waistcoat can create a splash of color. Or this versatile garment can be worn without the jacket for a less structured elegance. Here the Red and Bronze Floral Tapestry and Silk Steampunk Victorian Lapeled Gentlemen's Vest is worn over a pair of contrasting plaid trousers. The vest, which is made from a silk tapestry fabric with silk Dupioni lapels, boasts a watch pocket and a red satin back and lining. The plaid trousers bear a flap front with six-button closure and a lacing at the back for a custom fit. (See more from DASOWL on pages 200-201.)

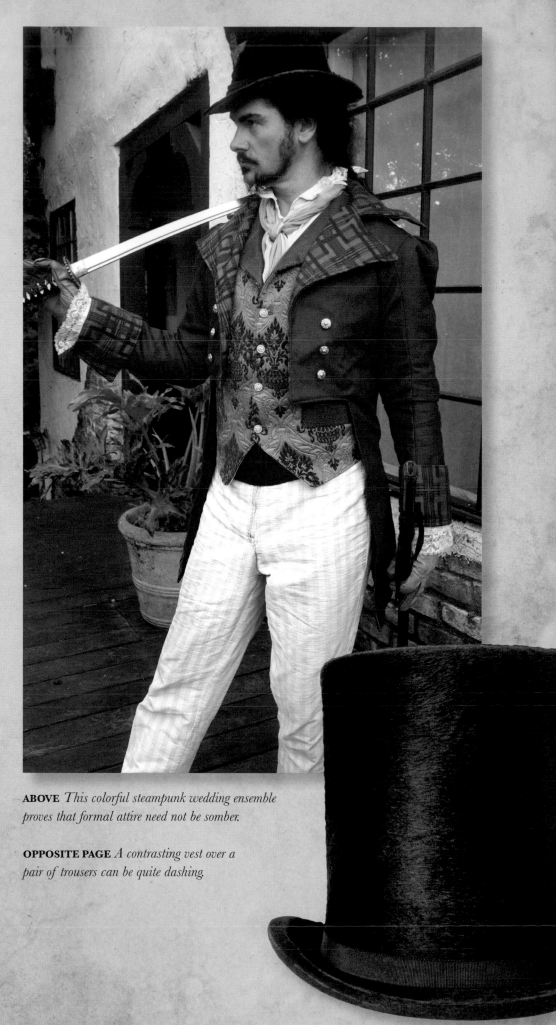

ABOVE *This colorful steampunk wedding ensemble proves that formal attire need not be somber.*

OPPOSITE PAGE *A contrasting vest over a pair of trousers can be quite dashing.*

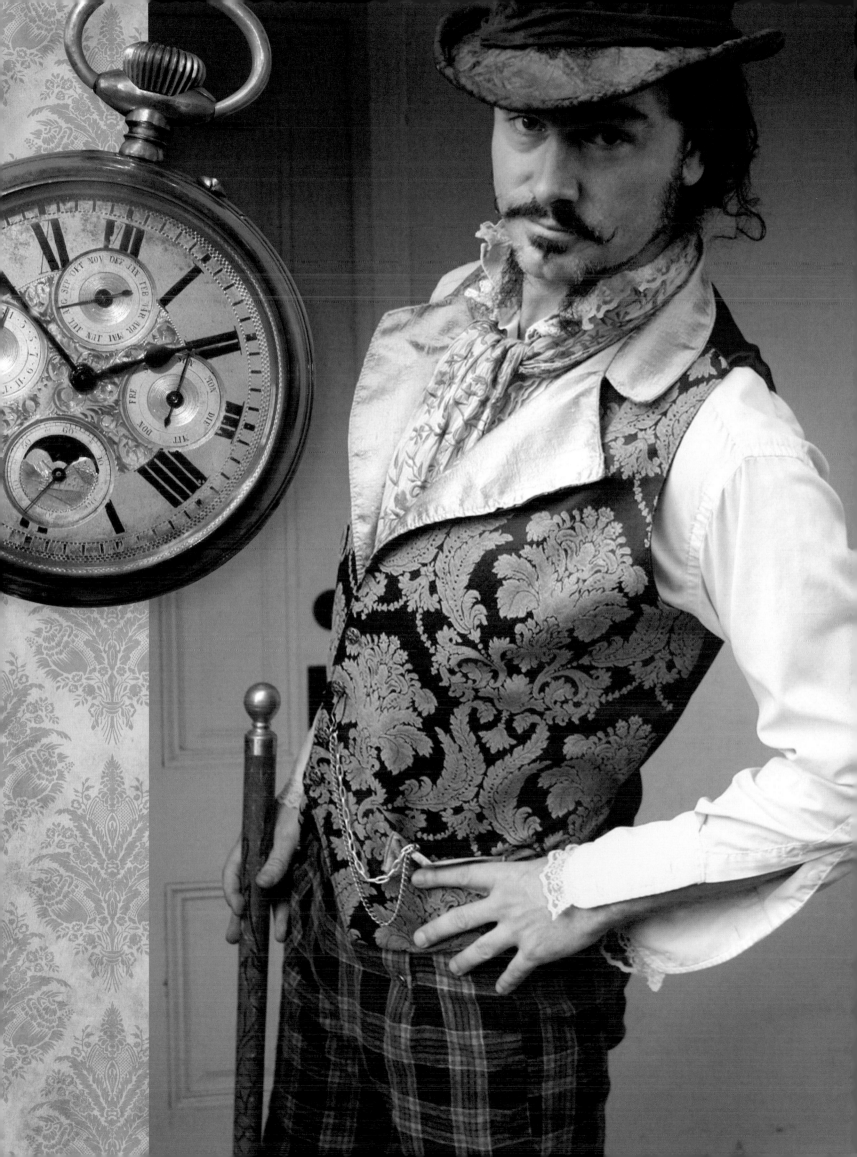

Costume Mercenary

It started with a button. So says designer Jeannette Ng of Costume Mercenary. She and her partner were shopping for buttons in Hong Kong. They came upon a special one in the shape of an inside-out gear with a screw as a bar across the middle. The button led her partner to begin sketching and talking about steampunk. With a design in hand, they took a trip to a sample room where professional tailors got to work fabricating the item. And the Steampunk Coat came into the world. Sometime after that, Costume Mercenary was born.

In a floor-grazing black-and-burgundy coat, she could be an ambassador from a past that never was. Perhaps she is a techno-priest from an advanced civilization. Or an inventor sent on a time-traveling mission to save the future. Constructed from cotton velvet and faux suede, the Steampunk Coat features many pockets and a multitude of D-rings, loops, and pouches for all manner of retro-futuristic gear. Buckles on the sleeves and at the hem allow for shorter lengths, adding extra versatility and keeping the coat's cuffs safe from alchemical experiments, Bunsen burners, and messy snacks.

Cloaked in rich blue velvet, this model could be an honored academician, a brilliant scientist from a past—or possibly a future—world. Her blue unisex velvet tailcoat is festooned with long rows of decorative buttons set off by the brocade revers. This cotton velvet coat features a full skirt and faux silk lining. It fastens at the waist with two brass clasps. A frilly linen shirt and circle skirt complete her dashing and distinguished look.

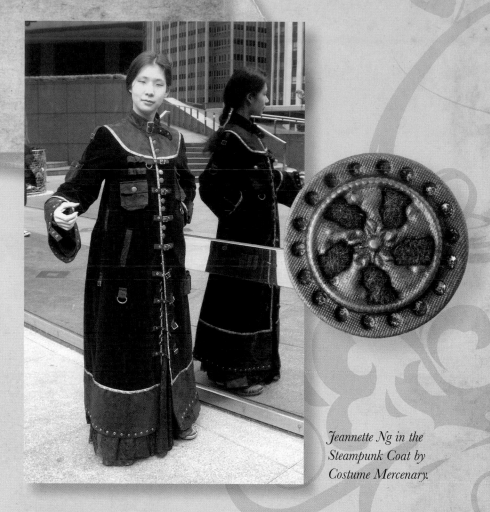

Jeannette Ng in the Steampunk Coat by Costume Mercenary.

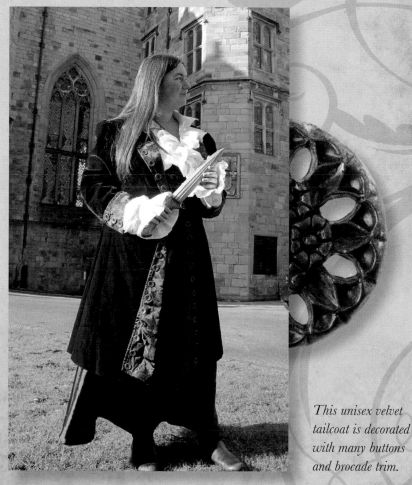

This unisex velvet tailcoat is decorated with many buttons and brocade trim.

Before becoming involved with steampunk, Ng was, and still is, active in live action role play (LARP). She discusses the differences between LARP and steampunk, her history of costuming, colonialism, and building Chinese-inspired techno-fantasy in an extensive and fascinating interview on Jayme Goh's blog *Silver Goggles*. In addition to steampunk gear, Costume Mercenary also designs elven cloaks, chitons, robes, and outfits based on characters from wuxia, a genre of Chinese story that centers on the adventures of martial artists.

Costume Mercenary, as the name may imply, has also created outfits on commission. Jaymee Goh's Steampunk Magistrate is one stellar example. Goh wanted an outfit for her magistrate steamsona, a Qing Dynasty official engaged in the tracking of opium smugglers in Malaya. The design evolved, starting with sketches based on historic looks and ending with a finished product. Goh's coat consists of green silk and is fully lined and edged with a green silk of a lighter hue. The coat sports engraved jade buttons and hidden side-seam pockets. At the chest, a hand-embroidered rank badge displays steampunk symbolism. Traditionally, rank badges were embroidered with images of animals or birds. Goh's rank badge depicts cogs and gears, suggesting that the wearer bears all the virtues of a machine while serving as a part of the great machine of the state. For more of Costume Mercenary's designs, see page 175.

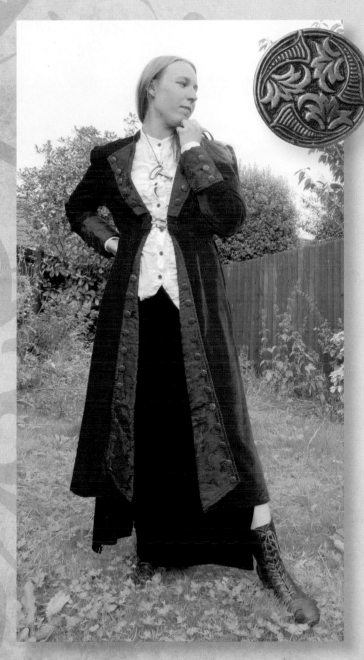

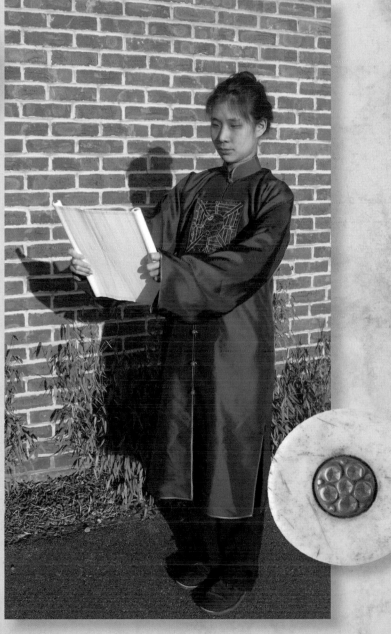

This tailcoat is crafted from a stretch velvet and sports brocade lapels and a stretch silk lining. Brass buttons adorn the cuffs, lapels, and the slit at the back.

Jeannette Ng models the Steampunk Magistrate coat that was commissioned by Jaymee Goh.

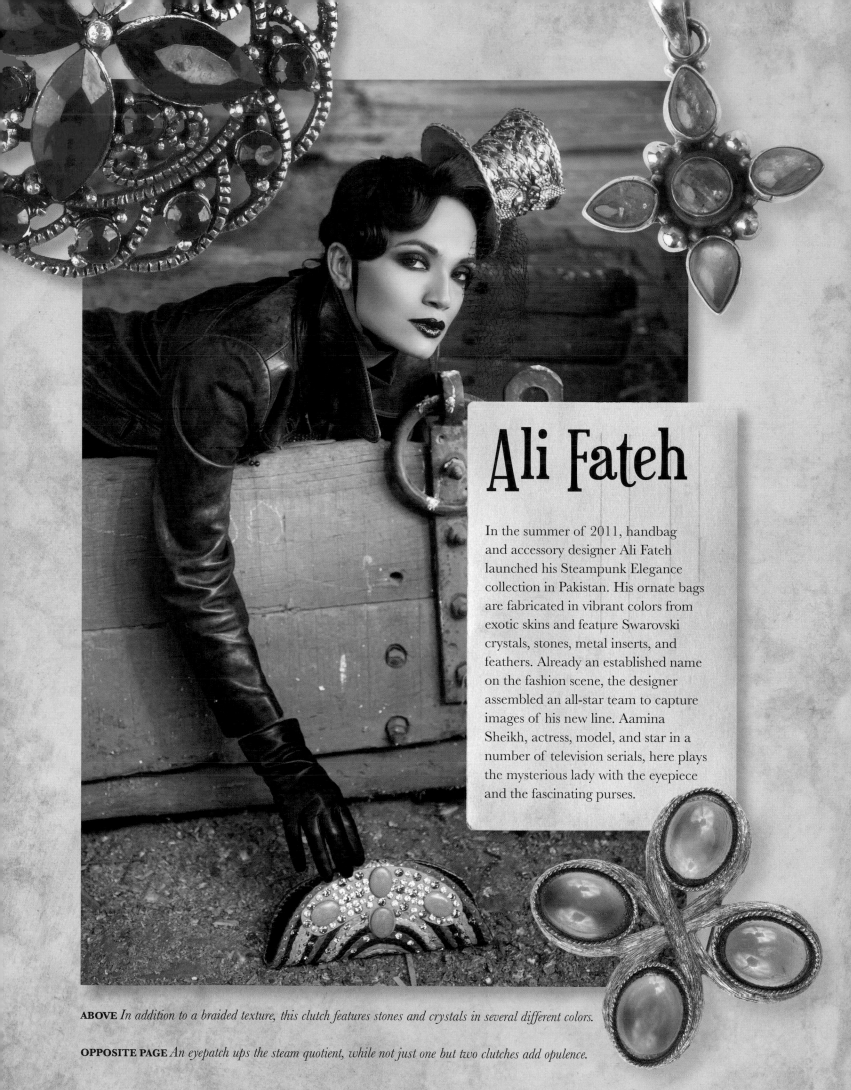

Ali Fateh

In the summer of 2011, handbag and accessory designer Ali Fateh launched his Steampunk Elegance collection in Pakistan. His ornate bags are fabricated in vibrant colors from exotic skins and feature Swarovski crystals, stones, metal inserts, and feathers. Already an established name on the fashion scene, the designer assembled an all-star team to capture images of his new line. Aamina Sheikh, actress, model, and star in a number of television serials, here plays the mysterious lady with the eyepiece and the fascinating purses.

ABOVE *In addition to a braided texture, this clutch features stones and crystals in several different colors.*

OPPOSITE PAGE *An eyepatch ups the steam quotient, while not just one but two clutches add opulence.*

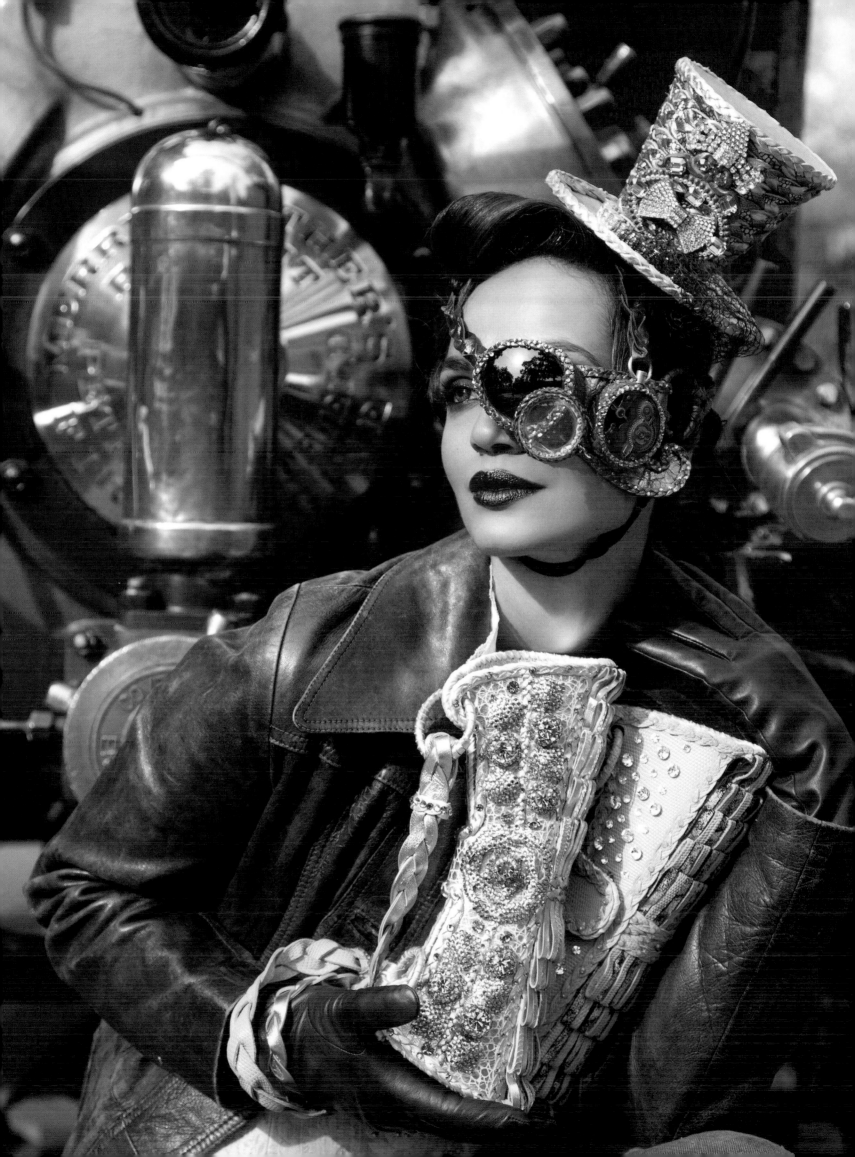

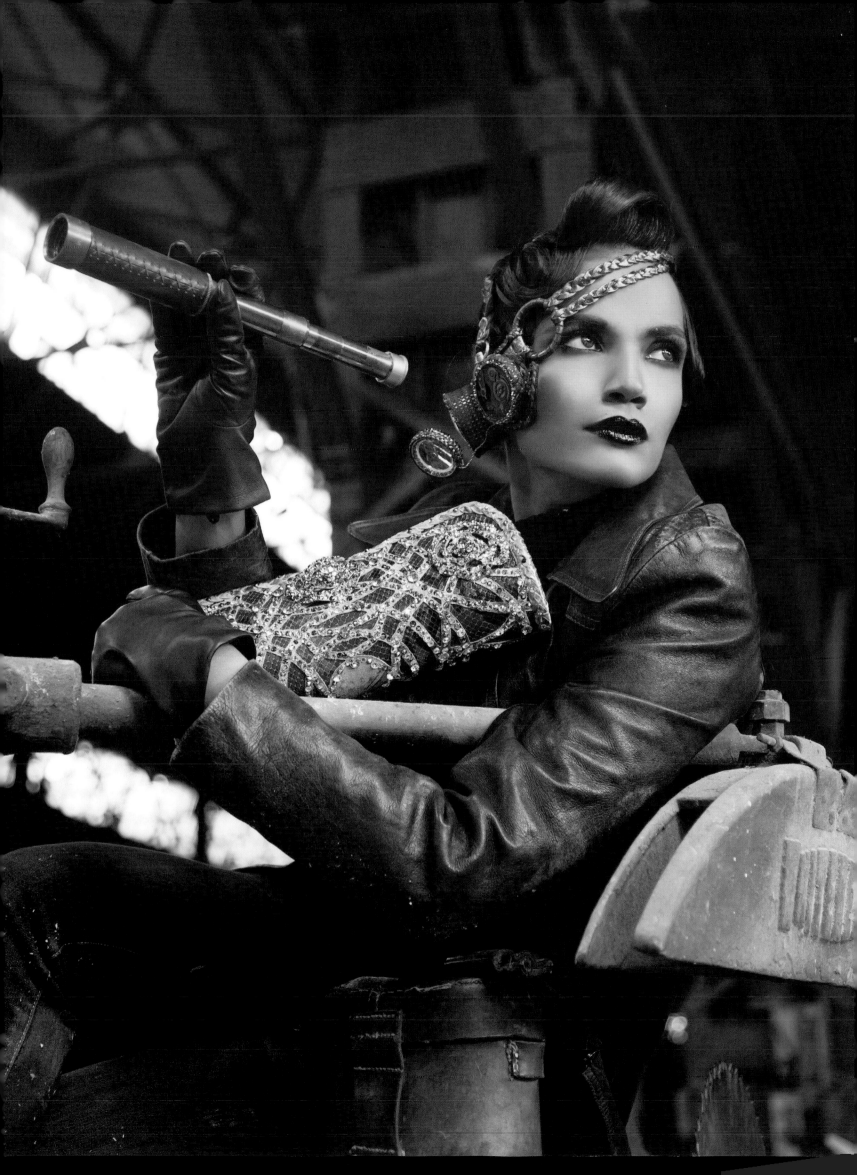

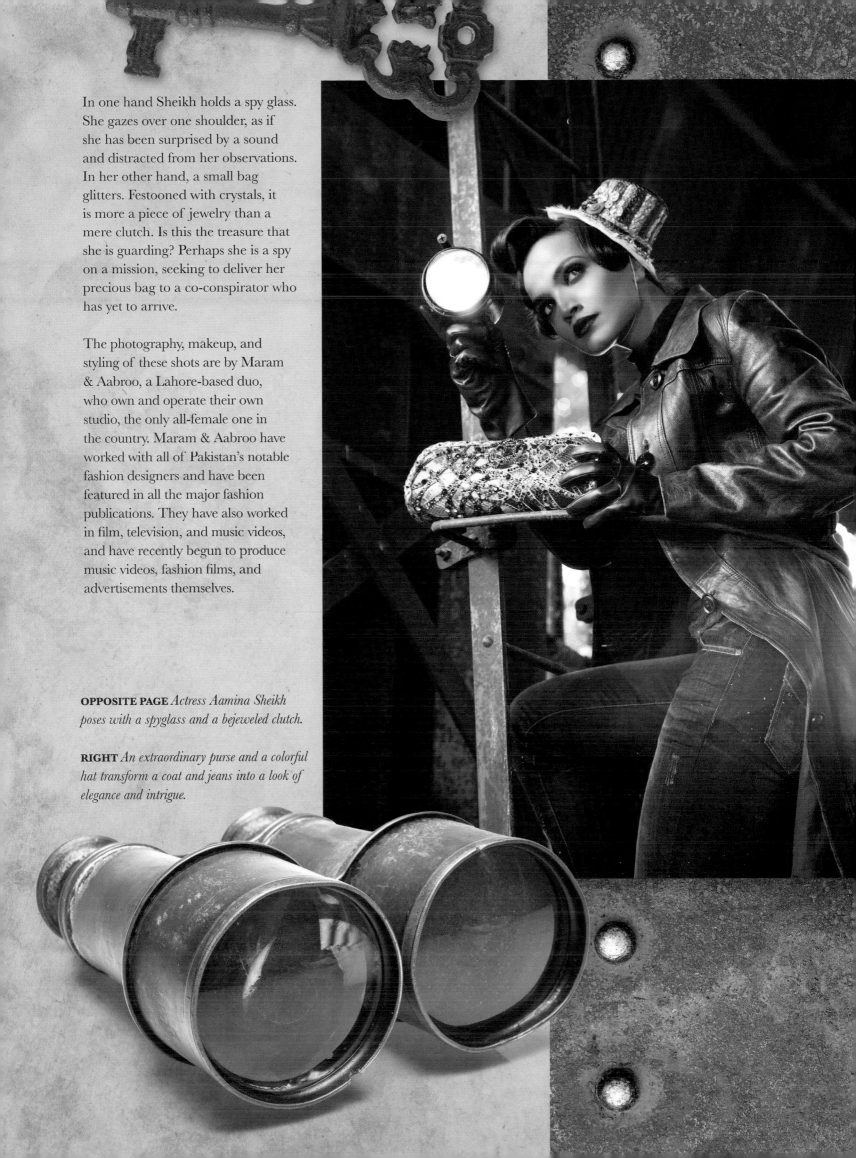

In one hand Sheikh holds a spy glass. She gazes over one shoulder, as if she has been surprised by a sound and distracted from her observations. In her other hand, a small bag glitters. Festooned with crystals, it is more a piece of jewelry than a mere clutch. Is this the treasure that she is guarding? Perhaps she is a spy on a mission, seeking to deliver her precious bag to a co-conspirator who has yet to arrive.

The photography, makeup, and styling of these shots are by Maram & Aabroo, a Lahore-based duo, who own and operate their own studio, the only all-female one in the country. Maram & Aabroo have worked with all of Pakistan's notable fashion designers and have been featured in all the major fashion publications. They have also worked in film, television, and music videos, and have recently begun to produce music videos, fashion films, and advertisements themselves.

OPPOSITE PAGE *Actress Aamina Sheikh poses with a spyglass and a bejeweled clutch.*

RIGHT *An extraordinary purse and a colorful hat transform a coat and jeans into a look of elegance and intrigue.*

KvO Design

Karen von Oppen has brought an eye for detail and deep understanding of fantasy into her design work for more than twenty years. With a strong background in the arts—she earned her BFA from Parson School of Design in fine art and illustration—she treats her creations more like artwork than like commercial products, paying meticulous attention to every detail. Originally from Detroit, and now based in Bucks County, Pennsylvania, von Oppen has long found inspiration in the work of comic book artists. She admires "the empowering way they adorn their characters and heroines."

Like so many others, von Oppen says that her fascination with steampunk probably started before the aesthetic had a name. She was initially drawn to the steampunk community by the visual impact of the clothing. "I've always been enamored of the fashions of the Victorian era. The fine tailoring and the exquisite construction appealed to the perfectionist in me, and the elegant designs, and the corsets—oh, the corsets!—appealed to my feminine side."

Imagine the scene: A crunch of autumn leaves and the dull thud of muffled hoofs announce an arrival. Mounted on her nobel steed, she appears, wending her way through the trees. She could be a princess, a heroine from a novel, a lady from another century. She could be acting out her dreams or she could be riding into ours.

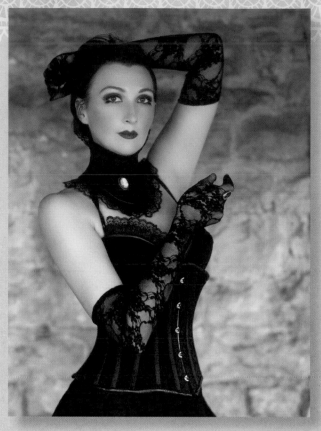

ABOVE *Model Dottie Poole wears a high-rise plum brocade neck corset that is trimmed in ruffled black lace, along with a matching underwire bra and corset.*

BELOW *In a black and gold brocade overbust corset and a full length silk skirt, this lady is ready for an elegant night out.*

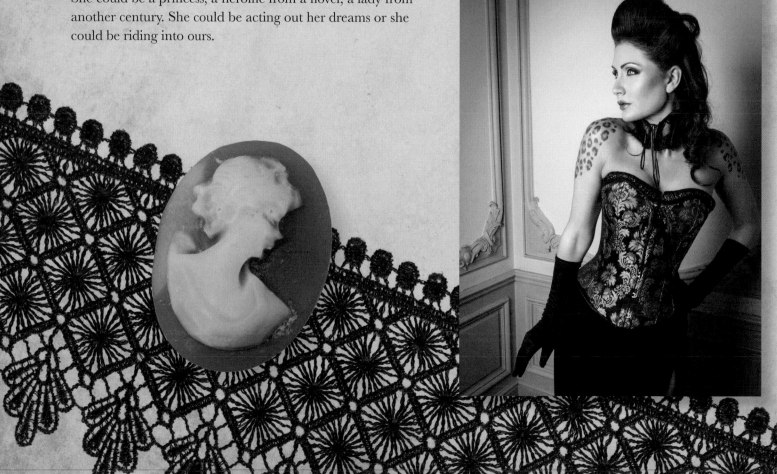

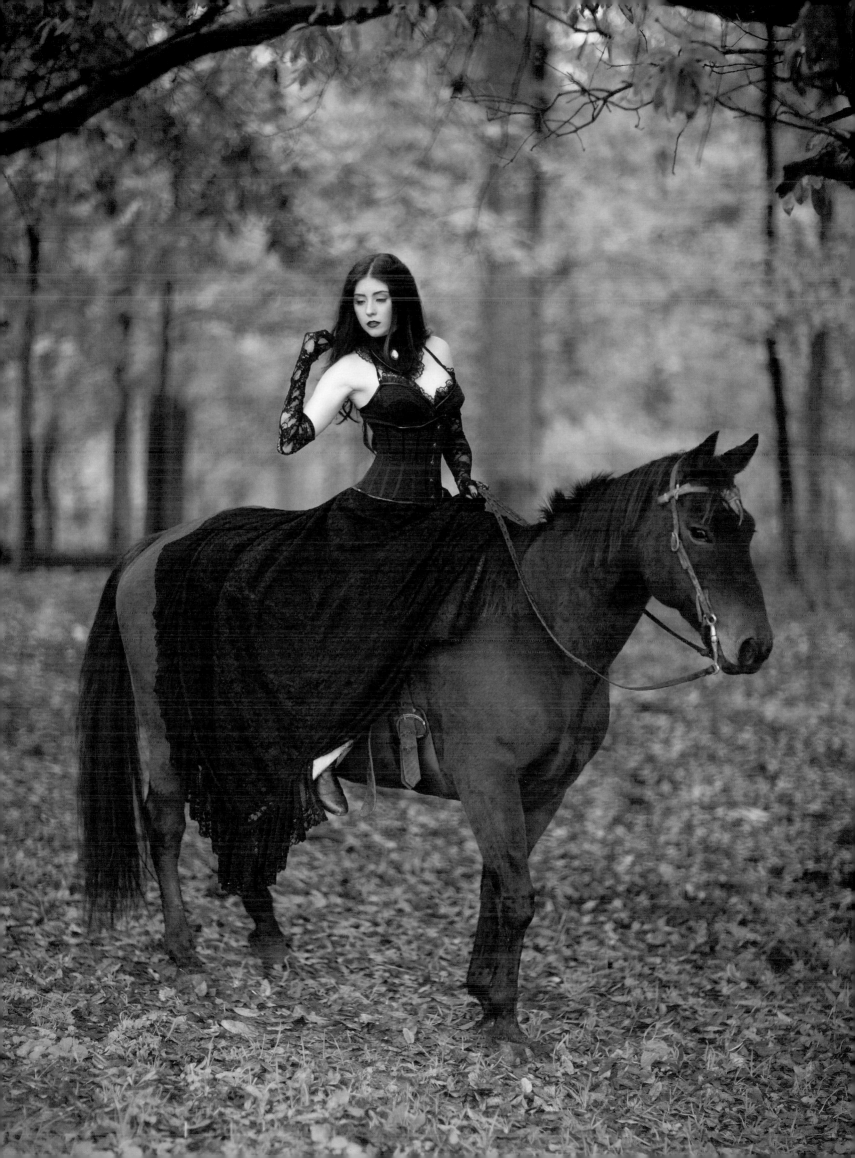

While it was the fashions that initially attracted her, soon von Oppen realized that steampunk is so much more. She found a "movement full of incredible camaraderie, imaginative invention, unabashed whimsy, and wonderfully ornate and carefully executed objects of beauty." She sums up by saying that once she had found steampunk, she felt she had found her niche.

While von Oppen sells some of her accessories through brick-and-mortar boutiques, she mostly connects with customers via the Internet and at shows and conventions. Her elaborate ensembles and corsets are always custom made for the individual client. In addition to traveling to events, creating and cutting patterns, von Oppen executes her designs herself to make sure that the quality of the stitching is equal to her meticulous vision. She stresses that a good corset—and she has made a lot of them—"should feel like a hug, and should empower the wearer . . . with grace and confidence." She enjoys helping her clients bring their visions to life and feels honored to be "given the task of summoning forth a client's alter-ego or inner fantasy."

Lately von Oppen has been focusing on the creation of accessories, such as the items pictured here. She loves the way accessories can transform a simple, plain, or conservative outfit into an extravagant and unique look. In addition to creating for her own line, von Oppen's work has appeared in film, video, stage, and on television. And her designs have been featured in *B-Metro Magazine*, *Gothic Beauty*, and *Sinical Magazine*.

An ornately embossed, faux-leather fitted vest fixed with brass turn-lock closures, black leather 3-buckle corset belt, short lace-trimmed brocade circle skirt, and floating gear filigree necklace, all by Karen von Oppen.

A regal lace collar with light boning can transform a plain outfit from ordinary to extraordinary.

In a ruff of black lace (complete with octopus ornament), a feathered mini Victorian-style riding hat, and a red satin bandeau top, this young lady's look is far from ordinary.

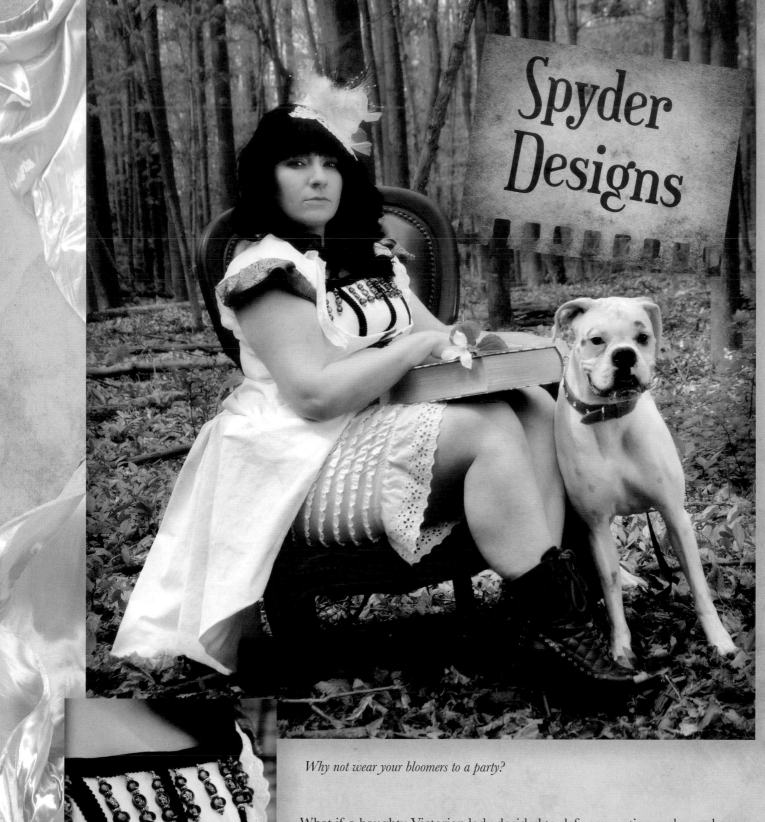

Spyder Designs

Why not wear your bloomers to a party?

What if a haughty Victorian lady decided to defy convention and wear her bloomers to a garden party? That is the question designer Morrigana "Meg" Pehlke of Spyder Designs posed and her answer came back as this jaunty outfit. In addition to frilly bloomers, model Sarah Jai is wearing an overbust corset and an underbust long tea coat with a brown button placket. Her booties are by Hades, and her fascinator was custom made for this outfit by Inside My Wicked Wardrobe. The detail shows the tea coat's buttons and the black ribbon and beadwork that offset the corset's white fabric. Pehlke says, "I enjoy making bloomers an everyday sight in my fashion." With undergarments so snazzy, why not show them out of doors?

(See more outfits from Spyder Designs on pages 122 and 150-151.)

Try embellishing a plain white camisole with some black ribbon and beads. We all should be so well dressed!

KMKDesigns

The Gothic Lolita Ballerina skirt from KMKDesigns is crafted from black polyester tulle and has a black cotton lining, which is cut as a full circle skirt for extra volume. While this petticoat makes a fun skirt, it also does its duty as an undergarment, adding fullness and lift under skirts and dresses. And it can even be machine washed. How's that for melding the modern and the retro?

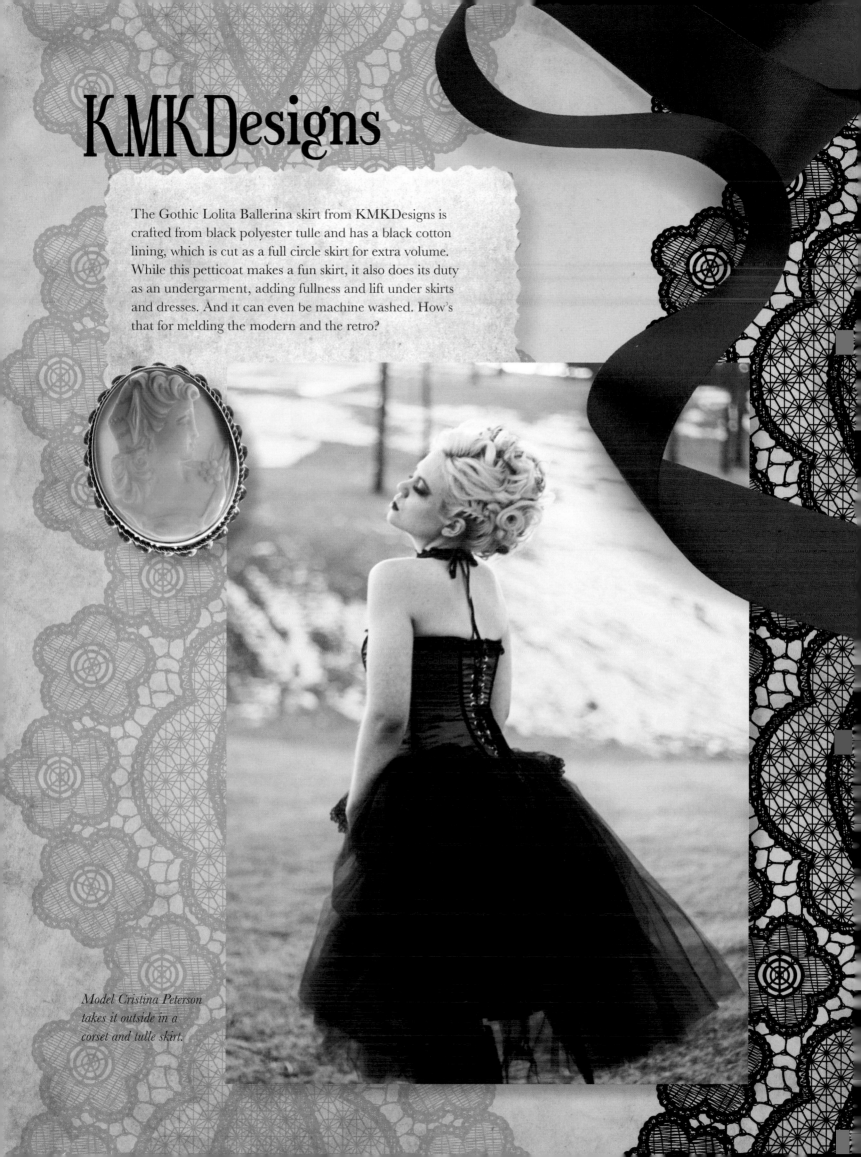

Model Cristina Peterson takes it outside in a corset and tulle skirt.

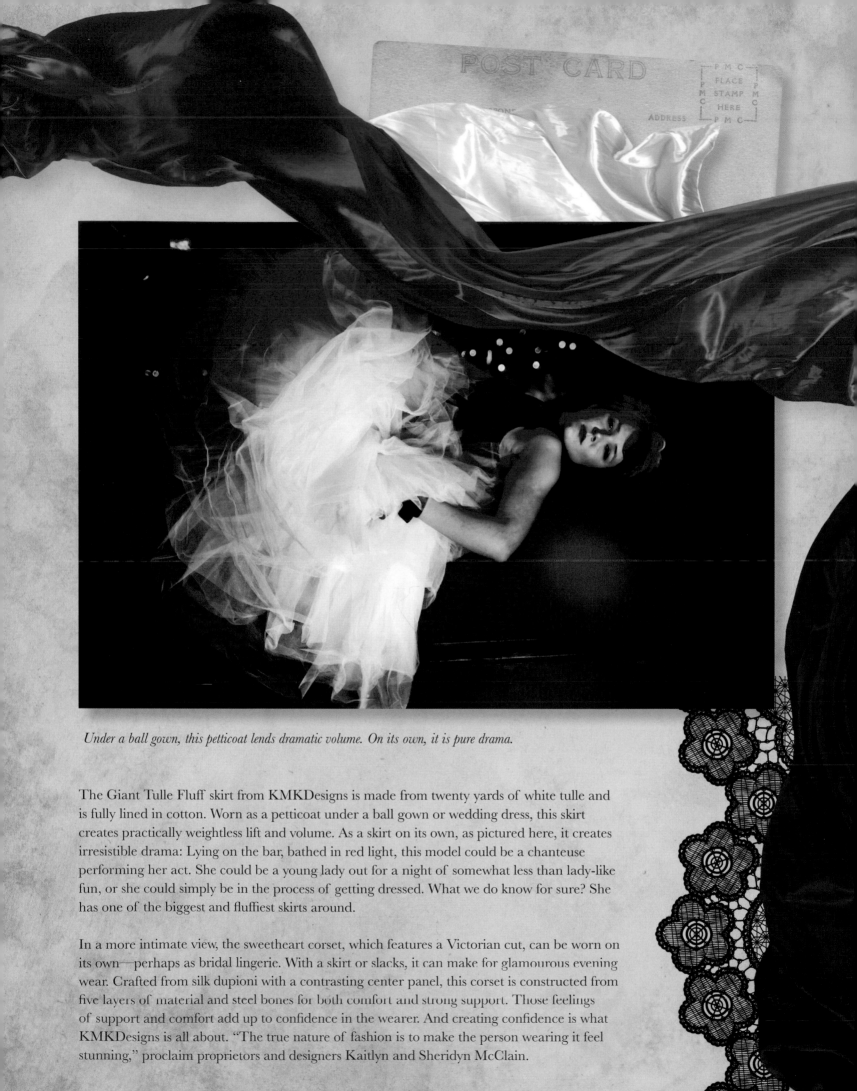

Under a ball gown, this petticoat lends dramatic volume. On its own, it is pure drama.

The Giant Tulle Fluff skirt from KMKDesigns is made from twenty yards of white tulle and is fully lined in cotton. Worn as a petticoat under a ball gown or wedding dress, this skirt creates practically weightless lift and volume. As a skirt on its own, as pictured here, it creates irresistible drama: Lying on the bar, bathed in red light, this model could be a chanteuse performing her act. She could be a young lady out for a night of somewhat less than lady-like fun, or she could simply be in the process of getting dressed. What we do know for sure? She has one of the biggest and fluffiest skirts around.

In a more intimate view, the sweetheart corset, which features a Victorian cut, can be worn on its own—perhaps as bridal lingerie. With a skirt or slacks, it can make for glamourous evening wear. Crafted from silk dupioni with a contrasting center panel, this corset is constructed from five layers of material and steel bones for both comfort and strong support. Those feelings of support and comfort add up to confidence in the wearer. And creating confidence is what KMKDesigns is all about. "The true nature of fashion is to make the person wearing it feel stunning," proclaim proprietors and designers Kaitlyn and Sheridyn McClain.

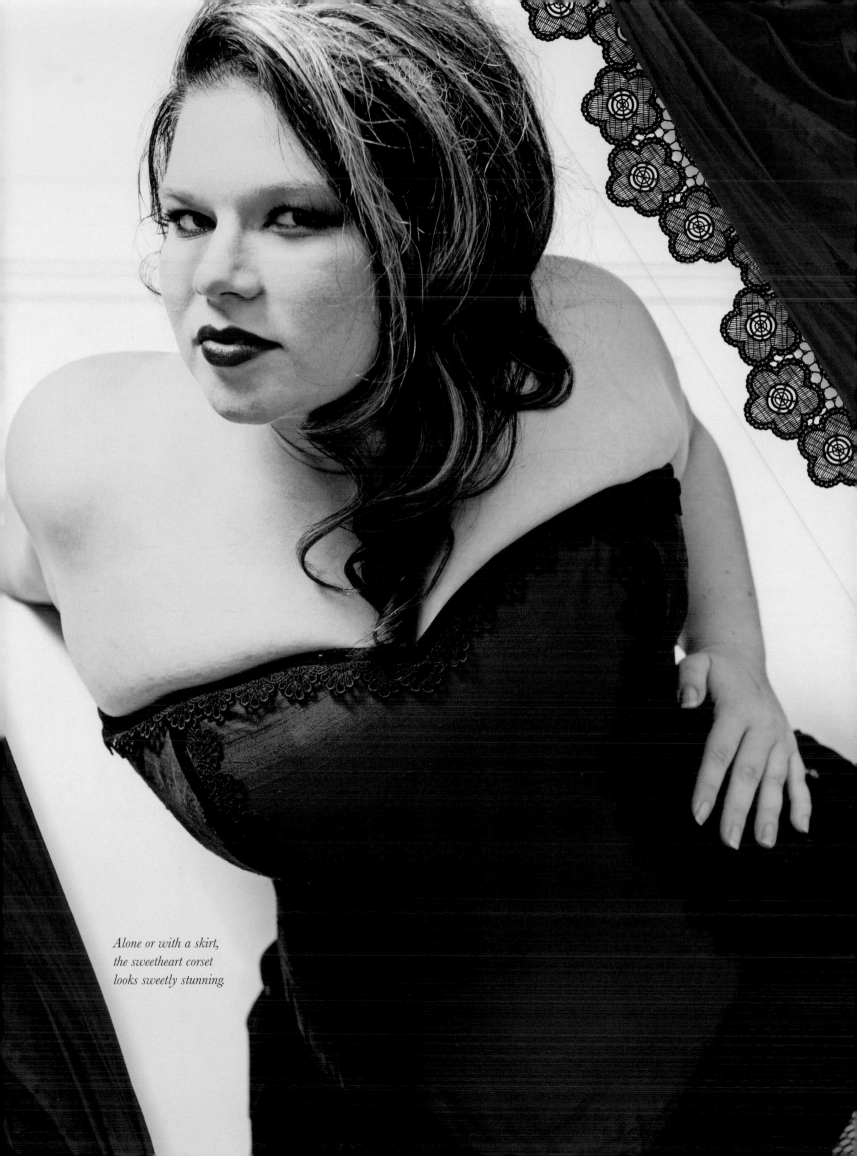

Alone or with a skirt, the sweetheart corset looks sweetly stunning

Ms. Purdy's

Feathers and lace and beads! Steampunk hats can be lavish and exuberant. They can also be elegant and chic. These toppers are designed to perch on top of the head and are held in place either with an elastic band that passes under the hair and rests at the nape of the neck or with a comb.

Belinda Lockhart creates hats like these under her label Ms. Purdy's. Working out of her home in Clinton, Iowa, she has made hats for nine years and has been selling under her own label for five. Lockhart finds inspiration in old books and movies, and sometimes the vision of a new hat just pops into her head. Then she hurries to her studio and gets to work with her fabric, flowers, feathers, and trim. In addition to the hats that she sells on eBay and Etsy, which include wedding hats, ones for church, Kentucky Derby hats, and steampunk looks, Lockhart has designed custom hats for a broad range of women—from toddlers to a lady celebrating her ninety-seventh birthday. She also crafts the visions of individual steampunks. She says, "Steampunk is hard and soft at the same time, and it's very sexy. I love that."

All in black, this mini riding topper with its beaded trim, black feathers, and train will raise the level of any outfit.

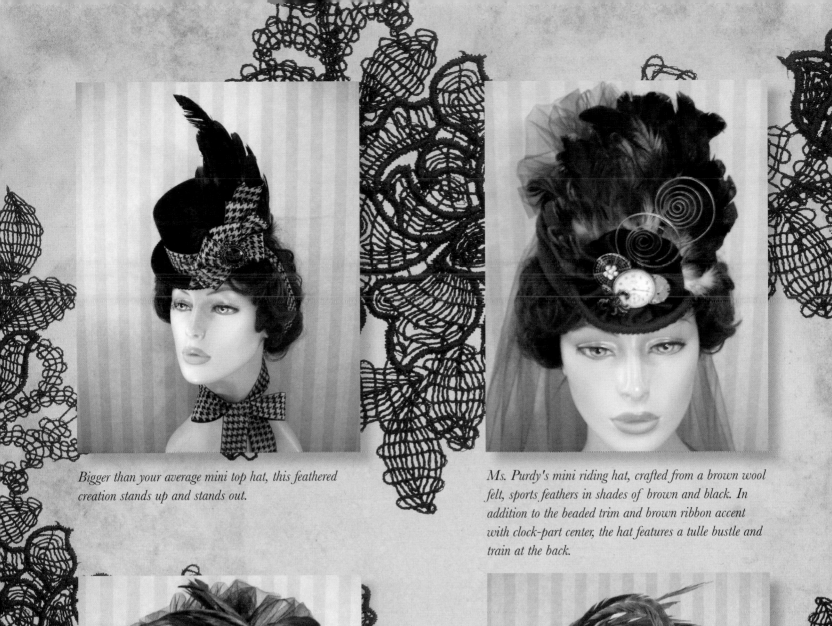

Bigger than your average mini top hat, this feathered creation stands up and stands out.

Ms. Purdy's mini riding hat, crafted from a brown wool felt, sports feathers in shades of brown and black. In addition to the beaded trim and brown ribbon accent with clock-part center, the hat features a tulle bustle and train at the back.

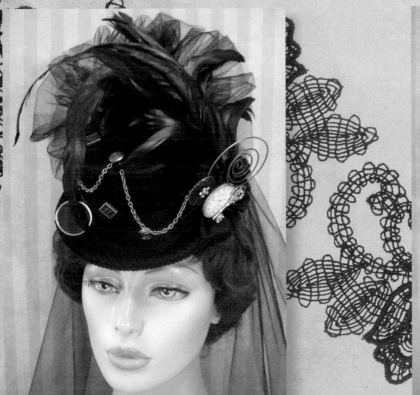

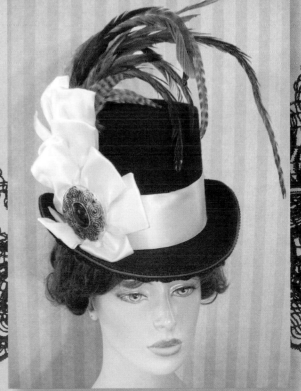

This mini top hat with black coque feathers and black trim displays steampunk accents, including clock parts and an ornamental key.

This full-sized top hat features dramatic striped coque feathers and bold ribbon accents.

Harvash

A former ballet dancer, milliner Harvy Santos was born in the Philippines and now lives in London. Since he left the Hong Kong Ballet in 2005, he has been creating his own hat and costume designs under his label Harvash full time. After moving to London in 2008, Santos "went hat-mad and just kept making hats." He studied with Rose Cory, the late Queen Mother's milliner, and then enrolled in a one-year course at Kensington and Chelsea College. Since earning his Higher National Certificate with Distinction from Kensington and Chelsea, Santos has apprenticed for milliners Noel Stewart, where he worked on headpieces for Australian pop-diva Kylie Minogue, and for the influential and radical Stephen Jones, where he helped create the hats for runway fashion shows.

Santos has also worked for the Royal Opera House, crafting hats for their productions and for the dancers of the Royal Ballet. In 2010, Santos was listed by Vogue.co.uk as one of their favorite new milliners. Fashion journalist Phoebe Frangoul described Santos's work as "elegantly energetic." In 2011, one of Santos's hats won an award from the Worshipful Company of Feltmakers.

Santos created this steampunk hat, complete with clockwork gears, watch hands, and Roman numerals, as part of a collection. Instead of giving these hats model numbers, Santos bestowed on each one a name, a character, and a bit of a backstory. This one is "Fionnuala Huntington." The designer imagines her as the widow of a Victorian-era clockmaker.

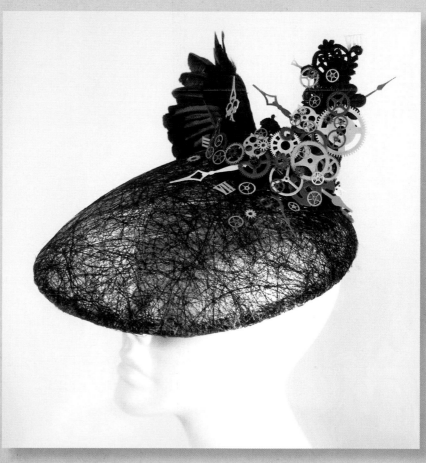

Award-winning London-based milliner Harvy Santos named this steampunk hat "Fionnuala Huntington."

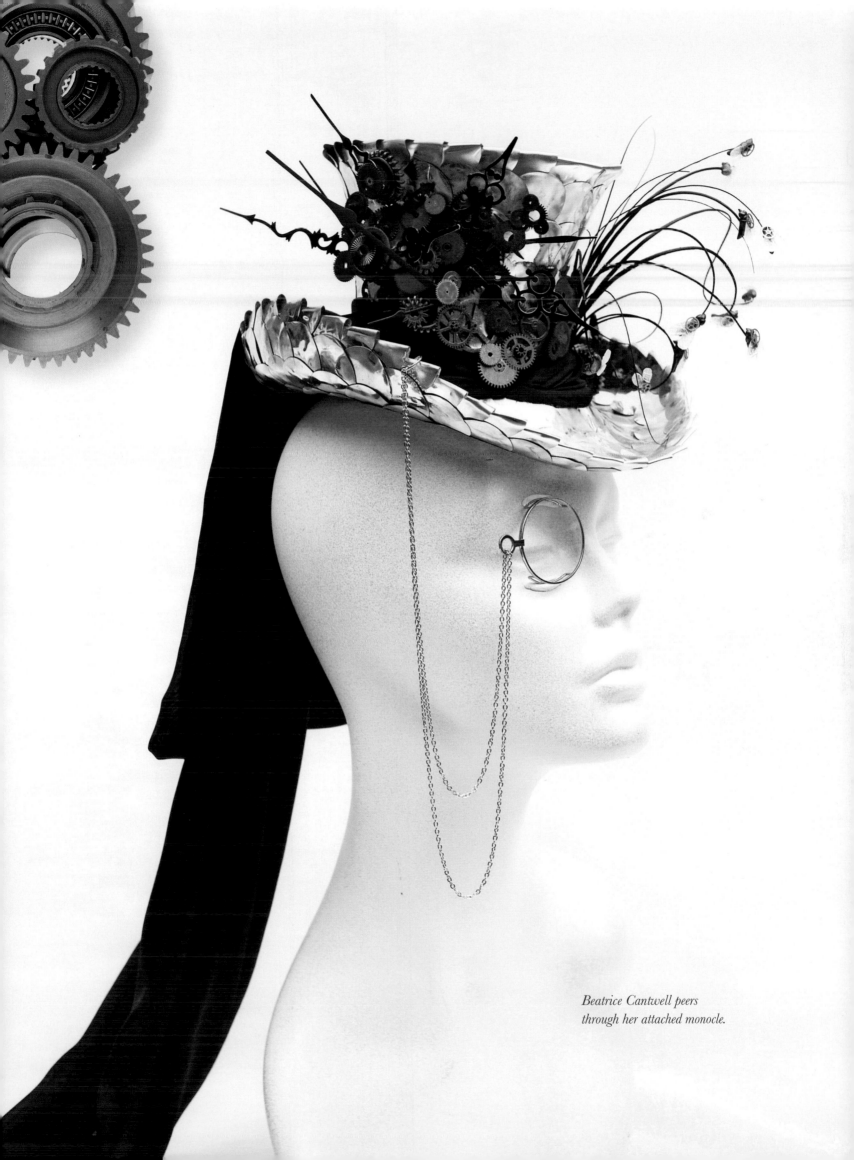

*Beatrice Cantwell peers
through her attached monocle.*

With wings on each side plus an assortment of gears and watch hands, this stylish cap, called "MR Flit," seems to summon the Roman god Mercury, all the while exuding the energy of flight. Santos imagines MR Flit as a disabled postman. Luckily, his headgear provides him with steam-powered wings. Beatrice Cantwell (see page 69), a woman's topper, while equally energetic seems more restrained. An attached monocle and a black train at the back lend her a playful and easy elegance. VR Alexandrina with its long spikes seems perfect for the offbeat bride, a queen, or anyone who likes to protect her personal space.

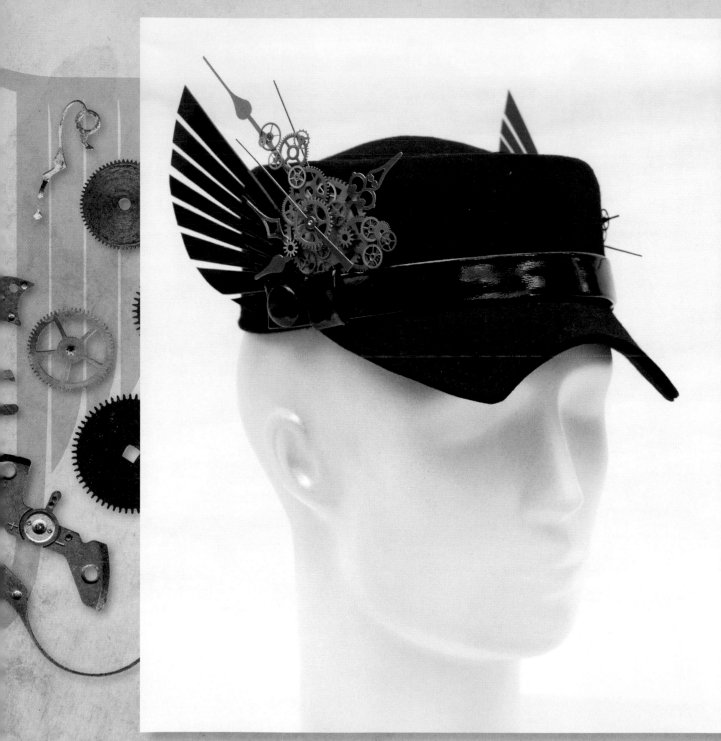

ABOVE *In the mind of its creator, the hat called "MR Flit" belongs to a postman.*

OPPOSITE PAGE *With VR Alexandrina, Santos imagines Queen Victoria as a time-traveler who has landed in 1980s London where she is influenced by the high fashion and punk designers of the day. The central crown of this headpiece is modeled on the iconic diamond crown that Queen Victoria wore.*

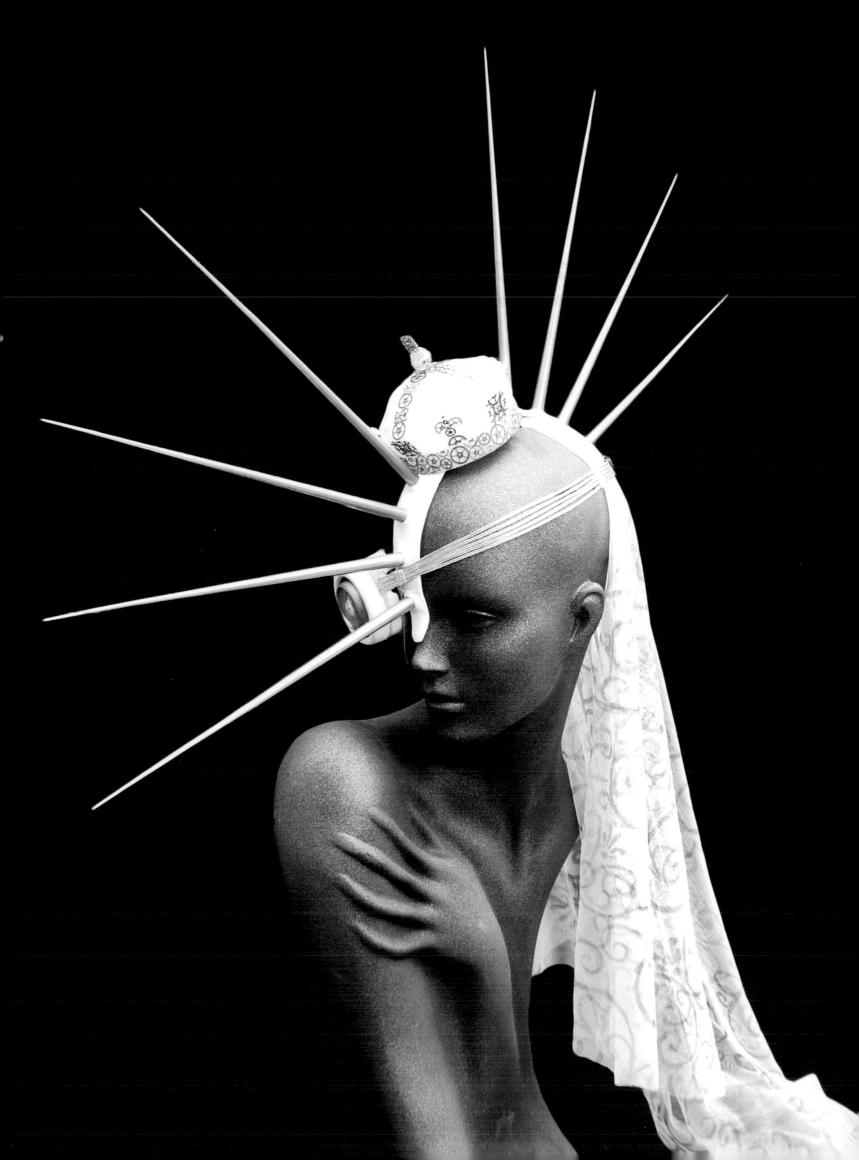

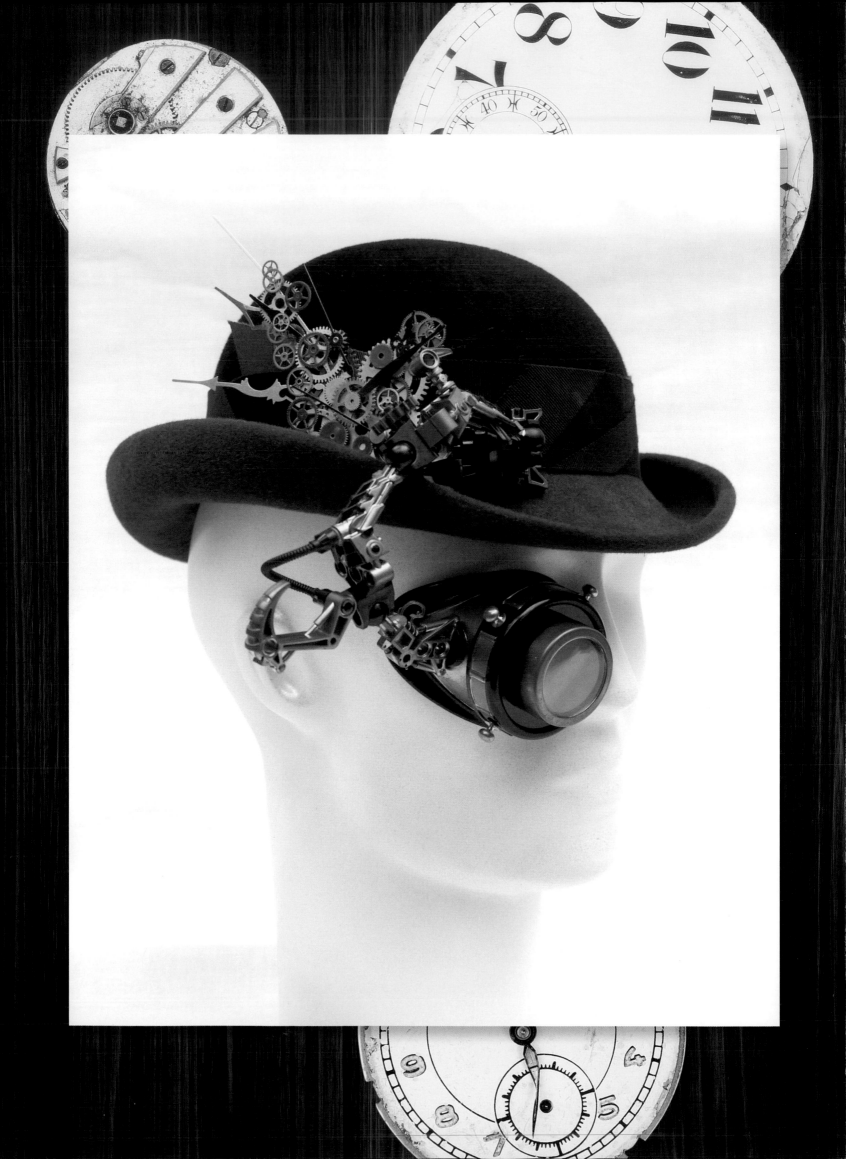

Santos originally created three steampunk hats to enter in a millinery competition. He made it as far as the semifinals and then decided he wanted to expand the collection, and exhibit his creations at The Asylum, Europe's largest steampunk event, which is held in September of every year in the City of Lincoln, UK. Each hat has its own personality and story. SF Hickey is an horologist who specializes in pocket watches that serve as time traveling devices. He is assisted by boy genius Alister. After the workday is done, SF Hickey transforms himself into MR G Teal, a playboy and gambler, who poses as a member of the aristocracy. In a Robinhood-ish turn, Teal cheats the wealthy out of their money and then lavishes his gains on the ladies of the night.

Corsets and crinolines, frock coats and kimono, top hats and lace collars and spats, the elegance of a world gone by and the innovation of today. Fine and Formal steampunk dress has sprung from a number of different traditions. It is fabricated by a range of varied designers and worn by a diverse and growing community. Next we'll look at ways to make your own personalized top hat and a pair of spats. Then we'll take a look at musicians and performers and others with a theatrical bent whose looks are crafted for the stage.

OPPOSITE PAGE *SF Hickey is an old-time horologist who leads a double life.*

TOP *Alister is a boy prodigy who works as SF Hickey's assistant.*

BOTTOM *MR G Teal is composed of a black velour crown, a black and hunter green "betting ticket" hatband, and a hunter green brim.*

Steampunk Your Top Hat

By Won Park

DIY

Version 1

You Will Need

Top hat
Small clock face
Clock hands
Craft glue
Pocket watch face
Various clock gears
Steampunk goggles

It doesn't take much to transform your plain top hat into a Steampunk Top Hat. The top hat was worn during the Victorian era, so it already suits the steampunk style. In this tutorial I will show you a few simple ways to make your top hat stand out.

This project is simple. Yet first you must procure a top hat. You can find top hats online or support your local hat shop. A real wool felt top hat can be expensive, but if you wait till Halloween, there will be a plethora of costume top hats available at more reasonable prices.

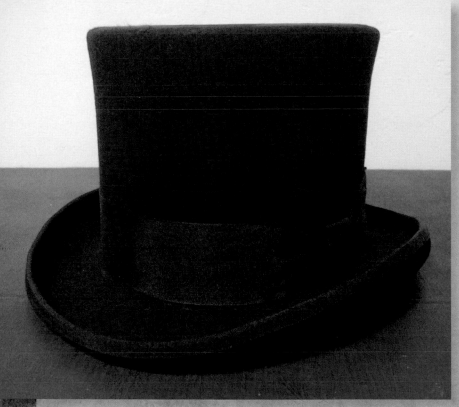

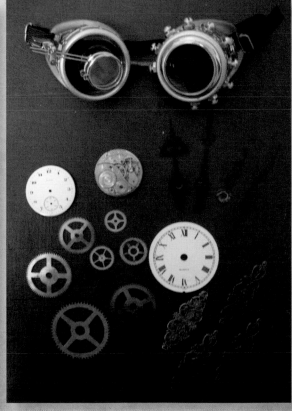

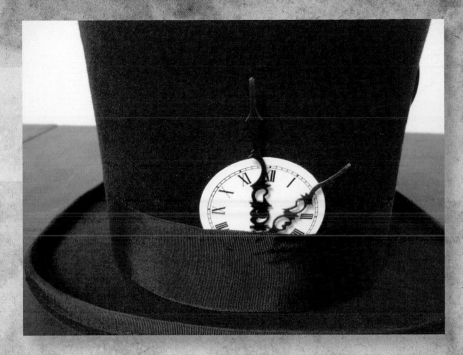

1 Glue the clock face and clock hands on the side of the top hat under the band.

2 Glue the pocket watch face on the front along with small clock gears.

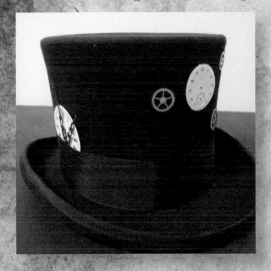

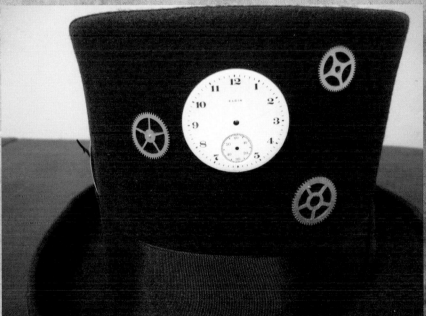

3 Place goggles on the top hat.

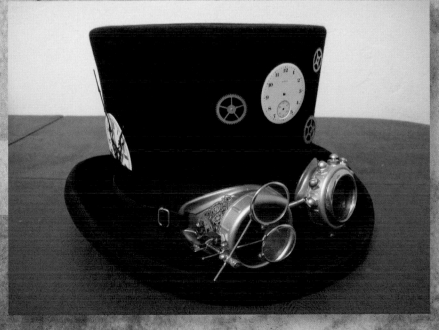

Version 2

Remember that steampunk style is extremely versatile and is an extension of your own personal style...so go nuts (and bolts)!

You Will Need

¼ yard embroidered fabric
Top hat
Scissors
Craft glue
Various clock gears

Clock and watch faces
Clock hands
Filigree jewelry bases
Steampunk goggles

1 Cut a 9" wide strip of your embroidered fabric long enough to wrap around the hat band leaving an overlap of 4-5".

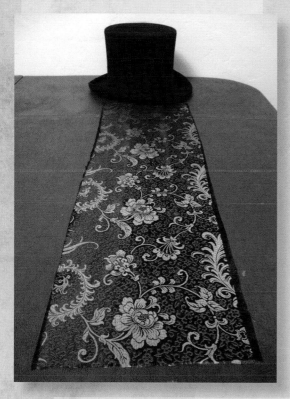

2 Fold the fabric lengthwise in thirds.

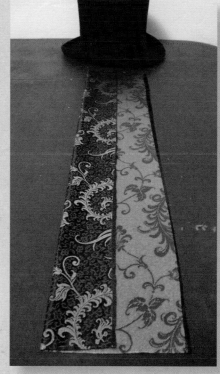

3 Starting at the side of the hat, tuck the top corner of the fabric down and glue to the hat.

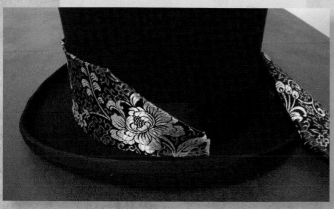

4 Wrap the fabric around the hat. Tuck the top corner down and glue to the other end of fabric.

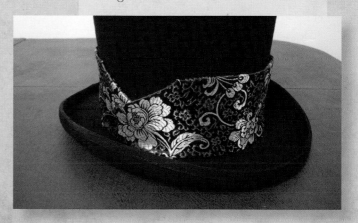

5 The fabric will create a V shape—perfect to frame a clock face with hands or any other decorative element that you like.

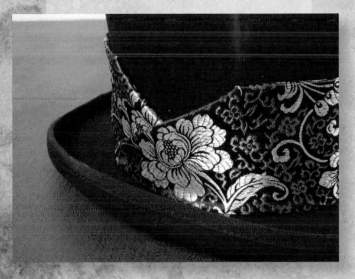

6 Decorate the hat with liberal application of gears, watch faces, and filigree jewelry to your liking. Don't forget the goggles!

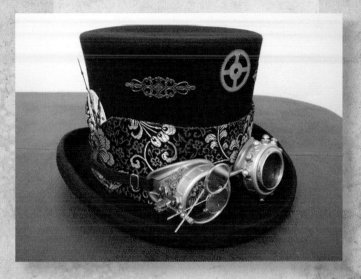

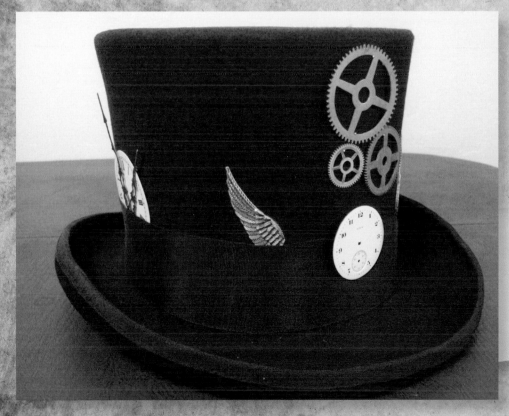

Here's a photo of another Steampunk Top Hat style to inspire you!

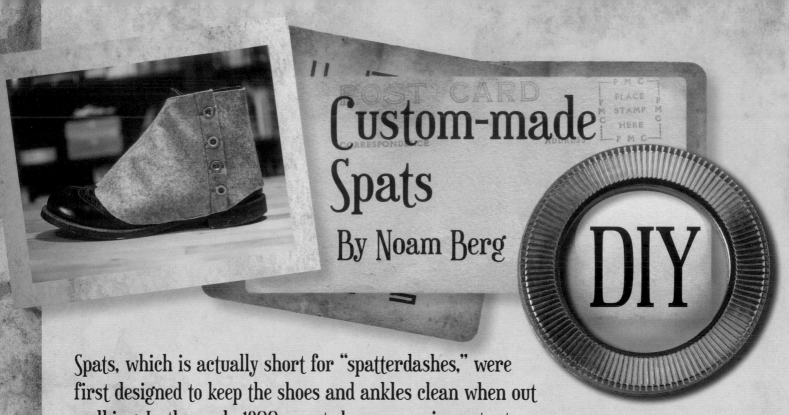

Custom-made Spats

By Noam Berg

POST CARD

P M C
PLACE
STAMP
HERE
P M C

DIY

Spats, which is actually short for "spatterdashes," were first designed to keep the shoes and ankles clean when out walking. In the early 1900s, spats became an important accessory for the well dressed man. Today steampunks of all genders wear them, and you can make your own. This project is not hard. So, give it a try.

For your spats, you'll want to buy a good thick felt that won't unravel at the cut edges. First you will make a pattern to fit a pair of your boots (or shoes). Then you will sew your snazzy new accessories.

You Will Need:

One yard plain muslin
 (or scrap fabric)
Scissors
Binder clip
Pencil or marking pen for sewing
Painter's tape or masking tape
One yard thick felt
Pins
An iron
Needle or sewing machine
Thread that matches or
 complements the felt
8 buttons
Seam ripper or craft knife
Two pieces of ¾" elastic strap

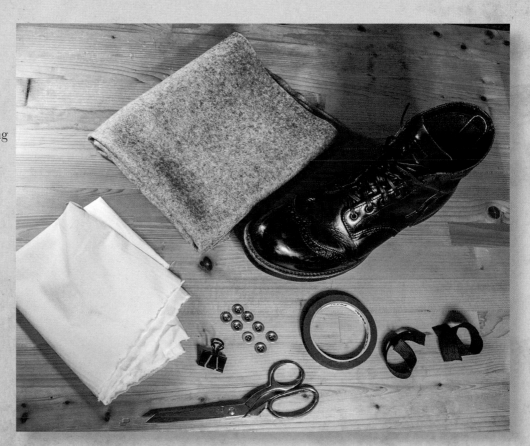

The Pattern

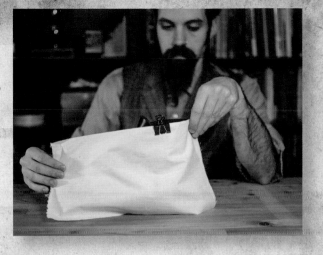

1 Cut a piece of muslin large enough to wrap the entire outside half of one boot. Use the binder clip to fix the fabric to the top of the boot, on the outside.

2 Mark the top line of the spat, either at the top of the boot or just below the top.

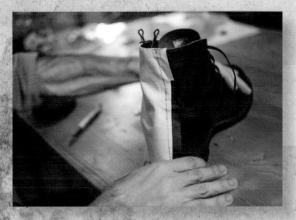

3 Wrap the fabric around the back and tape it in place. Mark a line down the back center.

4 Smooth the fabric around the contours of the boot, from back to front. Mark a line down the center of the front, from the top line down to the end of the fabric.

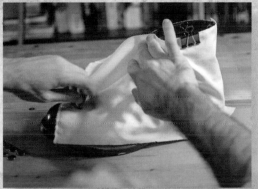

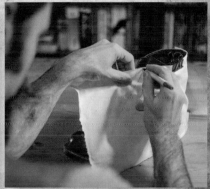

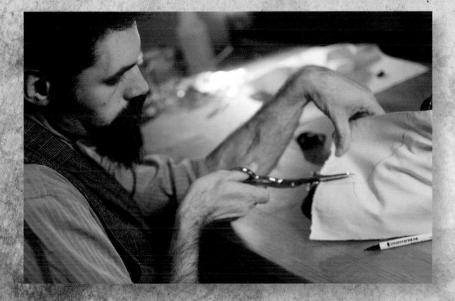

5 Trim the fabric along the front center line and tape it down.

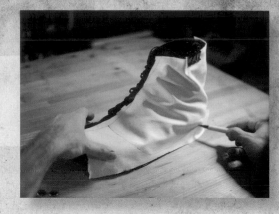

6 Mark a line for the bottom edge of the spat, from the top center line to the rear center line. How far you want the spat to reach in the front is up to you.

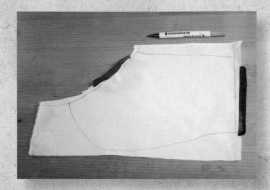

7 Remove the fabric from the shoe and darken the outlines you have drawn. Trim the fabric along the outlines of the pattern. We will call this part Pattern Piece #1.

8 Reattach Pattern Piece #1 to the boot. Mark a vertical line down the side, where you want the buttons to go.

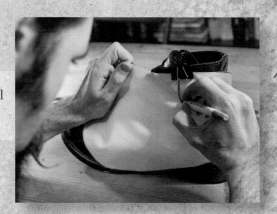

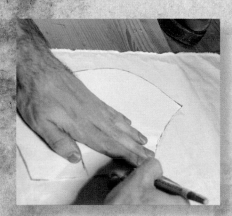
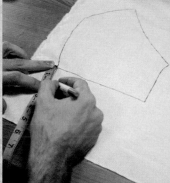

9 To create Pattern Piece #2, lay Piece #1 on the muslin. Trace the front section of Piece #1, up to the button line. Extend the pattern 1½" past this line. This extra fabric will allow you to create a strong buttonhole placket.

10 To make Pattern Piece #3, trace the back section of Piece #1. Cut out Pieces #2 and #3. And your pattern is ready for use. Note: Because your pattern pieces are custom made for your boot, they may look a bit different from the ones pictured here.

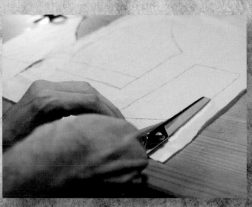

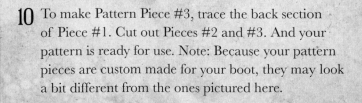

The Spats

1 Get out your felt and give it a good pressing. Pin all three pattern pieces to the felt and trace them. Unpin the pattern pieces and set them aside.

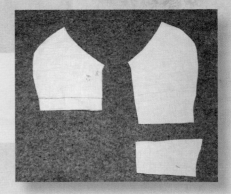

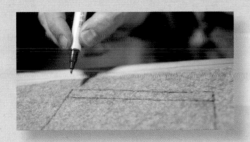

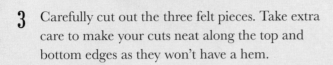

2 Add ½" of seam allowance where the felt pieces will meet at the spat's front and back center lines.

3 Carefully cut out the three felt pieces. Take extra care to make your cuts neat along the top and bottom edges as they won't have a hem.

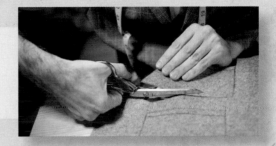

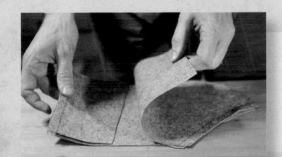

4 So you can see how everything fits together, place felt piece #1 on a flat surface and position pieces #2 and #3 on top of it. Make sure that the inside of the fabric is facing out. First you will sew pieces #1 and #3 together. Line them up along the back seam and pin them together.

5 Sew the seam (either by hand or machine) and press it.

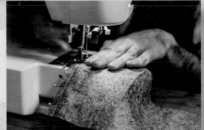

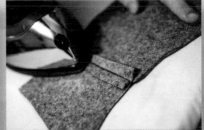

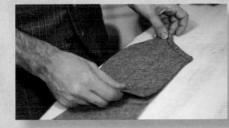

6 Line up felt pieces #1 and #2 along the front center line, with the inside of the fabric facing out, pin them together, and sew the seam.

7 To allow the seam to lay flat, cut small V-shaped notches into the seam allowance.

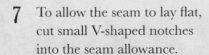

8 Press the seam. Because the seam is curved, you may have to use the edge of the ironing board and the tip of the iron to get in there.

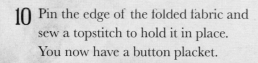

9 Now you will make the button placket. Remember the extra 1½" you added to piece #2? Fold that end of piece #2 in 1". Make sure you're folding it inward and have the right side of the fabric facing out. Press the fold.

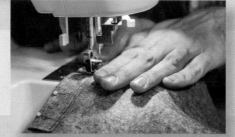

10 Pin the edge of the folded fabric and sew a topstitch to hold it in place. You now have a button placket.

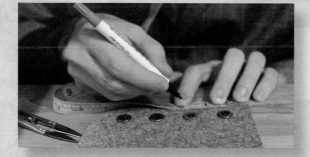

11 Mark where you want your button holes to go along the center line of the placket.

12 Use your sewing machine to stitch the buttonholes, employing the buttonhole foot, then carefully slit both layers of cloth in the middle with a seam ripper or a small blade. Or create buttonholes by hand by cutting slits with a small craft blade. Cut them just wide enough to fit each button through snugly.

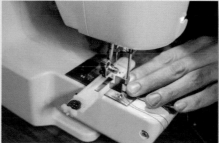
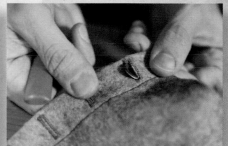

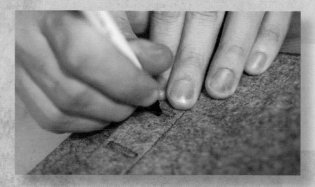

13 Once the buttonholes are finished, line the placket up with piece #3 so that it overlaps about ½". Mark the position of the buttons through the buttonholes.

14 Sew the buttons onto piece #3 as marked.

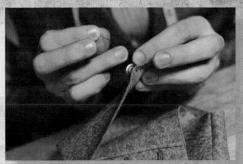

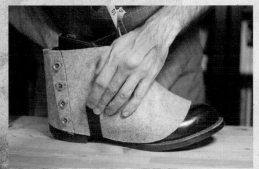

15 Put the spat on your boot. Position an elastic strap under the sole, just in front of the heel. Pin the strap to the inside of the fabric. Then sew the strap to the inside of pieces #1 and #2.

16 To make a second spat, get out your pattern pieces, flip them over, and begin again. When your second spat is done, put the pair on and strut your stuff!

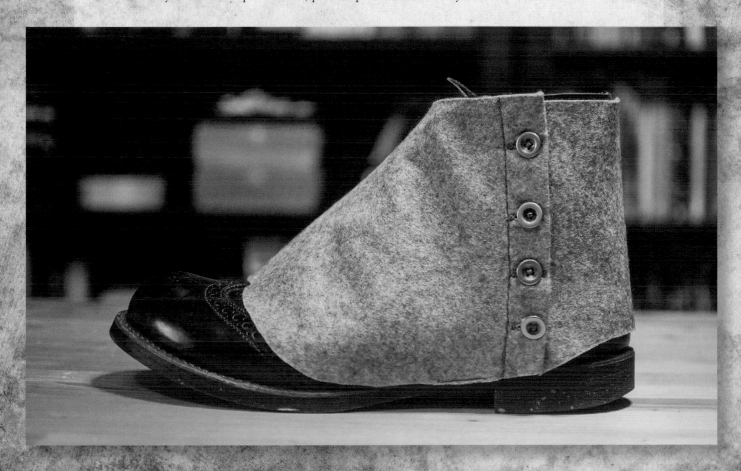

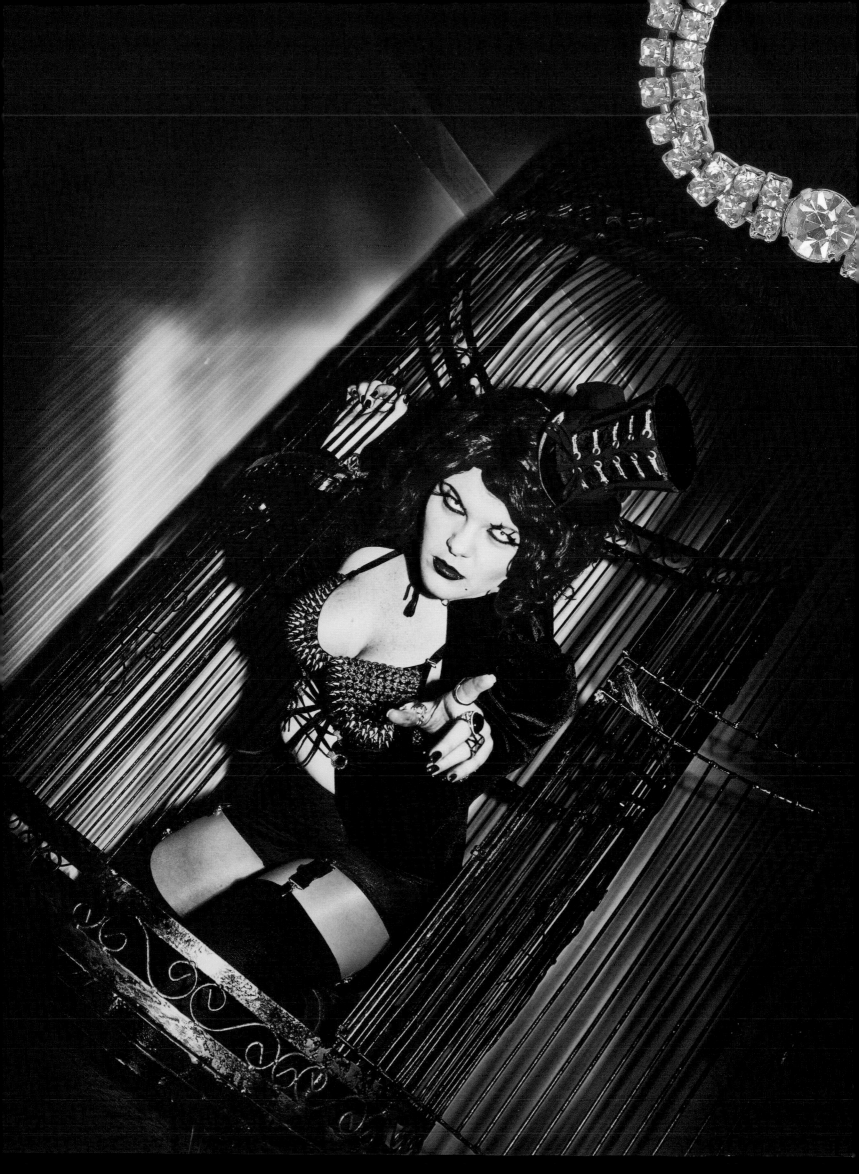

CHAPTER TWO
STAGE CRAFTED

INSIDE THE TENT, IT IS DARK. MUSIC RISES. A PIPE ORGAN. A SPOT OF
LIGHT BEGINS TO GROW. DARK SHAPES. STRIPES OF SHADOW. A CAGE.
A FIGURE INSIDE STIRS. A WOMAN. THE LIGHT GROWS AS THE CAGE
DOOR OPENS. NOW SHE IS FULLY VISIBLE, ON HER KNEES, HER CLEAVAGE
EXPOSED. WITH ONE HAND SHE CLUTCHES THE BARS OF HER CAGE. WITH
THE OTHER SHE POINTS, HER BLANK EYES STARING, SINGLING OUT AN
AUDIENCE MEMBER IN THE FRONT ROW.

Belladonna Belleville, a character created by Panda Ayotte, is the ringmistress of
the Belleville Circus. Born in the mid-nineteenth century, into a life of privilege,
Belladonna was accustomed to beautiful things. But after her family was slain by
political oppressors, Belladonna was on the run. She married into a welcoming
circus family and changed her style, finding beauty in new and more theatrical
ways. A dark character, Belladonna appears at steampunk and goth events. She
also performs as the narrator on the Haunted Hayride at Witch's Woods in
Westford, MA. Ayotte says, "I'm a fantasy- and horror-based steampunk rather
than a sci-fi steampunk, and many of my looks are inspired by drag fashion." To
achieve her fabulous and somewhat spooky look, much of Belladonna's outfit is
custom made, including her velvet tailcoat, gold spiked bra, hot pants with the
letter B on each cheek, and her top hat. She's also wearing chunky gold jewelry,
black stockings with garter clips, a pair of vintage boots, and a wig. White
contact lenses help push her glam look to the dark side.

In addition to performing as Belladonna, Ayotte has written academic articles
about the horror genre. She's currently writing a novel featuring Belladonna,
and she co-authors the dark culture blog *The Unkindness*. Ayotte also serves as
public relations director of Steampunk World's Fair, the largest steampunk event
in the world, featuring fashion and performers, ah, yes, performers. . . .

OPPOSITE PAGE *Panda Ayotte takes the spotlight as Belladonna Belleville, ringmistress
of the Belleville Circus.*

Airship Isabella

Airship Isabella is a company of artists and performers, catering to the film and TV industries. The group also performs at events, parties, and conventions around Texas and the southeastern United States. In addition, airship members lead DIY workshops, in which they share their knowledge and encourage everyone to be creative. They create art for themselves and for others to enjoy. Imagine the scene: An actress, dressed in white lace, sits on the edge of an outdoor stage. She reads from a book, her British accent ringing out above the vocal and enthusiastic audience. Behind her on the stage, a man in steampunk regalia—leather gaiters, a top hat with goggles, and an arm guard—paces. He visits the desk on stage, inspecting a few papers. Another man, full of good cheer, enters. "Ba, humbug," the first man intones. He is Scrooge from *A Christmas Carol* by Charles Dickens.

The group's costumes are a mixture of custom-made items, modified clothing, hand-built leather pieces, and custom accessories. While all crew members create their own outfits, several members specialize in costuming and design clothing for the group's commissioned projects. With approximately twenty-two members, ranging from full-time to "when they can" status, the Airship Isabella has many skills—from fire spinning and sculpting, to graphic arts and theatrical directing. And Mr. Fox possesses a talent for making head-turning Eldredge tie knots. The Isabella crew sells some of their wares—accessories, leather goods, jewelry, goggles, and vests—via their New Orleans based Etsy shop.

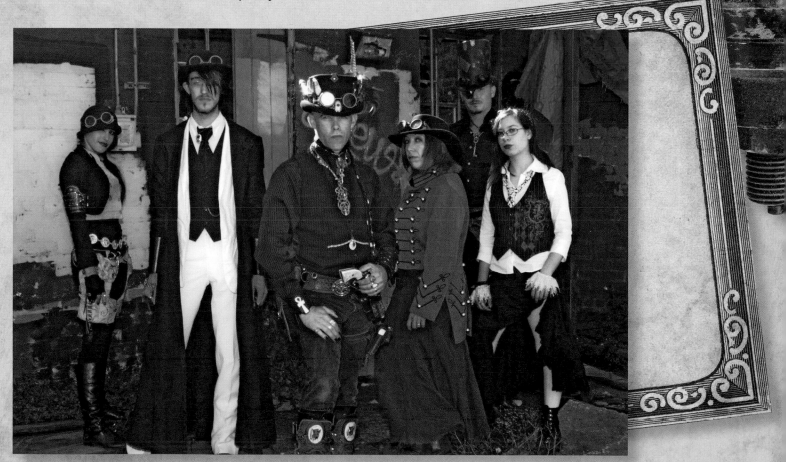

Members of the Airship Isabel, (from left to right) Suzeaux Ryette, Mr. Fox, Captain Cedric Whittaker, Amelia Whittaker, Byron Highmore, and Kitty Livingston.

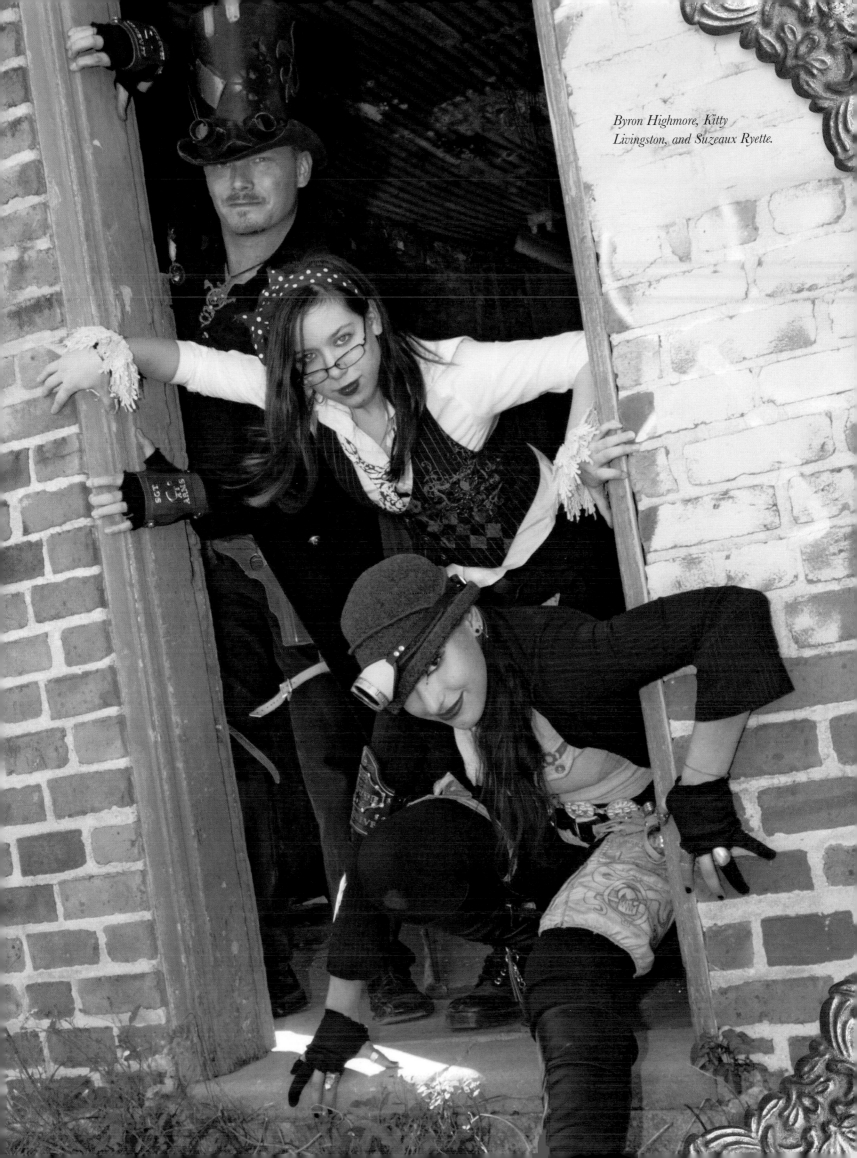

Byron Highmore, Kitty Livingston, and Suzeaux Ryette.

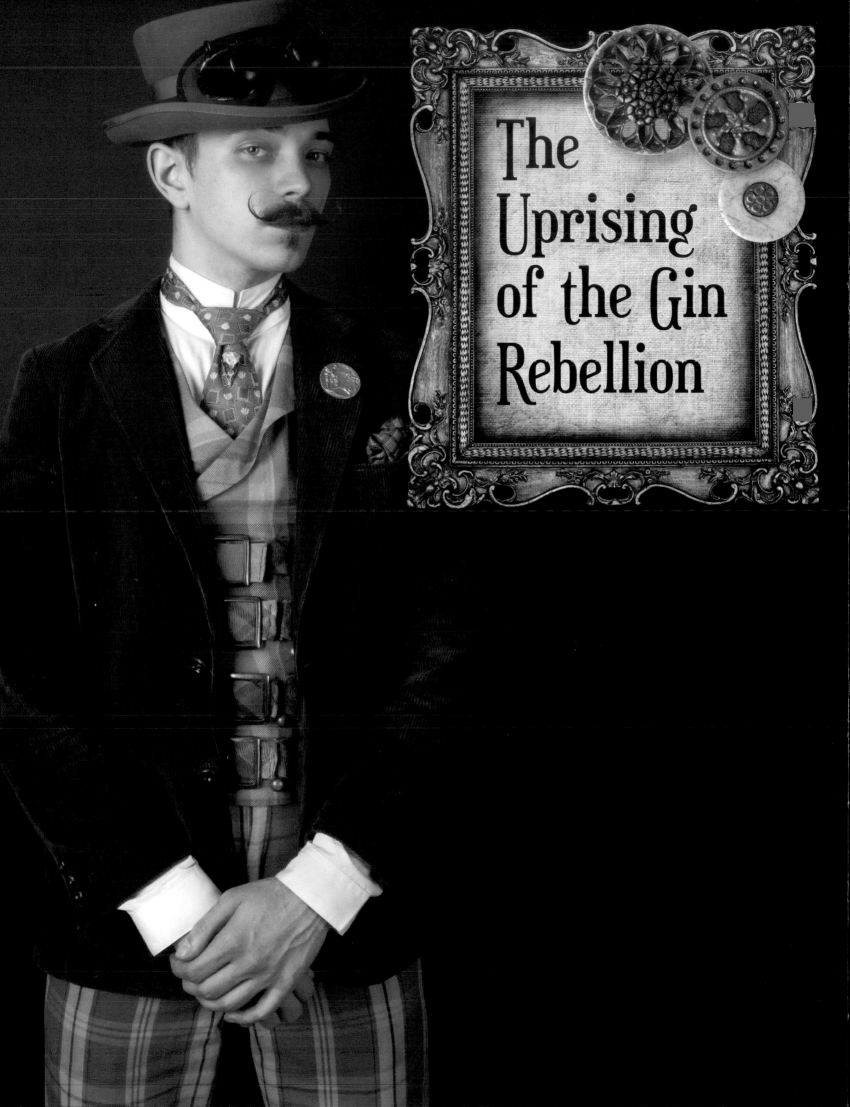

The Uprising of the Gin Rebellion

Some years ago in Atlanta, Catherine Barson was visiting a friend. Accompanying herself on the guitar, she sang a song she wrote herself called "Freak Show." One of her friend's roommates joined her, improvising on his accordion. Then another roommate with a guitar made it a threesome. After the song was done, the three realized they had a lot of musical interests in common. Jason Bush, a guitar player, and Nick Picard, an accordionist, had been playing together for about a year and had performed at the first Steampunk World's Fair, an annual event held in May in New Jersey. By the time the next year's fair rolled around, the three musicians were a band: The Uprising of the Gin Rebellion. Bush uses the stage name H. M., Picard is known as Renfield, and Barson is Ophelia Baptista.

Here Ophelia wears a thrifted blouse with a leather corset and tailcoat. H.M.'s black mourning ensemble, an original design and creation, is lightened with the addition of a red shirt. The striped fabric of the waistcoat is set to the bias to match the contrasting angle of the pockets on the pants. The high-waisted pants lace in the back for a precise adjustable fit. Renfield's brown outfit (**LEFT**) is a mixture of thrifted, purchased, modded, and custom-made items, while his black ensemble consists of self-made jewelry, velvet waistcoat, and a mourning coat. His shirt, tie, and pants were acquired from thrift shops, and the goggles are antique.

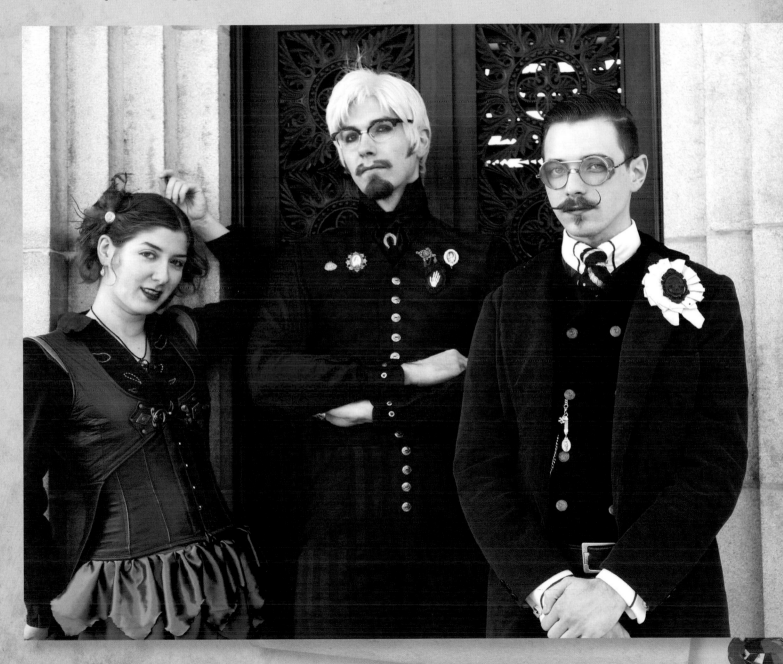

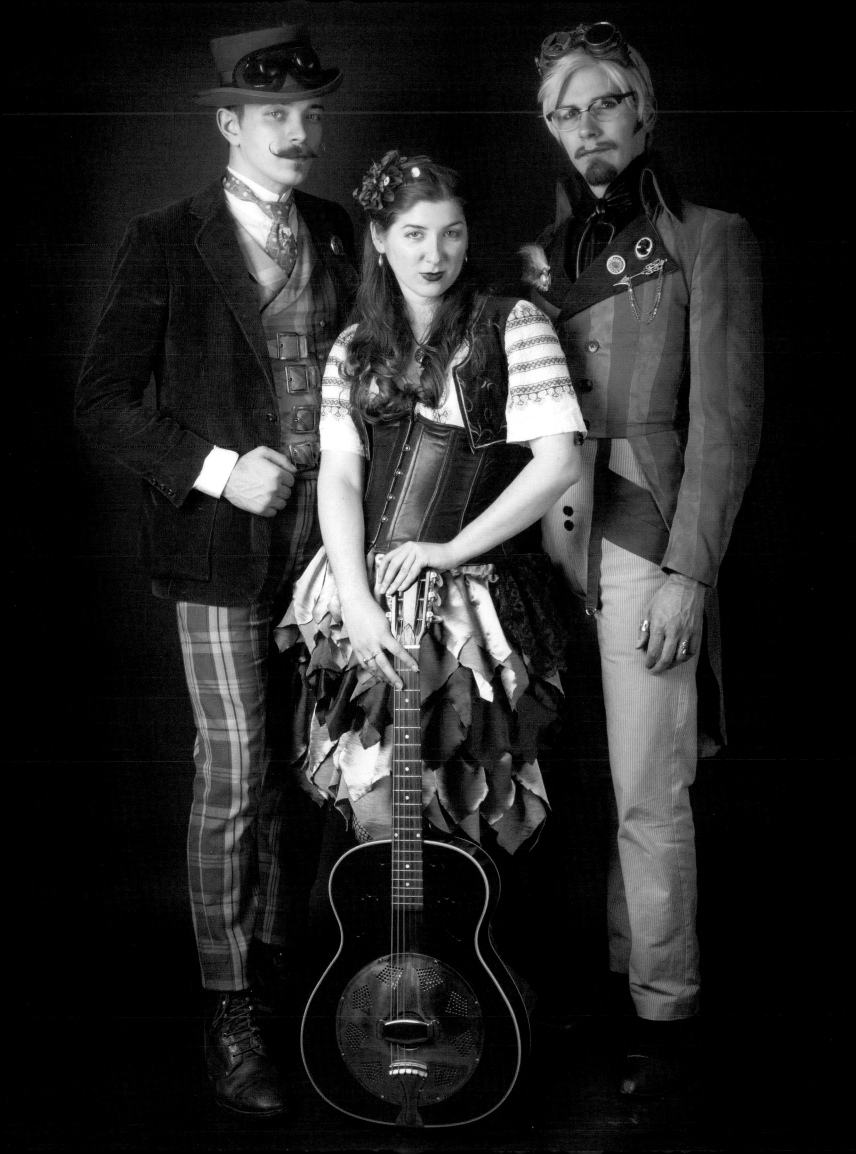

Known for their music, which they describe as dark cabaret, and for their fine sartorial style, The Uprising of the Gin Rebellion appears at events and conventions, coffee shops, and art galleries. Their sound is inspired by vaudeville, early American folk songs, musical theater, and eastern European traditions. Self-described dapper dandies, H. M. and Renfield often wear bold colors and aren't afraid to mix patterns—plaid trousers with a botanical brocade vest and a jacket of an entirely different fabric, or a mash-up of different plaids. Phil Powell cites them as among his style inspirations.

As part of his brown outfit, Renfield designed and fabricated his waistcoat. His plaid pants are a collaboration between him and H.M. The purple lapels of H.M.'s orange tailcoat provide dynamic contrast. This original design is meticulously constructed. Note that the coat's stripes line up precisely at the waistline.

Renfield's outfit, below, consists of plaid pants, a thrifted shirt, and purchased boots and hat. Renfield made his cravat, brocade waistcoat, coat, and jewelry, including the coyote tails. H. M. wears an outfit of his own creation, which he calls his "underwater steampunk" look. He made the teal checked waistcoat, yellow pants, and white shirt according to his own design and pattern.

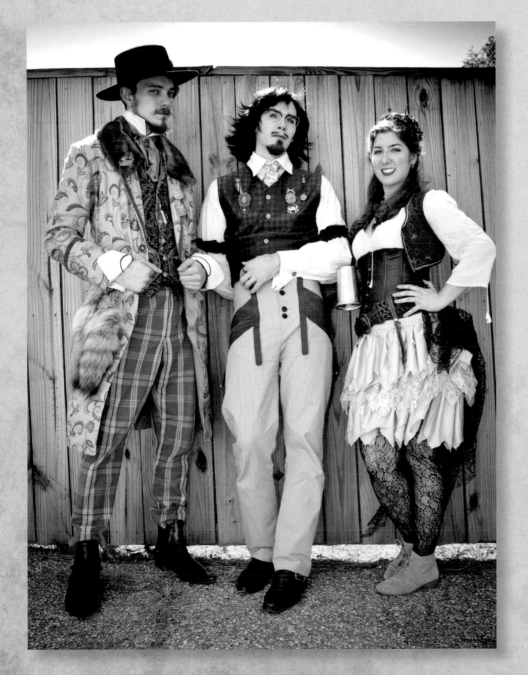

OPPOSITE PAGE *Renfield (**LEFT**) is dressed in a waistcoat of his own design and pants designed and executed by him and H. M. Ophelia (**CENTER**) wears a blouse from Romania with a self-made skirt and vest. H. M. (**RIGHT**) wears the trousers from his underwater ensemble with an orange tailcoat of his own design.*

LEFT *In addition to making his tie, coat, and waistcoat, Renfield (**LEFT**) made his jewelry and coyote-tail accessories. H. M. (**CENTER**) wears the original version of his underwater steampunk look. Ophelia sports a vest and lace bustle skirt that she made herself.*

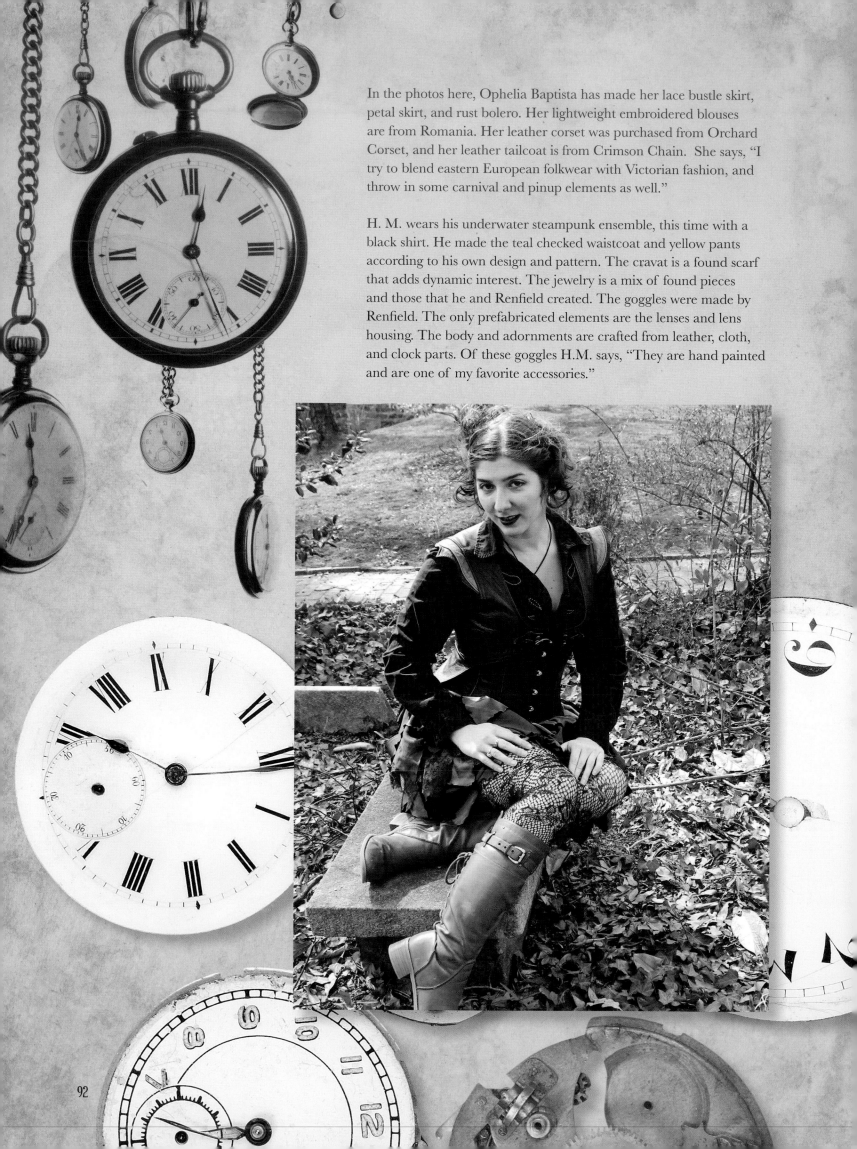

In the photos here, Ophelia Baptista has made her lace bustle skirt, petal skirt, and rust bolero. Her lightweight embroidered blouses are from Romania. Her leather corset was purchased from Orchard Corset, and her leather tailcoat is from Crimson Chain. She says, "I try to blend eastern European folkwear with Victorian fashion, and throw in some carnival and pinup elements as well."

H. M. wears his underwater steampunk ensemble, this time with a black shirt. He made the teal checked waistcoat and yellow pants according to his own design and pattern. The cravat is a found scarf that adds dynamic interest. The jewelry is a mix of found pieces and those that he and Renfield created. The goggles were made by Renfield. The only prefabricated elements are the lenses and lens housing. The body and adornments are crafted from leather, cloth, and clock parts. Of these goggles H.M. says, "They are hand painted and are one of my favorite accessories."

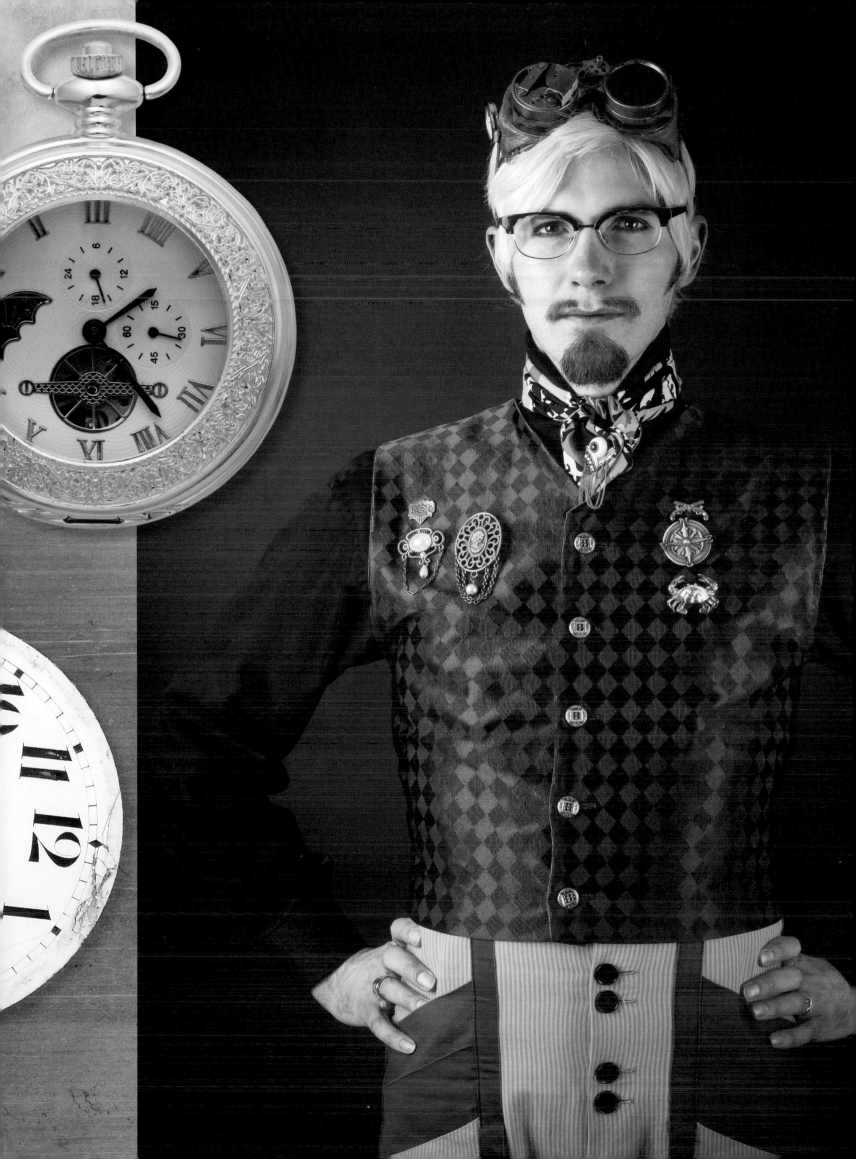

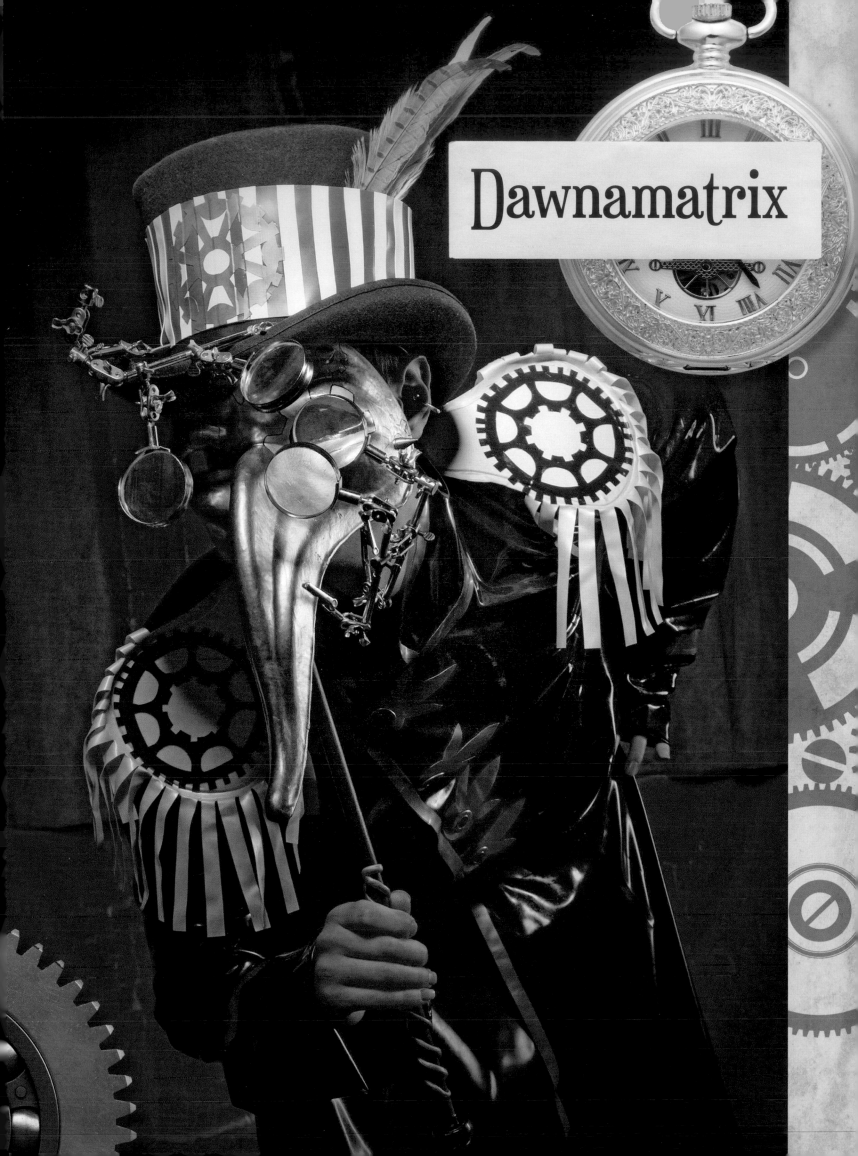

Dawnamatrix

These latex looks are the creations of Dawn Mostow, the award-winning designer behind the Dawnamatrix label. Mostow, who takes inspiration from the craftsmanship of kimonos, historical fashions, fantasy series, and superhero films, comes for a long line of tailors. While living in Japan, she studied the art of both wearing and designing kimonos. She went on to earn her MFA in New Forms from Pratt Institute in New York City and is currently pursuing a second master's degree in Visual Arts from Harvard. Her work has been described as straddling "the line between fetish wear and fine art." And indeed, her work has been shown in museums and gallery spaces around Boston, including the State House of Representatives, Harvard University, the Boston Children's Museum, and the Charles River Museum of Industry and Innovation.

When working with latex, Mostow explains, the drafting process is similar to creating fabric patterns. But "instead of being stitched together, the panels of sheet latex are chemically bonded using a solvent-based adhesive." The highly theatrical look of Dawnamatrix fashions are popular in the clubwear and fetish communities, as well as with cosplay and sci-fi convention-goers. Mostow's designs are also favored by performers working in music video and cinema productions.

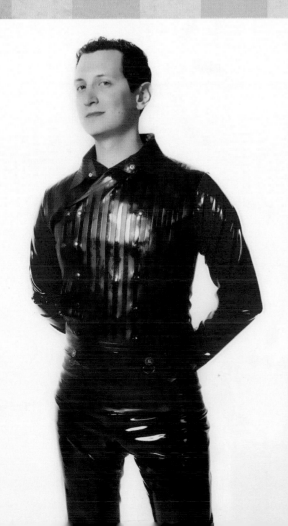

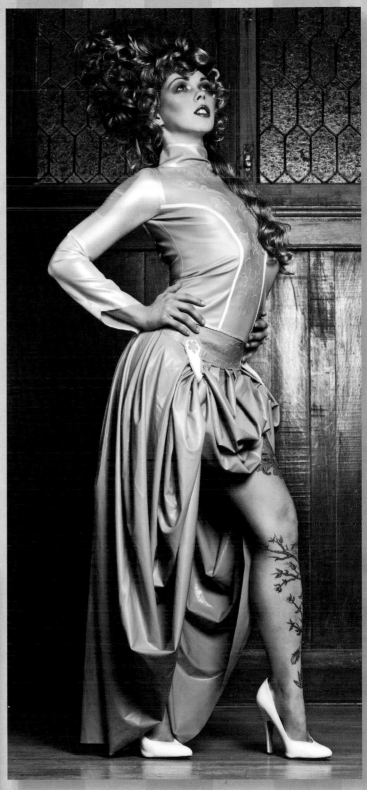

OPPOSITE PAGE *This model, dressed in a latex trench coat, a striped hatband with a gear decoration, and a plaster mask, plays the part of the ringmaster in a steampunk burlesque circus.*

ABOVE *The latex Courtesan Skirt drapes and flows like high-end satin.*

LEFT *Crafted from textured latex, the pinstriped vest and cummerbund fasten with snaps.*

The League of S.T.E.A.M.

This is the performance troupe the League of S.T.E.A.M., a group of artists, actors, and inventors who present stage shows, interactive live entertainment, and demonstrations of their fantastic and fully-functional gadgets. Those include tools such as the "Phantom Eradication Apparatus," a backpack-like device that shoots bursts of steam to drive away paranormal pests, and the "Hunting Utility Gun," which, with the pull of a trigger, launches a net twenty feet into the air. Troupe members play retro-futuristic monster hunters. Poised and ready for action, they have come from the Victorian era to help make our world a safer, zombie-free place. They also make it a more fun place.

Dubbed the "Steampunk Ghostbusters" by the *L.A. Weekly*, the League's presentations, which are modeled on old-time medicine shows, have been described as part magic show and part circus. In addition to appearing at conventions, festivals, weddings, nightclubs, and corporate events, the League has shared the limelight with groups from the music world. League members appear in various roles in the music video "The Ballad of Mona Lisa" by Panic! at the Disco. The League also records its own videos for their award-winning web series "The Adventures of The League of S.T.E.A.M."

But what does S.T.E.A.M. stand for? Supernatural and Troublesome Ectoplasmic Apparition Management, of course.

The monster hunters, along with their specialized equipment, have gathered.

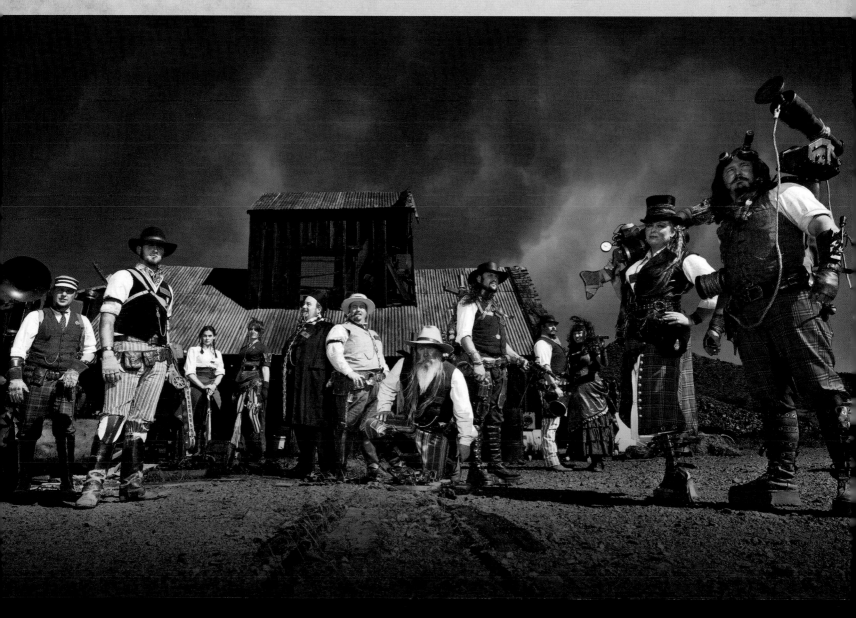

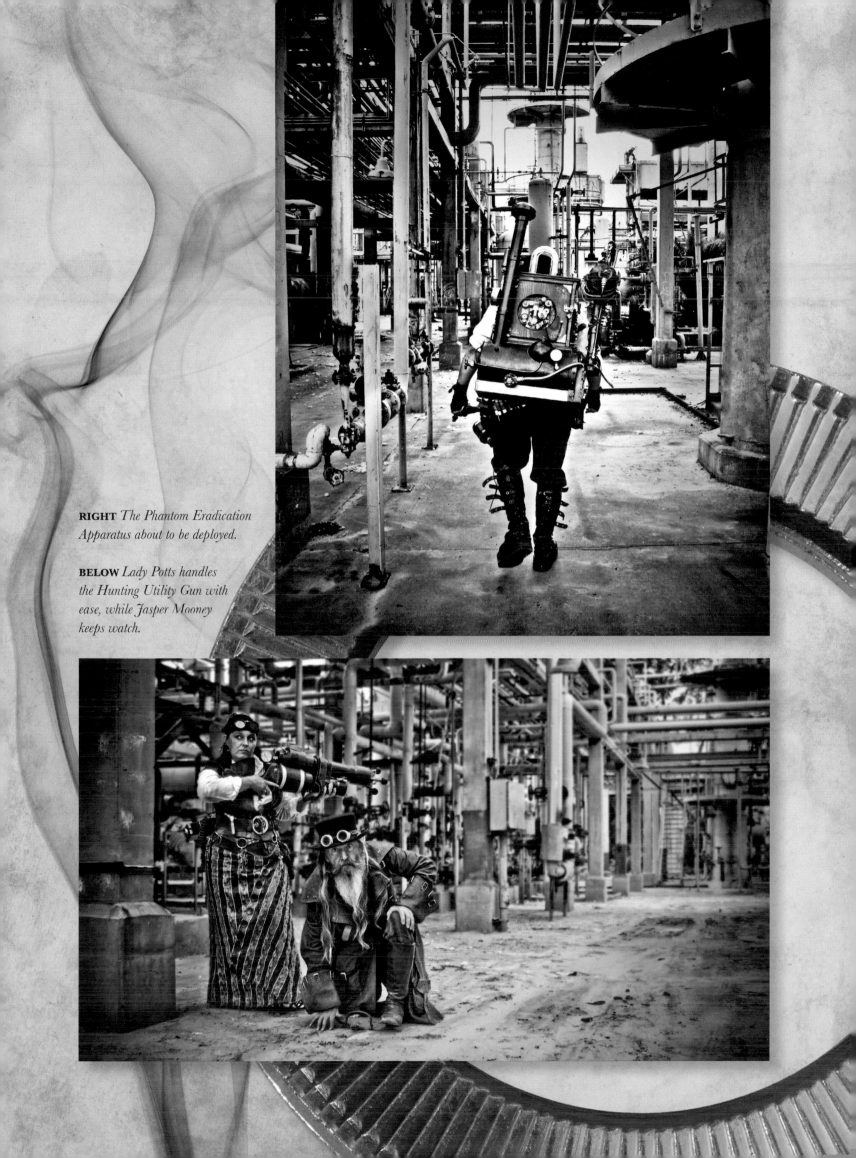

RIGHT *The Phantom Eradication Apparatus about to be deployed.*

BELOW *Lady Potts handles the Hunting Utility Gun with ease, while Jasper Mooney keeps watch.*

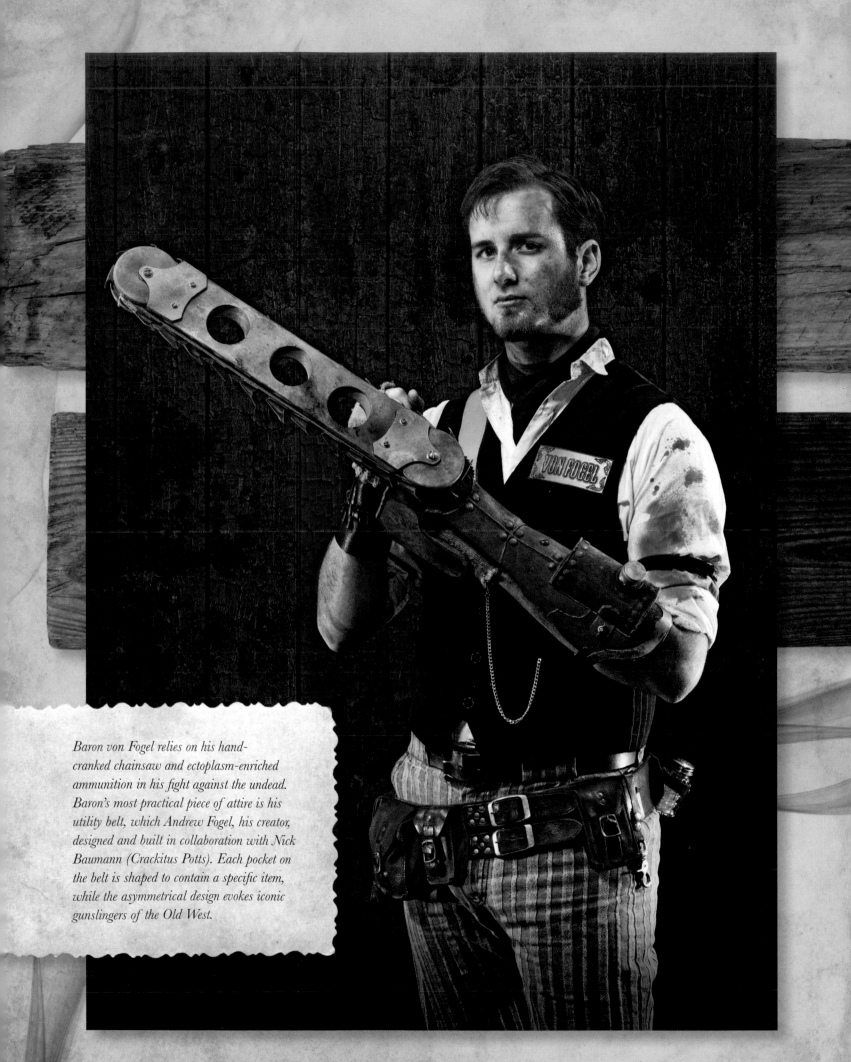

Baron von Fogel relies on his hand-cranked chainsaw and ectoplasm-enriched ammunition in his fight against the undead. Baron's most practical piece of attire is his utility belt, which Andrew Fogel, his creator, designed and built in collaboration with Nick Baumann (Crackitus Potts). Each pocket on the belt is shaped to contain a specific item, while the asymmetrical design evokes iconic gunslingers of the Old West.

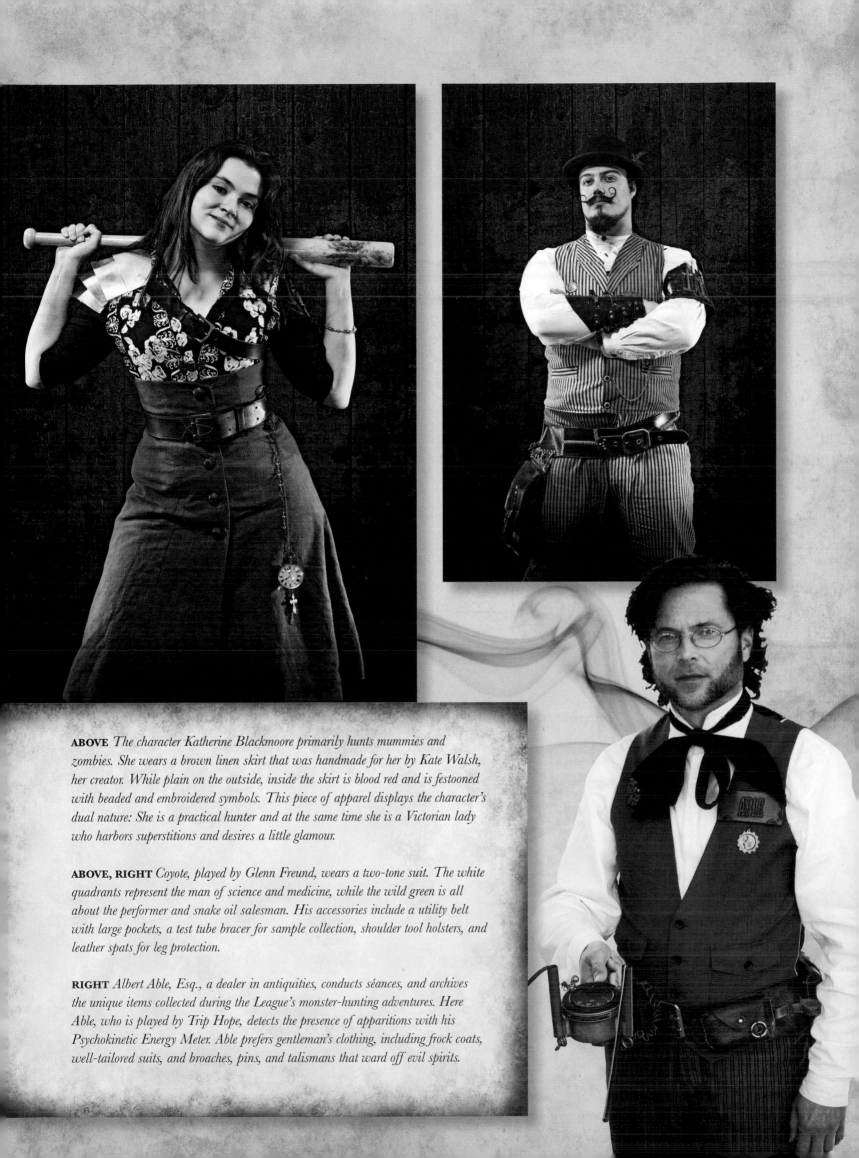

ABOVE *The character Katherine Blackmoore primarily hunts mummies and zombies. She wears a brown linen skirt that was handmade for her by Kate Walsh, her creator. While plain on the outside, inside the skirt is blood red and is festooned with beaded and embroidered symbols. This piece of apparel displays the character's dual nature: She is a practical hunter and at the same time she is a Victorian lady who harbors superstitions and desires a little glamour.*

ABOVE, RIGHT *Coyote, played by Glenn Freund, wears a two-tone suit. The white quadrants represent the man of science and medicine, while the wild green is all about the performer and snake oil salesman. His accessories include a utility belt with large pockets, a test tube bracer for sample collection, shoulder tool holsters, and leather spats for leg protection.*

RIGHT *Albert Able, Esq., a dealer in antiquities, conducts séances, and archives the unique items collected during the League's monster-hunting adventures. Here Able, who is played by Trip Hope, detects the presence of apparitions with his Psychokinetic Energy Meter. Able prefers gentleman's clothing, including frock coats, well-tailored suits, and broaches, pins, and talismans that ward off evil spirits.*

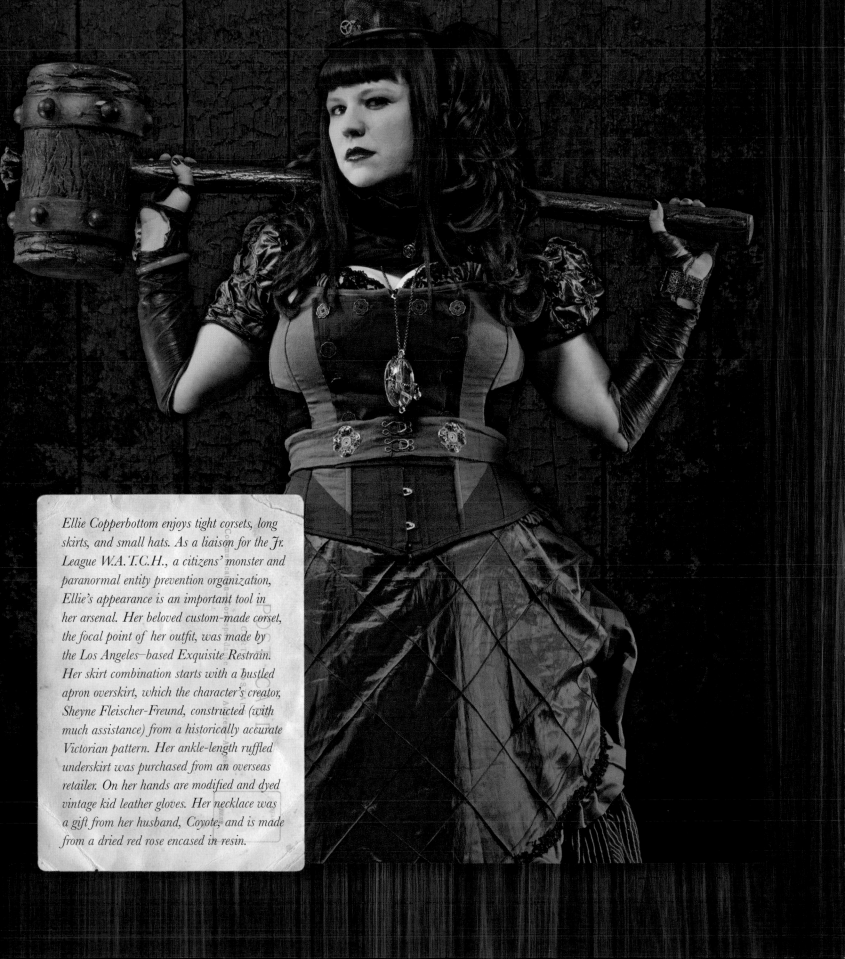

Ellie Copperbottom enjoys tight corsets, long skirts, and small hats. As a liaison for the Jr. League W.A.T.C.H., a citizens' monster and paranormal entity prevention organization, Ellie's appearance is an important tool in her arsenal. Her beloved custom-made corset, the focal point of her outfit, was made by the Los Angeles–based Exquisite Restrain. Her skirt combination starts with a bustled apron overskirt, which the character's creator, Sheyne Fleischer-Freund, constructed (with much assistance) from a historically accurate Victorian pattern. Her ankle-length ruffled underskirt was purchased from an overseas retailer. On her hands are modified and dyed vintage kid leather gloves. Her necklace was a gift from her husband, Coyote, and is made from a dried red rose encased in resin.

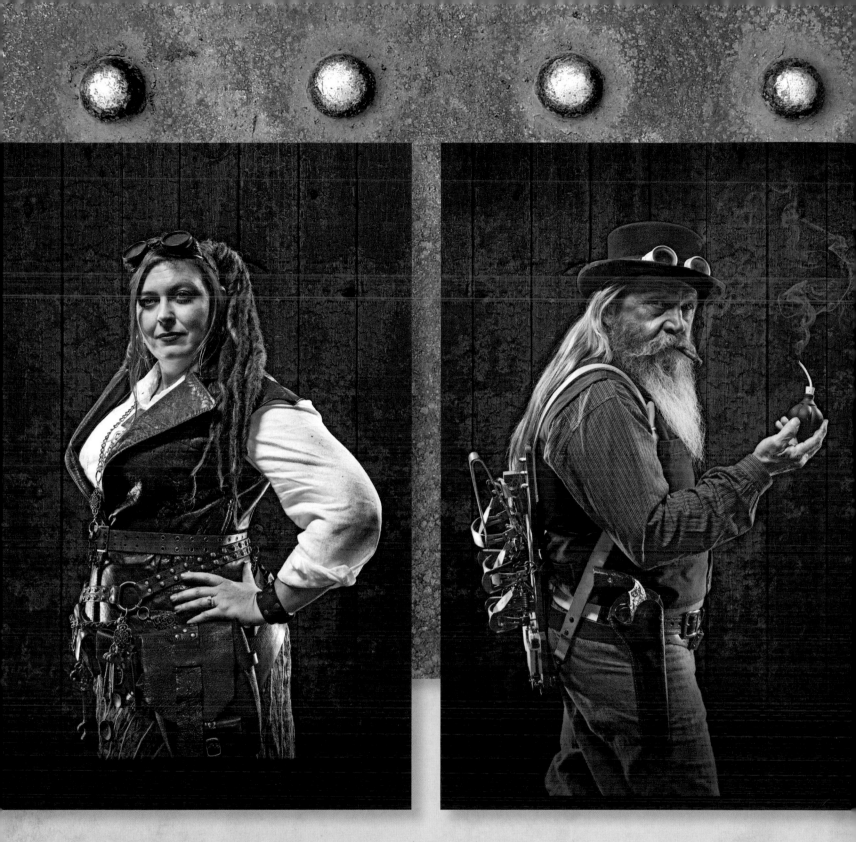

ABOVE, LEFT *Lady Ameliorette Potts (Robin Blackburn) is at the ready in her protective leather vest and sassy button-down skirt. Her trusty hip pouch carries all she needs for coordinating the efforts of the League of S.T.E.A.M. Never one to run from a filthy fight, she proudly displays the grime that comes with the job of keeping the League of S.T.E.A.M. (especially her husband Crackitus Potts) on track.*

ABOVE, RIGHT *Jasper Mooney (Duane Matthews) is the League's lycanthrope expert. Because Mooney's time is spent in the field, he dresses for the hunt in rough-and-tumble clothing. A canvas double-breasted vest, knee-high boots, and riding trousers are the norm. He carries specialized grenades, silver and steel traps, moonlight vision goggles, and his ever-trusty silver Schofield pistol, filled with silver bullets.*

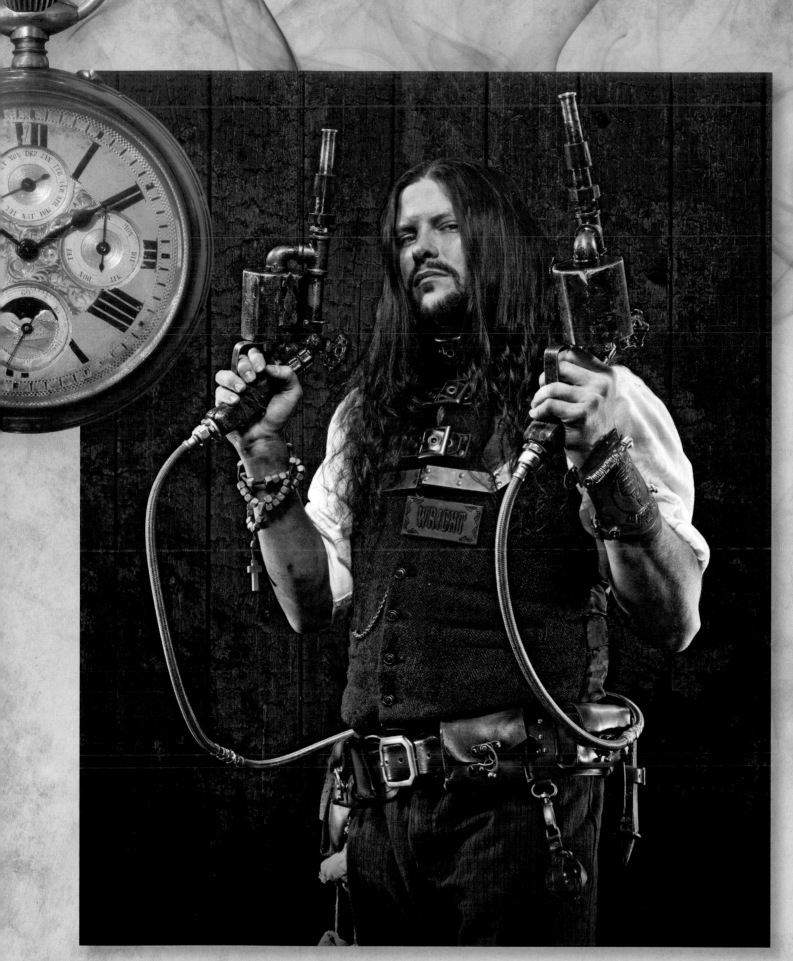

Sir Conrad Wright III (Conrad Wright Jr.), a vampire elimination specialist, uses his Mobile Vampire Elimination Pack to douse the undead with Holy Water. More concerned with durability than with style, Sir Conrad favors tough trousers, a shirt with sleeves that will roll up and up, and a vest. Most important, although they are not visible in his photo, are his just-below-the-knee boots, which are key for vampire stomping!

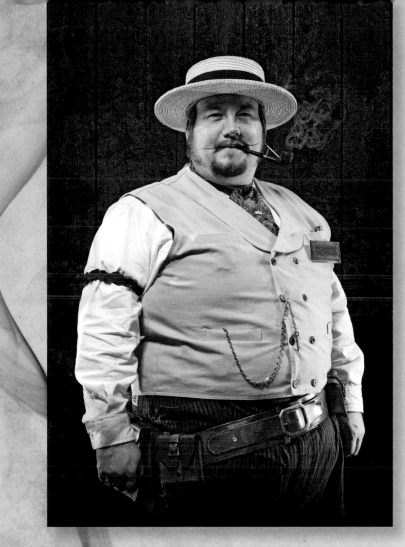

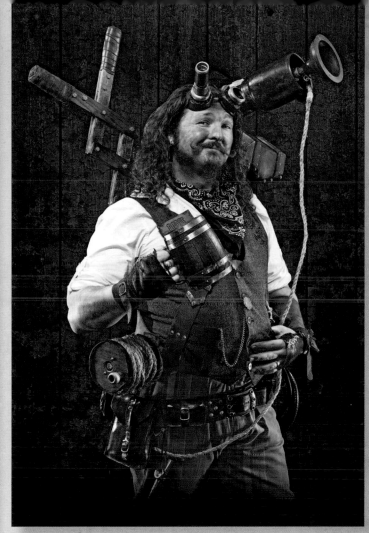

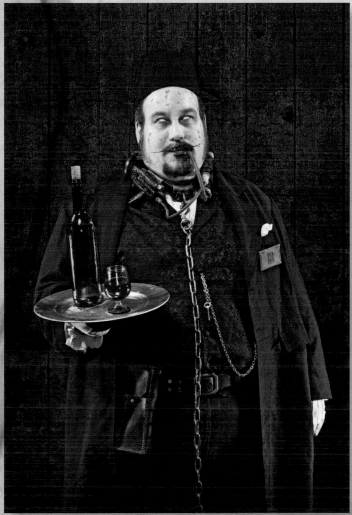

TOP, LEFT *Russ Isler plays both Thaddeus and his twin brother Zed, who is a zombie. Thaddeus, decked out for a trip to Old Tucson, wears a double-breasted waistcoat, striped trousers, and shirt from Frontier Classics. As a gentleman of a certain size, he's found quite a few well-priced options from the makers of western wear. His classic straw boater hat, which he puts away reluctantly every Labor Day, is the real deal, crafted in Venice, Italy from four layers of Koberg straw.*

TOP, RIGHT *The League's "Nonlethal Weapons Expert," Crackitus Potts (Nick Baumann), favors simple attire of cotton, canvas, and linen. His well-worn ensembles are usually heavily accessorized—from his leather hand wraps to his gunslinger-style utility belt laden with a variety of pockets, tools, and gadgets. Most important: a sturdy pair of leather boots with good traction. As Crackitus says: It is the wise man that, when faced with danger, can run away and live to run away another day!*

LEFT *Once the twins dressed identically, or nearly so, distinguished only by their hats. Since Zed contracted his "condition," he's been stuck in one outfit...more or less. No one enjoys changing Zed's clothes. Thaddeus dresses him in "butlering" attire—black trousers, waistcoat, frock coat, and a fancy shirt with ruffled cuffs, and always a signature fez. This classic look was the very first outfit that Isler acquired, proving that steampunk never goes out of style.*

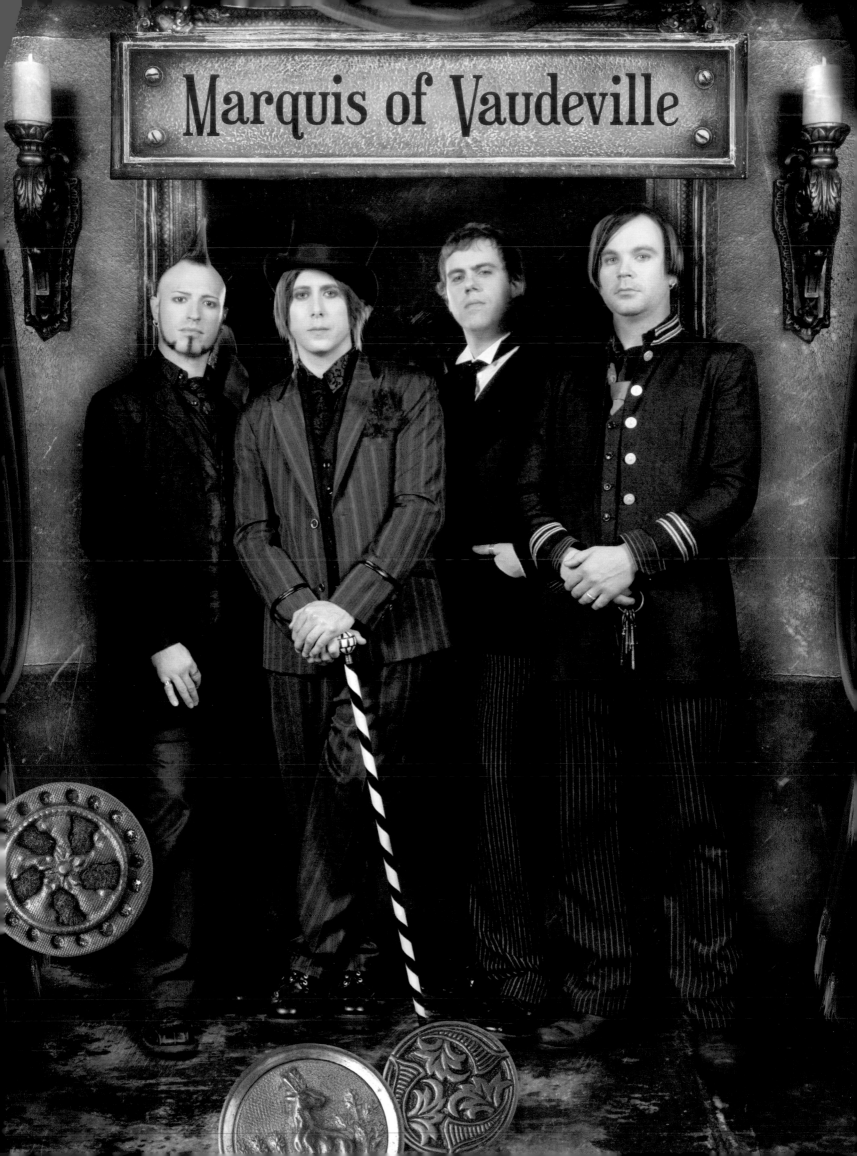

Marquis of Vaudeville's sound has been described as progressive psychedelic punk cabaret. The influence of glam rock and 80s New Wave are also felt. The *Dallas Observer* called their self-titled debut album, which appeared in 2009, "a shrewd fusing of twinkly pop, gaze-at-the-stars vocals and melancholy melody outlined with edgy, trenchant guitars." The *Observer* continues by saying that Marquis of Vaudeville's music bears "a healthy dose of rock 'n' roll with a fair share of emotion, invention and imagination." The band's songs are played frequently on music website such as OurStage.com and on Dallas's leading rock/alternative radio station.

Although the group does not call itself a steampunk band, it has a large steampunk following. In addition, the band members enjoy steampunk and neo-Victorian aesthetics. And, like steampunks, they believe in the power and driving force of the imagination. Their attire, which is typically sourced from local designers and thrift shops and supplemented with a little online shopping, reflects their sense of invention and free expression. As a group, they bounce outfit ideas off one another, discussing structure, color, and accessories, to achieve a cohesive look. They share smaller accoutrements amongst themselves and mix and match to make things work. Says lead singer Toby Lawhon, "Needless to say, our wardrobes are extensive."

OPPOSITE PAGE *Four gentlemen, meticulously dressed, well groomed, but with an edge—a punk sensibility with a taste of gothic darkness. From left to right: Phil Helms, Toby Lawhon, Bryan Geddie, Tyrel North.*

TOP, RIGHT *Reflected in a mirror with a candle, the bandmates seem like apparitions from another age. From left to right: Toby Lawhon, Bryan Geddie, Kelly Grace, Phil Helms.*

RIGHT *The members of Marquis of Vaudeville have taken to the streets, where their punkiness blooms into an idealized vision of nineteenth century squalor. From left to right: Kelly Grace, Toby Lawhon, Bryan Geddie, Phil Helms.*

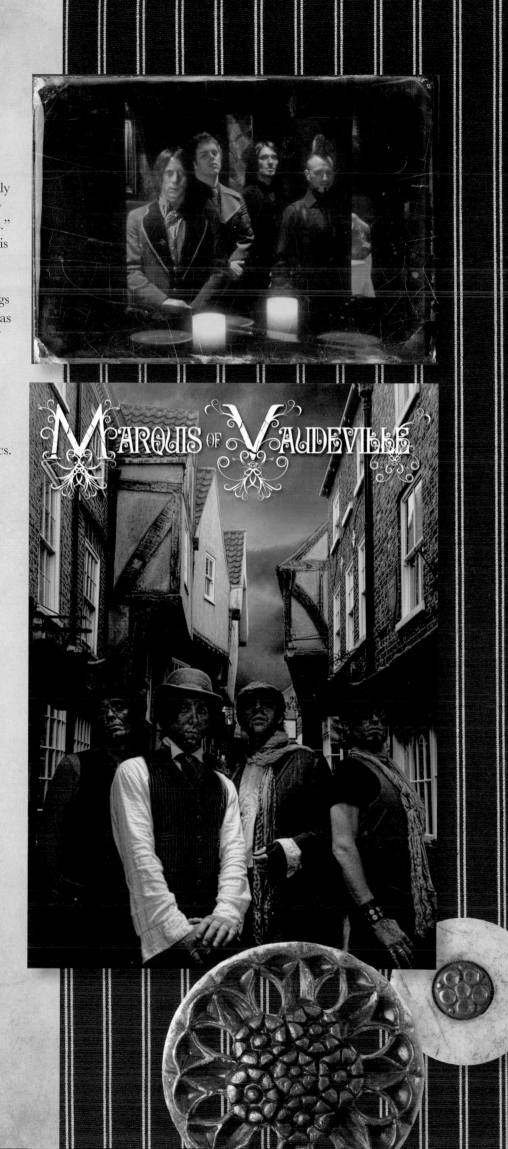

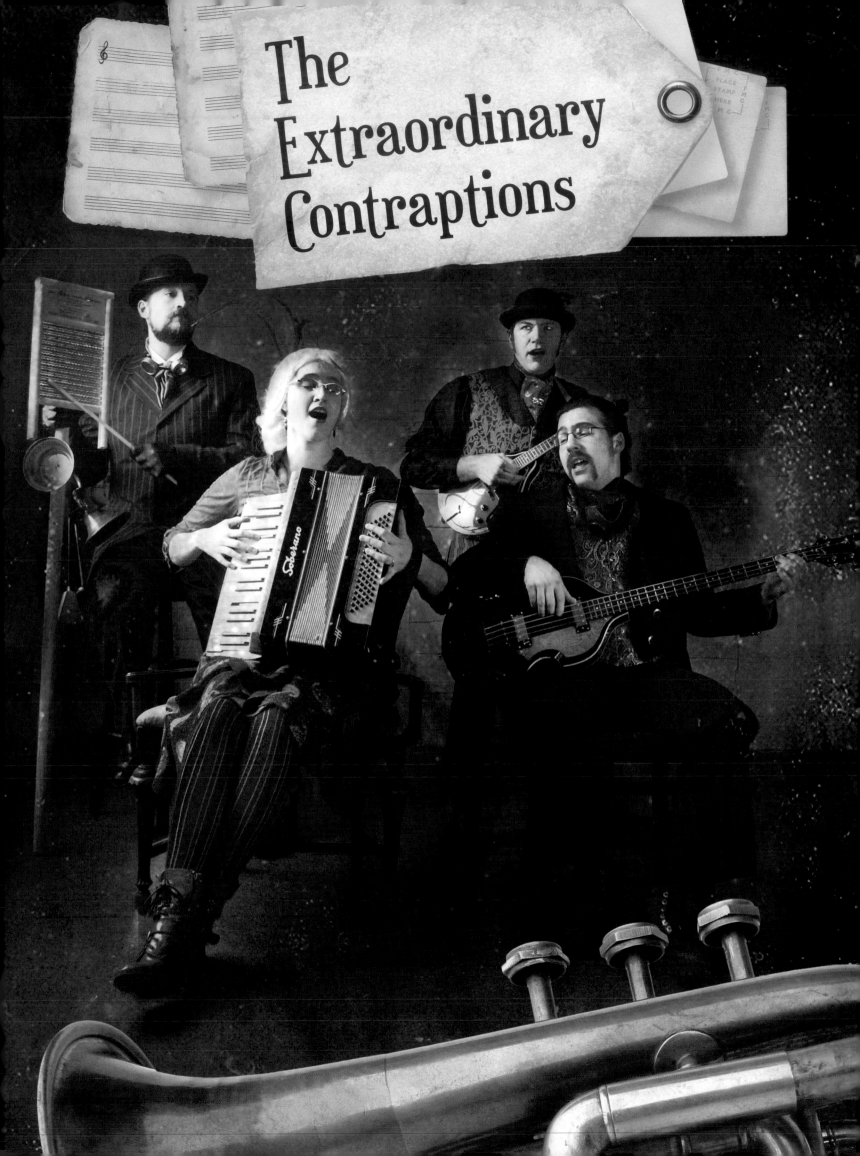

They have a back story involving airship pirates, a chemist, an unpredictable trans-dimensional transport device, and a character with uncontrollable emotions. We are not sure exactly what to believe, but we do know that The Extraordinary Contraptions formed as a rock band in the summer of 2007. To date the Atlanta-based foursome has three CDs out—*Inappropriate On Purpose* (2008), *Scratch the Aether* (2010), and *The Time Traveler's Constant* (2012). They are known for their theatrical performances, musical abilities, and talents for staying in character.

When asked about his performance attire, Teodore Birchard explains that his "garments are assembled from the found items of an unfortunate clown vs. gangland rumble that occurred in the late 1890s." Sephora Bostwick, who describes herself as "your average time-traveling super-educated scientist gal from an alternate dimension," tries to maintain decorum by wearing "frilly shirts, bright patterns, lace, stockings, and ruffles." Her true nature shines through in her accessories—her worn leather bag typically has a wrench sticking out of it, and her lovely parasol serves double duty as a pistol. Here Aelus wears a skirt and vest that were made for him by Cat Harrison of Venusian Airship Pirate Trading Co. He made his arm garters himself. Dimitri is kitted out in a tuxedo shirt, thrift store slacks, and a used tailcoat on which he replaced the buttons. He's also wearing a pair of Soviet surplus goggles, a corset vest from Ties That Bynde Designs, and a pair of flamboyant socks that may or may not match his outfit.

The band plays around Atlanta and has also appeared at AnachroCon, S.T.E.A.M. Fest, The Steampunk Empire Symposium, DragonCon, and GeekOut.

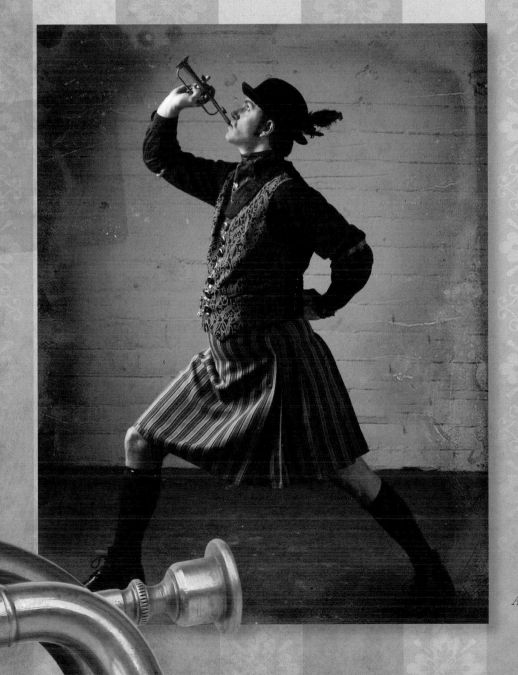

Aelus shows off in a skirt and brocade vest.

Painless Parker

Painless Parker is the stage name of Noam Berg, a member of New York City's steampunk community and the writer of five of the DIY sections in this book. Performing as Painless Parker all around town, Berg dresses in "Edwardian worker-dandy style." In other words: waistcoats, tweed, bow ties, newsboy caps and bowlers, and a good stiff mustache wax. He acquires his threads at thrift shops and discount stores. And we know he makes a mean pair of suspenders. (See the chapter on Work Gear.)

Painless Parker performs at an outdoor event.

In a vest, tie, and bowler, Painless Parker, accompanying himself on the mandolin, sings in praise of the working class. Here he has taken his message to the street, performing in downtown Manhattan in October, 2011, during Occupy Wall Street's residence at Zuccotti Park. Steampunk Emma Goldman (see page 182), who has just declaimed "The New Declaration of Independence" by the historic Emma Goldman, and a number of onlookers join him, raising their voices to belt out the chorus. In another mood, Berg plays himself, wearing a checked jacket and bow tie. He steps to the microphone during a steampunk get-together, adjusts his tie, and explains to those gathered exactly what he is wearing.

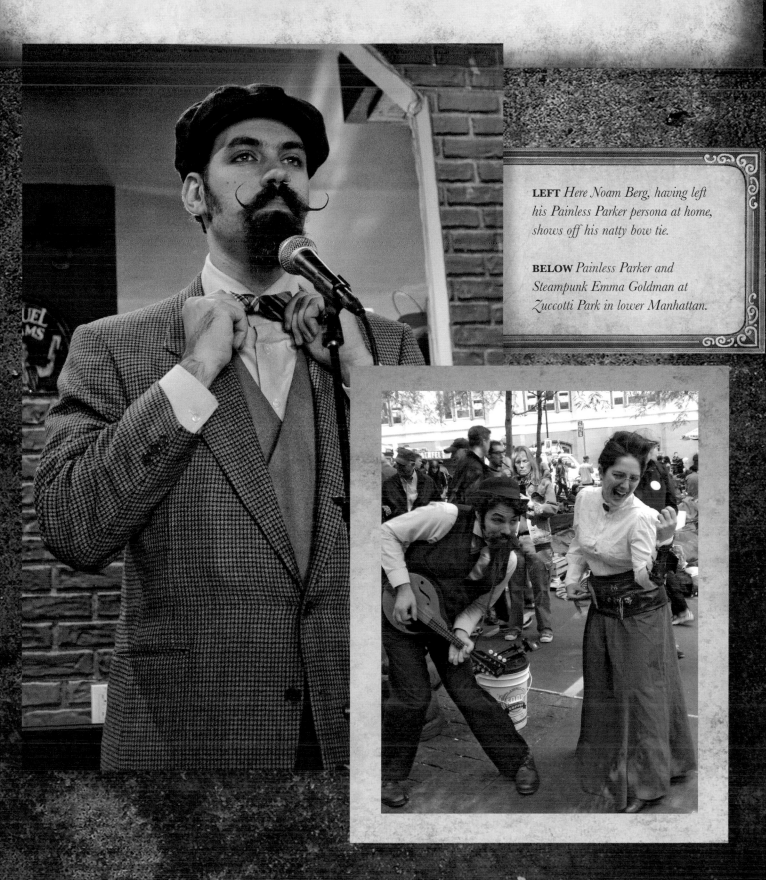

LEFT *Here Noam Berg, having left his Painless Parker persona at home, shows off his natty bow tie.*

BELOW *Painless Parker and Steampunk Emma Goldman at Zuccotti Park in lower Manhattan.*

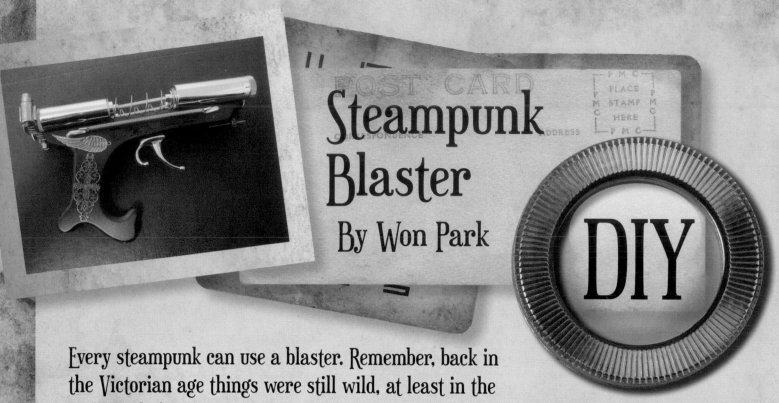

Steampunk Blaster

By Won Park

DIY

Every steampunk can use a blaster. Remember, back in the Victorian age things were still wild, at least in the West. So let's get you armed.

You Will Need:

One 8" wooden plate holder
Miniature screwdrivers
 (Phillips and flat)
Two plastic chrome toilet roll
 holders
Craft glue
Two 1" hose clamps
One brass colored plate hanger
Wire cutters
Drill and drill bits
Instant glue
Four pushpin hangers
Two ¾" sink aerator adapters
Two 3" coil springs
Hot glue gun
One brass mini coat/hat hook

1 Unscrew hinges from wooden plate holder and discard the hinges. Dismantle the two toilet roll holders. DO NOT discard the springs; you will use them in Step 9. Note that each toilet roll holder is made up of two cylinders of unequal size.

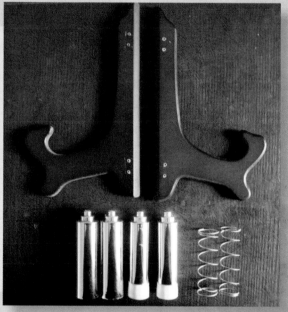

2 Glue the two halves of the plate holder together so the hinge holes are on the outside. This is the base for your gun.

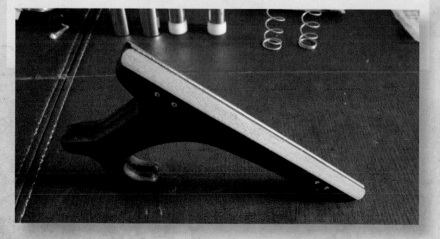

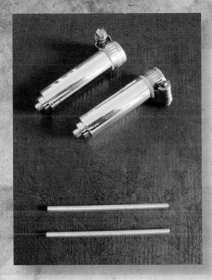

3 Locate the two smaller cylinders from each toilet roll holder. Attach a hose clamp to each open end. Remove the two brass colored springs from the plate hanger and discard the rest. Using wire cutters, clip off the rings at the end of the springs.

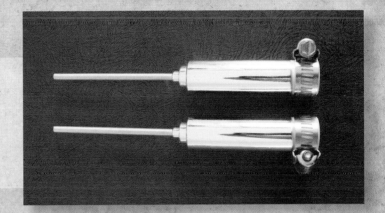

4 Insert the brass springs into the nipple end of the cylinders with the clamps. (If there is no hole, you will have to drill one to fit the spring.) Insert the spring about 1" and secure it with instant glue.

5 Use wire cutters to cut the pin on the pushpin hangers in half. Insert these pushpins into the hinge holes of the base.

6 Using craft glue, attach an aerator to the open end of each larger toilet roll cylinder.

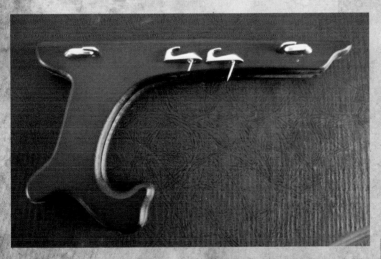

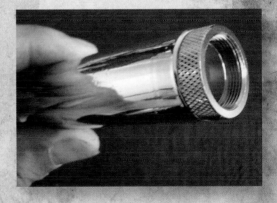

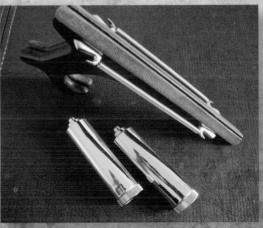

7 Attach the two coil springs to the pushpin hangers on the sides of the base.

8 Using hot glue, attach the two large toilet roll cylinders to each other.

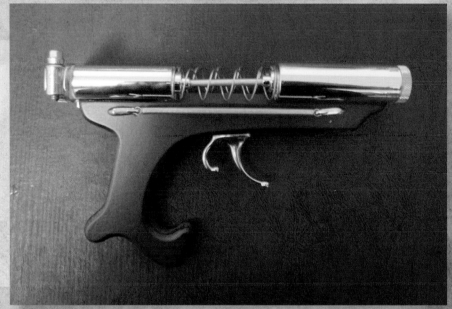

9 Slide the toilet roll spring over the brass colored springs that are attached to the smaller cylinders. Insert the brass springs into the nipple end of the larger cylinders (which you just glued together). Using hot glue or craft glue, attach the toilet roll cylinder assembly to the top of the gun base with the hose clamps at the back.

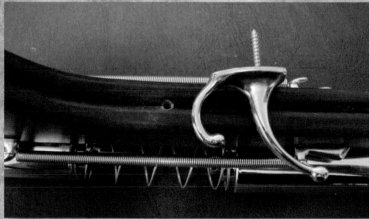

10 On the underside of the gun base, drill a hole to accommodate the screw on the coat/hat hook.

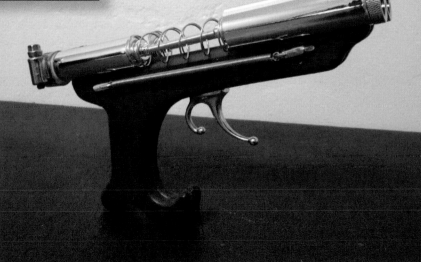

Your Steampunk Blaster is now complete!

To embellish your Steampunk Blaster, you can use:

small clock gears
watch cogs
clock hands
brass nuts, bolts, and washers
filigree jewelry bases

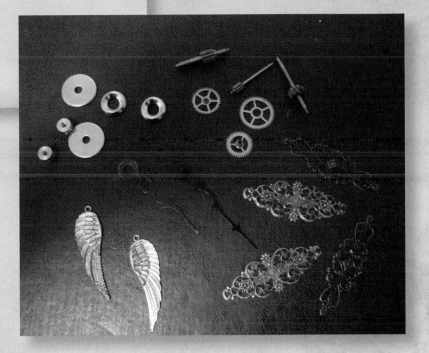

Here are some examples to inspire you in creating a Steampunk Blaster that reflects your personality! Hey, if you're going to have a Steampunk Blaster, you might as well have one for people to admire.

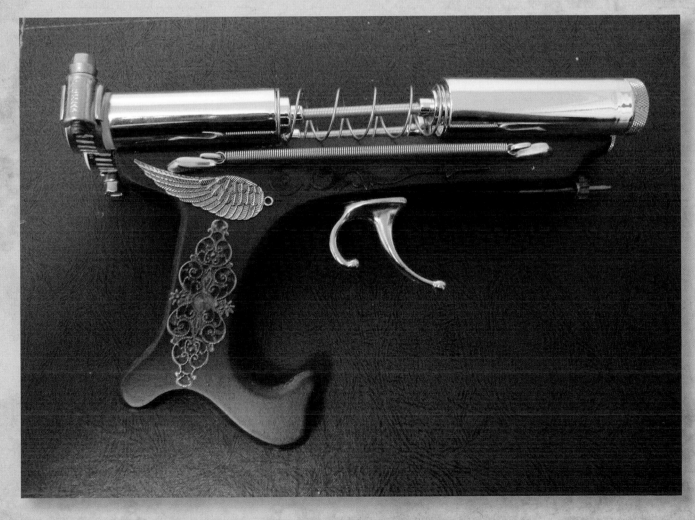

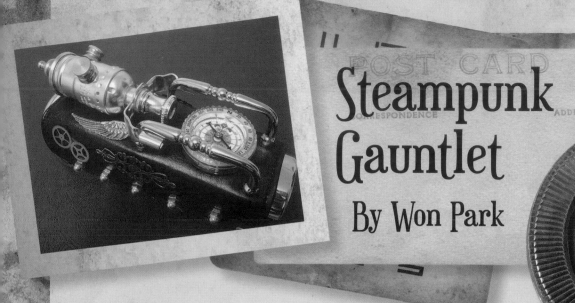

POST CARD

Steampunk Gauntlet

By Won Park

DIY

This gauntlet is constructed from a mix of new lamp parts, hardware, and upcycled leather. I used leather from an old purse that I bought at a local thrift shop. Feel free to adapt these ideas to suit available materials and your personal tastes.

You Will Need:

A piece of leather big enough to wrap around your forearm
Heavy duty scissors
One flexible plastic binder
One ⅜" diameter lamp nipple 1" long
One brass lamp socket
One lamp shade holder (wire harp removed)
One flat round knurled nut
Two finials (three styles are shown here. You will need two.)
Two reducer nuts
Two brass lamp end caps
Two finishing washers
Two nylon bushings
One ⅜" diameter lamp nipple ¾" long
Two lock nuts
One lamp check ring
 (large enough to cover the open end of the lamp socket)
Drill and drill bits
Craft glue or hot glue
Two decorative brass drawer handles
 (find shorter screws for the handles)
Rotary hole punch
16–20 small brass bolts and nuts
10–12 brass finishing nuts (acorn or cap nuts)
Flat head screwdriver
Eyelet puncher
14–16 small brass eyelets
A 3' length of leather cording

1 Form the base of your gauntlet by cutting the leather into a shape that will wrap around your forearm. Leave a 2" gap at the inside of your arm. Later you will add laces to hold your gauntlet closed.

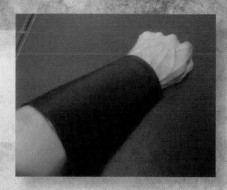

2 Cut out a 2" strip from the flexible binder. Make this strip the same length as your gauntlet. Then cut two ½" wide strips from the binder. Make them an inch shorter than your gauntlet. Put the leather and plastic strips aside for now.

3 Now for the hardware. First you will make the decorative brass gadget at the elbow-end of your gauntlet. Screw the 1" lamp nipple into the end of the lamp socket. Slide on the lamp shade holder followed by the knurled nut. Then add a finial. Remove the top section of the socket and set it aside for Step 6.

4 To make the knobs on the lamp socket, screw a reducer nut into one of the lamp end caps. Put a finishing washer over a nylon bushing and then insert the brushing into the reducer-end cap assembly. Make a second knob the same way.

5 To make the projecting end of the lamp-socket assembly, screw a lock nut to one end of the ¾" lamp nipple. Then slide the nipple through the lamp check ring. Secure the check ring with the remaining lock nut. Add the remaining finial.

6 Retrieve the top section of the lamp socket that you removed in Step 3. Locate the switch slot and drill two holes in the socket, as shown. Make sure that these holes are big enough for your brass bolts as this is where the lamp socket will fasten to the leather of the gauntlet.

7 Now you will make two holes in the socket to accommodate the knobs. First drill a hole opposite the holes you made in Step 6. Make sure it is big enough for the nylon brushing. Then make another hole 90° away from your first brushing hole.

8 Get the knobs you made in Step 4. From the inside, insert the nylon bushings into the two holes drilled you drilled in Step 7.

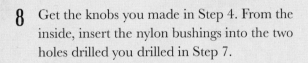

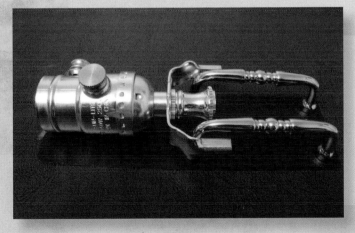

9 Glue the reducer-end cap assemblies and washers to the nylon bushings. Let the glue dry. Place the lamp socket assembly and the two brass handles on the larger strip of plastic. Mark where the handles meet the plastic. Mark the two holes on the bottom of the lamp socket assembly.

10 Using the rotary hole punch, punch out holes in the plastic at the places you marked in Step 9. Make sure the holes are big enough to fit your brass bolt.

11 Punch out 5–6 holes evenly spaced on the two smaller plastic strips.

12 Arrange the plastic pieces on the underside of the leather. On the large plastic strip, make sure that the two holes for the lamp socket assembly are at the wider end of the leather. Use the plastic as a template to mark where you will punch holes in the leather. Punch out all the holes using the rotary hole punch.

13 Attach the plastic strips to the underside of the leather with the brass bolts. Keep the head of the bolt on the inside of the gauntlet.

14 Settle the lamp assembly over the two bolts at the wide end of the leather base. Secure each bolt with a nut.

15 Attach the brass handles to the bolts at the center of the leather base. Screw brass nuts onto the outer brass bolts.

16 Add finishing nuts. Glue the finial assembly that you made in Step 5 to the open end of the lamp socket.

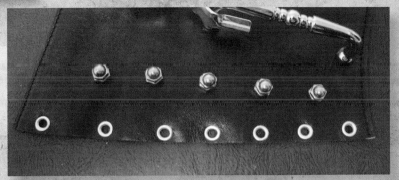

17 Punch out 7–8 holes on both of the long edges of the leather base. Use the eyelet punch to attach brass eyelets to the holes.

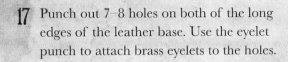

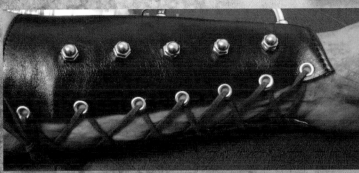

18 Lace the gauntlet edges together by threading the leather cord through the brass eyelets.

Hurray! You have just completed your Steampunk Gauntlet!

Now let's decorate it! Here's a picture of a Steampunk Gauntlet for inspiration. Feel free to embellish your Steampunk Gauntlet to suit your own style. For a more feminine look, use ribbon to bind the gauntlet instead of leather cord.

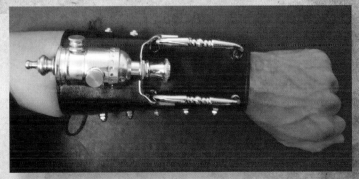

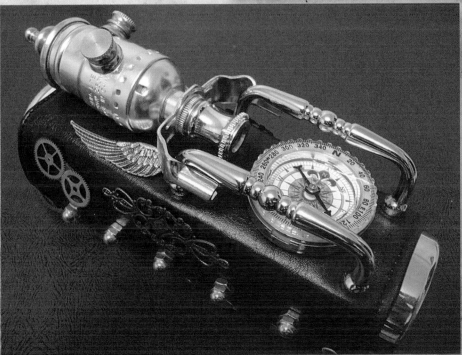

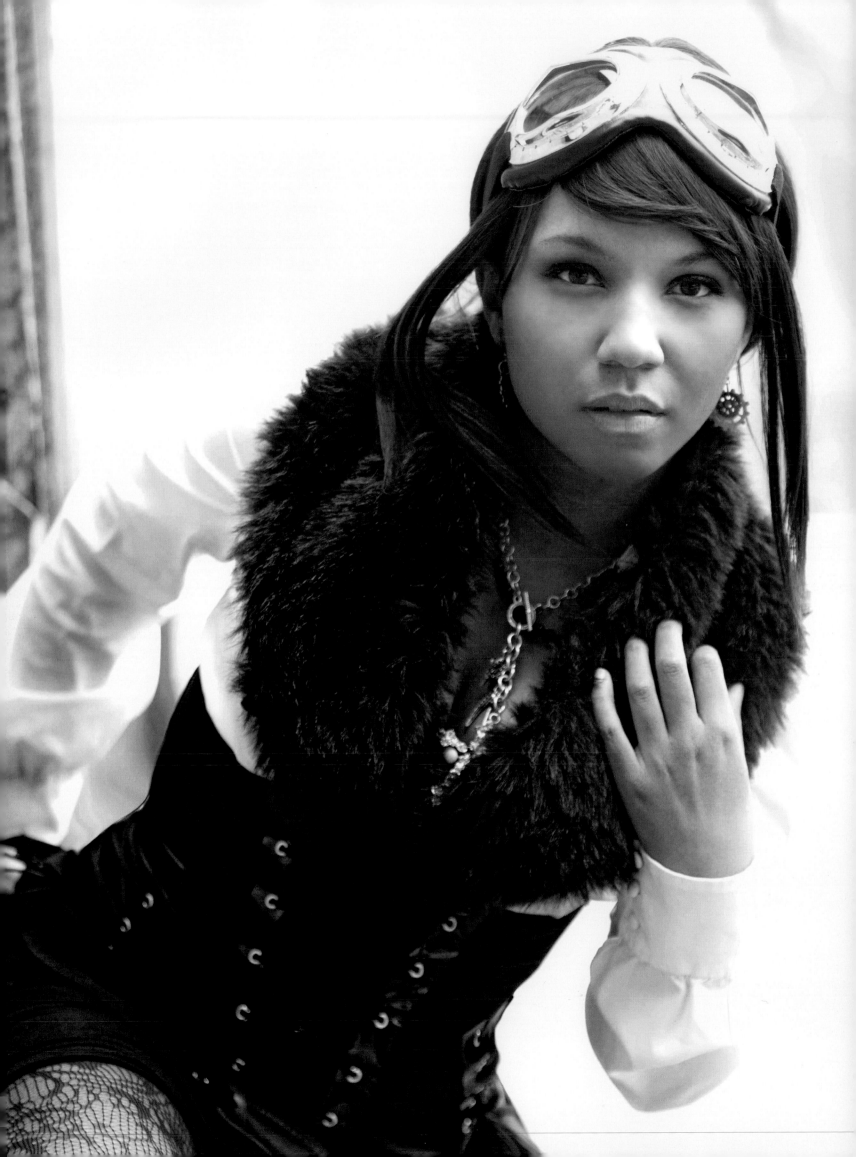

CHAPTER THREE

ADVENTURE WEAR

She follows the dark, winding street, stopping at the signpost that marks the crossroad at the edge of town. At the post's base, secreted in the shrubbery, she finds what she seeks. She pulls on black leather gloves, lifts the worn leather satchel, and opens it. Inside, a pistol and a tightly bundled stack of franc notes. She pockets the cash, lights a match, extracts a slip of paper from the bag, and examines the carefully printed address, committing it to memory. She draws match and paper together. The flame swells and the ashes of the address fall. She has her instructions and knows what she needs to do.

Although she may not have experienced exactly this scenario, Aries, a Moorish assassin and the alter ego of Nivi Hicks, is probably familiar with this setup. Hicks explains that her character always took jobs, no questions asked—as long as she was paid. Upon going after a certain mark, though, the tables turned on her. Aries was captured and forced to perform as a gladiator in a series of underground games. Where once she fought for money, now she fights for survival. Hicks has outfitted her character in thrift shop finds, which she has tweaked to lend an original feel. Over her pirate-style blouse is the fur trim from a jacket. Hacked-up leggings, lace tights, and knee-high combat boots complete her look. In addition to being Aries's creator, Nivi Hicks is the director of SaltCity Steamfest, Utah's first steampunk convention.

Adventure. We all crave it. We all need it in our own particular variety. Steampunks know how to bring adventure into their lives—and into their clothing. Adventure wear includes military looks as well as outfits for explorers and pirates and aeronauts. Here also are armor for an emperor, looks that fuse eastern and western traditions, and goggles. We mustn't forget the goggles.

OPPOSITE PAGE *Nivi Hicks poses as her character Aries.*

Spyder Designs KvO Design

A pair of goggles can up the steam quotient of any outfit. That said, before running out to buy a pair of goggles, the sensible steampunk asks—Do goggles make sense for my clothing concept or character? Should they really be a part of this outfit? It all depends on the sartorial idea. Certainly an airship-pirate look could include a pair of goggles. An outfit in the style of an explorer, aeronaut, train conductor, or general? Check. In short, anyone who needs eye protection—and in the realm of adventure wear during an age of steam, that can be a sizable chunk of the population.

Daring adventurer Matt is wearing a Spyder Designs Holmes Coat (a lined, full-length overcoat), in addition to a pair of goggles that come from designer Morrigana Pehlke's personal collection. The goggles are, in fact, the first pair that she ever bought. And where is Matt's adventure leading him? He looks to the skies. An airship journey could well be in his future.

Designer Karen von Oppen has outfitted this lady adventurer in high pirate style. Along with her vintage Bakelite and metal mesh goggles, she wears a white linen airship pirate shirt. Her hand-painted distressed corset features an adjustable shoulder strap, and her leather and chain bandolier bears a solid brass vintage skull and crossbones buckle. She looks equally prepared to plunder a stylish ship or to steal a few hearts.

OPPOSITE PAGE *Matt wears a pair of goggles from designer Morrigana Pehlke's personal collection.*

ABOVE *Wearing goggles can be quite fetching... and taking goggles off can be more so.*

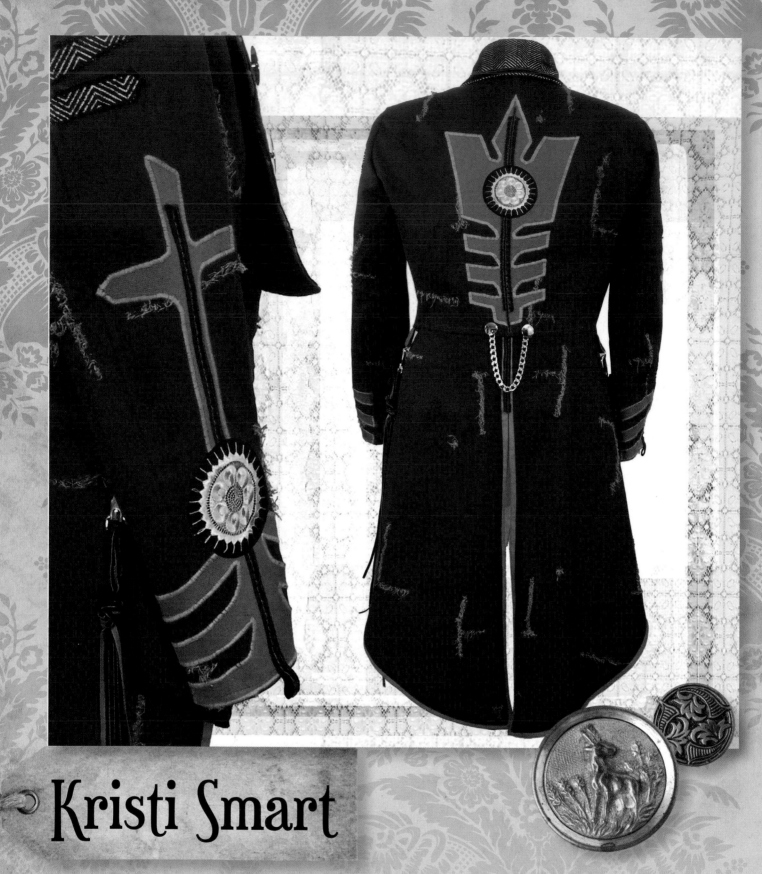

Kristi Smart

Pirate style appears in the collections of big name designers from time to time. Everyone from Vivienne Westwood to Alexander McQueen, John Galliano, Phillip Lim, and Anna Sui has been taken by the swashbuckling romance of the high seas. Luckily steampunk pirates never seem to go out of style, whether they travel the seas or prefer to adventure via airship. What airship pirate wouldn't want to take off in this men's distressed red coat? Artfully tattered and featuring anime inspired appliques, the coat is the product of Pasadena-based designer Kristi Smart.

Kristi Smart earns her bread and butter creating what she calls "everyday" costumes, "fancy things you can wear on a daily basis that stand out." Smart designs and fabricates custom and off-the-rack frock coats. The designer has created under her own label since the mid-1980s, when her father gave her a few bags of leather and suede scraps. She set to work transforming the bits and pieces into leather and mesh scarves; then she tried shawls and dresses with fringe. She has made costumes for Trans-Siberian Orchestra and been featured in Belle Armoire, a magazine that focuses on wearable art. One of her coats even made an appearance on *So You Think You Can Dance*.

The black Pirate Princess Coat, another Smart creation, with gold and black trim and embroidered red silk cuffs, back panel, and lapels, will surely cause the ladies to shriek, "Ahoy!" The Steampunk Vest, with its antique brass-toned rings, has the dash to travel anywhere while turning the trip itself into an adventure.

OPPOSITE PAGE *The perfect coat for the captain of the airship pirates.*

TOP *The Pirate Princess coat features embroidery on panels of red silk.*

BOTTOM *The simple elegance of the Steampunk Vest has led it to become one of Smart's bestsellers.*

Edward Von Arkham

Has this cheerful pirate hit the mother lode? Perhaps he's pulled up a mysterious box of sunken treasure. Or he's plundered a ship. But wait, Captain Edward Von Arkham is not that kind of pirate. Born in England in the thirtieth century, Von Arkham studied science and engineering and became a great inventor, perfecting a means of time travel with his Eternity Clock. When the British crown tried to seize ownership of his innovative clock, Von Arkham went underground and then was forced to flee. He took to an airship and became captain of the MHS (Mad Hatter's Ship) Hysteria. Von Arkham and his crew engage in varied adventures, which they document and post on YouTube. (See "MHS Hysteria" for their ship's log.)

RockLove

Captain Edward Von Arkham is the captain of the MHS Hysteria.

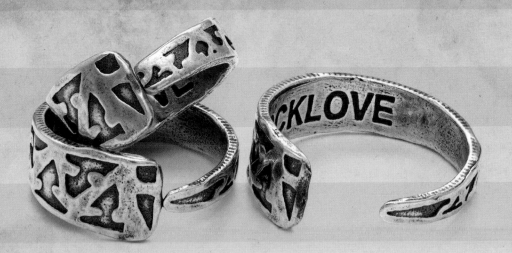

CLOCKWISE FROM TOP, LEFT *RockLove designer Allison Hourcade created the Palimpsest Bee Compass Pendant in collaboration with author Catherynne M. Valente to help promote the writer's 2009 novel* Palimpsest; *Hand carved from solid brass, the suckers on this tentacle are fully three-dimensional; This Imperial Crown Ring has been cast from a button pulled from a British military uniform circa 1899.*

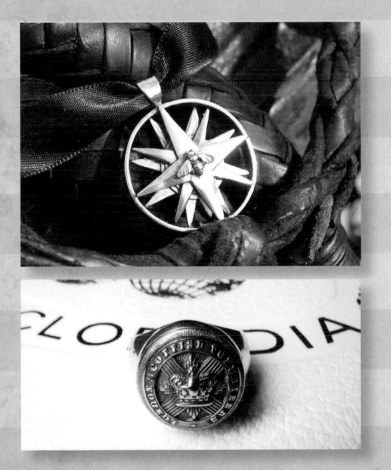

Isaiah Max Plovnick, Captain Von Arkham's creator, has chosen specific items in constructing an outfit for his character. The clothing pictured here—leather jacket, shirt, vest, pants, boots, and bow tie—all come from thrift and consignment shops. The Captain's tool belt is made from a leather weight-lifting belt accessorized with a watch, chain, and leather tool caddy. His goggles were custom made by Thomas Willeford of Brute Force Studios and then modified by Plovnick. The leather bandolier across the captain's chest is ornamented with dangling keys, parts from a brass door lock, a three-hole punch, and an antique barometer, which represents the gauge of a mechanical heart.

Plovnick's hat, known as the Topsy Turvy Topper was custom made from a Scala top hat. The Topper, is encircled by a leather belt and brass hat band. The hat's chimney on Plovnick's right side and the gadgets on his left were built with brass plumbing components. The clockwork mechanism on the hat's front is made of parts from an anniversary clock and a circular mantle clock. Plovnick concludes: "The sum total of all the above is: I look delicious." Did we mention that Von Arkham is a "certified madman"?

Hi Tek Designs by Alexander

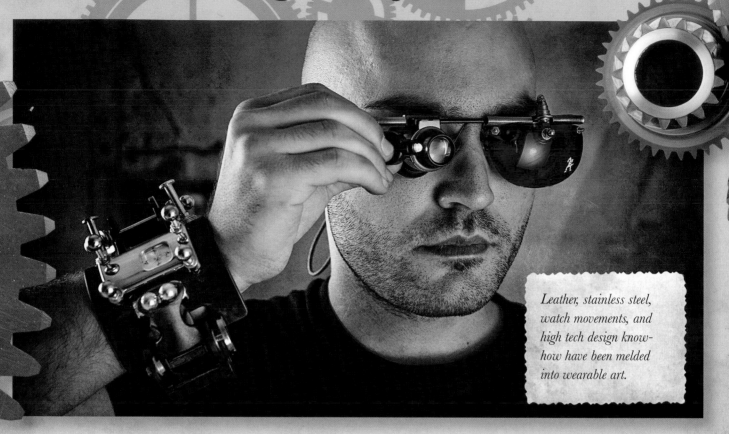

Leather, stainless steel, watch movements, and high tech design know-how have been melded into wearable art.

Pirates and others with a taste for high-end plunder will drool over designer Alexander Tasou's accessories, which he markets under the label Hi Tek by Alexander. Since the 1980s, the designer has united industrial design with surrealism in his accessories. Some consider him to be a father of steampunk style. Like many steampunks, Tasou has a passion for integrating the past with the future. In addition to goggles and watches, Tasou also creates clothing and has outfitted musicians, such as Michael Jackson, Anita Baker, and Tori Braxton, for video shoots and album covers. His work has been seen in feature films such as *Demolition Man* (1993) and *Judge Dredd* (1995). Tasou's watches are in the permanent collection of the Musée du Temps in Benançon, France. Hi Tek by Alexander also makes eyewear for artists and performers—which the company describes as "unusual and affordable pieces of art." Both Madonna and Lady Gaga have been spotted in his glasses.

This watch is from Hi Tek Designs Steampunk line. Handcrafted from leather and stainless steel, the chunky three dimensional timepiece embodies adventure and time travel. Specialized high-tech sunglasses will keep the traveler focused. Binoculars are useful on any adventure. They look great hanging around the neck or suspended from a wide leather belt. Goggles, of course, are always dashing. These goggles bear stainless steel lenses, a riff on industrial safety glasses with a definite future and forward-looking feel.

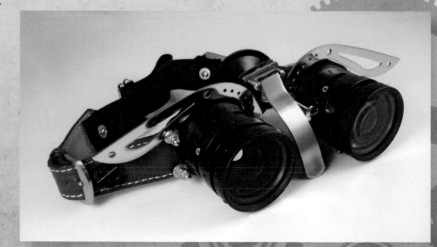

Every adventurer needs binoculars. These ones get extra panache with the addition of steel wings.

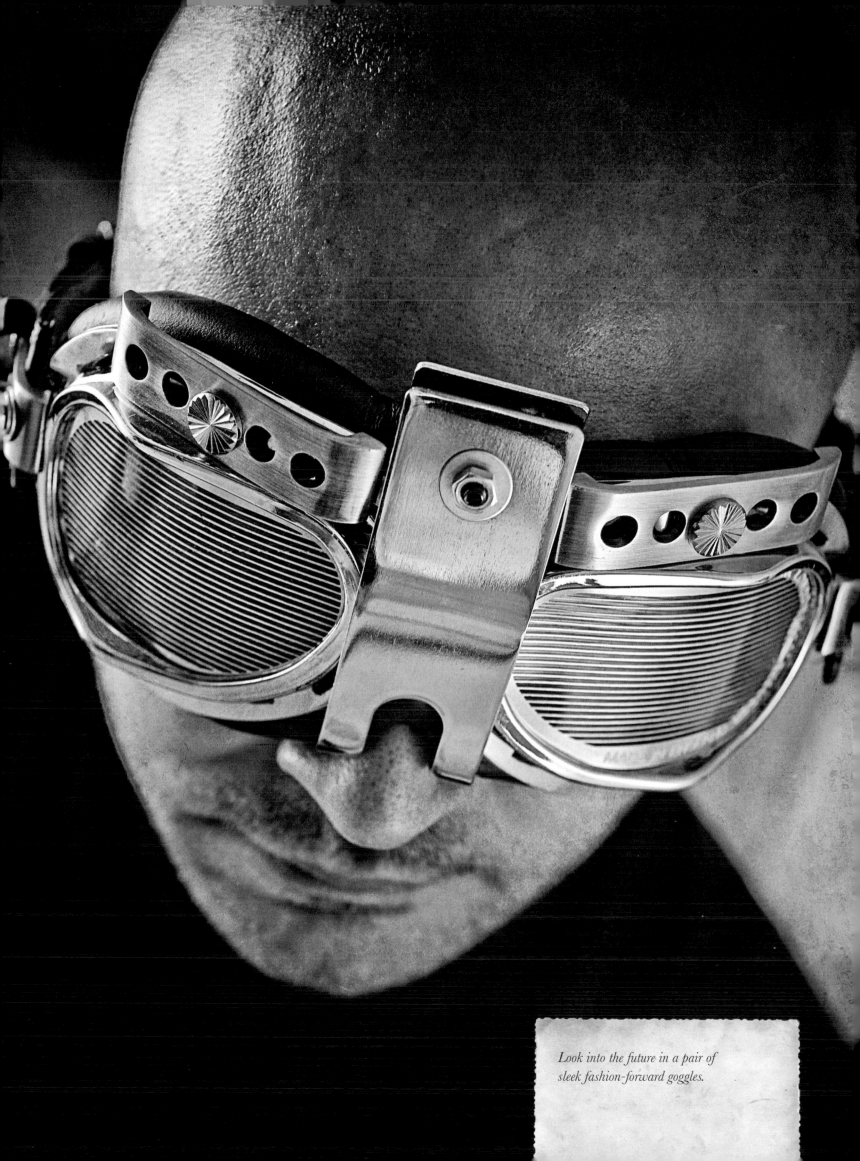

*Look into the future in a pair of
sleek fashion-forward goggles.*

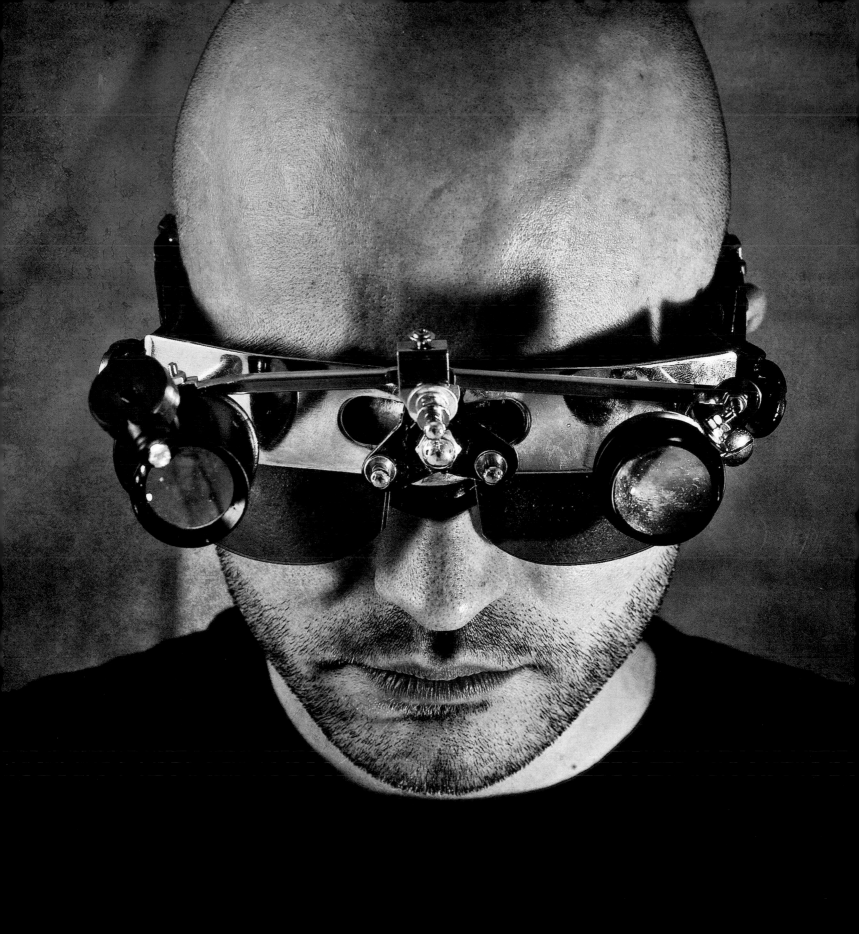

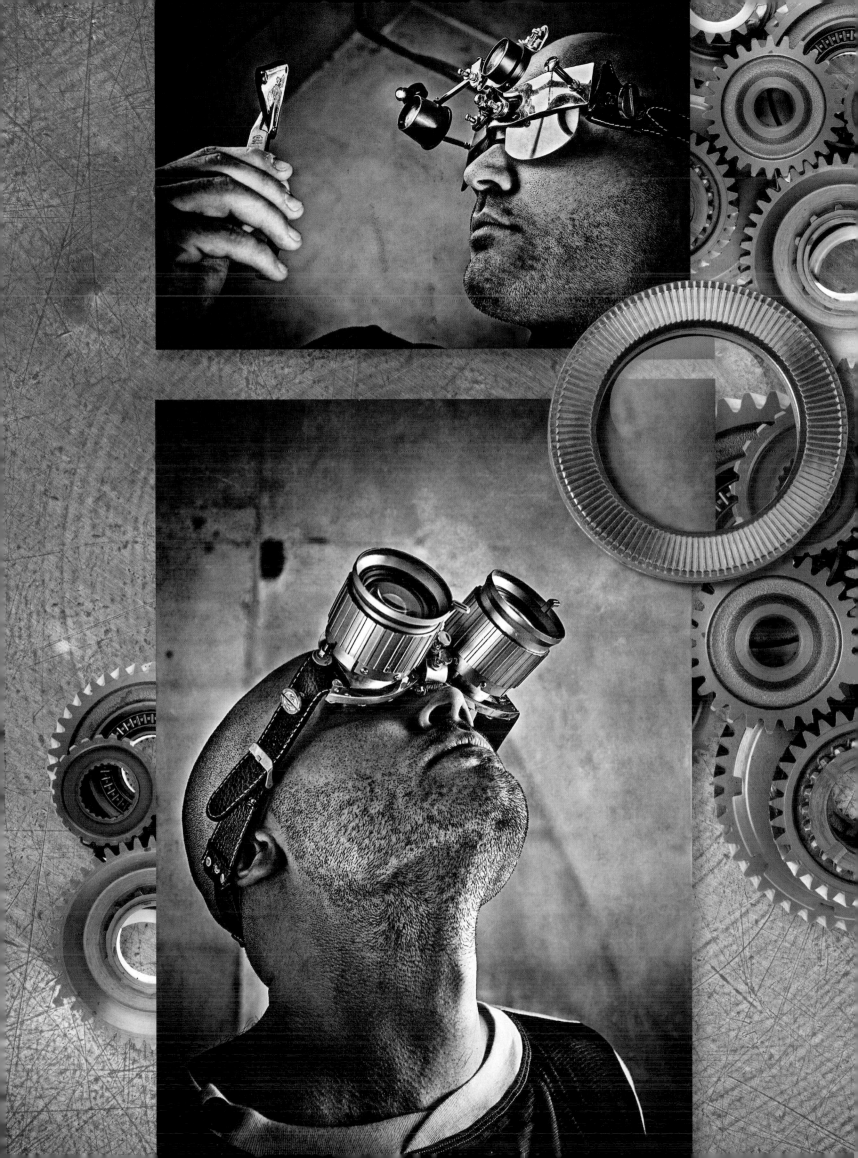

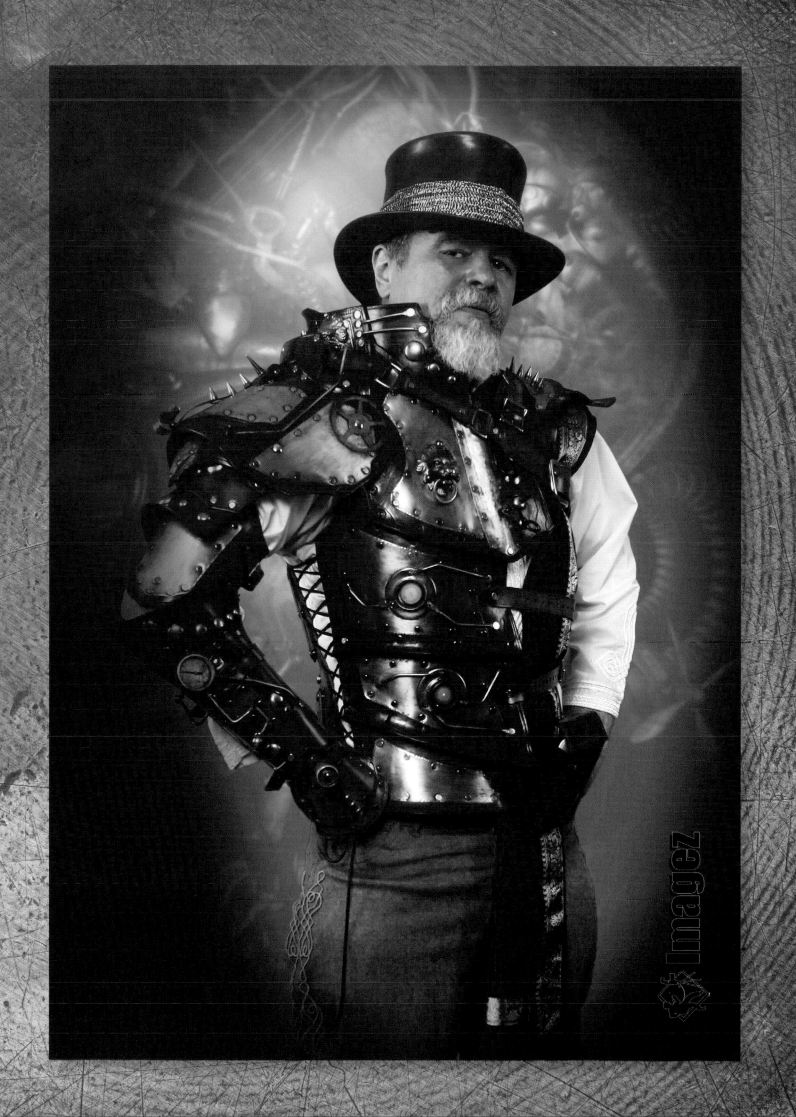

SkinzNhydez

Brute Force Studios

Ian-Finch-Field, the creative force behind SkinzNhydez, crafts wearable art, from masks, gauntlets, and bracers to goggles and suits of armor. Based in Vancouver, British Columbia, Finch-Field has always been a maker. After some years focusing on wood and metalwork, Finch-Field began creating with leather in 2008 and soon afterward founded SkinzNhydz. His art has been featured in the 2012 film *Doctor Glamour*, a short that has toured steampunk cons and film festivals; in the book *1000 Steampunk Creations*; and in a number of magazines. Outside of the steampunk community, Finch-Field may be best known for creating Justin Bieber's steampunk gauntlet for the video "Santa Claus is Coming to Town."

Here John Gannon cuts a powerful figure, encased in leather and brass. He could be a benevolent emperor or the leader of a post-apocalyptic army of liberation. Clad in the Emperor's Armor of Empowerment by SkinzNhydez, he will probably be the center of attention. Crafted from vegetable tanned leathers and brass, this unusual suit features two working LED lights. Rivets, buckles, snaps, gears, cogs, nuts, bolts, and odds and ends complete the look.

Although he may not be armored, Robert Brown, lead singer of the band Abney Park, is still well protected and ready for adventure—on stage or in the wilds of life. In addition to his typewriter arm guard, with its intriguing spread of decorative keys, Captain Robert wears Original Solid Brass Goggles by Brute Force Studios. Both items are handcrafted in Pennsylvania. (See more work from Brute Force Studios on the next page.)

Brute Force Studios

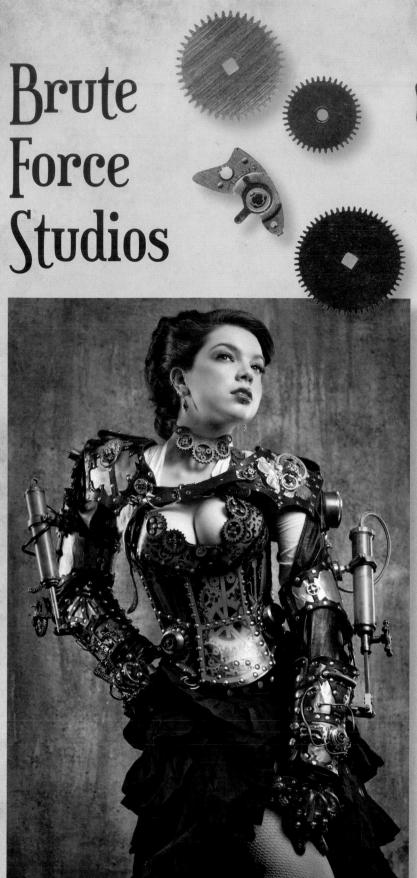

Brute Force Studios, helmed by Thomas Willeford, who has been making steampunk gear for more than twenty years, produces looks such as these from a workshop in Harrisburg, Pennsylvania. Willeford is also the author of the popular *Steampunk Gear, Gadgets, and Gizmos*, a book that divulges some of his "trade secrets" by providing step-by-step instructions for crafting a number of Brute Force designs. Willeford's work has been featured in many books and magazines, and appeared in film and television programs. In 2009, the art of Brute Force Studios was included in a ground-breaking steampunk exhibition at the Museum of the History of Science in Oxford, England. Willeford and partner, Sarah Hunter, who not only models but also creates her own line of adult gadgets and serves as press and public relations liaison for the studio, appear at Steampunk conventions nationwide.

Model Sarah Hunter, known as Lady Clankington, an infamous adventuress, appears as if from a dream, a sepia tinted revery of adventure and gadgets. Is she human or is she machine? Perhaps she is a mix of the two. Her arms seem mechanized, super human, and yet, she possesses the grace of a real live girl. She carries her replacement arms well, which takes some energy as each arm, constructed from leather and metal, weighs about ten pounds. This style by Brute Force Studios was worn by actor Nathan Fillion on the ABC show *Castle*. Hunter's corset and bra are made from leather, as is the choker at her neck.

Now Hunter plays a retro-futuristic gunslinger with a hint of Weird West flavoring. In a custom-made leather underbust corset, Hunter does not have to seek adventure. Rather, adventure comes looking for her.

ABOVE *Custom Clockwork Corset and Bra set and Dr. Grimmelore Superior Replacement Arms by Brute Force Studios.*

OPPOSITE PAGE *Custom corset and arm guard by Brute Force Studios.*

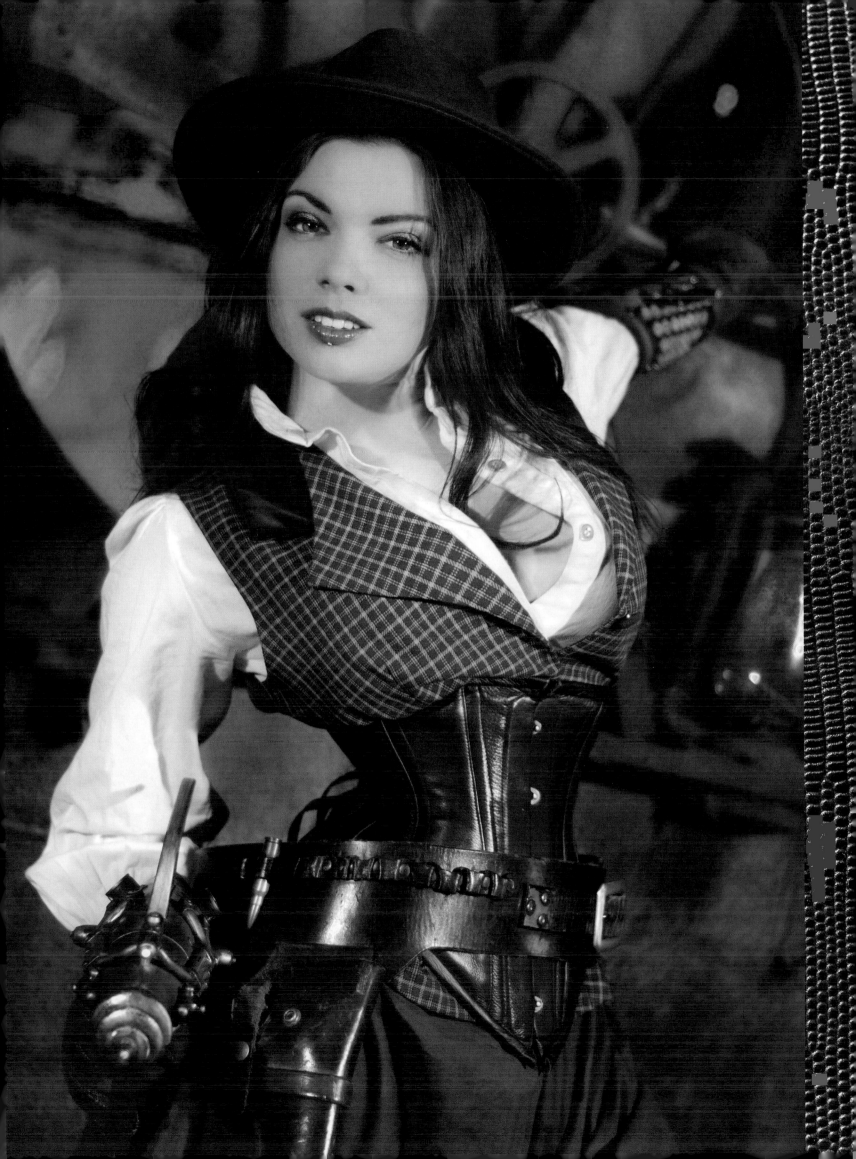

Michael Salerno

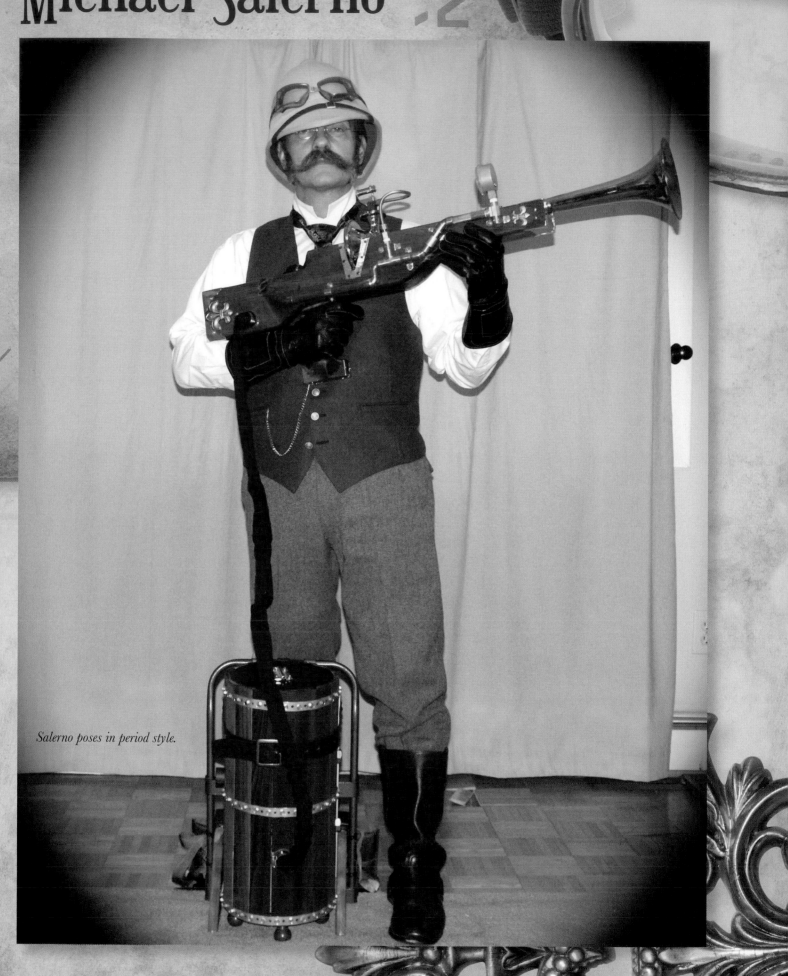

Salerno poses in period style.

The creation of Michael Salerno, the Sonic Disorienter is made of two components—a sound wave projection funnel, in reality a horn salvaged from a retired fire truck, which is mounted on a wooden gunstock; and a small air compressor, fitted into a backpack. Most of the device's parts are crafted from traditional materials, including wood, fabric, steel, brass, and copper. Inside the backpack, in addition to the air compressor, two motorcycle batteries and a one gallon air tank stand ready for activation. Pressing the priming key on the gunstock starts the compressor working. A pressure gauge tells the user when the air tank is full. The trigger releases the air into the horn, which then blares.

Fascinated by science and old mechanical objects since childhood, Salerno found steampunk to be a natural fit. In addition to building the Sonic Disorienter and a number of other functional gadgets, he has also created a fully developed steamsona, complete with a detailed backstory, for his character Professor Fumolatro. A professor of engineering and a member of a secret organization called the Veritas League, the professor engages in varied adventures, including a trip to Tangiers in search of a mysterious book.

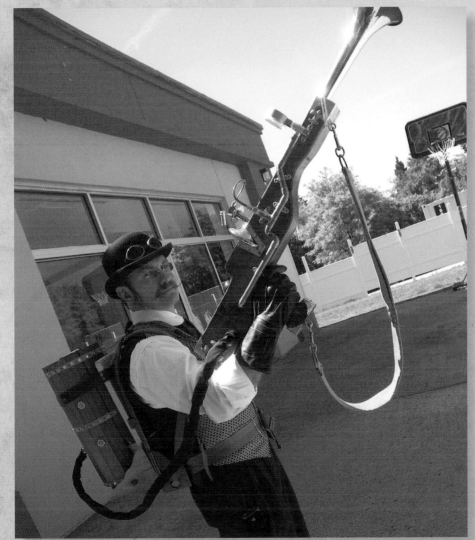

Here Professor Angelus P. Fumolatro aims his weapon at would be attackers. The barrel glints in the sunlight. The professor depresses the device's priming key. He checks the gauge, steadies himself, and pulls the trigger. A blast of sound, one hundred and twenty five decibels of air-horn screech, stops his attackers in their tracks. Disoriented by the horn, they lose their focus, and the professor makes a quick get away.

TOP *Salerno checks his gauge before he pulls the trigger.*

BOTTOM *The Sonic Disorienter, created by Michael Salerno, is a nonlethal device of self-defense.*

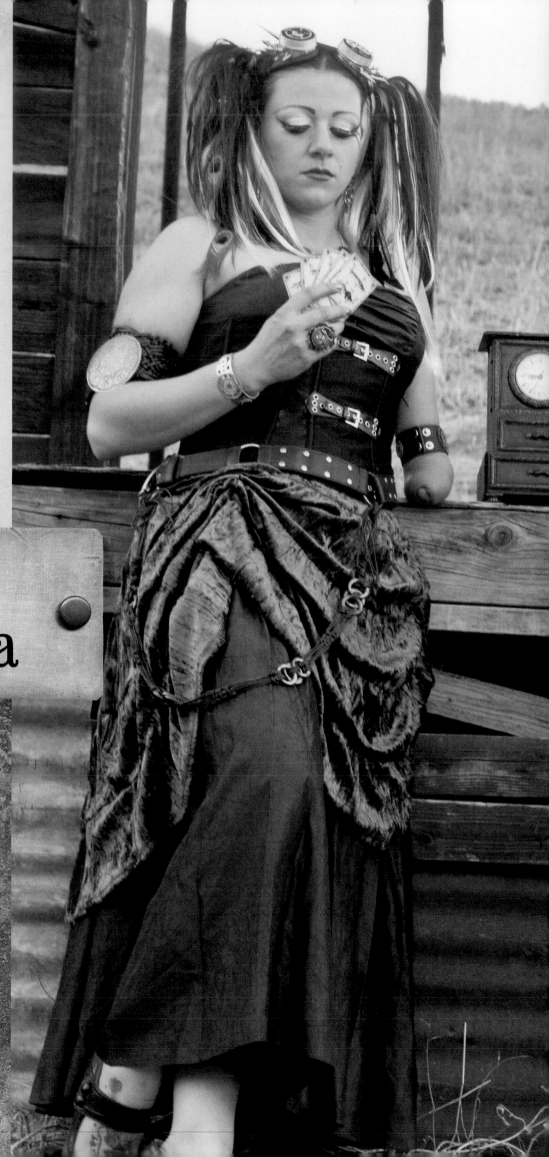

Two bonny steampunk lasses enjoy a game of cards. The leisure activity amuses and yet, as time passes, they long for adventure. In the sky, they spot a rainbow, and they feel that luck may be on their side. On a lark, they set off toward the magical arc of colored light. In their travels, they find a four-leaf clover. Excited by this turn of events, they hurry to the workshop of their friend. They surprise Keith in his labors and present him with the clover. He seems skeptical at first, but then he too sees the rainbow. The three trace the rainbow to its end, where they encounter a leprechaun. A chase ensues. Keith, on his wheels, easily overtakes the leprechaun, who then presents the friends with his pot of gold.

Disabled Life Media

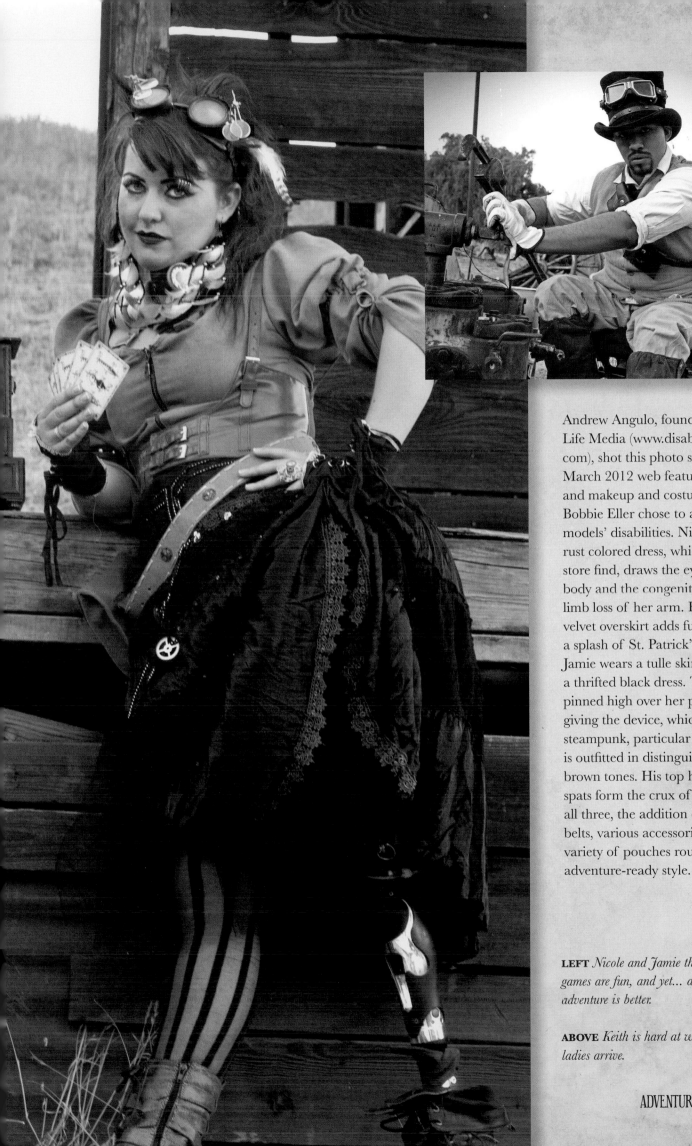

Andrew Angulo, founder of Disabled Life Media (www.disabledlifemedia. com), shot this photo story for his March 2012 web feature. Angulo and makeup and costume director Bobbie Eller chose to accentuate the models' disabilities. Nicole's long rust colored dress, which was a thrift-store find, draws the eye to her upper body and the congenital partial limb loss of her arm. Her green velvet overskirt adds fullness and a splash of St. Patrick's Day color. Jamie wears a tulle skirt underneath a thrifted black dress. The skirt is pinned high over her prosthetic leg, giving the device, which seems totally steampunk, particular focus. Keith is outfitted in distinguished earthy brown tones. His top hat, vest, and spats form the crux of his look. For all three, the addition of goggles, belts, various accessories, and a variety of pouches round out their adventure-ready style.

LEFT *Nicole and Jamie think card games are fun, and yet... and yet... adventure is better.*

ABOVE *Keith is hard at work when the ladies arrive.*

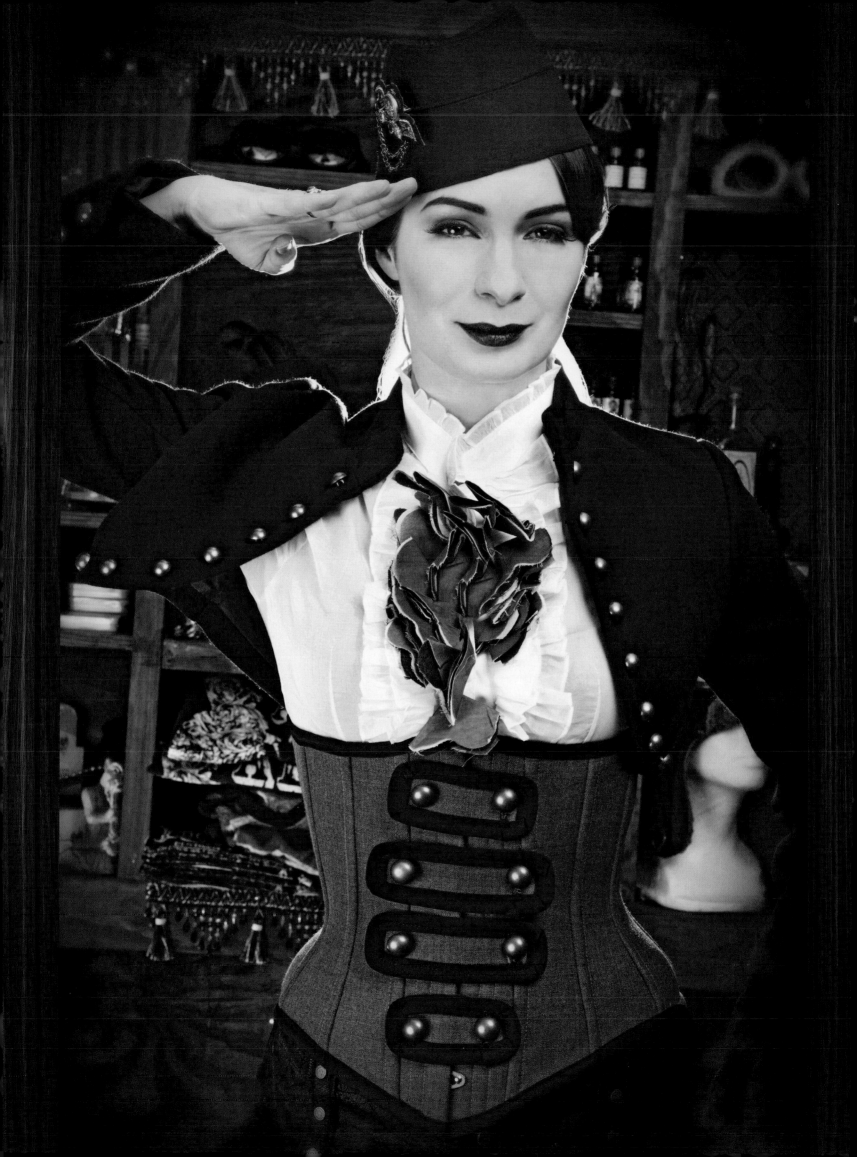

Clockwork Couture

Is she a new recruit reporting for duty? Or is she recruiting a crew for her own steam-powered dirigible? Either way, actress Felicia Day plays the part to a perfect T in a frilly blouse, jodhpurs, and cropped jacket. Her military-style underbust corset, made to the specifications of Clockwork Couture's Donna Ricci, is crafted from denim and features long tails at the back. Each tail is decorated with a hand-sewn soutache. Ricci's appreciation of Victorian design, coupled with her desire for fashions suitable for the empowered woman, have led her to create practical and stylish looks for adventuresome ladies. And don't forget the hat! Complete with rank insignia, Day's is modeled after caps worn by the Royal Navy.

Felicia Day, who has appeared in numerous television and web shows, here is dressed in white as a steampunk version of Codex, one half of her dual character on the comedy web series *The Guild*, which centers on a group of online gamers and their misadventures in the real and virtual worlds. Not only does Day star in the show, but she created the series and writes each episode herself. Steampunk Codex is wearing a custom-made steel-boned corset over her puffed-sleeve blouse and long full skirt, a Derby on her head. Ricci is dressed in Clockwork Couture's Parliament Coat, Victoria Blouse, and Back in Black Bustle Skirt.

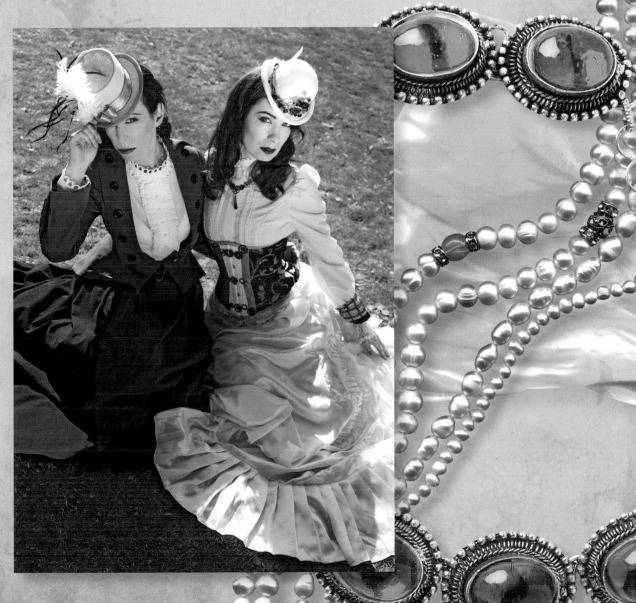

OPPOSITE PAGE *Actor Felicia Day poses in steamy military style.*

RIGHT *"Captain" Donna Ricci, designer and proprietor of Clockwork Couture, poses with Felicia Day, who is dressed as a steampunk version of her character Codex.*

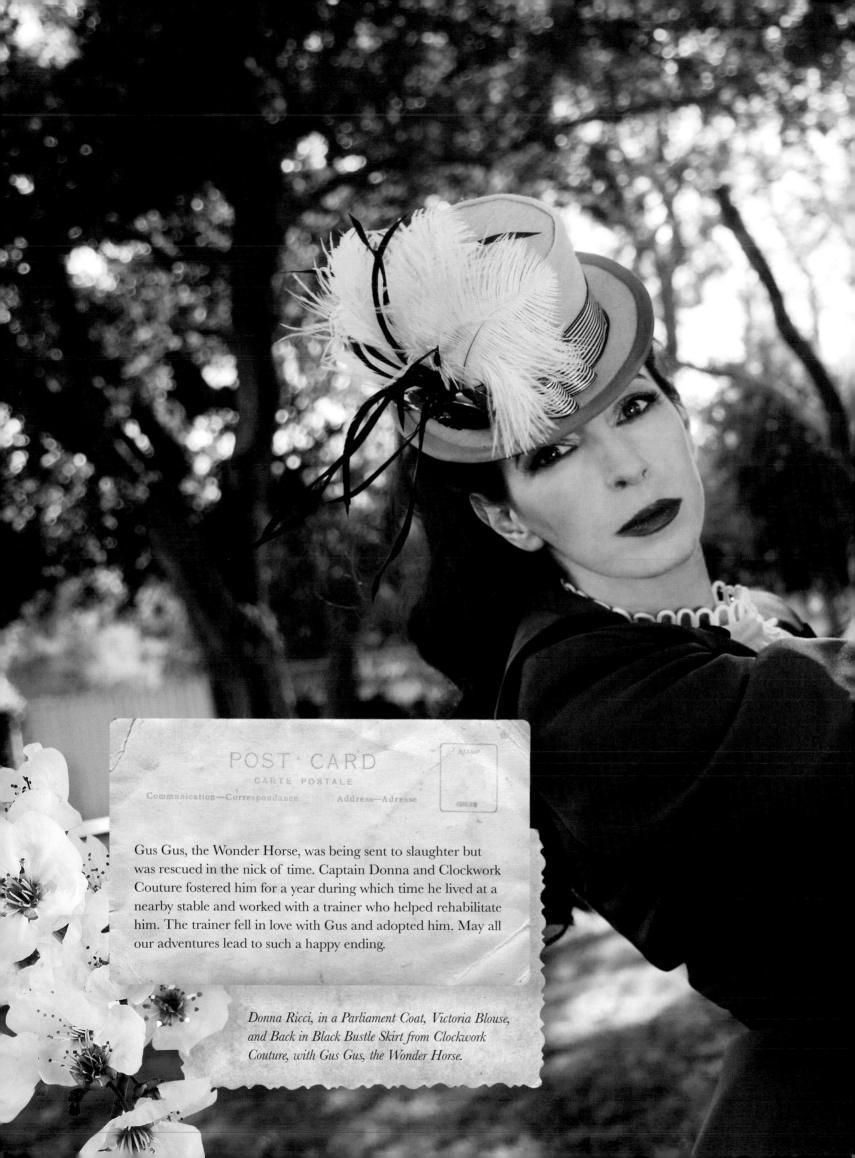

POST·CARD
CARTE POSTALE

Communication—Correspondance Address—Adresse

STAMP

Gus Gus, the Wonder Horse, was being sent to slaughter but was rescued in the nick of time. Captain Donna and Clockwork Couture fostered him for a year during which time he lived at a nearby stable and worked with a trainer who helped rehabilitate him. The trainer fell in love with Gus and adopted him. May all our adventures lead to such a happy ending.

Donna Ricci, in a Parliament Coat, Victoria Blouse, and Back in Black Bustle Skirt from Clockwork Couture, with Gus Gus, the Wonder Horse.

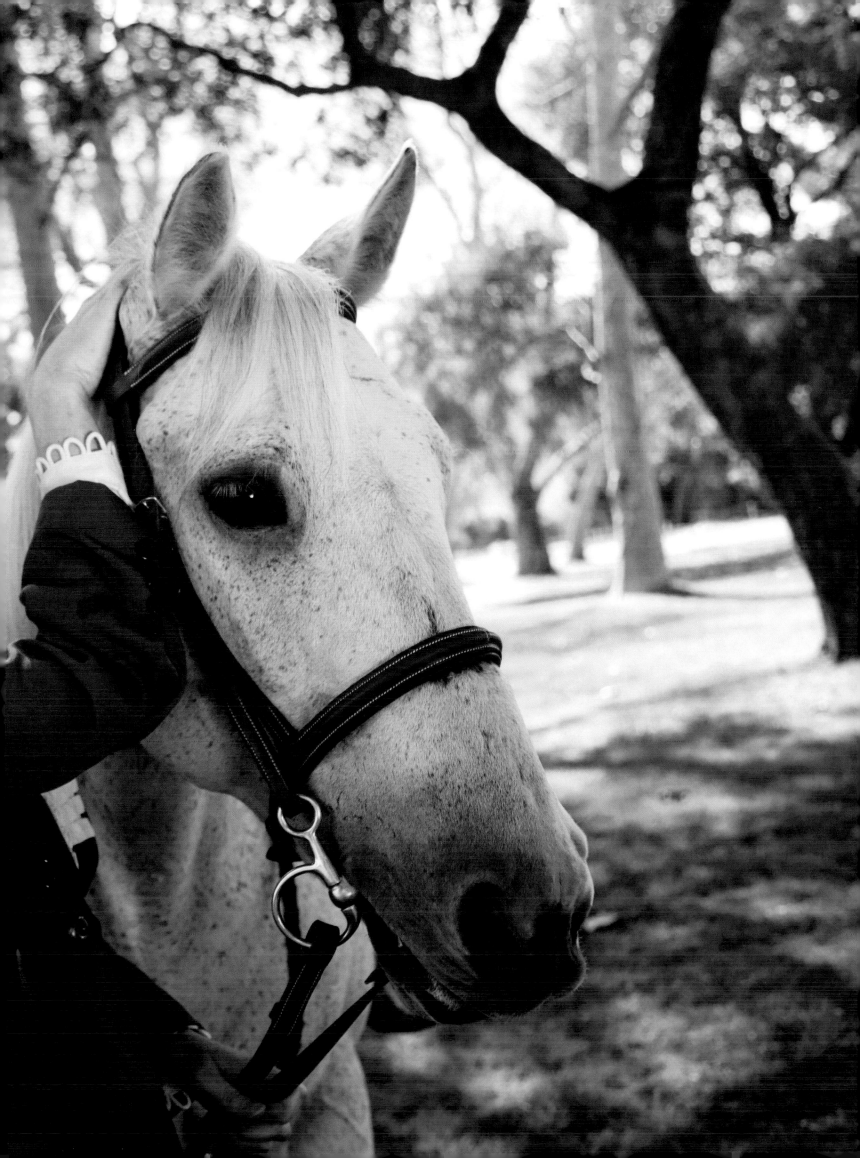

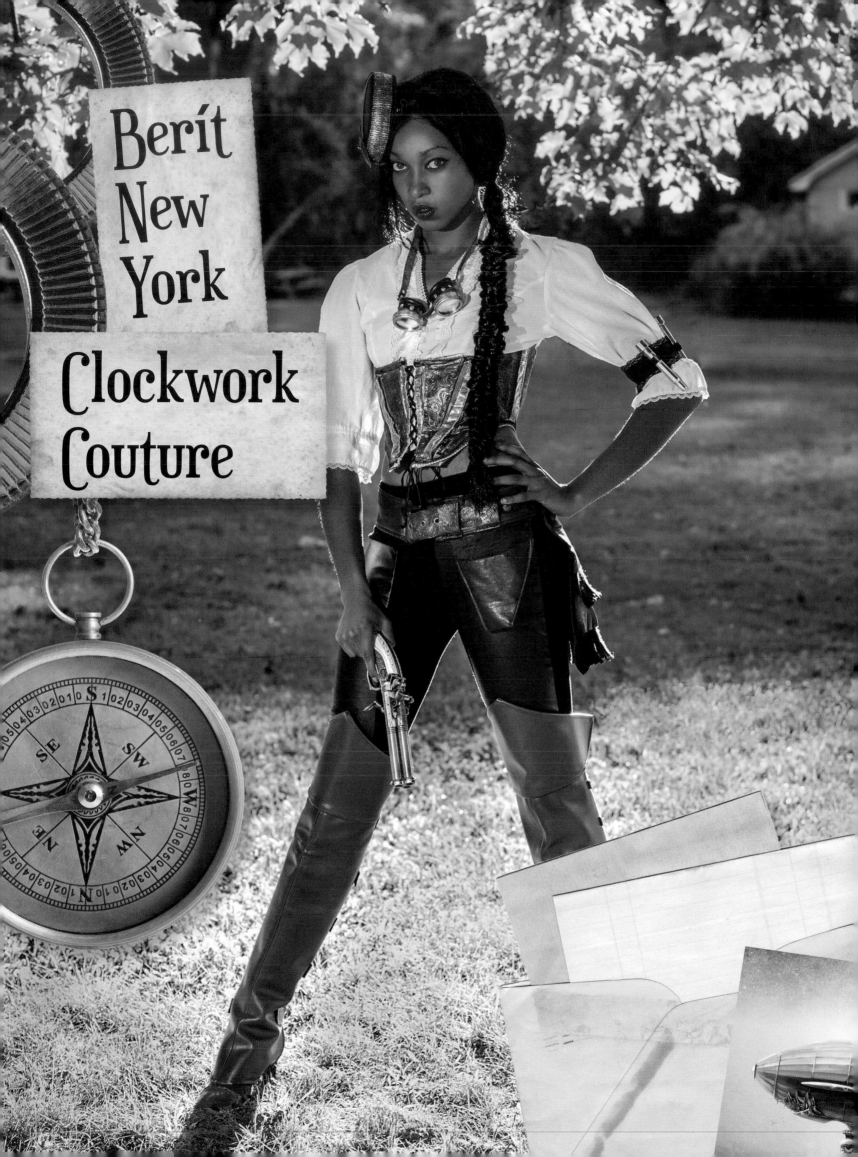

Berít
New
York

Clockwork
Couture

The British military pith helmet, which is traditionally made from the spongy inner layer of plant stems and covered with cloth, was designed to protect the wearer from the sun. The pith helmet first went into service in the 1840s. In the 1870s, the helmet became popular among almost all European military personnel serving in tropical colonies. By the mid-nineteenth century, the hat was considered a necessary protection against the sun for civilian Westerners in the tropics. While this hat style may have signified the romance and adventure of colonial exploration for Europeans, it undoubtedly meant something else to the indigenous population. The pith helmet was the headgear of an occupying military force.

Today the pith-helmeted tropical explorer look carries an emotional load for many people. Of course steampunks know their history, and they like to rewrite it. The image of Grant Imahara in this British colonial-style outfit is suggestive. What if there had been no British Empire, but instead a steam-driven Asian nation had become a superpower and colonized the world?

Model Toni Barnes, in an outfit by Berít New York, looks to be a superpower capable of subverting history herself. Her vinyl thigh-high spats emphasize the length and strength of her legs. Over her vintage blouse, she wears a holster belt and waist cincher with copper boning while her sleeve garter holds extra ammunition. What if fierce women like this had populated the Wild West? What if such a stylish gun-toting lass were sheriff?

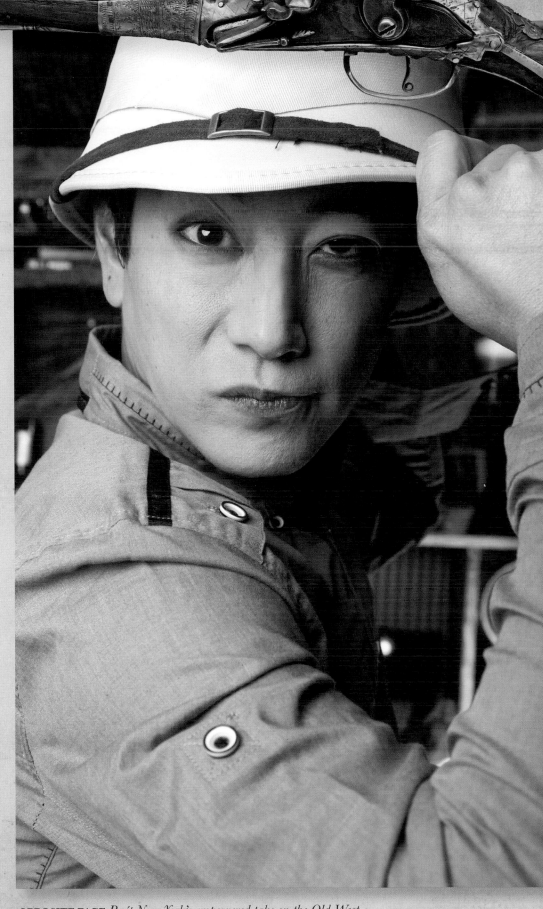

OPPOSITE PAGE *Berít New York's empowered take on the Old West.*

ABOVE *Electronics expert Grant Imahara, of television's* MythBusters, *outfitted by Clockwork Couture and ready to go. Imahara is no stranger to steampunk. In addition to modeling for Clockwork Couture, he has guest starred on the web series* The Adventures of the League of S.T.E.A.M.

Maurice Grunbaum

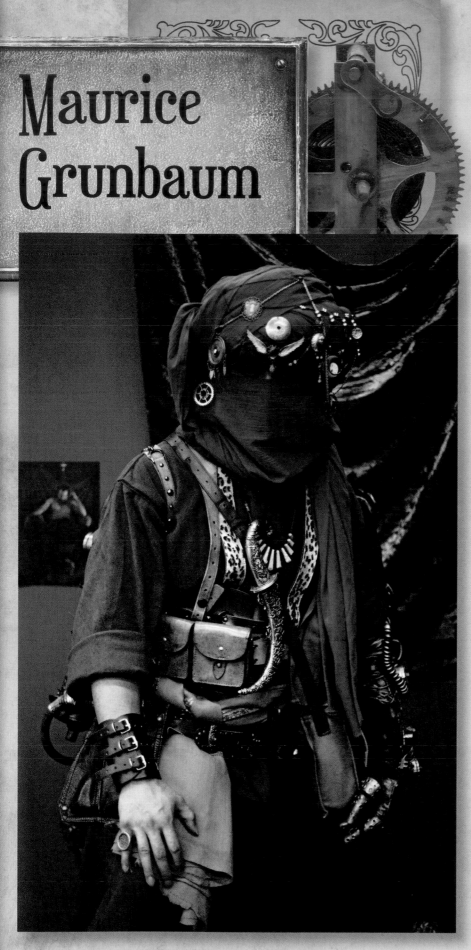

Maurice Grunbaum is an independent self-taught retro-futurist artist, living about twenty miles west of Paris. He particularly enjoys working with fabric and leather-like materials. In addition to creating costumes, Grunbaum also paints, illustrates graphic novels, and makes dolls, sci-fi weapons, hats, and other steampunk props—such as heavily embellished gauntlets encrusted with seashells, like the ones pictured here. Grunbaum searches flea markets for unusual items that he then transforms into his retro-futuristic art. As a fan of a number of science fiction authors, including those who work in comic books, graphic novels, and manga, Grunbaum pays tribute to them all with his prodigious output.

Grunbaum's Steampunk Tuareg from Mars outfit was inspired by Alan Moore and Kevin O'Neill's *The League of Extraordinary Gentlemen*. The Tuareg are a nomadic people of northern Africa. Tuareg men typically cover their faces and heads with a blue veil and turban. Grunbaum has added leather wrist cuffs, multiple bags and pouches, and a gauntlet on his left hand. Among the jewelry on his turban are clockwork elements, gears, lock parts, and wings.

A number of Grunbaum's outfits are based on historic military uniforms, but rather than simply reproduce a look, Grunbaum mixes and combines elements from several historic traditions to create something new. Graunbaum's work spans continents as well as time. He has drawn inspiration from Northern Africa, Mexico, and Europe, as well as from his Vietnamese heritage. Grunbaum's steampunk projects all have three main driving principles: Do It Yourself, recycling, and multiculturalism. He says: "My steam is, above all, retro-futuristic and multicultural."

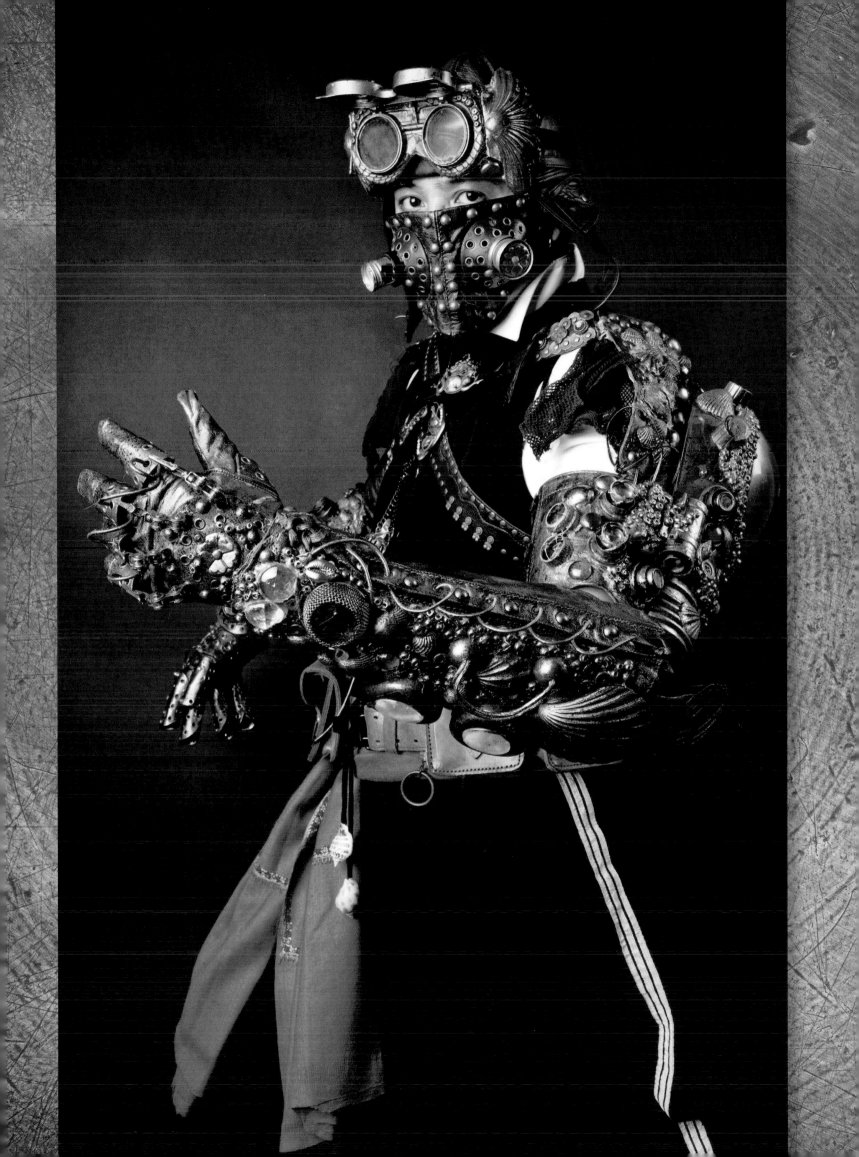

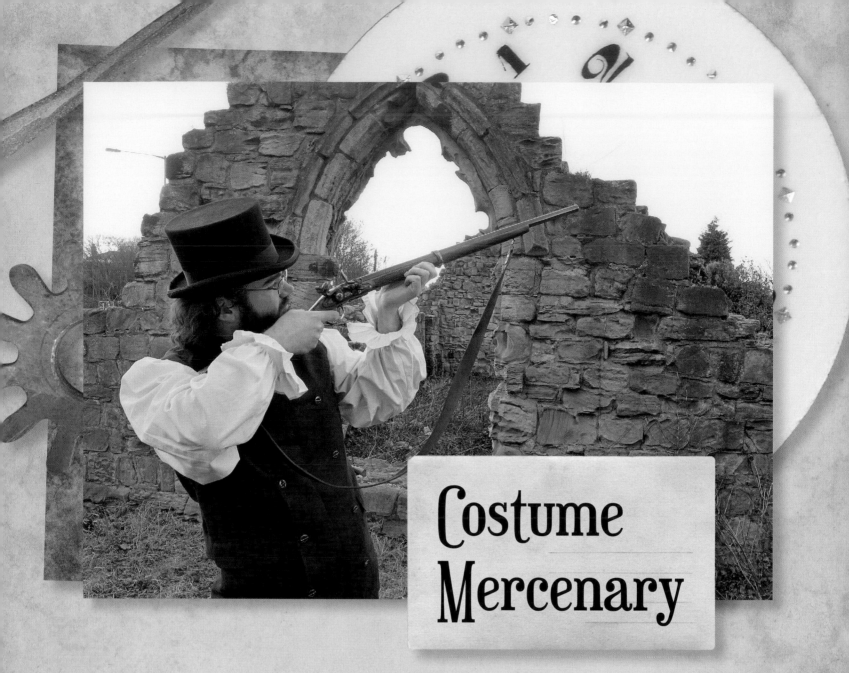

Costume Mercenary

A waistcoat, or vest, lends dash and swagger to anyone and can turn a regular day into an adventurous one. This subtly-steampunk version, which features double-breasted styling and Costume Mercenary's cog-and-screw buttons, elevates a pair of pants and a shirt into an outfit fit for an outing. (The gun is optional.)

The slits in designer/model Jeanette Ng's green dress reveal a generous amount of leg. They also allow for quick getaways, whether on foot, bicycle, or via horseback. The Buckle Cheongsam is an example of Costume Mercenary's Ricepunk style. "Ricepunk" is the term Jeannette Ng coined to describe her brand of steampunk with a Chinese-inspired aesthetic. In this dress, she takes a classic Chinese cheongsam, or mandarin gown, and steams it up by adding square brass buckles. On top of her head, she wears a pair of goggles that she handcrafted from beer cans. Ng, who often models her own creations, found the "dragon lady undercurrent" of this shoot difficult. She writes that the stereotype of the "deceitful and domineering" Asian woman is "a lot to live up to."

In another example of Ricepunk style, Ng models the Ricepunk Traveler ensemble, which consists of a mix of garments—ones inspired by Asian dress and those inspired by the British past. A Regency-style waistcoat sits over a beige linen shirt-jacket and a pair of black linen pants, both of which are tailored in a traditional Chinese manner. Throughout this traveler's peregrinations, she will be well protected. At her back, an Asian bamboo hat, and on her head, steampunk googles.

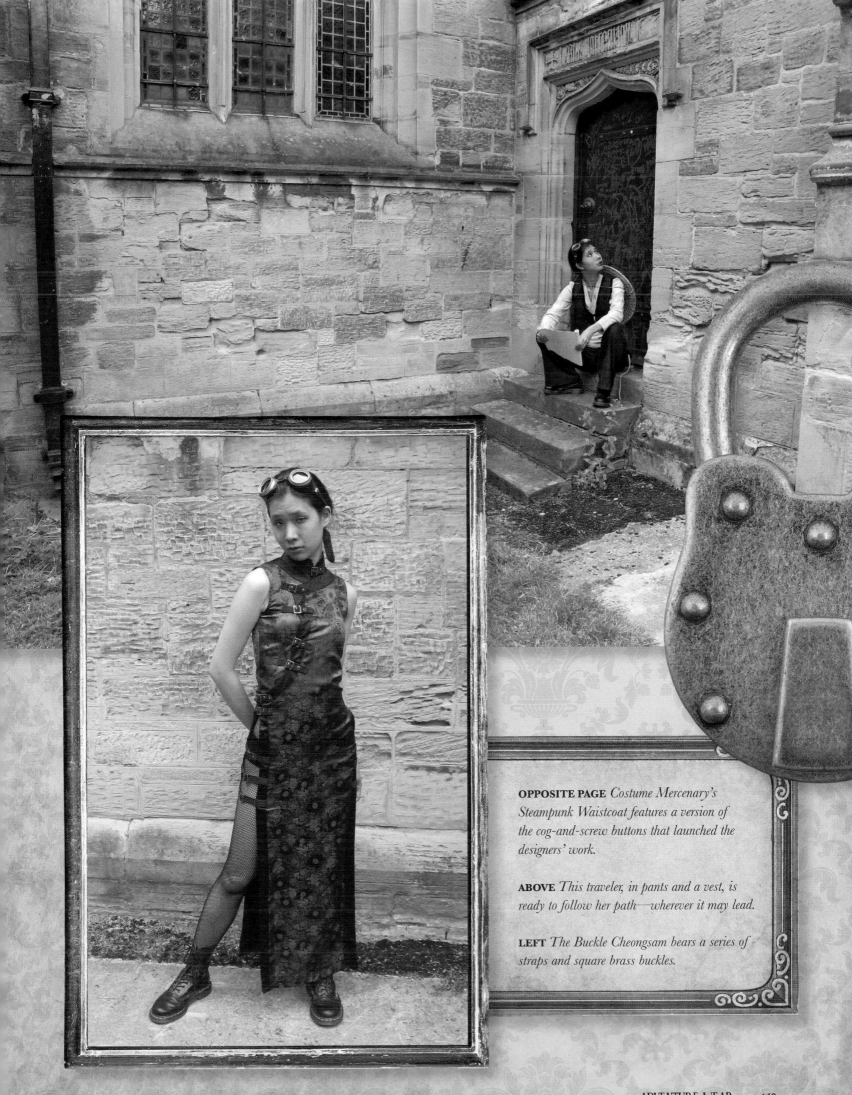

OPPOSITE PAGE *Costume Mercenary's Steampunk Waistcoat features a version of the cog-and-screw buttons that launched the designers' work.*

ABOVE *This traveler, in pants and a vest, is ready to follow her path—wherever it may lead.*

LEFT *The Buckle Cheongsam bears a series of straps and square brass buckles.*

Spyder Designs

Morrigana "Meg" Pehlke, a self-taught designer and seamstress, began creating steampunk clothing under her label Spyder Designs in 2010. She had inherited a cache of sewing odds and ends from her grandmother, a seamstress for the world-renowned Stratford Festival Theatre. This event, coupled with her involvement with the Society for Creative Anachronism, led her to reading and research on fabrics and clothing silhouettes. Soon she was designing. Based in Stratford, Ontario, Pehlke began by crafting women's wear but quickly realized that steampunk men were in need of clothing, too. In addition to creating steamy fashions, Pehlke organizes steampunk fashion shows at conventions such as Ryu-Kon.

This adventurous urban model, in her burgundy cape and festive hat, seems ready to take on any challenge—a sprint for the bus, jaywalking, a sudden gust of wind. With her protective spats, she's equally well prepared for a hike across the moors. Her outfit is one of the first created by Spyder Designs. Her hat was made for the designer by Tracey Wolfe-Dill of Inside My Wicked Wardrobe in Stratford, Ontario.

Spyder Design's Victorian Vigilante works outside the law to keep the cobblestone streets safe. While so engaged, he shows off his style in a handmade leather top hat from Australia's Cobb and Co., a frilled gentleman's shirt, and Spyder's own Holmes Coat.

The shoulder-length leather gloves on this lady airship captain took the designer two whole days to construct. Her weapon is a Nerf Maverick gun, hand-painted and antiqued by the designer. In addition, she wears a bowler hat, a skirt, knee-high spatterdashes, an underbust corset, and a leather vest. Around her neck dangles a silver key.

FAR LEFT *Fighting the wind and ready for adventure in an ensemble by Spyder Designs and a hat from Inside My Wicked Wardrobe.*

LEFT *A Victorian vigilante.*

OPPOSITE PAGE *This airship captain takes a break to cool her jets.*

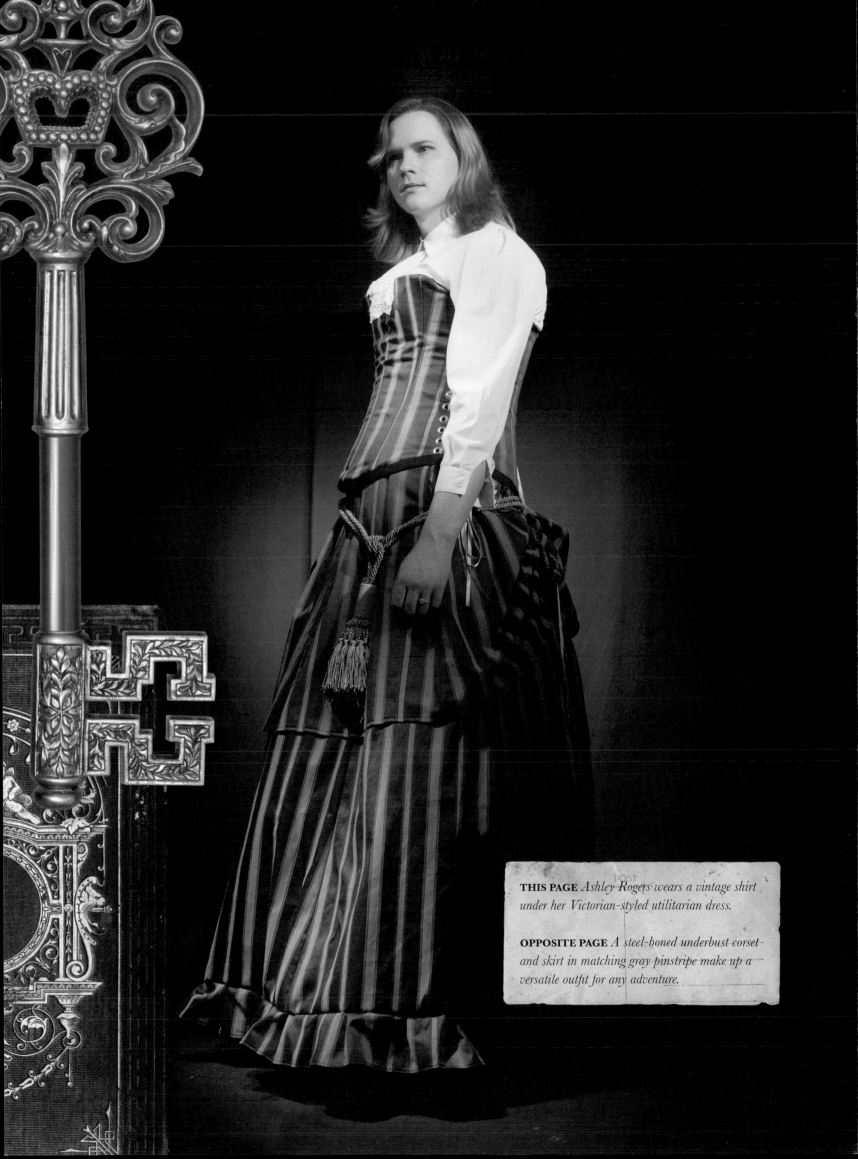

THIS PAGE *Ashley Rogers wears a vintage shirt under her Victorian-styled utilitarian dress.*

OPPOSITE PAGE *A steel-boned underbust corset and skirt in matching gray pinstripe make up a versatile outfit for any adventure.*

Festooned Butterfly

Angie Carter of Festooned Butterfly learned to sew from her grandmother, mother, and aunt. The Halloween costumes that her mother made her were probably her biggest inspirations for perfecting her craft. As a child, watching the women in her family work, she practiced with scraps of fabric and eventually started making doll clothes. In college she studied English literature and medieval history and today likes to dress in steampunk style herself. She says she is "most comfortable wearing a corset and a pair of boots."

In addition to creating adventurous formal ensembles, Carter makes proper outfits suited to outdoor adventures. "Adventuring does not mean you cannot be a lady," she says. This brown striped dress, which consists of a steel-boned overbust corset and a skirt, is made from cotton duck, a strong fabric akin to canvas. In designing this look, Carter started with the shape of a Victorian dress as her base. To make it as utilitarian as possible, she crafted the dress in a tough no-nonsense fabric, a material that could stand up to getting tossed off a horse, climbing a tree, or trekking through a thicket of thorns

Amanda Troutman's gray outfit, which is composed of a steel-boned underbust corset with a halter neckline in gray suiting fabric with a matching skirt, seems just the costume for striding through the forest. Note the clips on each side that hike her hemline up and the corset's handy pockets, perfect for a watch, loose change, or botanical samples encountered on her travels. In addition to her ladylike and practical suit, Troutman wears a cream-colored cotton underskirt.

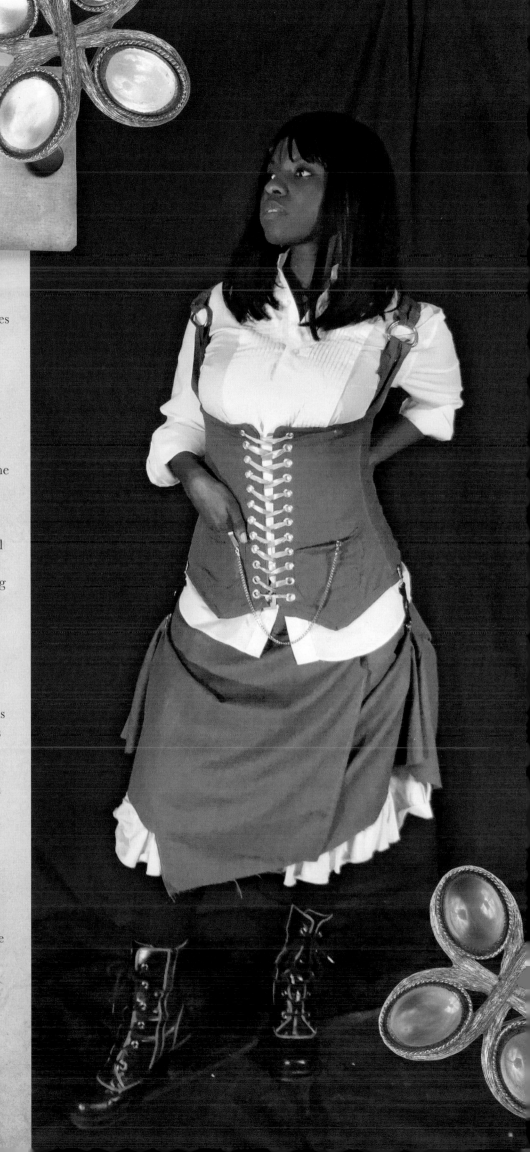

As in her ladies' formal wear, Carter often mixes eastern and western traditions. This character seems to have picked up his clothing on his travels. Could he be a ship's captain, sailing the waters of East Asia? He wears an orange vintage haori over a button-front shirt. At his waist, a steel-boned men's corset is covered in gray corduroy. The corset seems both decorative and protective, almost like a strategic piece of armor. A leather belt and scarf over the corset add rakish charm, while jersey arm warmers crafted in complementary shades of burnt orange and gray seem functional and dashing. In contrast, this versatile black men's ensemble, which was created for a Day of the Dead celebration, has its feet firmly planted in the New World. The outfit features a cotton and satin jacket embellished with metal studs and paint, and a cotton vest.

Carter, who is a member of The Red Fork Empire, a group of steampunk and futuristic artists and makers, finds inspiration in the creativity of that community. She also loves to see what steampunks do in crafting new versions of idealized Victorian fashions.

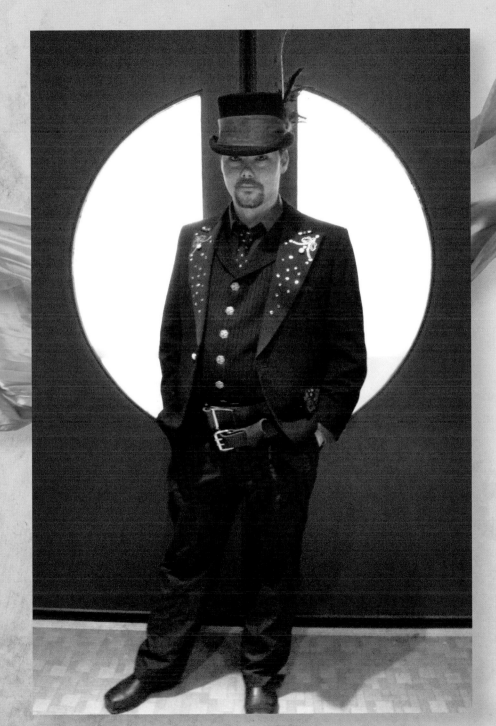

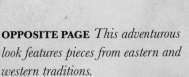

OPPOSITE PAGE *This adventurous look features pieces from eastern and western traditions.*

LEFT *A hand-painted jacket with metal studs sets this outfit apart.*

Tony Ballard-Smoot, who is known in the steampunk community as Anthony LaGrange, captain of the Airship Archon, first encountered steampunk in 2008 at the sci-fi convention Dragon*Con and at an event in Columbus, Ohio, called Gothcoming. The aesthetic and the innovation of steampunk hooked him right away; he formed Airship Archon and was dubbed captain. The Airship meets monthly for a build day, in which the crew gathers to work on projects—from sewing and painting to constructing props and crafting jewelry. Airship Archon also participates in panels, and gives presentations and lectures at many of the steampunk, sci-fi, and anime conventions in the Midwest and East Coast.

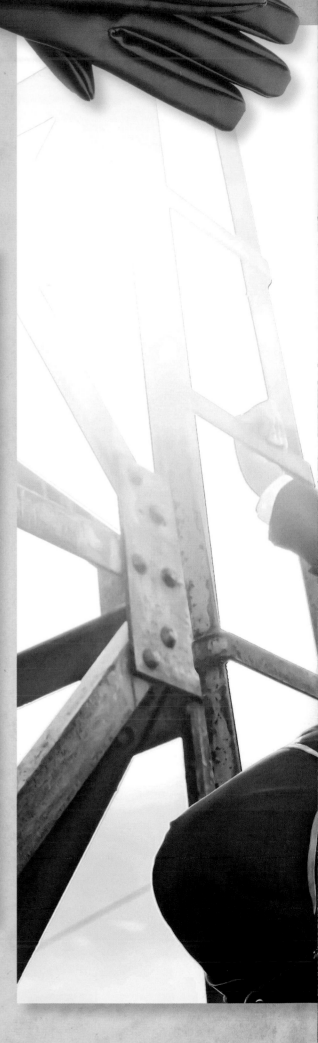

ABOVE *LaGrange's brown vest was made by Kelly Farrow, a North Carolina–based costume seamstress. His undershirt and pants were thrifted, and he painted the stripes on the pants himself.*

This action-ready, western-inspired ensemble is made up of a black coat, vest, trousers, and a bowler.

Tony Ballard-Smoot

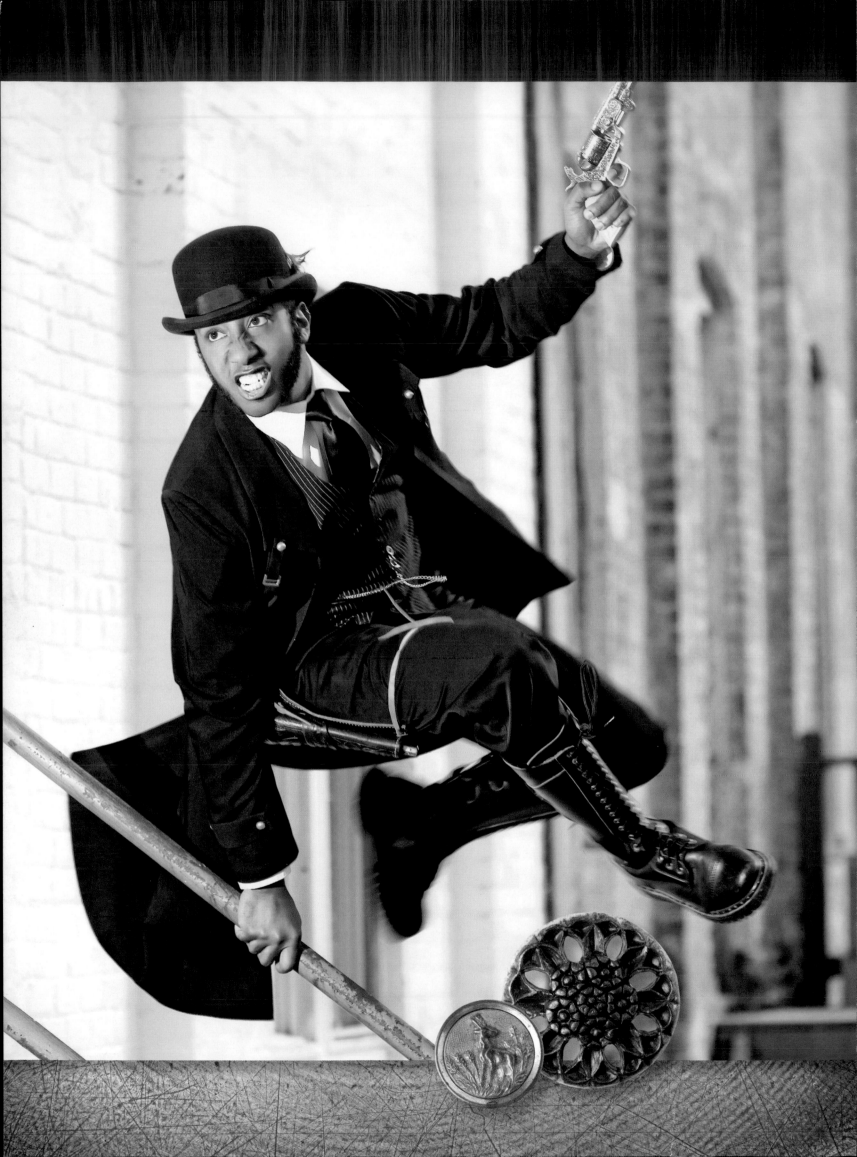

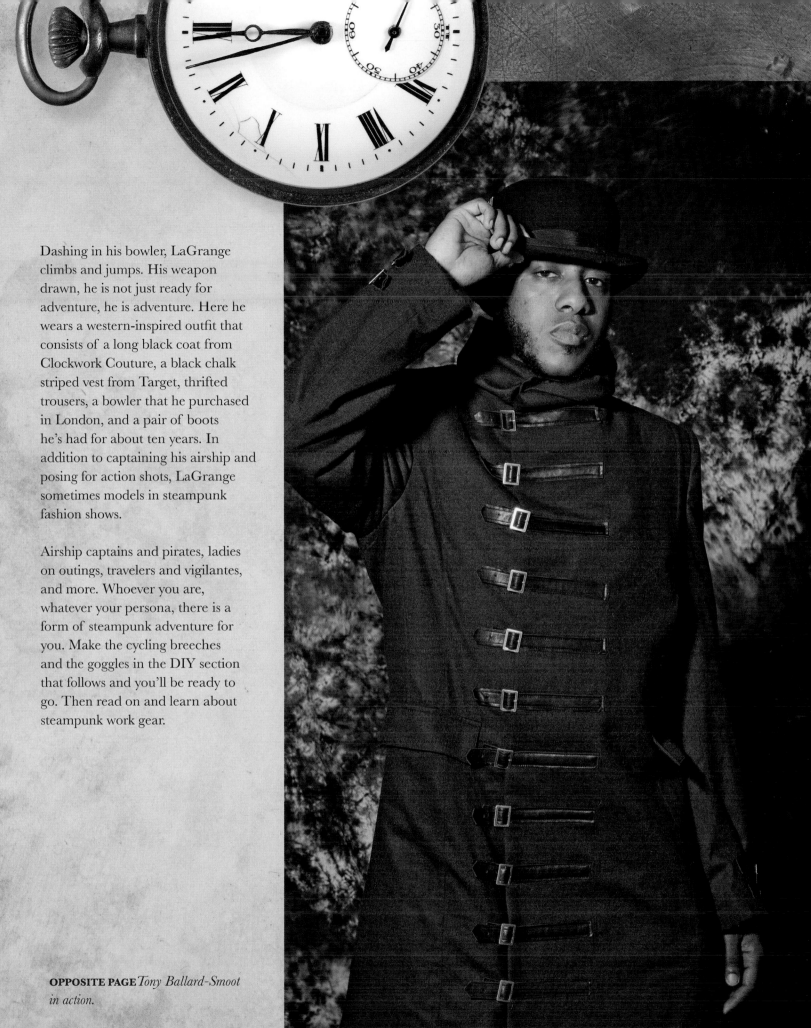

Dashing in his bowler, LaGrange climbs and jumps. His weapon drawn, he is not just ready for adventure, he is adventure. Here he wears a western-inspired outfit that consists of a long black coat from Clockwork Couture, a black chalk striped vest from Target, thrifted trousers, a bowler that he purchased in London, and a pair of boots he's had for about ten years. In addition to captaining his airship and posing for action shots, LaGrange sometimes models in steampunk fashion shows.

Airship captains and pirates, ladies on outings, travelers and vigilantes, and more. Whoever you are, whatever your persona, there is a form of steampunk adventure for you. Make the cycling breeches and the goggles in the DIY section that follows and you'll be ready to go. Then read on and learn about steampunk work gear.

OPPOSITE PAGE *Tony Ballard-Smoot in action.*

RIGHT *LaGrange models a coat by KMKDesigns.*

Cycling Breeches

By Noam Berg

The bicycle was first introduced in the nineteenth century. By the 1860s, a bicycle craze swept both Europe and the United States. Innovations in bicycle design led to another bike craze in the 1890s. Retro-cycling events, known as tweed rides or tweed runs, take place in many corners of the globe today. Another good excuse to dress up!

You Will Need:

A pair of trousers
Suspender buttons, if desired
Sewing marker
Scissors
Sewing machine or needle
Thread
Seam ripper
Tape measure
6 buttons for the leg closure
Pins

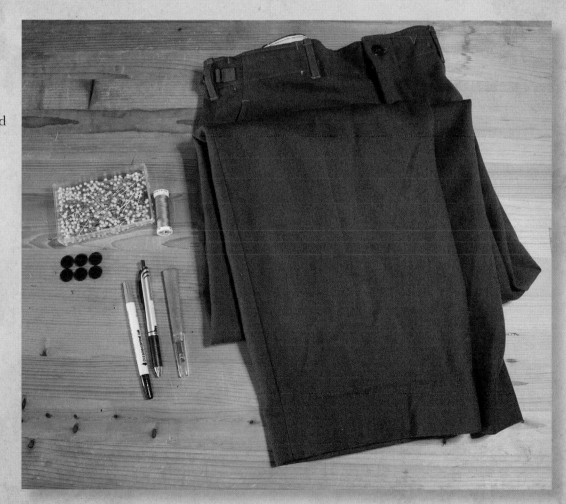

1. If you intend to wear your breeches with suspenders and your pants don't have buttons yet, sew suspender buttons to the inside of the waistband.

2. Put the trousers on. Make a mark on the outside seam, just below the knee. Make another mark at the calf midway between the knee and ankle. This will be where you will cut the trouser legs. The fabric you cut off will be used for making the cuff.

3. Take off the trousers. Smooth out the fabric. Transfer both marks you made in Step 2 to the remaining leg. Then carefully trim the pant legs at the calf mark. Lay the excess fabric aside for now.

4. Sew an anchor or bar stitch just below the knee at the place you marked in Step 2.

5. With a seam riper, open the outside seam up to the anchor stitch.

6 Use a tape to measure the circumference of your calf, midway between your knee and ankle. Add an inch to this measurement for ease. So, if your calf measures 14¾", your final measurement in this step will be 15¾".

7 The trouser leg will need to taper down to the final measurement you found in Step 6. To achieve this taper, press and pin a series of gathers until your measurement is matched.

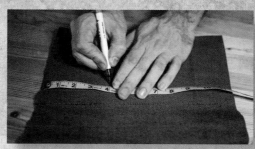
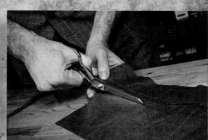

8 Get the fabric you trimmed from the trousers in Step 3. To make the cuff, you are going to cut a 4" strip from the fabric. Use your final measurement from Step 6 plus ⅝" hem allowance for the length.

9 Fold over ¾" of fabric on the top and bottom, and press the folds.

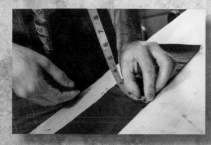
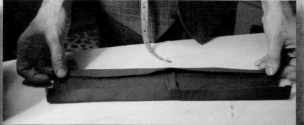
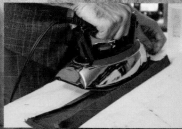

10 Fold the entire 4"-piece at just a bit beyond the halfway mark, as shown. When you attach the cuff to the trouser leg, you will want the outside edge of the cuff to overlap the inside edge. Press the fold.

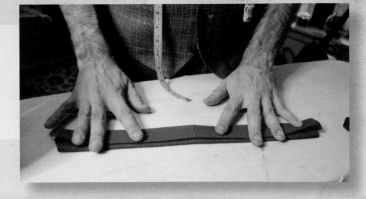

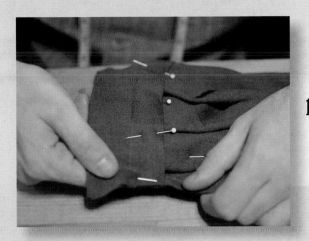

11 Open the fold you made in Step10, retaining the ¾" folds from Step 9. Carefully turn the trousers inside out, retaining the gathers you made in Step 7. Pin the shorter side of the cuff to the inside the pant leg.

12 Sew the cuff to the inside of the pant leg. You'll be sewing through a few layers of fabric, including the gathers, so go slowly. Reverse the pants so the outside is facing out again. When you've completed this step, one side of the cuff will be attached to the inside of the pant leg. The other side will be loose and ready to be sewn into place, but first. . . .

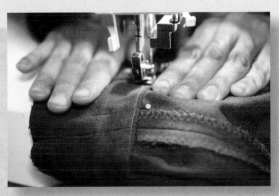

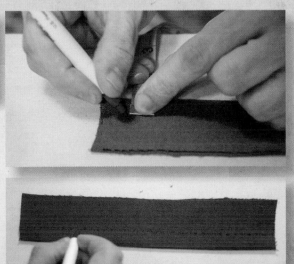

13 You are going to use another piece of the excess fabric to make a button loop—a double layer strip that is ⅝" wide with an ⅛" seam allowance. To do this, you'll need a piece of fabric that is at least 5" wide. Fold the fabric, as shown, then measure ⅝" from the fold and mark the line.

14 Press the strip. Then sew a seam along the line you marked in Step 13.

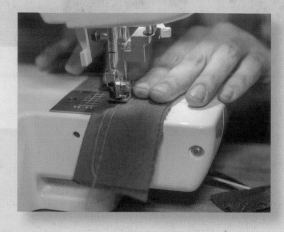

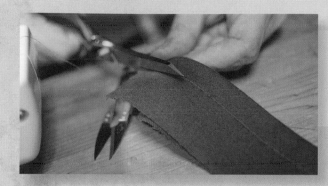

15 Carefully trim away the open side of the fabric, leaving about ⅛" seam allowance. Make sure not to cut into the seam.

16 You have been working with the inside of the fabric out. Now it is time to turn the seam side in. You may want to use a knitting needle to help you do this, but be careful not to tear the fabric. Then press the fabric.

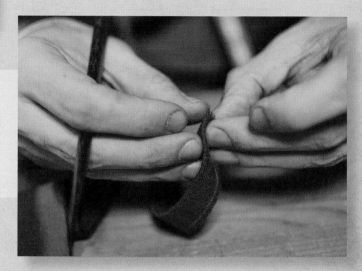

17 Fold the strip to make a triangular button loop, as shown. Press the fold, then sew across the base of the triangle to secure it.

18 Slip the button loop you just made into the pant cuff, with the triangle facing toward the back. Use one of your buttons to measure how far out the loop needs to sit, then pin the button loop in place.

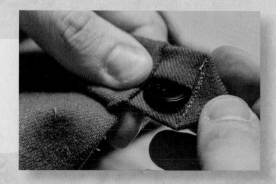

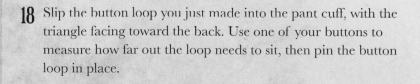

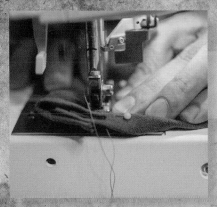

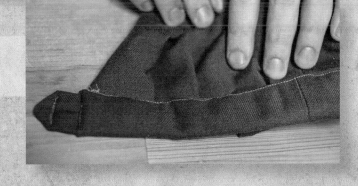

19 Sew the button loop into the cuff.

20 Now that all the pieces are in place, sew the top of the cuff to the pant leg.

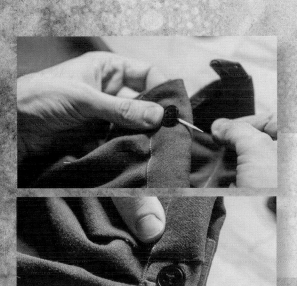

21 Try on the breeches. Pull the button tab backward until a snug fit is achieved. Mark where the button should go on the other side of the leg. Sew the button on. To prevent your button from resting too tightly against the fabric, slip a toothpick under it while you sew. If you like, add additional buttons fore and aft for an adjustable fit.

22 Complete Steps 4 through 21 on the second leg. Then you are done. Go ride a bike!

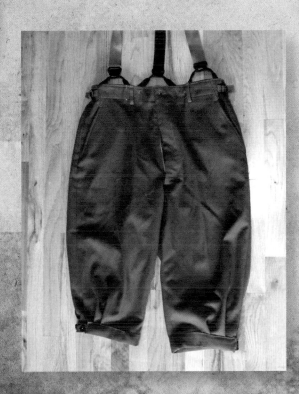

POST CARD

CORRESPONDENCE

ADDRESS

P M C
PLACE
STAMP
HERE
P M C

Steampunk Goggles

By Won Park

DIY

What good is a Steampunk without a good pair of goggles? In this simple tutorial you will make your very own protective eyewear—Steampunk style! If you can start with a pair of vintage goggles, it will lend your look a deeper level of steam.

You Will Need:

One pair of welding goggles with
 separate eyepieces
Metallic paint (optional)
One roll copper colored craft wire
One long bolt
One pocket watch casing (bezel only)
Craft glue
Drill and drill bits
11 or 12 small brass bolts and nuts
Screwdriver
Instant glue
Two filigree jewelry bases
Six (or more) watch gears of various sizes
Four small clock gears
Two small watch movements (optional)
One clip-on dual magnifier

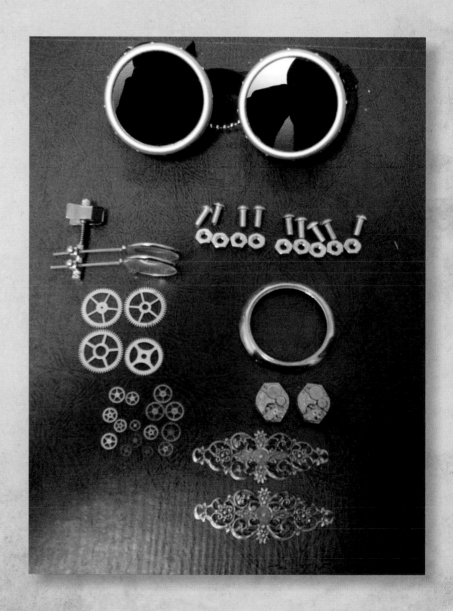

1 Disassemble the goggles. Remove the lenses and the ball chain that connects the two eye pieces, and take off the head strap. If you want to paint them, this is the time. If you are using vintage goggles, it's probably better to leave them their original color. Note: many pairs of commercially available goggles will have two sets of lenses—clear ones and dark ones.

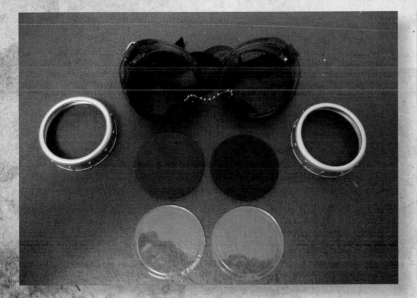

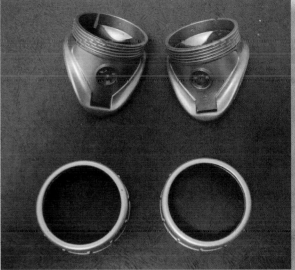

2 Wrap the copper colored craft wire in a coil around the long bolt. Make the coil approximately 1" long. Remove the bolt from the coil.

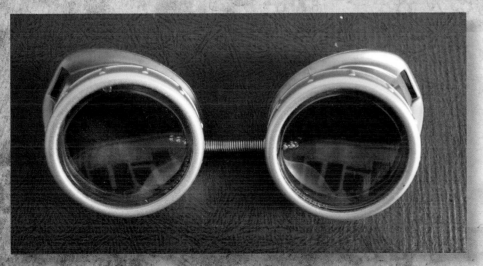

3 String the ball chain through the wire coil and refasten the eyepieces together. Make sure the goggles fit your face! Decide whether you want to use the clear or the dark lenses and reassemble the goggles.

4 Attach the pocket watch bezel to the outer rim of one of the lenses using craft glue.

5 On the eyepiece with the attached bezel, drill 10 or 11 evenly spaced holes around the edge. Make these holes big enough to accommodate the brass bolts. Note: DO NOT drill holes on the edge that will be close to your nose. Having a bolt sticking into your nose can be very uncomfortable.

6 Drill a hole on the temple side of the other lens that will fit a brass bolt.

7 Thread a nut on to one of the brass bolts. Then screw the bolt into the single hole.

8 Repeat the previous step with the holes on the other lens.

9 Use an instant bonding glue to attach a filigree jewelry piece to the temple side of each lens.

10 Glue desired clock or watch gears onto the filigree jewelry bases. If you want to attach heavier watch movements, use craft glue.

10 Attach the clip-on dual magnifier to the single bolt that you added in Step 7. Reattach the head strap.

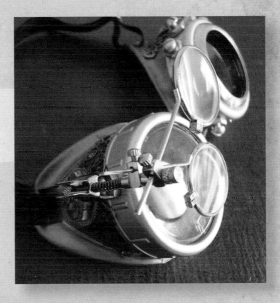

Your Steampunk Goggles are now finished!

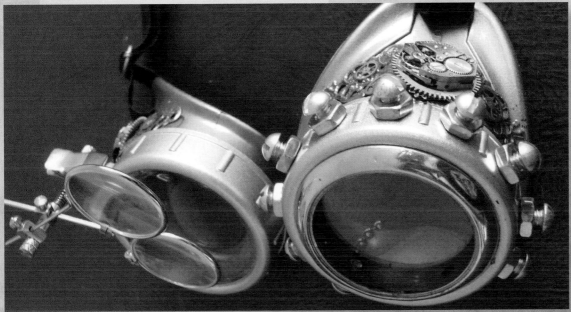

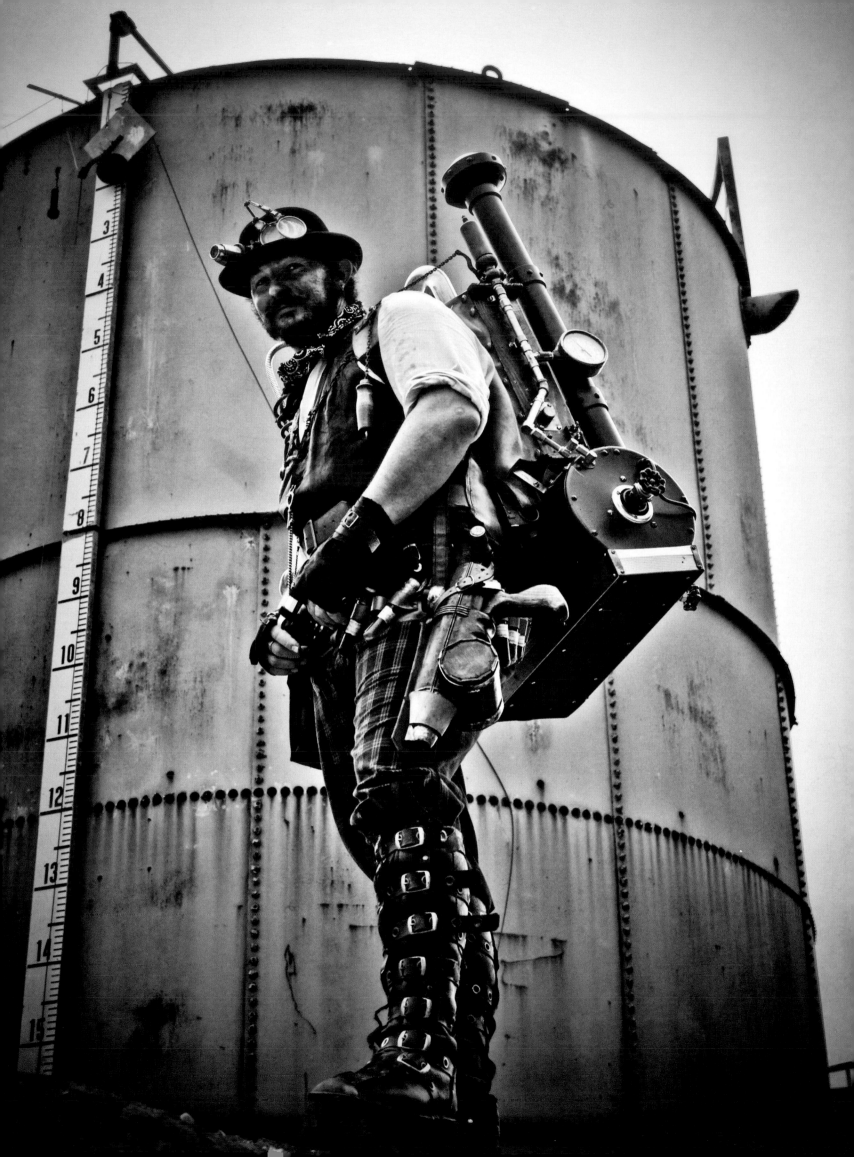

CHAPTER FOUR
WORK GEAR

HIS PHANTOM ERADICATION APPARATUS SHOOTS A BURST OF STEAM, HE SEIZES THE BOTTOM RUNG OF THE IRON LADDER, AND HOISTS HIMSELF UP, COMING TO STAND NEXT TO A DISUSED OIL TANK. THE APPARATUS AT HIS BACK BELCHES LOUDLY, BUT THE SOUND DOES NOT WORRY HIM. HE SURVEYS THE INDUSTRIAL LANDSCAPE. HIS INSTINCTS TELL HIM DANGER IS NEAR. HIS TRAINING IN APPARITION APPREHENSION KEEPS HIM FOCUSED. PREPARED AND WELL OUTFITTED, HE IS SURE TO FLUSH HIS QUARRY. ECTOPLASMIC ENTITIES, BEWARE!

Nick Baumann plays Crackitus Potts, the League of S.T.E.A.M.'s "Non Lethal Weapons Expert." While Potts is often seen armed with a device that shoots a toilet plunger (see page 103), here he's ready to get to work with his steam-powered weapon. Goggles, leather hand wraps, and the many pouches hanging from his belt suggest that he's up for any active job.

Steampunk work gear? Take your steampunk to work? Not exactly, but almost. Many steamsonas are created around professions or are derived from trades. Classic examples drawn from idealized visions of Victorian London include chimney sweeps, shopkeepers, mechanics, railroad personnel, and scientists (including mad ones). We've also heard of steampunk doctors and nurses, seamstresses, cyborgs, and spiritualists.

OPPOSITE PAGE *In addition to his specialized gear, Crackitus Potts wears a bowler, a vest over a white shirt, plaid pants, leather hand wraps, and sturdy custom-made boots with multiple straps.*

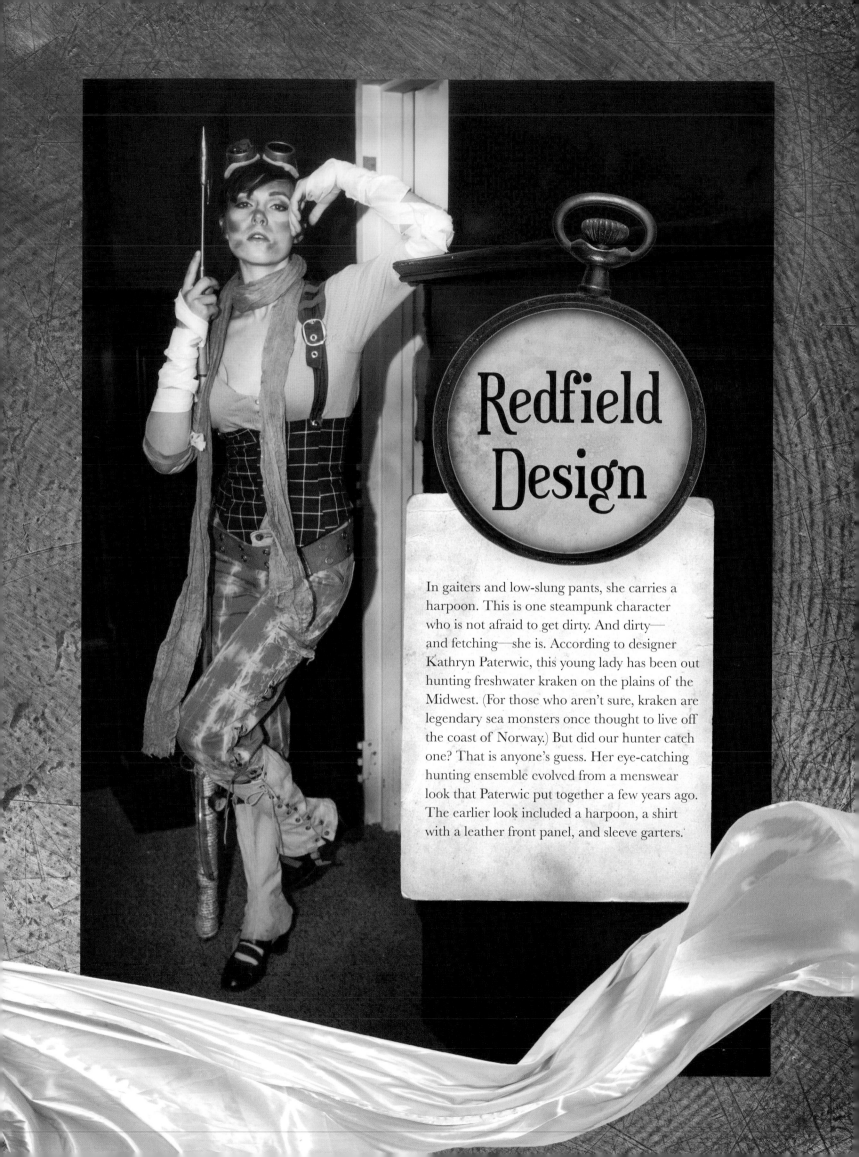

Redfield Design

In gaiters and low-slung pants, she carries a harpoon. This is one steampunk character who is not afraid to get dirty. And dirty— and fetching—she is. According to designer Kathryn Paterwic, this young lady has been out hunting freshwater kraken on the plains of the Midwest. (For those who aren't sure, kraken are legendary sea monsters once thought to live off the coast of Norway.) But did our hunter catch one? That is anyone's guess. Her eye-catching hunting ensemble evolved from a menswear look that Paterwic put together a few years ago. The earlier look included a harpoon, a shirt with a leather front panel, and sleeve garters.

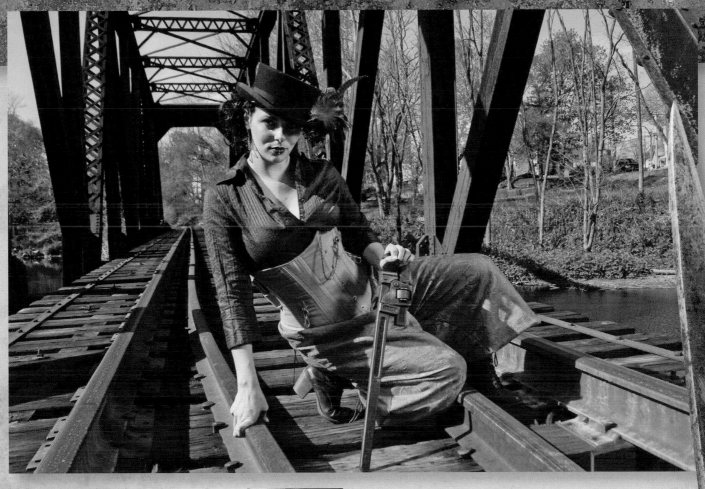

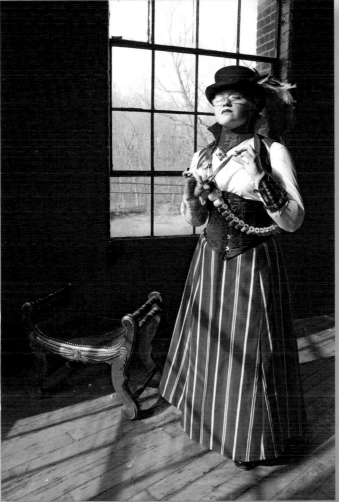

Working on the railroad is tough and gritty, but this young lady pulls it off with cool style. Her wide-legged trousers allow for ease of movement, which is important when dealing with steaming locomotives. Paterwic herself knows a thing or two about steam. Here she is pictured in her steampunk seamstress outfit. Of her ensemble, Paterwic says: "It has changed over the years, and there are many variations. This is the most current."

(For more about Kathryn Paterwic and her label Redfield Design see page 40.)

OPPOSITE PAGE *Kraken hunting can be a dirty job, but a young lady can still look good doing it.*

ABOVE *These versatile Redfield pants bring glamour to any job.*

LEFT *Designer Kathryn Paterwic dressed as a steampunk seamstress.*

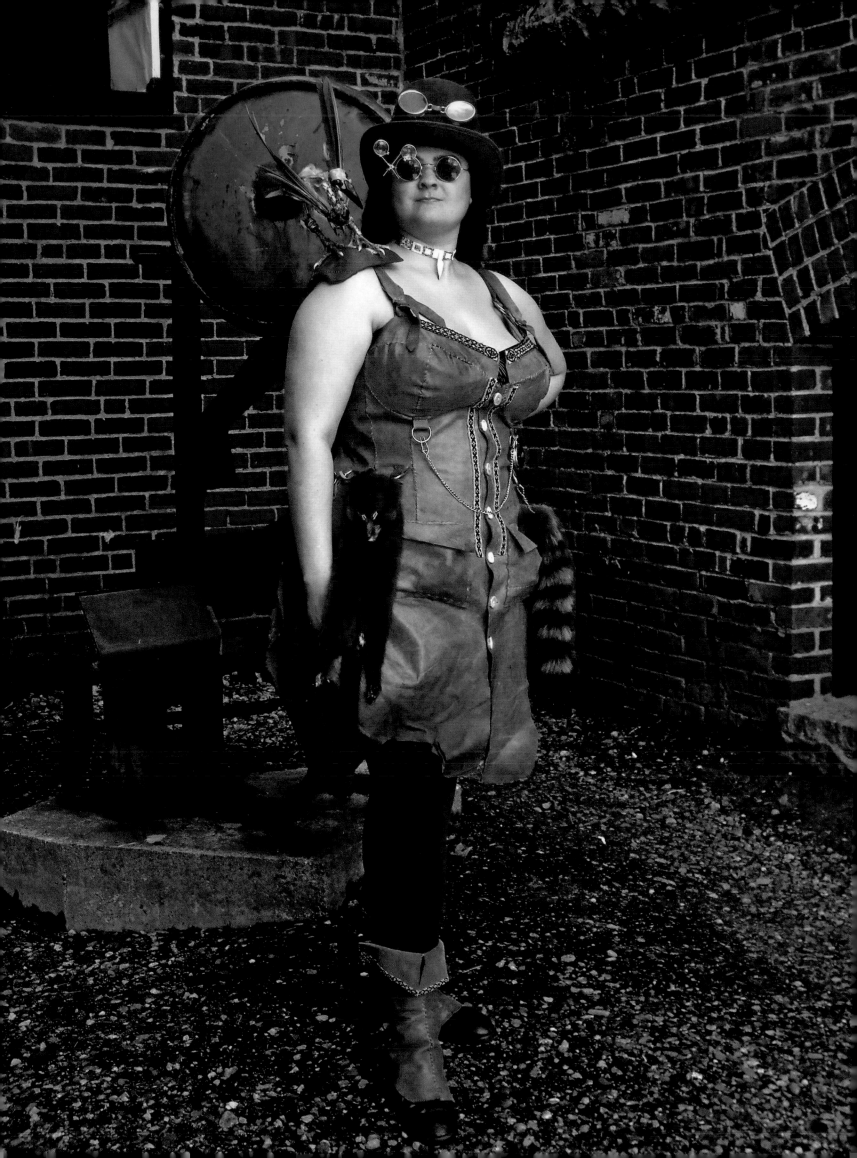

Monique Poirier
Costume Mercenary

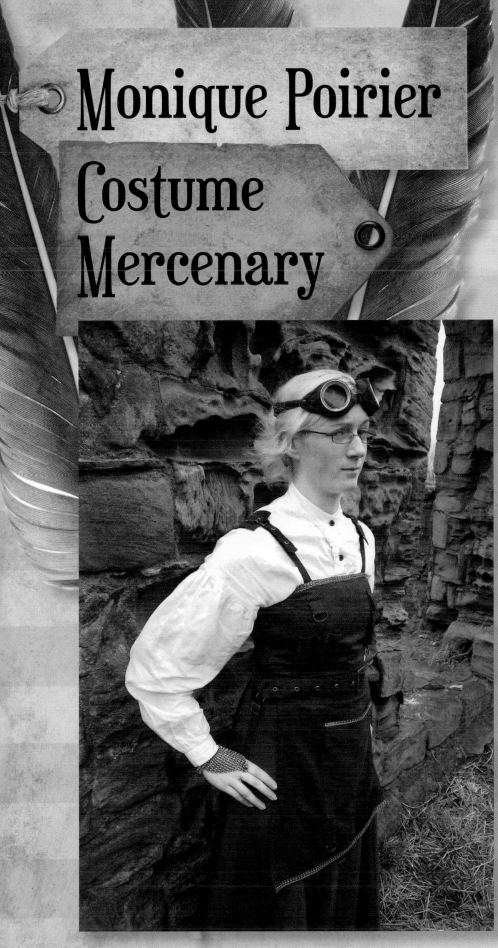

OPPOSITE PAGE *Monique Poirier wears one of her handcrafted Native American steampunk dresses.*

ABOVE *Costume Mercenary's Streampunk Dress seems perfect for girl geniuses everywhere.*

Monique Poirier is a member of the Seaconke Wampanoag Tribe, and she is a steampunk. Her character pictured here is a wise woman and a practitioner of science. Poirier decided that she wanted her character to wear a lot of leather because the Wampanoag people, who were among the first indigenous peoples of the Northeast to encounter Europeans, did not wear cloth prior to European contact. She says, "My choice to wear leather is a direct rejection of the assimilation of European technologies." She crafted the dress, which features hand-stitched and hand-loomed beadwork, including hand-carved wampum pieces, herself. On her right, she wears a weasel-skin medicine pouch; on her left, a raccoon tail.

A mechano-revenant crow perches on Poirier's shoulder. She made this creature from bones, feathers, clay, watch parts, jewelry pieces, wire, and a chemical glow stick. The crow, which is both mechanical and a being returned from the dead, serves as her character's spiritual adviser and as a companion who aids her in her studies. Poirier attends steampunk conventions on the East Coast, where she appears on panels. She has been featured on Jaymee Goh's blog *Silver Goggles* and has guest blogged on Diana M. Pho's *Beyond Victoriana*. Rumor has it that she's working on an idea for a steampunk novel.

Costume Mercenary's Steampunk Dress, crafted from brown faux suede and green wool, is the perfect attire for a lady scientist or inventor. Handy test-tube holders grace the chest. Multiple brass D-rings hang ready to hold keys, flashlights, tools, and gadgets yet to be invented. And of course there are pockets. In the back, a row of straps allow for bustling of the skirt, and the shoulder straps are adjustable. This apron-style dress is worn over a white linen blouse. Bracelets forged from brass chain mail and a pair of goggles round out the inventive look.

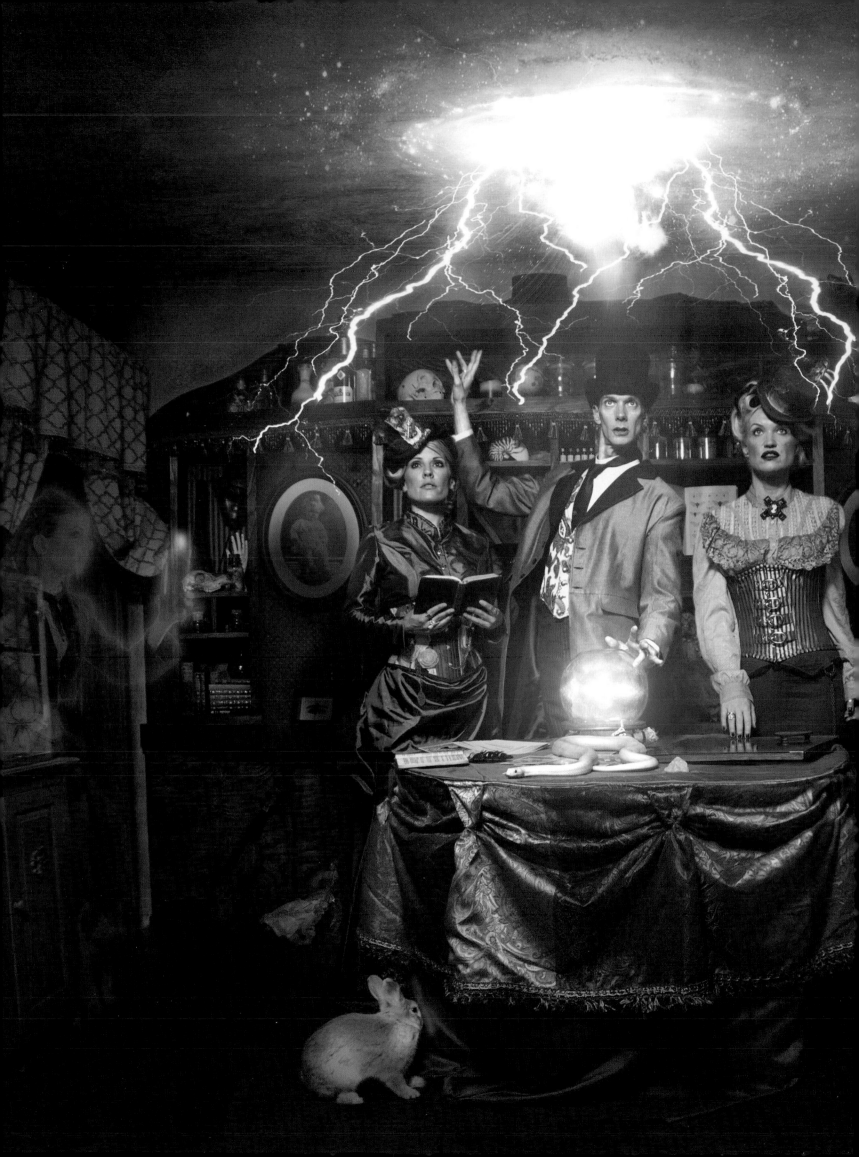

Clockwork Couture

Séances such as this one rose to popularity with the growth of the Spiritualist movement, which many describe as beginning in the late 1840s in New York State. Kate and Margaret Fox, who were twelve and fifteen years old at the time, and their parents had recently moved into a new home. The house had a reputation of being haunted. Soon the girls began to hear rapping noises. They quickly learned to control the sounds and soon persuaded their family and neighbors that they were communicating with a spirit. They gained followers, many of whom were involved in the era's reform movements—fighting against slavery and for women's rights. By the 1850s, the Fox sisters were famous for their séances. Soon hundreds of people began to imitate them and claim otherworldly communicative powers.

Actor Emma Caulfield, who is probably best known for her role as Anya Jenkins on the television series *Buffy the Vampire Slayer*, wears the tight-lacing Winter Blooms Corset created by Clockwork Couture's corsettiere over her taffeta dress. Doug Jones, another *Buffy* actor, who played in the 2004 *Hellboy* and was the faun in *Pan's Labyrinth* (2006), is dapper in a frock coat and brocade vest. Camilla Rantsen, a writer and producer on the 2004 film *Bandwagon*, which stars Caulfield, and on the television series of the same name, is decked out in neo-Victorian style. Her lace-festooned blouse is crafted from practical and washable polyester.

This successful séance appears to have raised a few spirits. But what are the dead wearing?

Tom Banwell SkinzNhydez

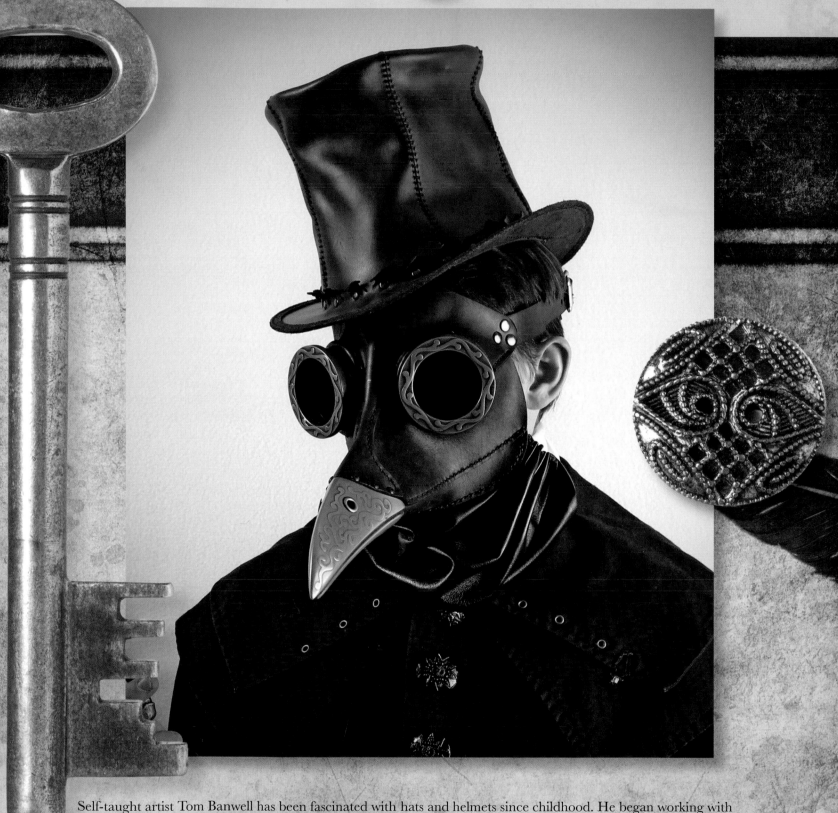

Self-taught artist Tom Banwell has been fascinated with hats and helmets since childhood. He began working with leather in 1972. After years of making belts, purses, and sandals, he started his own business designing and fabricating Western leather hats. He then learned to cast in resin and, since 2008, has been creating leather masks, some of which incorporate resin components. Banwell's steampunk work has been featured in a number of books and magazines and in three different museum exhibitions, including a historic show at Museum of the History of Science at Oxford.

Here a plague doctor approaches in his black hat and long coat. His breath whistles through the nostril holes of his mask. He raises his staff and pokes a prone victim, urging the diseased being to turn over. Based on an historic design, this black leather plague doctor's mask features a metal tipped beak. Both the beak and eyepieces are cast from aluminum and polished to bring out the embossed decorations. The mask's lenses allow the wearer to see out, but no one can see in. Soft lambskin covers the mask wearer's neck and chin, adding to the spooky fully-covered effect.

Ian Finch-Field of SkinzNhydez, who made the armor seen on page 132, designed and produced this plague nurse's mask for a rather different effect. The mask is handcrafted from vegetable tanned leather. Rivets adorn the beak, and eyelashes curl endearingly above each wide cut eye. The mask fastens with buckles and an embossed adjustable strap. Whatever will the Red Cross say?

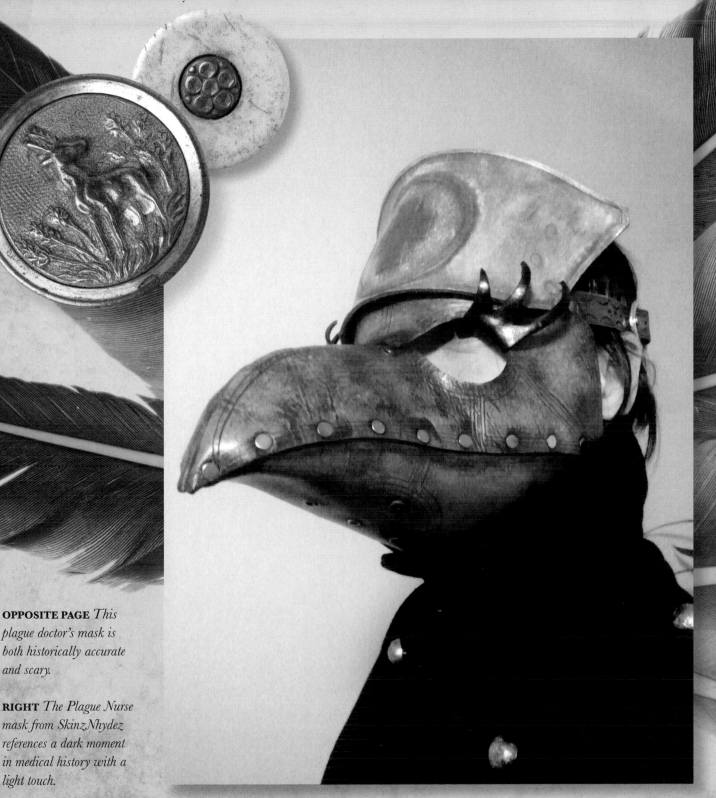

OPPOSITE PAGE *This plague doctor's mask is both historically accurate and scary.*

RIGHT *The Plague Nurse mask from SkinzNhydez references a dark moment in medical history with a light touch.*

Tom Keeler

Even cyborgs have jobs. This steamborg, the creation of New Hampshire–based Tom Keeler, has quite a backstory. In Keeler's invented history, his steamborg was originally created as a weapon in a shadow war between science and engineering geniuses with the express purpose of destroying the inventor Nikola Tesla. Tesla's secret daughter Nicole, a genius in her own right, discovered the killer cyborg and disabled it. She then installed her own newly designed analytical engine in its mind. With its new "brain," the steamborg became capable of "fuzzy logic" and abandoned the binary thinking that had guided it in the past. As a result, the steamborg was no longer compelled to fulfill its murderous mission, and set out to undermine the science shadow war on its own terms.

Keeler's steamborg look is made up of many parts. At base are items purchased from from a variety of specialty clothing shops that deal in antiquated designs. The spats were obtained from an army surplus store. Keeler converted a leather trench coat into his thigh-length jacket. He decorated a plain top hat with German driving goggles, laboratory clamps, a jeweler's loupe, and a clock face. Keeler's right arm is entirely handmade from metal and PVC pipes and is based on a design from Thomas Willeford's book *Steampunk, Gears, Gadgets, and Gizmos.* Keeler added a rotating mechanism so that the lethal right "hand" of his cyborg turns. All the better to shoot you with! Just under Keeler's chin, a Franklinian cardiomatic dynameter—in other words, a steamborg heart—beats. This gadget was designed by Keeler and fabricated from odds and ends. At the center, a plasma disk illuminates with lightning-style arcs when exposed to sound. Keeler designed his left arm himself and fabricated it from thrift store and flea market finds. The claw opens and closes thanks to a spring-loaded tripod system.

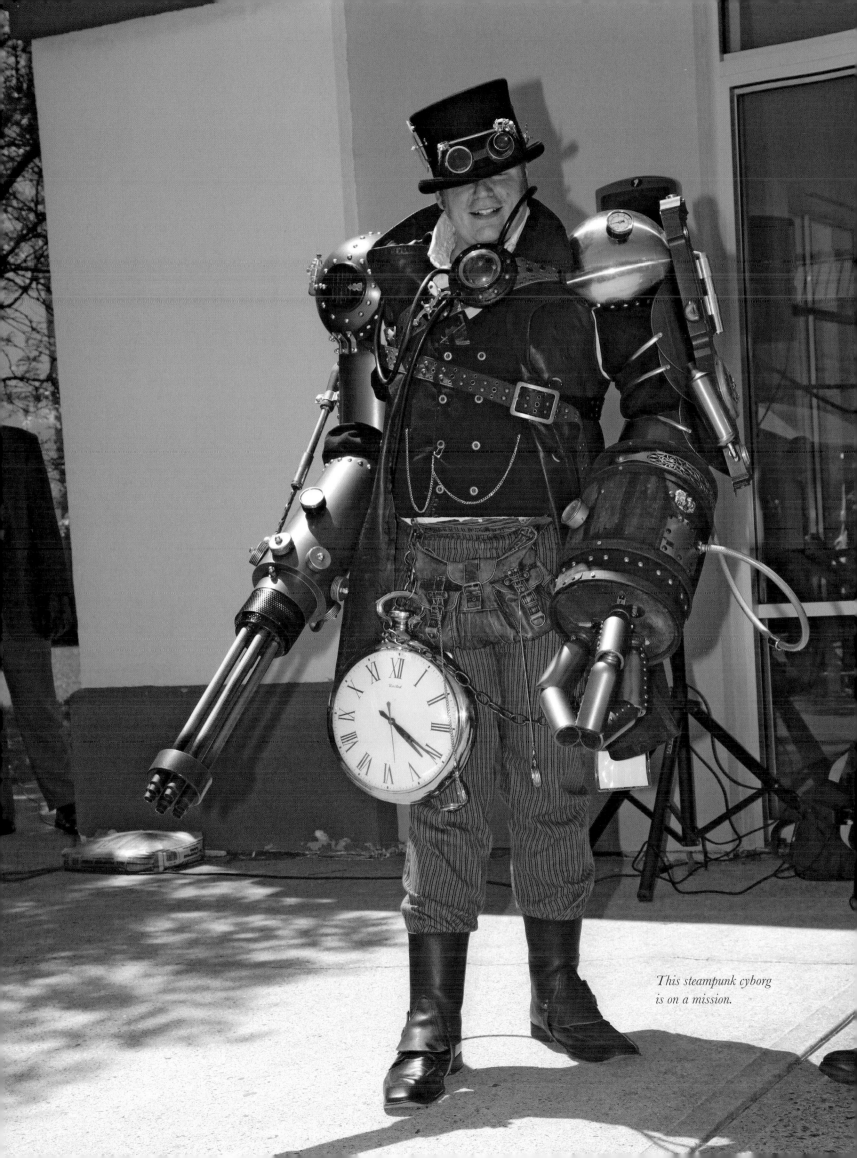

This steampunk cyborg is on a mission.

Steampunk Emma Goldman

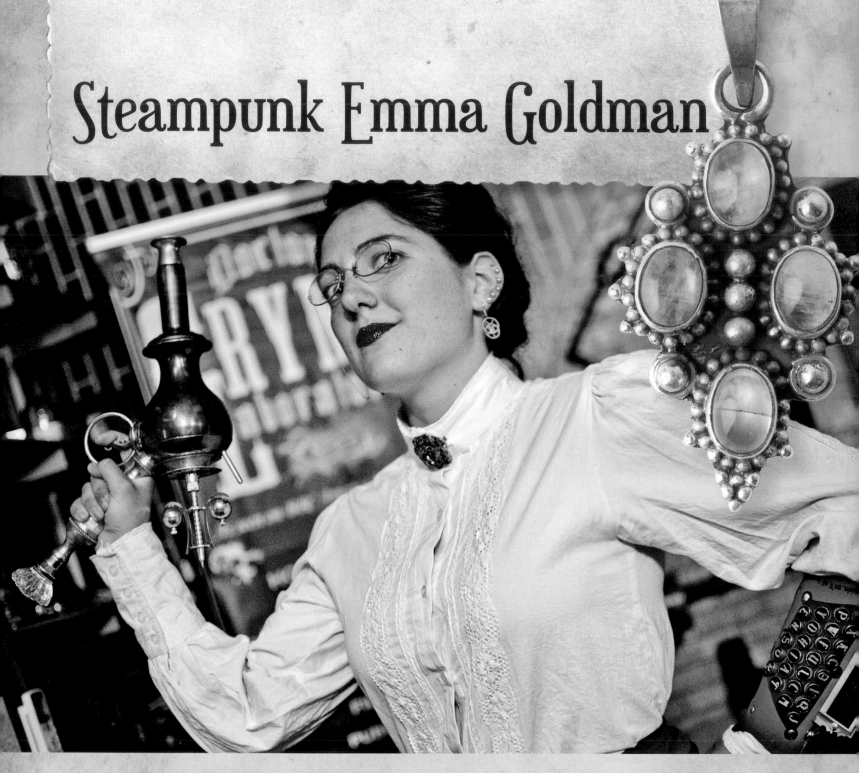

Here Steampunk Emma Goldman is armed with a retro-futuristic device.

Steampunk Emma Goldman, a character embodied by Miriam Rosenberg Roček, is a time-traveling, alternate history version of the historical anarchist Emma Goldman. As her character, Roček runs discussions at steampunk conventions and stages protest-style performances. (See page 109.) She also maintains a Facebook page and a blog where she writes about nineteenth-century events and individuals who should be more widely known today. In all her work, she links history to what is happening today. A Free Oscar Wilde rally began with a discussion of the suppression of sexual minorities in the nineteenth century and turned to a present day case of a transwoman who had recently been imprisoned for defending herself from a hate crime. "It's important for us to recognize that the issues we all face today have long histories, and that the battles that were fought in the past are not over," she says.

Roček feels that steampunks, who typically are interested in learning about the past and speculating about the future, are in a perfect position to talk about politics. Furthermore, Emma Goldman, because she was ahead of her time on so many issues, is the perfect time-traveler with whom to have those discussions. Her Streampunk Emma Goldman outfit is based on images of the young Goldman, including her mugshots and caricatures in political cartoons. Her glasses, the signature pince-nez, are iconic, typically allowing people to recognize the character right away. She calls her arm guard, which serves as her time-travel device, the Means of Production.

From politics to hunting, medicine and science to the world of the spirit, steampunk personas often have jobs to do and outfits that go along with their chosen métiers. Next get ready for some work-ready DIY projects: Learn to make sleeve garters and suspenders.

TOP, LEFT *Miriam Rosenberg Roček poses as Steampunk Emma Goldman in her signature pince-nez and glitter lipstick.*

TOP, RIGHT *Here Steampunk Emma Goldman is armed with a retro-futuristic device.*

ABOVE *When Steampunk Emma Goldman pushes the red button, something big is bound to happen.*

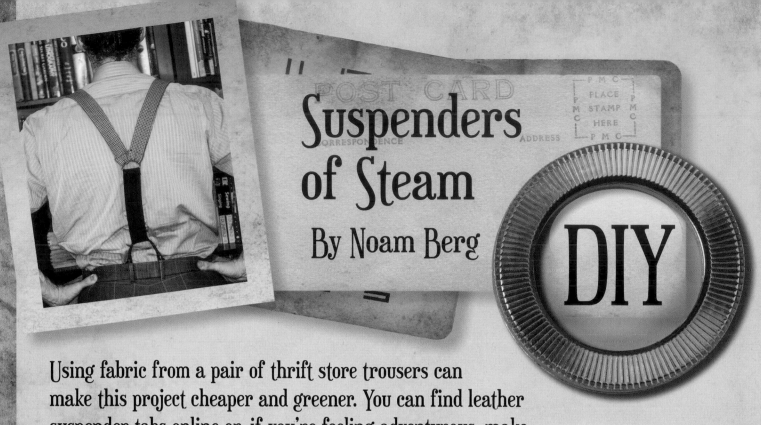

Suspenders of Steam

By Noam Berg

DIY

Using fabric from a pair of thrift store trousers can make this project cheaper and greener. You can find leather suspender tabs online or, if you're feeling adventurous, make your own out of scrap leather.

You Will Need:

Measuring stick and ruler
Sewing marker
½ yard of lightweight or medium non-fusible interfacing
½ yard of fabric
An iron
Pins
Needle or sewing machine
Thread
Scissors
Chopstick or knitting needle
Two buttons
A toothpick
7" of elastic, 1½" wide
Leather suspender tabs
Metal D-ring, at least 1½" wide on the flat side to accommodate the elastic

1 To figure out the length of your suspender straps, take a measurement from the center point between your shoulder blades, over the shoulder, down to the waist of your pants, and then halfway back up your chest. This will be much easier if you get a friend to help you!

2 On the interfacing, mark out two strips that are the length you found in Step 1 and 1½" wide. Leave the short ends open for now. You will draw them in the next steps.

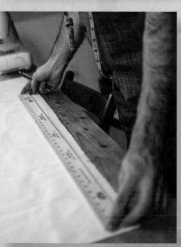
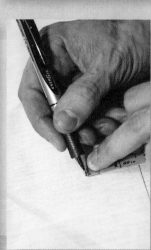

3 Complete one end of each strap with a straight line. Make the other end rounded or arc-shaped.

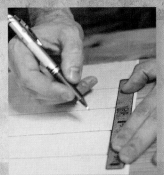 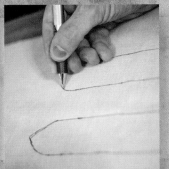

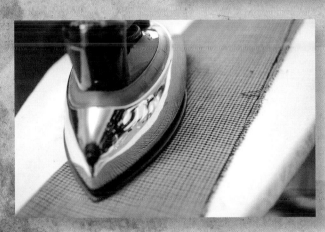

4 Fold your fabric in half. If it has a pattern, make sure the pattern on the top half is lining up with the pattern on the bottom half. If your fabric has a "wrong" side, make sure that the wrong side is facing out. Then press the fabric.

5 Position the interfacing on top of the fabric. Pin it in place. You now have a triple layer of material—interfacing on top and then two layers of fabric underneath it.

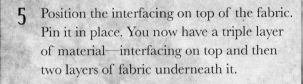 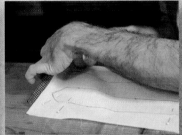

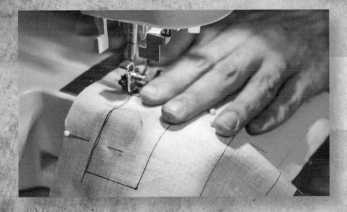

6 Sew along the lines marked on the interfacing, leaving the square ends of each strap open.

7 Once you're done sewing, carefully cut out the straps, leaving a ⅜"–¼" seam allowance.

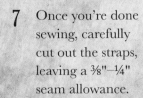 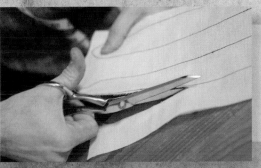 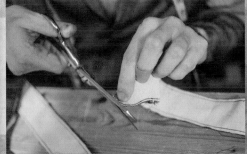

8 Now you are going to invert the three layers of the straps so that the interfacing is on the inside and the fabric is on the outside. To do this, work from the open square end. Go between the two layers of fabric and turn the straps inside out. Use a chopstick or knitting needle to push the material through, being careful not to tear it. Then press the straps flat.

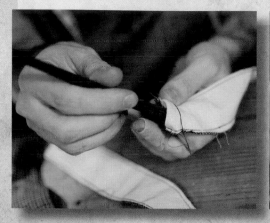
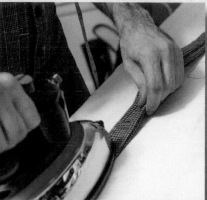
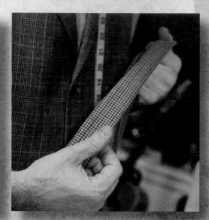

9 Sew a button on the closed end of each strap, as shown. To prevent the button from resting too tightly against the fabric, slip a toothpick under it while you sew. Note that the side of the strap with a button will be on the inside of your suspenders.

10 Using the buttonhole foot on the sewing machine, make a buttonhole in each strap 5" from the button.

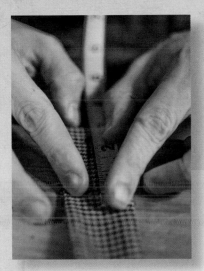

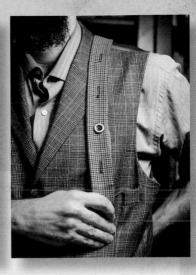

11 So that your suspenders will be adjustable, you are now going to make a series of buttonholes at 2"
 intervals. Seven to eight buttonholes should suffice, but make as many, or as few, as you like.

12 Get your D-ring and turn your attention to the open ends of the straps. Tuck the unfinished edges in.
 Then wrap one end around the curve of the D-ring. Pin the strap to itself ½" beyond the ring. Make
 sure that the overlapping edge of the fabric is resting against the button-side of the strap.

13 Sew across the strap to secure the D-ring. Then wrap and pin the second strap to the curve of the D-ring.
 Before you sew, make sure that the button and the overlapping edge of each strap are facing the same way.

14 Hold the D-ring with the inside of the straps facing down. Thread the end of the elastic through the D-ring and fold the end under, as shown.

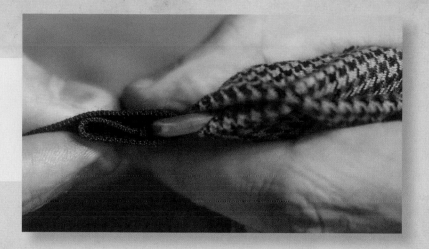

15 Pin the elastic around the D-ring with ½" overlap. Make sure that the overlap is facing the same way as the overlap on the straps. Then sew the elastic in place. Elastic can be problematic when using a sewing machine, so you may want to do this part by hand.

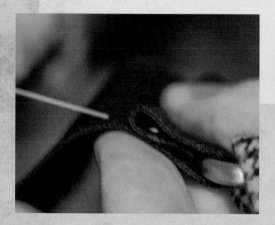
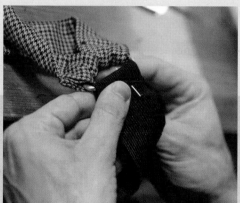
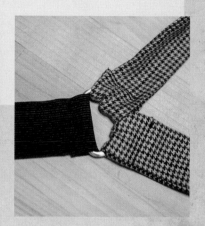

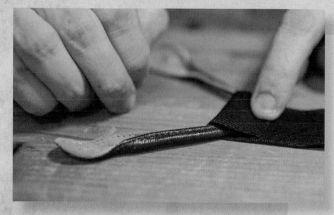

16 Take one of the leather suspender tabs, and fold the free end of the elastic over it. Make sure you have folded to the inside. Pin the elastic and sew it in place.

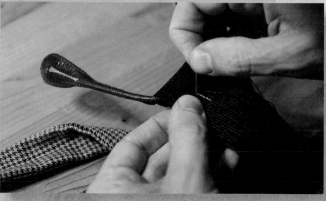
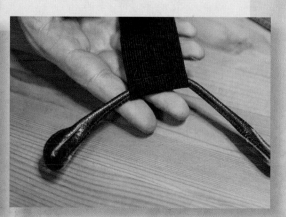

17 To finish off, fasten the buttons into the middle buttonhole on each strap. Fit a leather button tab through each of the resulting loops. Wear them with your favorite trousers.

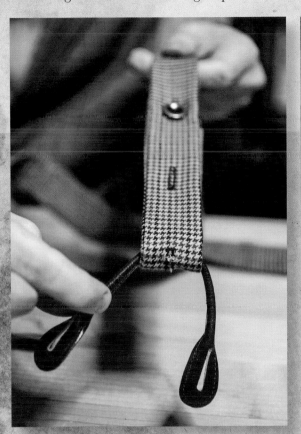

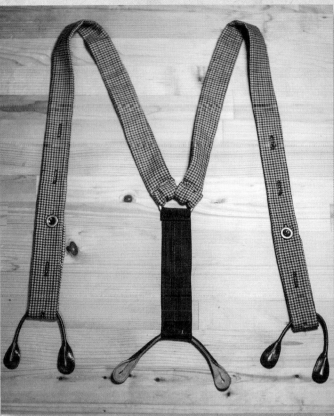

The finished suspenders!

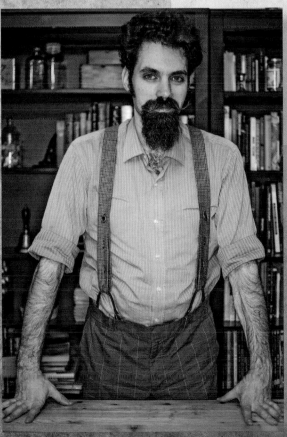

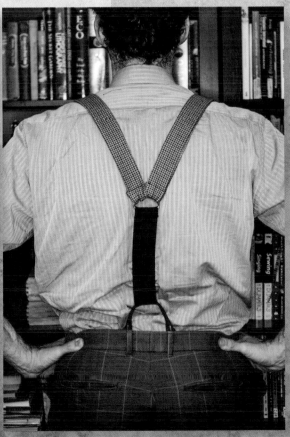

Sleeve Garters

By Noam Berg

DIY

Sleeve garters keep sleeves that are too long out of your way. They also look cool against the fabric of your shirt. Metal slides, which are also referred to as strap adjusters, can be found online. You'll want to make sure the width of your slides is just wide enough for the ribbon to fit through snugly. Of course, you can make a garter for your leg in the same way.

You Will Need:

Measuring tape
Pen and paper
1 yard grosgrain ribbon
Scissors
4 metal slides
Pins
Thread
Needle

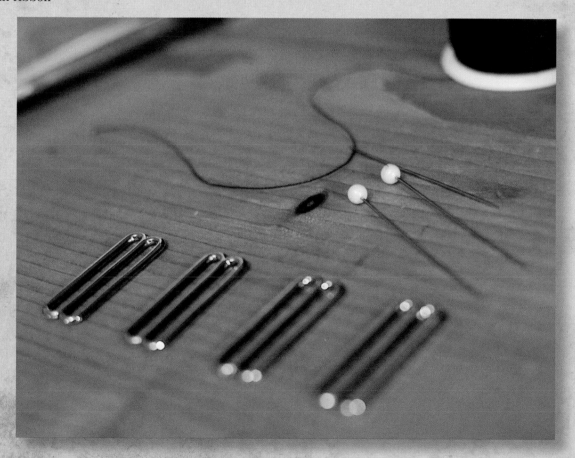

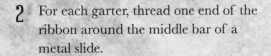

1 Measure around your arm where you want to wear the garter. Write down the figure for the full circumference of your arm. Then add half of that number. (For example, if your arm measures 11" around, add 5½" for a subtotal of 16½".) Then add 2" more for seams, and get your total measurement. Cut two lengths of ribbon the same size as your total measurement.

2 For each garter, thread one end of the ribbon around the middle bar of a metal slide.

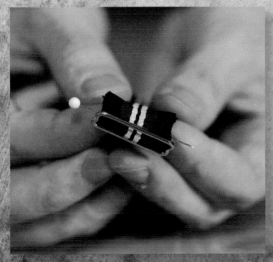

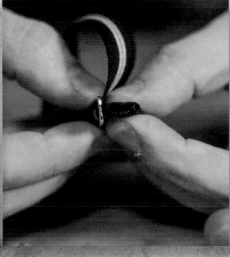

3 Fold ½" of the end of the ribbon over on itself, then fold over once more, as shown. Pin the folded end to the rest of the ribbon so that the ribbon forms a loop over the bar.

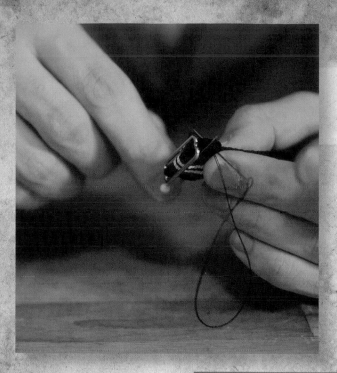

4 Sew the ribbon in place by stitching across it, near the far edge of the fold, away from the metal bar.

5 Thread the ribbon through a second metal slide.

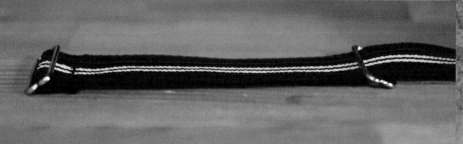

6 Bring the ribbon back and thread it through the top loop of the first slide, as shown.

7 Weave the ribbon through the other side of this slide. Then complete the circle back to the other side of the second slide and thread the end of the ribbon through. Note: It's easiest to do this while rotating the figure in your hands.

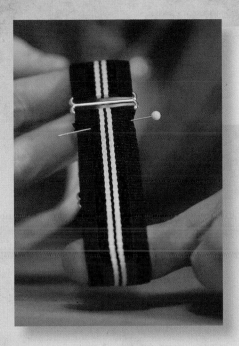

8 Just like you did in Step 3, fold ½" of the end of the ribbon over on itself, then fold over once more, so the fold is flush with the edge of the metal slide. Pin the ribbon together.

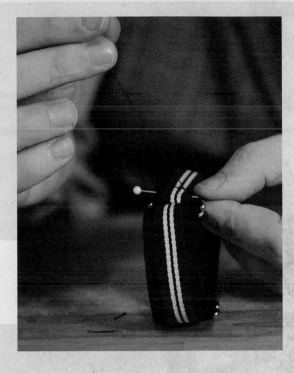

9 Stitch over the end of the ribbon to hold the metal slide in place.

10 You're done!

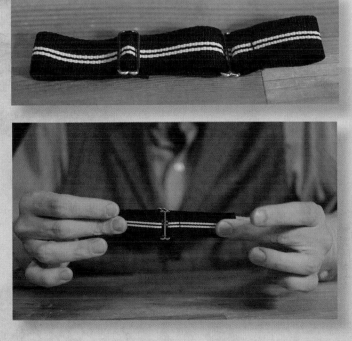

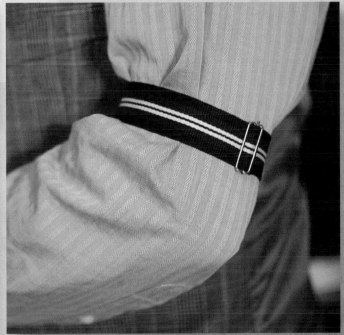

CHAPTER FIVE
STREET STYLE

HE PLAYS HIS OLD-STYLE ACCORDION IN FRONT OF ROCK FORMATIONS. OR IS THE BLEAK LANDSCAPE BEHIND HIM STEEL? PERHAPS HE IS THE SOLE SURVIVOR OF A HIGH-TECH DISASTER. THE NOTES OF HIS SONG RISE UP, BOTH HAUNTING AND INVITING. HIS TUNE DRAWS THE REMAINING MEMBERS OF HIS TRIBE OUT OF HIDING. THEY MOVE TOWARD HIM, SLOWLY AT FIRST, AND THEN WITH GATHERING SPEED. HE PLAYS ON, TILL A SMALL CROWD HAS GATHERED AT HIS FEET.

In real life, Margaret "Magpie" Killjoy is pictured here playing his accordion in front of a sculpture that stands before a hotel. Killjoy, who describes himself as an itinerant creator, an anarchist, and activist, is also a photographer who has worked in tintype, among other processes, and a member of the collective that publishes Combustion Books. In 2006, he started *SteamPunk Magazine*, one of the goals of which is to get steampunk culture offline and into the physical world. Killjoy is also a man who uses a woman's name. On Wren Awry's blog *The Seams & The Story*, Killjoy explains that he took the name Magpie when he was participating in forest defense in the Pacific Northwest because, like the bird, he collected shiny objects. Then, because Magpie can be a nickname for Margaret, people started calling him Margaret. He enjoys that his use of Margaret creates more gender ambiguity in the world.

Rather than dressing up as one might for the stage, Killjoy's clothing reflects the casual cool of the street. In addition to a Pinkerton vest from Lastwear (see page 196), Killjoy is wearing a shirt that a friend picked up from a "free box" in a punk house. His skirt was a gift from a friend who obtained the garment at a clothing swap. His pocket belt was made by yet another friend who cut the pockets and top off a pair of wool pants. And the accordion, which is probably from the 1940s, came from a thrift store. In contrast to steampunk's more costume-like outfits, steampunk street style encompasses looks that one could wear every day. Some say this is where one finds the "punk" in steampunk. That said, steampunk street style has quite a range, from punk to casual glamour to vintage-inspired looks with quite a few stops in between.

OPPOSITE PAGE *This version of street style has a punk feel with vintage influences.*

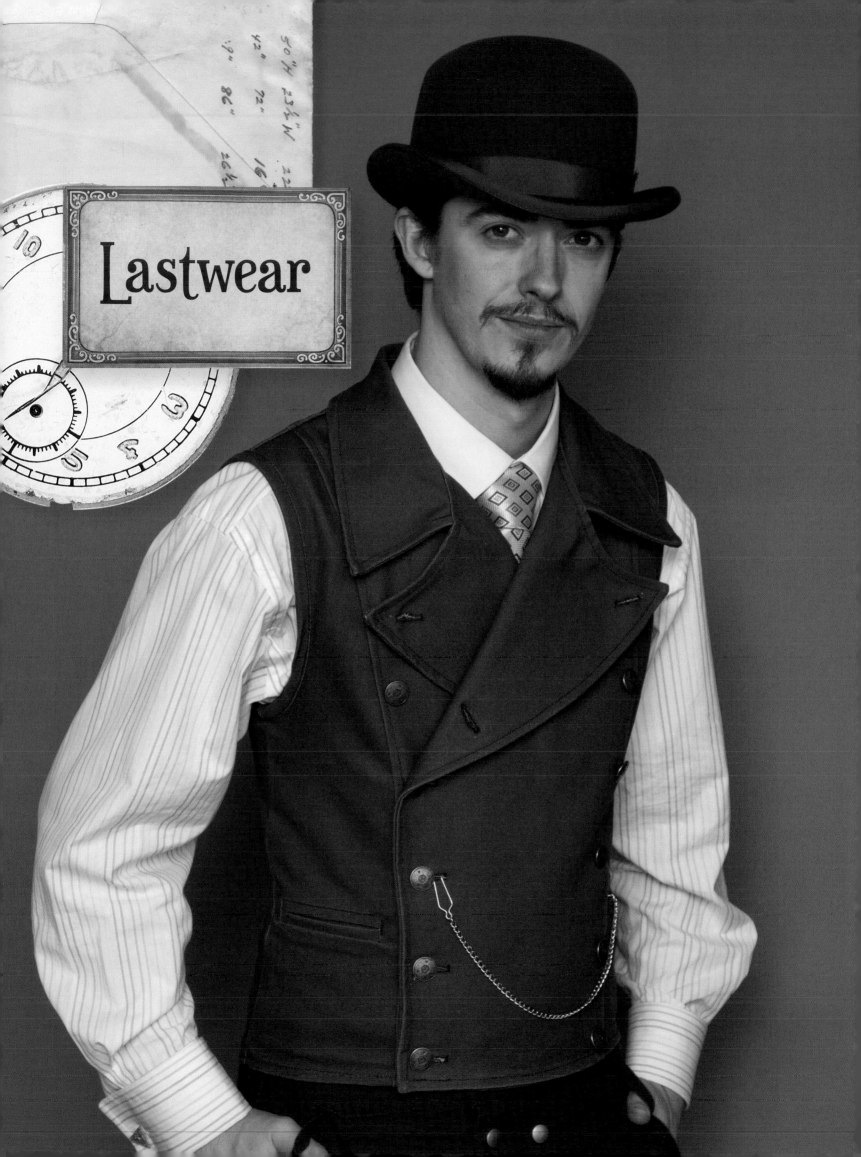

Lastwear

Founded in 2007, Lastwear, based in Seattle WA, designs "clothes for Steampunks, Time Travelers, Post Apocalyptic Nomads, and misfits of all stripes." Lastwear's clothes and name reflect the belief that it's better to buy quality once than throw it away a hundred times. In other words, the company's products are built to last. Initially, the Lastwear team posted all of their patterns online and allowed anyone to download them for free. They liked the idea of open information and felt confident that any sales lost due to people creating garments from their patterns would be balanced by the increased exposure. In practice, they found that converting the files to an Internet-ready format and uploading them was too time consuming, and they discontinued the practice in the spring of 2012. In addition to being featured in *The Steampunk Bible*, the Lastwear team has won Active Entertainment's Designer of the Year award.

In a bowler, double-breasted canvas vest, and pants with a long fly front, this gentleman time traveler would look dashing on the streets of today, yesterday, or tomorrow. He's dressed in Lastwear's Pinkerton Vest, which has been constructed from a cotton canvas shell with a lining of cotton shirting. This vest features double-welted side pockets and true double-breasted styling. The trousers are Cargo Steeplejacks. They have fitted calves, generous cargo pockets, and a fly that fastens with ten snaps. The Tanner Cap, a classic that looks good on everyone, is essential headgear for anyone battling air pirates, zombies, wind, rain, or even sun.

OPPOSITE PAGE *His outfit has an old-time feel and yet is contemporary.*

THIS PAGE *Everyone needs a hat, and the Tanner Cap works on anyone.*

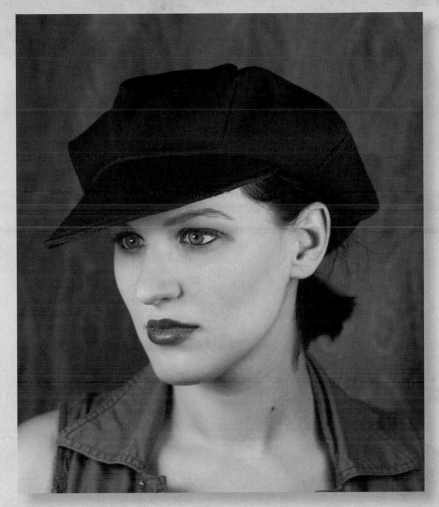

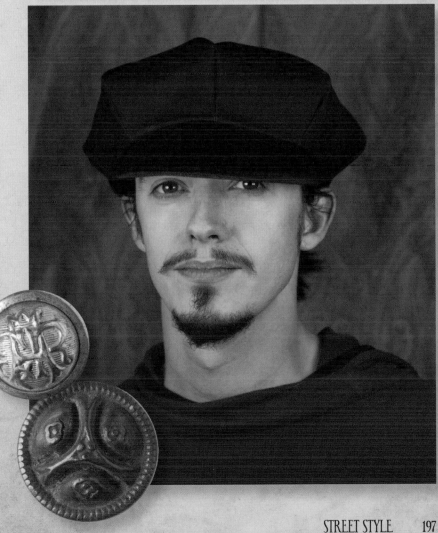

While Karen von Oppen received formal training as an artist, she is mostly self taught as a designer of clothing. A thorough grounding in human anatomy has aided her in her chosen profession. She feels that creating fashions is really most closely related to sculpting, especially when it comes to corsetry. Von Oppen learned her craft by working for other designers, examining commercial patterns, and studying books and periodicals. She also engaged in a fair amount of trial and error—some of which turned into happy accidents. Steampunks, goths, fetishists, rockers, and beauty queens have been buying her alternative fashions, fantasy couture, and unique corsets for more than twenty years.

The images here conjure the clang of a locomotive pulling into a station. The screech—steel on steel—as the train comes to a stop. A cloud of steam covers the platform. Then a woman appears, her hair loose about her shoulders. Despite her long journey, she looks fresh and ready to go in her black velveteen jacket with brass buttons and chain details. Under her jacket is a striped brocade waist cincher. Perhaps the comfort of her bloomer-length traveling knickers has helped insulate her from the stresses of the train. As she approaches, another lady emerges from the steam. She wears an overbust corset of gold and black brocade with lattice trim. Her neck is encircled with a lace ruff that features a central cameo. Her long skirt is lined with satin and tiered with lace. A third lovely lass strides through the mists. She's dressed in leather pants, a hand-painted corset, and a white linen shirt.

KvO Design

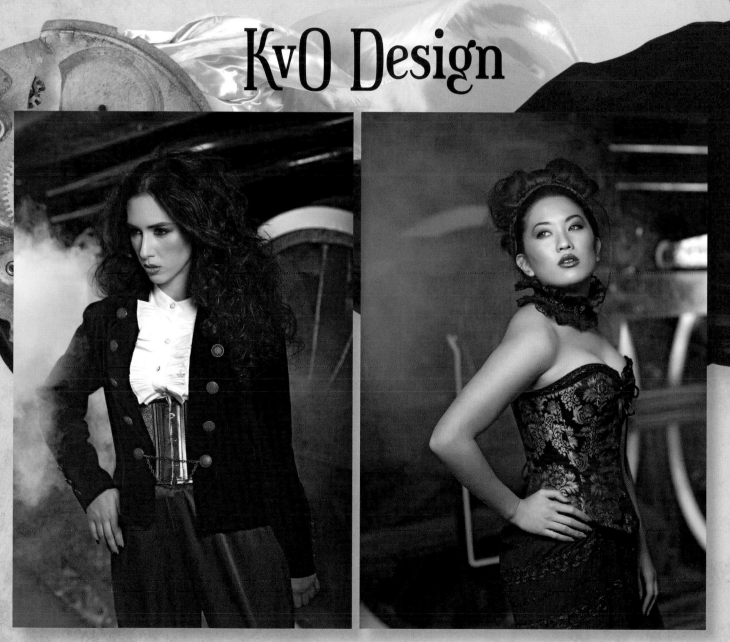

This travel ensemble includes a black velveteen jacket, a waist cincher, and a pair of knickers.

In an overbust corset and neck ruff, this model exudes glamour and romance.

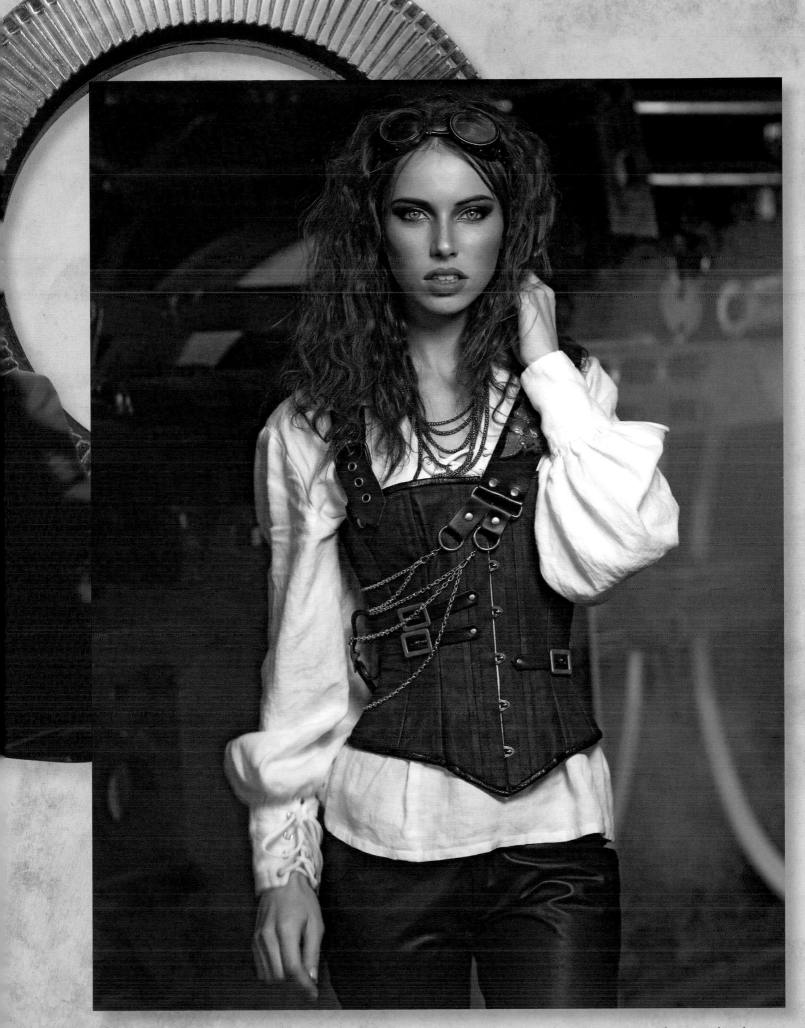

With goggles on top of her head and a decorative bandolier across her chest, this lady brings the adventurous nature of steampunk to the streets.

DASOWL

This jacket from DASOWL lends the man on the street a sense of casual elegance.

DASOWL is a San Francisco–based design team, consisting of Deborah Sciales and Oliver Lowe. They create their own brand of "mad" fashion, often employing discontinued and salvaged fabrics. Sciales, who has a background as an artist and graphic designer, founded her own company in 1997. She became increasingly "intrigued with the celebratory reintegration of fashion from bygone eras." She has worked as a costume and set designer for diverse clients—from local theatrical productions in the San Francisco Bay Area to the Bindlestiff Family Circus, from a Burning Man–inspired rock opera to the band The String Cheese Incident.

Gents on the street can look snazzy, too. This upcycled navy blue pinstriped jacket from DASOWL is eco-friendly, and it stands out with piping along the bottom edge and fancy lapels, cuffs, and back panels of silk brocade. Antique brass buttons add extra charm. In upcycling, one takes things that are being discarded and creates something new and better from them. Creating innovative fashions from already existing items of clothing reduces waste and cuts down on the consumption of new raw materials. Plus it looks really cool.

This upcycled women's jacket, fabricated from blue pinstripe material with tapestry applique, feels both contemporary and retro at the same time. The jacket's lapels, pockets, and large cuffs sport a contrasting maroon fabric. Two maroon panels—one at the waist and one at the shoulder blades—accent the back as well. Antique brass buttons finish off the look.

The Outer Great Vest, said to be based on a pattern from the 1890s, features dramatically large lapels and long tails. This versatile garment emphasizes the waist. Thrown over a pair of pants or a skirt, it can raise the style quotient of any outfit. Here it is crafted from an apricot floral pattern. Antique brass buttons close the vest at the waist. Unique without crossing into weird, this is another retro-futuristic creation that can happily travel the streets of today or yesterday or a week from Thursday or

Sciales currently serves as a costumer for the crew of the Neverwas Haul, a three-story self-propelled Victorian house on wheels that seems a bit like a mash-up of a trolley with a steamship and a house. The moving house has appeared at the Burning Man festival, at Maker Faire in the Bay Area, and has been featured in the book *Vintage Tomorrows*.

TOP *In an upcycled jacket with a touch of elegance, this model's mood seems playful.*

BOTTOM *This long vest highlights the waist and adds retro charm to a pair of pants and a shirt.*

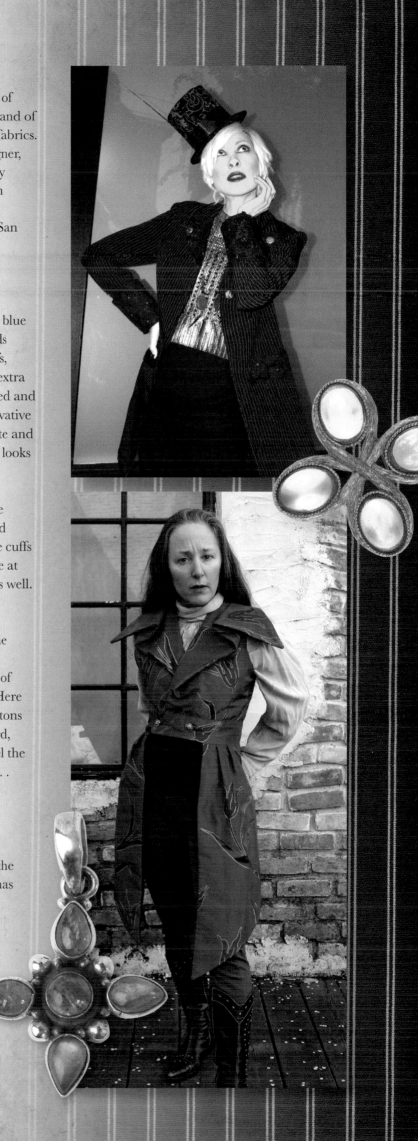

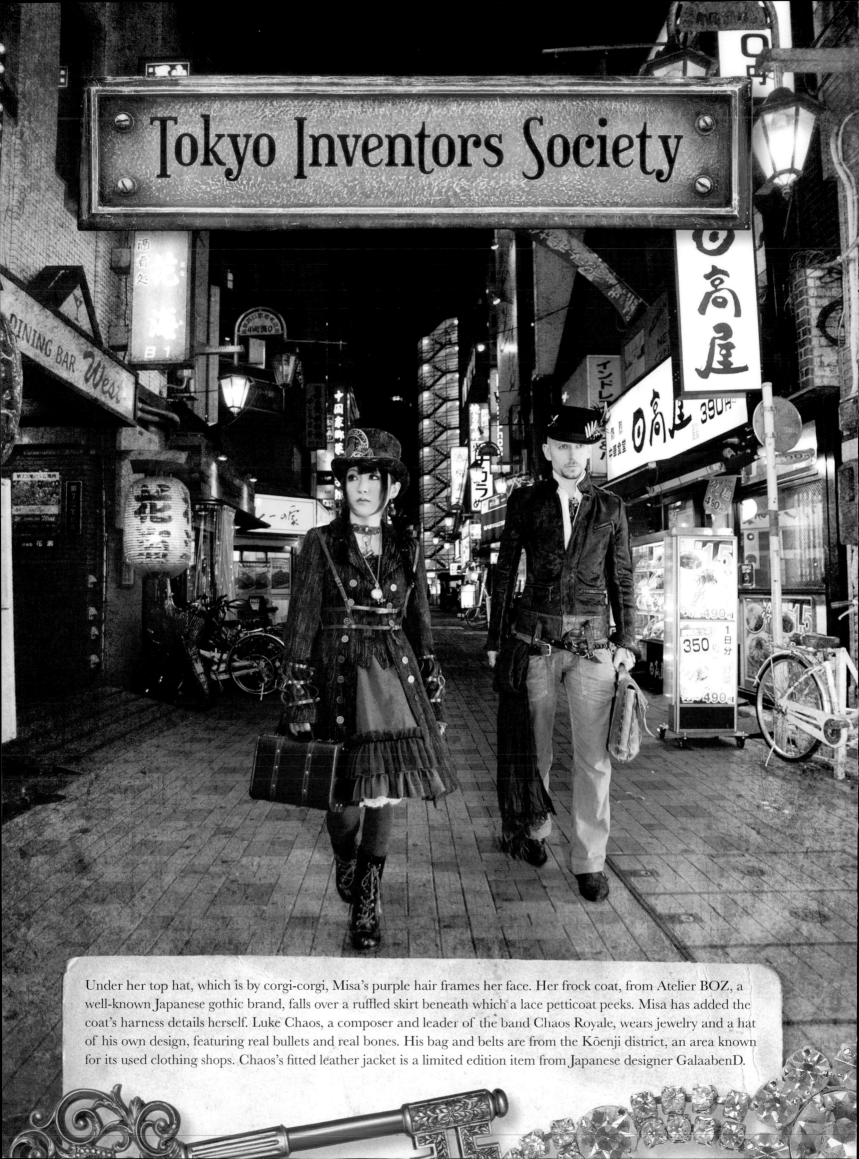

Tokyo Inventors Society

Under her top hat, which is by corgi-corgi, Misa's purple hair frames her face. Her frock coat, from Atelier BOZ, a well-known Japanese gothic brand, falls over a ruffled skirt beneath which a lace petticoat peeks. Misa has added the coat's harness details herself. Luke Chaos, a composer and leader of the band Chaos Royale, wears jewelry and a hat of his own design, featuring real bullets and real bones. His bag and belts are from the Kōenji district, an area known for its used clothing shops. Chaos's fitted leather jacket is a limited edition item from Japanese designer GalaabenD.

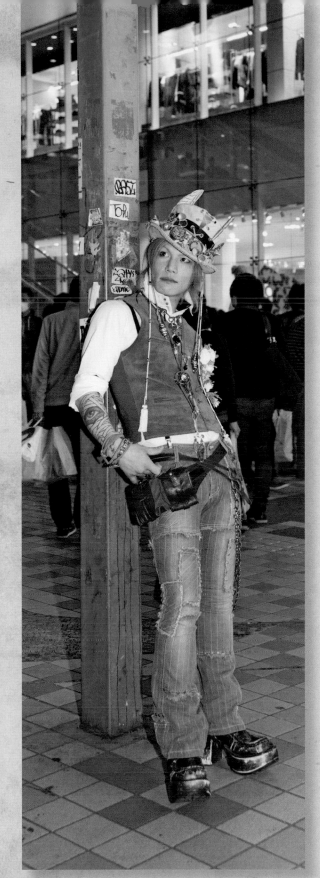

Kenny Creation, the vocalist of the industrial rock band I'm Still in the Haze, surveys the street. Creation's ensemble is a mix of items he made himself, vintage finds, and online deals. His hat is original to him, as are his accessories. In crafting these pieces, he incorporated two of his hobbies by reusing absinthe accoutrements and parts of hookahs. In the Shinjuku neighborhood of Tokyo, Kaori Kawabuchi browses in the shop A Story, which specializes in handmade watches and accessories. She's dressed in a contemporary version of the Taisho Roman style, a romantic look from the early twentieth century that features colorful kimono and elements of western fashions. Kawabuchi's hat, by Yako, is available at Abilletage, another Tokyo shop just downstairs from A Story. Her accessories are by Galucktone, a brand carried by A Story.

Chaos and Creation met through their music and discovered a mutual interest in steampunk. In 2011, they began organizing Steam Garden, a themed steampunk event that features music, performers, handmade crafts, and adventure. Their friends joined them, and the Tokyo Inventors Society was born.

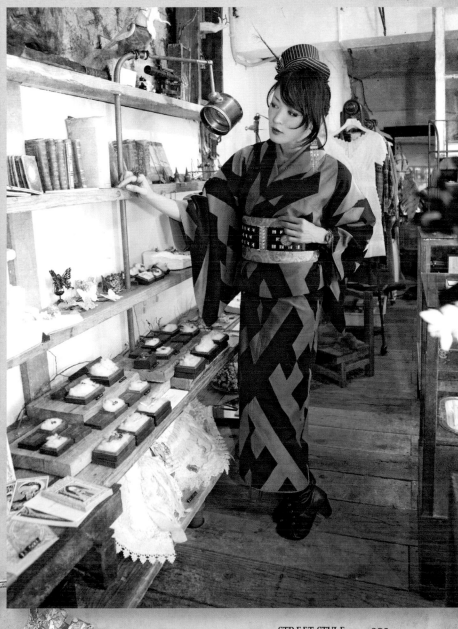

OPPOSITE PAGE *Misa, who serves as DJ at Steam Garden events, and Luke Chaos, one of the organizers, on the streets of Tokyo in their everyday steampunk attire.*

ABOVE *In addition to organizing, Kenny Creation DJs Celtic and neo-medieval music and plays electric bagpipes at Steam Garden events.*

RIGHT *Kaori Kawabuchi, a sword action performer and stunt artist, regularly performs at Steam Garden.*

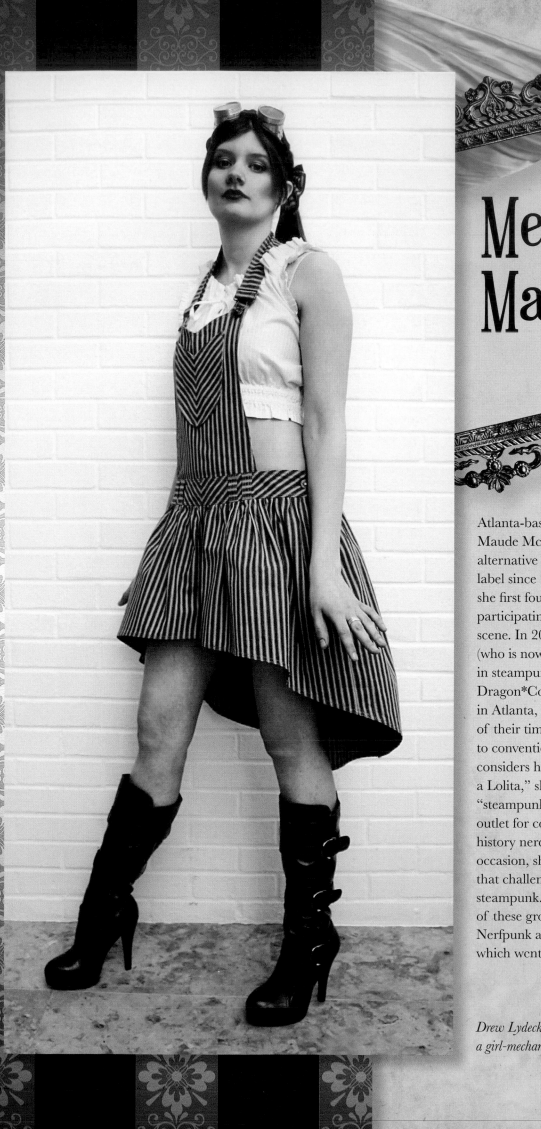

Megan Maude

Atlanta-based designer Megan Maude McHugh has created alternative fashions under her own label since 2003. That same year, she first found steampunk while participating in the convention scene. In 2006, she and Austin Sirkin (who is now her husband) dressed in steampunk style and attended Dragon*Con, a sci-fi convention in Atlanta, where they spent much of their time explaining steampunk to convention goers. Although she considers herself "to be primarily a Lolita," she says that she finds "steampunk to be a fun creative outlet for cosplay and for my inner history nerd." On more than one occasion, she has led cosplay groups that challenge and poke fun at steampunk. "The two most notable of these groups," she says, "are Nerfpunk and Rococopunk, both of which went viral on the Internet."

Drew Lydecker models a girl-mechanic look.

Megan Maude's designs range from gothic Lolita, to steampunk, to unique retro-inspired looks. She has displayed her clothing in fashion shows across the country, and has been featured in magazines such as *Gothic & Lolita Bible* and *Gothic Beauty*, and in books such as *1000 Steampunk Creations*.

In an overalls-style mini dress, Drew Lydecker's look references a steampunk girl mechanic. Her cotton twill dress has pockets to store tools, and the low-slung waistline can accommodate a utility belt. Holly Hickerson models a synthesis of styles—steampunk crossed with gothic Lolita. This versatile dress, with its layered skirt, is made from cotton shirting, silk dupioni, and wool suiting. In her wool deerstalker hat and houndstooth dress, model Allie Pixie could be a female Sherlock Holmes. At the same time, her outfit easily travels to the office or the store and out for a meal in the evening. Here we have three steampunk ensembles and not a corset in sight!

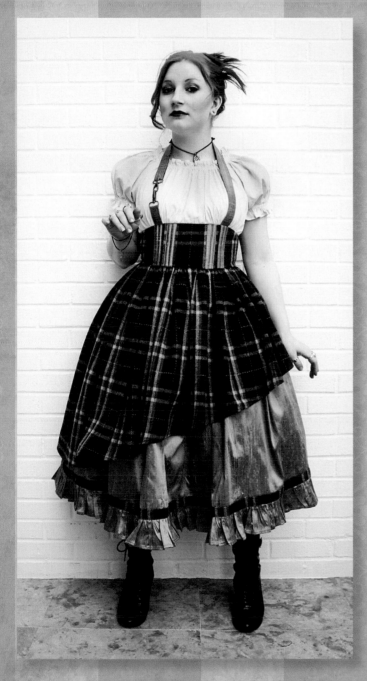

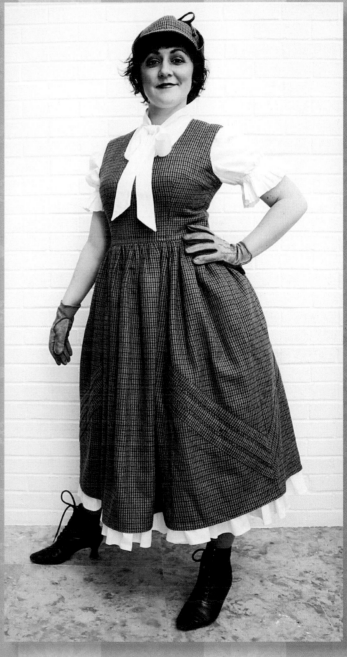

This layered skirt and sweet blouse display the influence of Lolita fashions.

This wool hat and dress recall the great Sherlock Holmes.

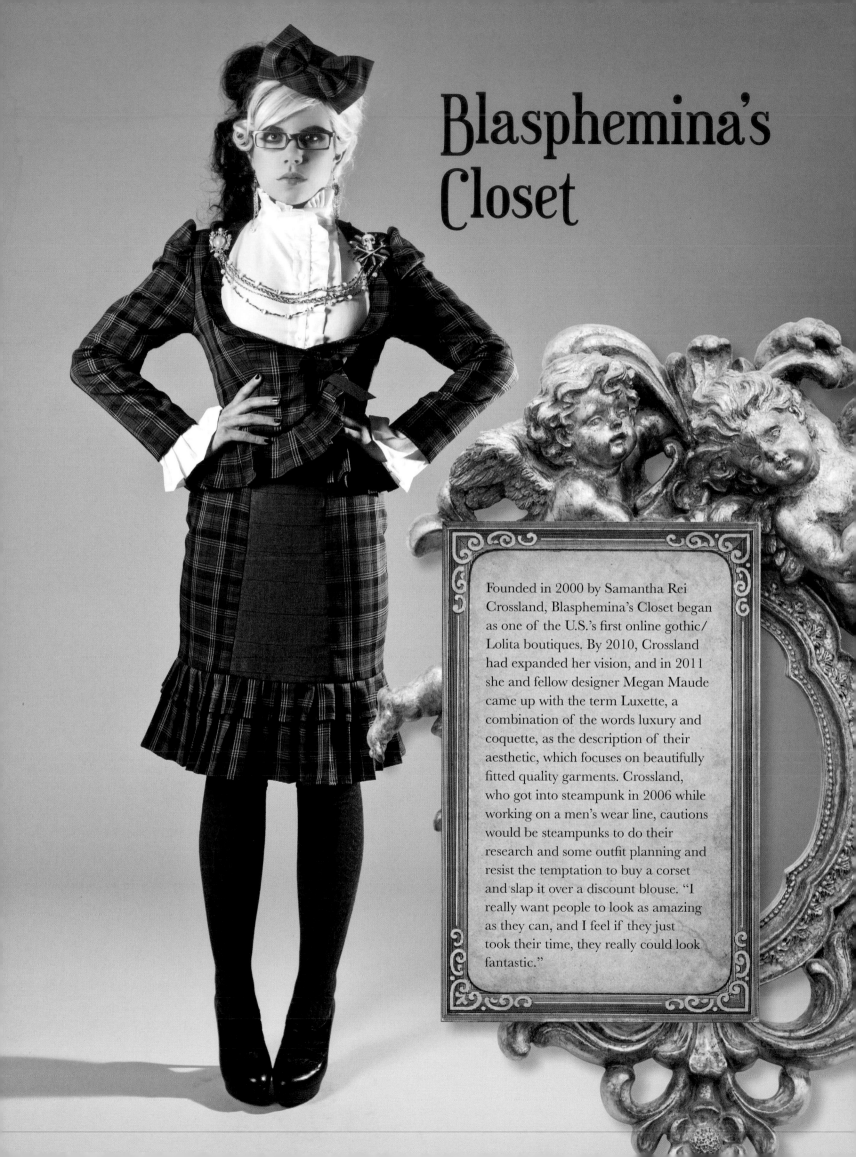

Blasphemina's Closet

Founded in 2000 by Samantha Rei Crossland, Blasphemina's Closet began as one of the U.S.'s first online gothic/Lolita boutiques. By 2010, Crossland had expanded her vision, and in 2011 she and fellow designer Megan Maude came up with the term Luxette, a combination of the words luxury and coquette, as the description of their aesthetic, which focuses on beautifully fitted quality garments. Crossland, who got into steampunk in 2006 while working on a men's wear line, cautions would be steampunks to do their research and some outfit planning and resist the temptation to buy a corset and slap it over a discount blouse. "I really want people to look as amazing as they can, and I feel if they just took their time, they really could look fantastic."

This plaid school girl look, which seems both proper and rebellious at once, gets all As. Inspired by private school uniforms, punk rock, and reform school girls, the suit is crafted from a wool and polyester blend.

The high-waisted yellow and black print skirt bears lines from Yeats: "Come away, O human child! To the waters and the wild." This outfit comes from the designer's spring/ summer 2013 collection, which was inspired by Peter Pan, *Le Petit Prince*, changelings, and the Yeats poem. The skirt's fabric is a custom print by artist Lee Blauersouth.

OPPOSITE PAGE *From the designer's Riot/Reform collection (fall/winter 2011), which was inspired by school uniforms, reform school, and punk rock.*

RIGHT *With a quote from Yeats just above the hem, this custom-printed cotton skirt comes from Second Star, the designers spring/summer 2013 collection.*

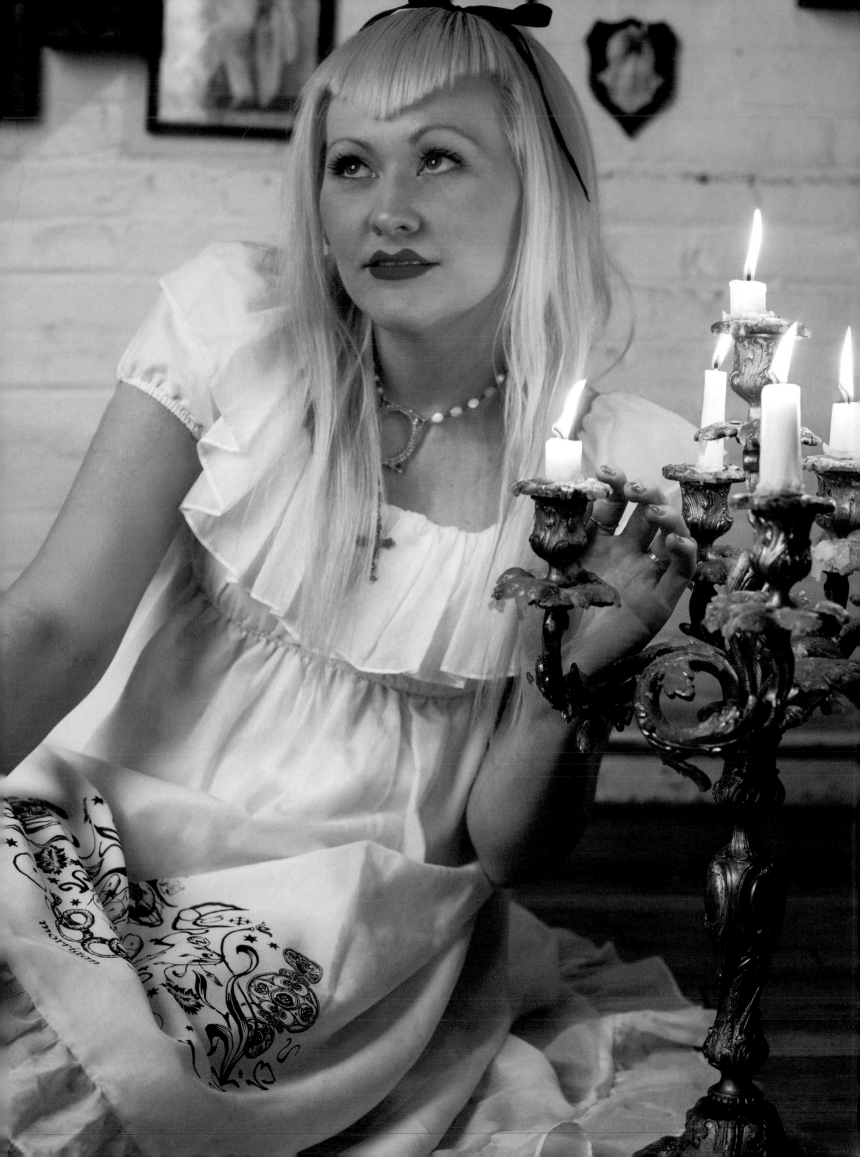

Morrigan New York

Designer Zoh Rothberg has created her own brand of neo-Victorian and elegant gothic Lolita-influenced fashions under the Morrigan New York label since 2008. With a background in art history, which she studied at the University of Chicago, Rothberg moved to New York City to learn pattern drafting. Although she had experimented with altering her own thrift store finds in high school to achieve a more gothic look, she did not start trying to make clothes for others till she was in her twenties. In addition to designing her own line, which is entirely fabricated in small factories in New York, Rothberg is interested in handsewing and Victorian methods of garment construction and enjoys researching how antique clothing was put together.

Model Sara Bender wears a dress of cotton voile—light, airy, and feminine. Gathers along the empire waist and ruffles at the neckline and hem add to the sweet charm. On the skirt, this dress features a print designed by New York City–based artist Seze Devres. The image is a collage of mystical symbols, including a hand with palm-reading glyphs on it, a pair of snakes, the sun, the moon, and a few flowers and flower buds. The print is intended to reference the spiritual experimentation of the nineteenth century, and both the artist's and the designer's shared interest in the sublime.

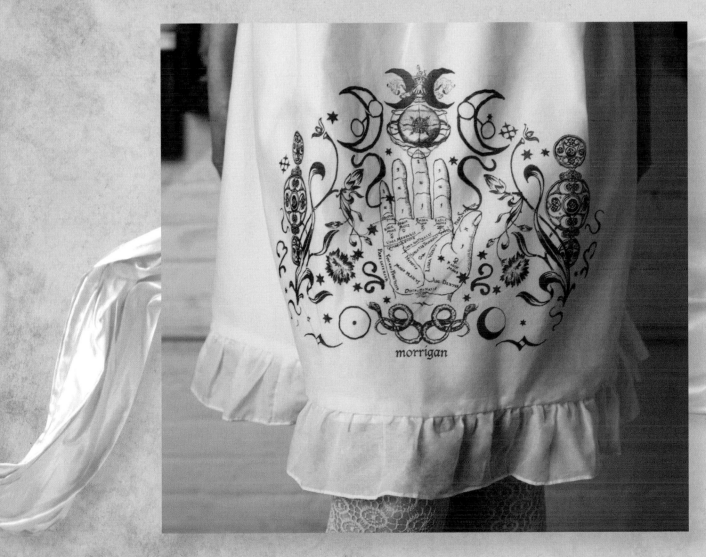

The image of a hand, mapped out like an old palm-reading chart, takes the central space in this design.

Like the dress on the previous page, this black outfit is from the Seze Devres print collection. Fabricated from cotton velvet, the dress has the print of the hand and a variety of symbols silkscreened in silver on the front of the skirt. On top of the dress, a matching taffeta corselette enhances the waist. The corselette ties in the back with ribbon, and it features the symbolic print hand-silkscreened in silver. Although the corselette is sturdy—it's backed with thick canvas and can be cinched tightly—it is not meant to reduce the waist, as a true corset does. It's intended as a fashion statement and to give the visual look of a waistline. The designer says: "For the corselette I was inspired by mid-century 'Swiss waists' that were worn on top of a skirt and blouse by young women during the Civil War Era."

The plaid dress is made from taffeta and has antique lace at the sleeves and neck. This look is inspired by garments from the 1880s and 90s. Note the huge puffed sleeves. "I wanted to evoke a doll-like, British sort of feeling," Rothberg says, "maybe like an antique doll." Rotheberg created this dress as a one-of-a-kind garment, but soon found customers asking about it. The dress has "become so popular I'm thinking about manufacturing it."

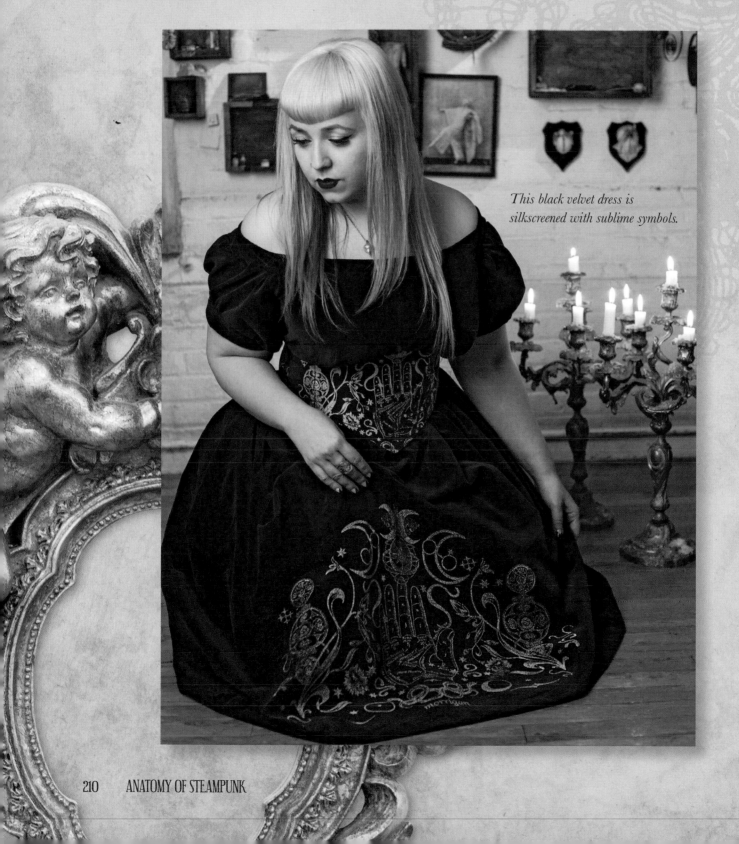

This black velvet dress is silkscreened with sublime symbols.

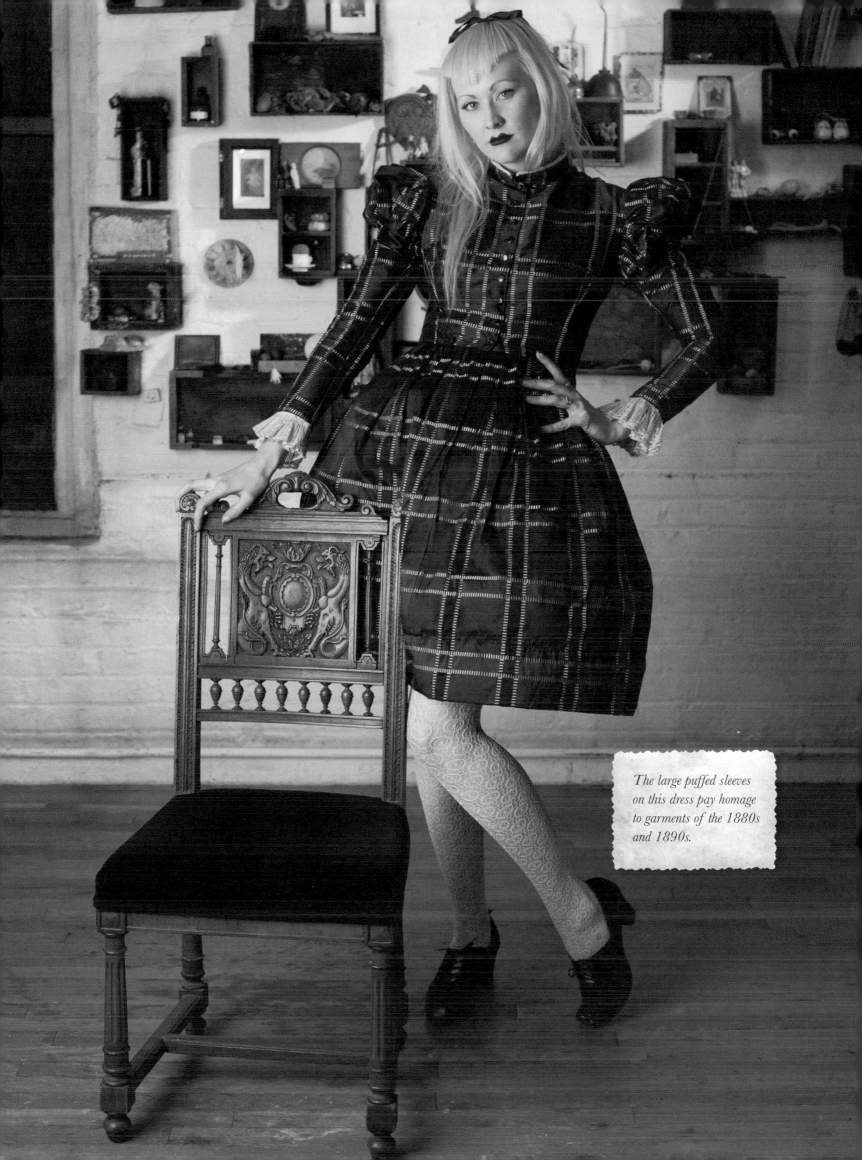

The large puffed sleeves on this dress pay homage to garments of the 1880s and 1890s.

Dressed in black with a beret, model Cindy Waters puts a polished spin on the bohemian look. This ensemble features a skirt from Morrigan's Nautical Series that bears a silk-screened illustration by artist Matthew Boyle. The print depicts two imagined scenes from *Moby Dick*, with quotes from the book running below. The series is "meant as a lighthearted riff on the 'sailor outfit' theme," Rothberg says. "The idea being that a charming Edwardian sailor outfit with a *Moby Dick* print would be hilariously depressing and cute, simultaneously." The skirt is crafted from 100% British-made cotton. In addition to the print, the skirt features a detachable cotton bow at the back.

Quotes and imagined scenes from Moby Dick *decorate this black cotton skirt.*

This white dress, which was inspired by images of Edwardian swimwear, is also from the Nautical Series and, like the black skirt, is made from British cotton and features two *Moby Dick* images and a detachable cotton bow at the rear.

Inspired by Edwardian swimwear, this dress features two Moby Dick *images.*

Steampunk presents many wearable clothing options, all of which are influenced by history. In this section, we have seen fashions inspired by Victorian and Edwardian times, items tinged with the gothic, and those suffused with the innocent charm of Lolita looks. Right now, we hear the clock ticking. In the next pages, learn to make a piece of jewelry from watch parts. Then read on and fashion your own custom cravat.

Steampunk Pendant

By Won Park

POST CARD

DIY

When pulling your personalized steampunk look together, top it off with a beautiful handmade steampunk pendant. In this tutorial you will learn how to make two different styles of pendants. Use these ideas as a guide to create your own special adornment.

Most of the jewelry items mentioned here can be found at your local craft store. Vintage pocket watches and watch movements can be found online.

You Will Need:

Watch and pocket watch parts, such as watch faces, plates, etc.
Mini screwdrivers
Jeweler's pliers
Craft glue/instant glue
Small file

Various watch and pocket watch movements

Small clock gears, pocket watch gears, and other parts

Charms and jewelry findings

Filigree jewelry bases

Crystal accents

This first pendant is the easiest to make and it is one of my best-selling styles. Items used for this pendant: a clock gear, a watch movement, a jewelry bail, and two crystal accents.

1 Make sure that the clock gear you're going to use is a bit larger than the watch movement. If your watch movement still has its face, remove it, and reserve the face for another project. File down any sharp pins that may be sticking out.

2 Attach the watch movement to the center of the clock gear using craft glue.

3 Add crystal embellishments wherever you like.

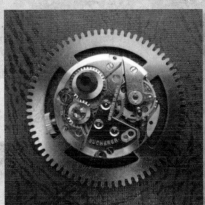

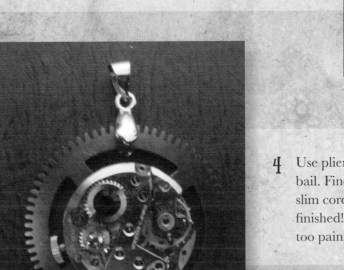

4 Use pliers to attach the bail. Find a chain or a slim cord, and you're finished! That wasn't too painful, now was it?

This next pendant is a bit harder to make, and it's fancy! You will need an old pocket watch movement, a filigree base big enough for the pocket watch to sit upon, crystal accents, a charm, a jump ring, and a bail.

1 If your pocket watch movement still has the face attached, remove it. Save the face for making other jewelry.

2 File down or snap off any sharp pins sticking out. Carefully remove the back plate of the pocket watch, being sure not to disturb the gears beneath.

3 To make sure none of the parts fall off, glue all the gears on the pocket watch in place, using an instant glue. Then attach the pocket watch to the filigree base with craft glue. Using a jump ring, attach the charm to the bottom of the filigree, then using pliers, add the bail to the top.

4 Glue on whatever crystal accents you like.

Here are some photos of a few additional steampunk pendants to inspire you in styling your own pieces.

Parts from watches and pocket watches went into the making of this pendant.

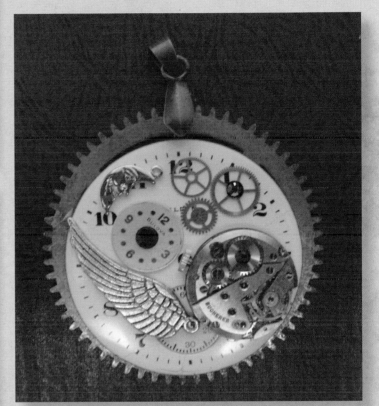

Here's a good way to use the face of a pocket watch.

A filigree jewelry base anchors a variety of small gears, a watch plate, and a movement. The addition of a charm and a few strategically placed crystals add contrast and depth.

Cravat

By Noam Berg

DIY

Adding neckwear to an outfit is a simple and easy way to conjure a bit of retro-steam. The cravat, which is considered to be the forerunner of the contemporary necktie, takes its name from the Croatian soldiers who first brought this essential accessory to France in the seventeenth century.

You Will Need:

A length of white cotton fabric, at
 least 60" across and 10" wide
Iron and ironing board
Tape measure
Measuring stick
Marking implement (sewing pen or
 tailor's chalk)
Scissors
Pins
Needle or sewing machine
Thread

1 Take your fabric and fold it in half lengthwise. Press the fold with your iron.

2 Mark the width of your cravat by measuring off 4" from the fold. Make a line parallel with the fold.

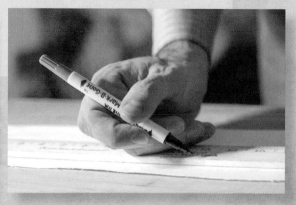

3 To create the ends, fold the fabric over at a 45° angle. Press the fold with your iron, then mark the line on the fabric.

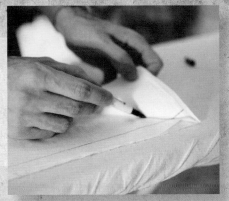
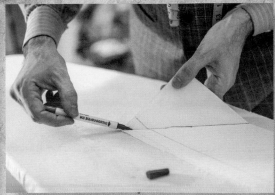

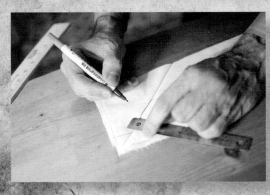

4 Add ¼" seam allowance on both ends and on the long side of the pattern.

5 Trim the fabric along all three seam allowance lines.

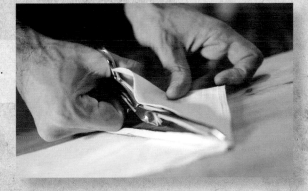

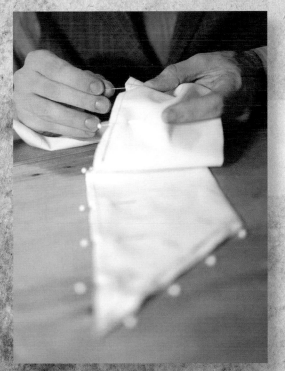

6 Make sure everything lines up nicely (give the fabric a pressing with the iron if you need to), then pin the seams.

7 Time to sew! Stitch the long seam and ONE of the short ends, leaving the other end open. Remove the pen or chalk lines you have marked by following the manufacturer's direction. Don't worry if the fabric does not look perfect. The surface you've been working on is about to become the inside of the cravat.

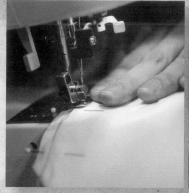

8 Turn the cravat inside out, and press it flat.

9 Fold in the seam allowance on both layers of the remaining open end and iron them into place.

10 Pin the seam together and sew along the open edge.

11 Give the whole cravat a final pressing to make sure it looks neat. You now have a cravat!

Here is how to tie your cravat:

1. With both hands, hold the cravat out in front of your neck. Position the center of the fabric over your throat.

2. Pass the ends around the back of your neck. Then bring both ends back to the front.

3. Investigate some historic neck wear knots, tie your favorite knot, or make a simple square knot.

4. Tuck the ends into a vest, or wear them out loose.

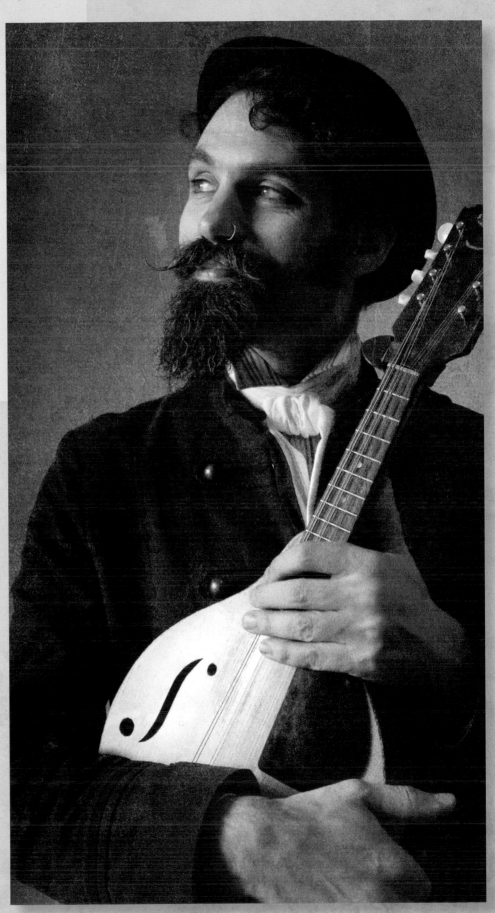

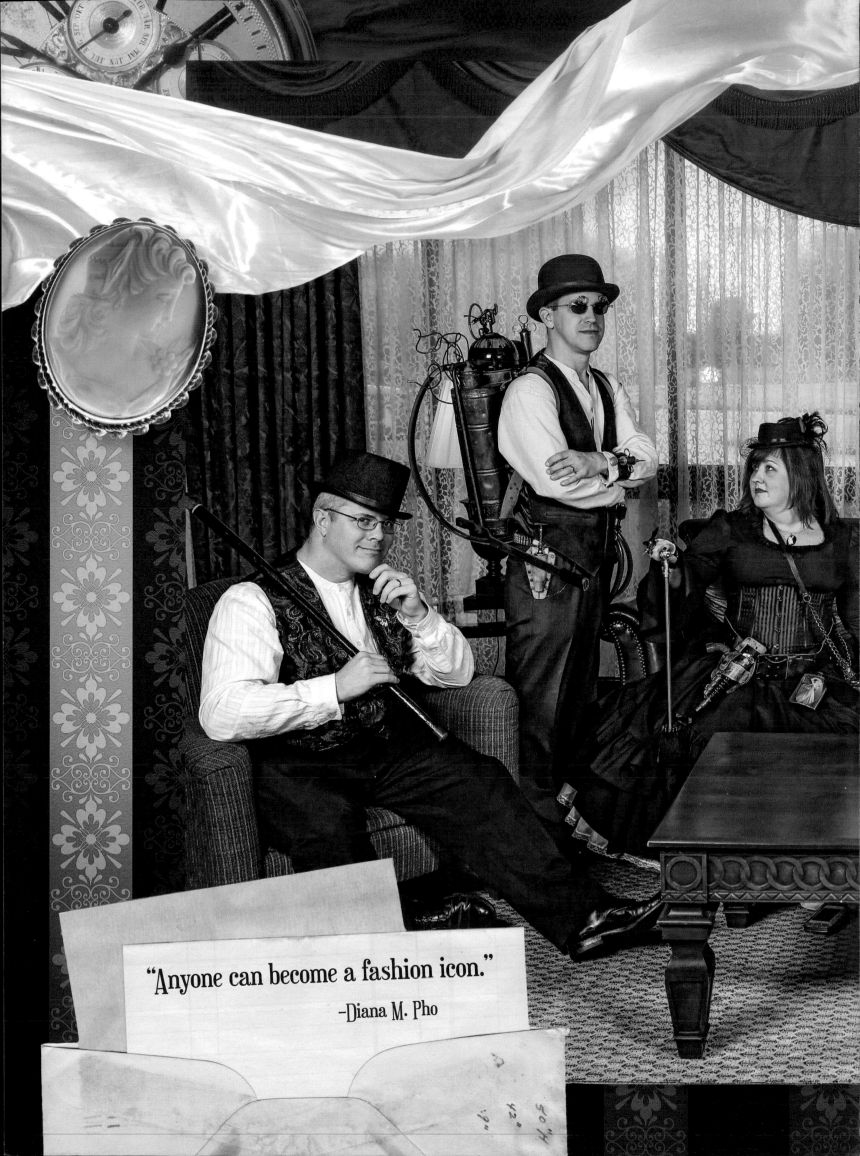

"Anyone can become a fashion icon."

-Diana M. Pho

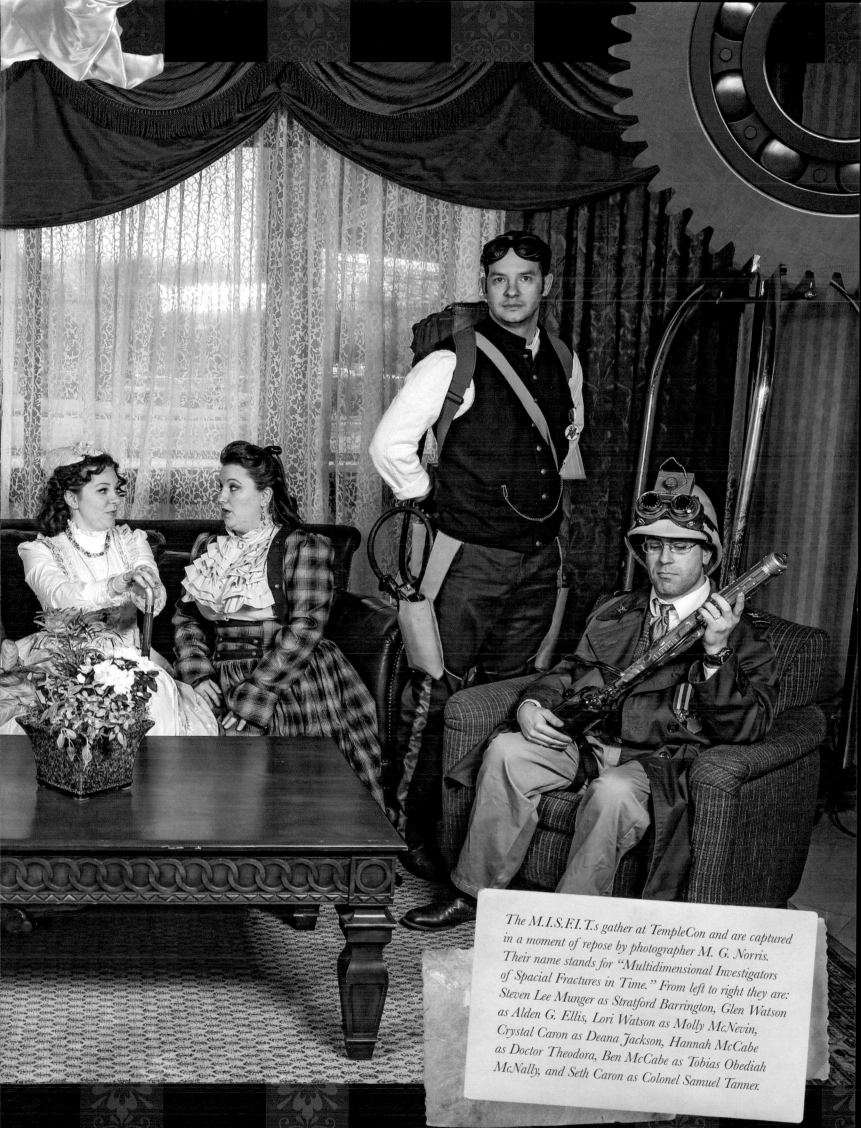

The M.I.S.F.I.T.s gather at TempleCon and are captured in a moment of repose by photographer M. G. Norris. Their name stands for "Multidimensional Investigators of Spacial Fractures in Time." From left to right they are: Steven Lee Munger as Stratford Barrington, Glen Watson as Alden G. Ellis, Lori Watson as Molly McNevin, Crystal Caron as Deana Jackson, Hannah McCabe as Doctor Theodora, Ben McCabe as Tobias Obediah McNally, and Seth Caron as Colonel Samuel Tanner.

Acknowledgments

This book owes so much to Diana M. Pho, who wrote the introduction and offered crucial guidance. Thanks also to K. W. Jeter and Catherine Siemann. For sharing their expertise in our DIY sections, I am grateful to Noam Berg and Won Park. Park, a Honolulu-based artist, mainly known for his origami work, has harbored a lifelong passion for science fiction and antiques. He plans to make more steampunk art and hopes to contribute to the steampunk lifestyle.

I'm indebted to photographer Babette Daniels (www.babetted.com) for shooting photos for Noam's DIY projects (pages 78–83, 160–5, 184–93, and 218–20). And a big thank you to graphic designer Tim Palin for his good humor, patience, and superlative work.

I would like to thank all the designers, photographers, and steampunks who provided images. So many of these creative individuals shared their work, life stories, and inspiration with me. I'll be forever grateful for their generosity. Individual photo credits are listed below. If any acknowledgments have been overlooked, they will be corrected in subsequent printings.

Katherine Gleason
New York City

Credits

ON THE COVER Model Sera Ferron shows off a necklace and eye patch of her own creation; Millinery: Green Bunny Hats; Corset: Timeless Trends Corsets; Makeup: Bunny Green; Photo: Robert Sleeper Photography LLC. **PAGE 2** Model: Aamina Sheikh; Makeup/styling/photo: Maram & Aabroo; Clutches: Ali Fateh. **PAGE 6** Photo of K. W. Jeter courtesy of K. W. Jeter. **PAGE 8** Model: Diana M. Pho; Hair/makeup: Ashley Lauren Rogers; Dress: Jayne Faire; Jewelry: Muses Well; Photo: Rachael Shane. **PAGE 9** Model: Dexter Raphael; Fashion/styling: Orli Nativ; Photo: Kate Conover; Editing: Kim Pho. **PAGE 10** Model: Joey Marsocci (aka Dr. Grymm); Mask/fashion: Joey Marsocci; Photo: Babette Daniels Photography. **PAGE 11** Models: Barbara No, Urena Howard, Dom Darby, and Sereene Brown; Fashion/styling: Orli Nativ; Photo: Knightmare6 Photography; Editing: Kim Pho. **PAGE 12** Models: Mary Holzman-Tweed and Phil Powell; Photo: Babette Daniels Photography. **PAGES 14–15** Model: Leah Siren; Dress: Rubenesque Latex; Hair/makeup: Pick Your Poison by Shauna LeMay; Photo: Dana Lane Photography(www.danalanephoto.com). **PAGE 16** Model: Phil Powell; Photographer: Denis Largeron. **PAGE 17** Model: Phil Powell; Photo: Babette Daniels Photography. **PAGE 18** Model: Donna Ricci; Hair/makeup: Tuesday Coren; Photo: Pixie Vision. **PAGE 19** Model: Donna Ricci; Makeup: Angel Jagger; Hair: Tuesday Coren; Photo: Derek Caballero. **PAGE 20** Model: Samara Martin; Photo: Jessica M. Lilley. **PAGE 21** Model: Diana M. Pho; Photo: Jessica M. Lilley. **PAGES 22–3** Model: Amanda Troutman; Photo: Angie Carter. **PAGES 24 + 26** (bottom) Model: Keri Lynn Timlin; Makeup: Cara Silverman; Hair: Jaime Luppino; Photo: Tarik Carroll. **PAGES 25–6** (top) Model: Jocelyn Cattley; Makeup: Cara Silverman; Hair: Jaime Luppino; Photo: Tarik Carroll. **PAGE 27** Model: Dark Tranquility; Photo: Knightmare6 Photography. **PAGES 28–9** Model: Agnieszka Koseatra Juros; Photographer: Tomasz Wnetrzak (www.dwojewkadrze.pl). **PAGE 30** Model: Crystal Welle; Hair: Sheridyn McClain and Elizabeth Sloan. **PAGE 31** Model: Eileen; Hair/makeup: M.C. Artistry; Photo: Joshua Spotts, Stray Things Photography. **PAGE 32** Model: Cassandra Rosebeetle; Makeup: Kristin Costa; Photo: Mark Feigenbaum. **PAGE 33** Model: Setna MacBryan; Photo: Mark Feigenbaum. **PAGE 34** Model: Kim Connolly; Photo: Mark Feigenbaum. **PAGE 35** Model: Kristin Etzold; Photo: Babette Daniels Photography. **PAGES 36–9** Model: Nijhum Nj Patra; Makeup/FX: Sara Capela; Assistants: Nidhi Gandhi, Yunus Ansari, and Prajakta Raokhande; Photo: Manoj Jadhav. **PAGE 40** Model: Belladonna Belleville; Hair/makeup: Holly Hickerson; Photo: Knightmare6 Photography. **PAGE 41** Model: Myra D'amaged; Hair: Brittany Martin; Makeup: Kara Sheftel; Photo: Raymond Peeples. **PAGE 42** Model: Victoria Morton Williams; Makeup Brittany Martin; Photo: Brittanie Jones Photography. **PAGE 43** Model: Shelley Nault; Hair/makeup: Big Tease Hair Designs; Photo: Kev Cool. **PAGE 44** Model: Kat John Adams; Photo: Babette Daniels Photography. **PAGE 45** Model: J. Hellum; Photo: Babette Daniels Photography. **PAGES 46–7** Model: Anthony Canney. Photo: Graffiti Photographic for Cloud Orchid Magazine. **PAGES 48–9** Model: Ari Giancaterino; Photo: Lucia Loiso. **PAGES 50–1** Model: Oliver Lowe; Photo: Deborah Sciales. **PAGES 52–3** Photos courtesy of Costume Mercenary. **PAGES 54–7** Model: Aamina Sheikh; Makeup/styling/photo: Maram & Aabroo. **PAGE 58** (top) Model: Dottie Poole; Photo: Gail Kilker. (bottom) Model: Sharon Tk; Makeup: Aleksandra Ambrozy; Photo: Elizabeth Kross. **PAGE 59** Model: Ryan Krasney; Hair/makeup: Blend; Photo: Gail Kilker. **PAGE 60** (left) Model: Isa Voros; Hair: Anna DeMeo; Makeup: Makeup Massacre; Styling: Karen von Oppen; Photo: Taryn True; (right) Photo: Frank Siciliano. **PAGE 61** Model: Emily Kayashima; Hair: Anna DeMeo; Makeup: Makeup Massacre; Styling: Karen von Oppen; Photo: Taryn True. **PAGE 62** Model: Sarah Jai; Hair/makeup: Shantell Bresset-Wakely; Photo: Maaike Roosendaal, Brilliant Images. **PAGE 63** Model: Cristina Peterson; Hair/makeup: M. C. Nelson Artistry; Photo: Amy Ballinger. **PAGE 64** Model: Kayley Johnson; Corset by Scoundrelle's Keep; Photo: Fairshadow Photography. **PAGE 65** Model: Crystal Welle; Photo: Fairshadow Photography. **PAGES 66–7** Photos courtesy of Belinda Lockhart. **PAGES 68–73** Model: Harvy Santos. **PAGES 74–7** Photo: Won Park. **PAGE 84** Model: Panda Ayotte as Belladonna Belleville; Photo: Babette Daniels Photography. **PAGES 86–7** Photo: Black Sails Photography. **PAGE 88** Model: Nick Picard; Top hat: Danny Ashby, Outland Armour; Photo: RBC Image. **PAGE 89** Models: Catherine Barson, Jason Bush, and Nick Picard; Photo: DM Photography. **PAGE 90** Models: Nick Picard, Catherine Barson, and Jason Bush; Photo: RBC Image. **PAGE 91** Models: Nick Picard, Jason Bush, Catherine Barson; Photo: Michael Stippich. **PAGE 92** Model: Catherine Barson; Photo: DM Photography. **PAGE 93** Model: Jason Bush; Photo: RBC Image. **PAGE 94** Model: Benjamin Gould; Photo: Dastardly Dave. **PAGE 95** (top) Model: Apnea; Photo: CYN Photography; (bottom) Model: Benjamin Gould; Makeup: Ryver Van De Pol; Photo: Kindred's Muze. **PAGE 96** Photo: Greg DeStefano. **PAGE 97** Photo: Lex Machina. **PAGE 98** Photo: Greg DeStefano; Editing: Andrew Fogel. **PAGE 99** (top) Photo: Greg DeStefano; Editing: Andrew Fogel. (bottom) Photo: Andrew Fogel; Editing: Andrew Fogel and Glenn Freund. **PAGE 100** Photo: Greg DeStefano; Editing: Glenn Freund. **PAGES 101–3** Photo: Greg DeStefano; Editing: Andrew Fogel. **PAGE 104** Photo: Will Bolton; Editing: Aimee Stewart. **PAGE 105** (top) Photo: Kyle Neil; Editing: Aimee Stewart; (bottom) Photo: Hogarts Photography; Editing: Aimee Stewart. **PAGES 106–7** Photos: © 2012 by Thomas Dodd (all rights reserved—used with artist's permission). **PAGES 108 + 109** (top) Photo: Babette Daniels Photography. **PAGE 109** (bottom) Photo: Unknown. **PAGES 110–19** Photo: Won Park. **PAGE 120** Model: Nivi Hicks; Photo: Justin S. Lofley, Lofley Photography. **PAGE 122** Model: Matt Coles; Photo: Morrigana Townsend-Pehlke. **PAGE 123** Model: Miki Sarroca; Hair/makeup: Stephanie of Eat Your Makeup; Assistant: Chris Chetwood; Photo: Kendra Paige. **PAGES 124–5** Photo: Kristi Smart. **PAGE 126** Model: Isaiah Max Plovnick as Edward Von Arkham; Photo: Nate Buchman. **PAGE 127** Photo: RockLove Jewelry. **PAGES 128–31** Model: Alexandros Makris; Photo: Alexandros Kokkinos. **PAGE 132** Model: John Gannon (Sky Capt. Gannon); Photo: Ninh T. Chau, Imagez Photography. **PAGE 133** (top) Model: Robert Brown; Photo: Thomas Willeford and Robert Brown; (bottom) Photo: Sarah Hunter. **PAGE 134** Model: Sarah Hunter; Hair/makeup: Debra Weite; Photo: Julie Ray Photography; used with permission of the F.J. Westcott Company. **PAGE 135** Model: Sarah Hunter; Photo: Scott Church. **PAGE 136** Model: Michael Salerno; Photo: Michael Salerno. **PAGE 137** Model: Michael Salerno; Photo: Nate Buchman. **PAGES 138–9** Models: Nicole Spain and Jamie Woodford; Makeup: Bobbie Eller; Costume: Andrew Angulo and Bobbie Eller; Hair: Celeste Olivarez; Photo: Andrew Angulo. **PAGE 139** (top) Model: Keith McPherson; Costume: Andrew Angulo and Bobbie Eller; Photo: Andrew Angulo. **PAGE 140** Model: Felicia Day; Hair/makeup: Eliza Jaegger; Photo: Pixie Vision. **PAGE 141** Models: Donna Ricci and Felicia Day; Hair/makeup: Eliza Jaegger; Photo: Pixie Vision. **PAGES 142–3** Model: Donna Ricci; Hair/makeup: Eliza Jaegger; Styling: Krystyn Ingram; Photo: Pixie Vision. **PAGE 144** Model: Toni Barnes; Hair: Jessica Parol; Photo: AUC Photography. **PAGE 145** Model: Grant Imahara; Hair/makeup: Tuesday Coren; Photo: Pixie Vision. **PAGE 146** Model: Maurice Grunbaum; Photo: Gilles Michel. **PAGE 147** Model: Maurice Grunbaum; Photo: David Salou. **PAGES 148–9** Photos courtesy of Costume Mercenary. **PAGE 150** (left) Model: Carla Coles; Photo: Morrigana Townsend-Pehlke; (right) Model: Greg Mizon; Photo: Maaike Roosendaal, Brilliant Images. **PAGE 151** Model: Mary King; Hair/makeup: Shantell Bresset-Wakely; Photo: Maaike Roosendaal, Brilliant Images. **PAGE 152** Model: Ashley Lauren Rogers; Photo: Raymond C. Peeples Jr. / Peeples Photography. **PAGE 153** Model: Amanda Troutman; Photo: Angie Carter. **PAGES 154–5** Model: Kevin Rychman; Hair: Angie Carter; Photo: Angie Carter. **PAGES 156–8** Model: Tony Ballard-Smoot; Photo: Rob Manko, Manko Photography. **PAGE 159** Model: Tony Ballard-Smoot; Photo: Graffiti Photographic for Cloud Orchid Magazine. **PAGE 160** (top) Photo: Noam Berg. **PAGE 165** (bottom) Photo: Noam Berg. **PAGES 166–9** Photo: Won Park. **PAGE 170** Model: Nick Baumann; Photo: Lex Machina. **PAGE 172** Model: Bootsi Dimitruk; Makeup: Brittany Marie Martin; Photo: Peeples Photography. **PAGE 173** (top) Model: Leah Siren; Corset: Fantasia; Makeup: Kara Sheftel; Hair: Brittany Marie Martin; Photo: Babette Daniels Photography. (bottom) Model: Kathryn Paterwic; Hair/makeup/photo: Kara Sheftel. **PAGE 174** Model: Monique Poirier; Photo: Allison Holmes. **PAGE 175** Photo courtesy of Costume Mercenary. **PAGES 176–7** Models: Emma Caulfield, Doug Jones, and Camilla Rantsen; Photo: Danielle Bedics; Digital artist: Krista Benson. **PAGE 178** Model: Matt Schmidt; Photo: Tom Banwell. **PAGE 179** Model: Cristy Johnson; Photo: Ian Finch-Field. **PAGE 181** Model: Tom Keeler; Photo: Knightmare6 Photography. **PAGES 182–3** Model: Miriam Rosenberg Roček; **PAGE 182** Photo: Babette Daniels Photography; **PAGE 183** (top, left) Photo: Carrie Meyer, Insomniac Studios; (top, right) Photo: Monique Poirier; (bottom) Photo: Unknown. **PAGE 194** Model: Margaret "Magpie" Killjoy; Photo: Matt Seemann. **PAGES 196–7** Photos courtesy of Lastwear. **PAGES 198–9** Photo: Kendra Paige; Hair/makeup: Stephanie of Eat Your Makeup; Assistant: Chris Chetwood; **198** (left) Model: Ashley Fernandez; (right) Model: Miki Sarroca; **199** Model: Megan Coffey. **PAGE 200** Model: Oliver Lowe; Photo: Deborah Sciales. **PAGE 201** (top) Model: Serena Toxicat; Photo: Deborah Sciales; (bottom) Model: Deborah Sciales; Photo: Oliver Lowe. **PAGES 202–3** Photo: Aki Saito; **202** Models: Misa and Luke Chaos; **203** (left) Model: Kenny Creation; (right) Model: Kaori Kawabuchi. **PAGES 204–5** Photo: Nate Buchman; **204** Model: Drew Lydecker; Makeup: Holly Hickerson; **205** (left) Model: Holly Hickerson; (right) Model: Allie Pixie; Makeup: Holly Hickerson. **PAGE 206** Model: Cristina Peterson; Makeup: Holly Luckes; Hair: Kati Hackett; Jewelry: Bionic Unicorn; Hat: Apatico; Glasses: Spectacle Shoppe; Photo: Fairshadow Photography. **PAGE 207** Model: Aja Akuee; Jewelry: Bionic Unicorn; Hair: Mahogany Plautz; makeup: Abbey Arthur; Custom fabric: Lee Blauersouth; Photo: Rhea Pappas Photography. **PAGES 208–13** Photo: Bianca Alexis Photography; Images © Morrigan New York; Stylist: Anne Arden McDonald; **208–9** Model: Sara Bender; **210** Model: Cindy Waters; **211** Model: Sara Bender; **212** Model: Cindy Waters; **213** Model: Sara Bender. **PAGES 214–17** Photo: Won Park. **PAGE 221** Model: Noam Berg; Photo: © 2013 by Steven Rosen (all rights reserved—used with artist's permission). **PAGES 222–3** Models: Steven Lee Munger, Glen Watson, Lori Watson, Crystal Caron, Hannah McCabe, Ben McCabe, and Seth Caron; Photo: M. G. Norris. **BACK COVER** Designer/Mask: Dawnamatrix; Model: Benjamin Gould; Photo: Dastardly Dave.

SUPPLEMENTAL ART, PAGES 1, 3–11, 13–54, 57–8, 60–70, 72–89, 91–119, 121–9, 131–9, 141–2, 144–69, 171–3, 175, 177–81, 182–93, 195–207, 209–24, BACK COVER and DUST JACKET; Photo: Thinkstock.